The Gentleman's House in the British Atlantic World 1680–1780

The Gentleman's House in the British Atlantic World 1680–1780

Stephen Hague
Rowan University, USA

palgrave
macmillan

© Stephen Hague 2015

All rights reserved. No reproduction, copy or transmission of this publication may be made without written permission.

No portion of this publication may be reproduced, copied or transmitted save with written permission or in accordance with the provisions of the Copyright, Designs and Patents Act 1988, or under the terms of any licence permitting limited copying issued by the Copyright Licensing Agency, Saffron House, 6–10 Kirby Street, London EC1N 8TS.

Any person who does any unauthorized act in relation to this publication may be liable to criminal prosecution and civil claims for damages.

The author has asserted his right to be identified as the author of this work in accordance with the Copyright, Designs and Patents Act 1988.

First published 2015 by
PALGRAVE MACMILLAN

Palgrave Macmillan in the UK is an imprint of Macmillan Publishers Limited, registered in England, company number 785998, of Houndmills, Basingstoke, Hampshire RG21 6XS.

Palgrave Macmillan in the US is a division of St Martin's Press LLC, 175 Fifth Avenue, New York, NY 10010.

Palgrave Macmillan is the global academic imprint of the above companies and has companies and representatives throughout the world.

Palgrave® and Macmillan® are registered trademarks in the United States, the United Kingdom, Europe and other countries.

ISBN: 978–1–137–37837–8

This book is printed on paper suitable for recycling and made from fully managed and sustained forest sources. Logging, pulping and manufacturing processes are expected to conform to the environmental regulations of the country of origin.

A catalogue record for this book is available from the British Library.

Library of Congress Cataloging-in-Publication Data

Hague, Stephen G. (Stephen George), 1967–
 The gentleman's house in the British Atlantic world, 1680–1780 / Stephen Hague (Rowan University, USA).
 pages cm
 ISBN 978–1–137–37837–8 (hardback)
 1. Gentry – Dwellings – United States – History. 2. Gentry – Dwellings – Great Britain – History. 3. Dwellings – Social aspects – United States – History. 4. Dwellings – Social aspects – Great Britain – History. 5. United States – Social life and customs – To 1775. 6. Great Britain – Social life and customs. 7. Social change – United States – History. 8. Social change – Great Britain – History. 9. Social mobility – United States – History. 10. Social mobility – Great Britain – History. I. Title.
E162.H15 2015
307.3'36097309033—dc23
 2015012346

Contents

List of Maps	vii
List of Figures	viii
List of Tables	x
List of Colour Plates	xi
Preface	xii
List of Abbreviations	xv

1	**Introduction**	1
2	**The Gentleman's House in Context**	9
	Gentlemen's houses in the west of England	10
	Gentlemen's houses in the British Atlantic world: when and where they were built	12
	The gentlemen who owned them	17
3	**Building Status**	26
	Architecture: form and style	27
	The gentry house to the 1720s	30
	Gentlemen's houses from the 1720s	36
	The building process for gentlemen's houses	42
	The economics of building	44
	Interpretation of meanings: gentlemen's houses as architecture	48
4	**Situating Status**	53
	The diversity of situations: change over time	54
	The function of gentlemen's houses: a 'beautiful villa or seat'?	57
	The surroundings of a gentleman's house	63
5	**Arranging Status**	73
	The size and arrangement of gentlemen's houses	74
	Interiors and spatial hierarchies	81
	Interior finishes	88
6	**Furnishing Status**	95
	Genteel displays in Britain	97
	Genteel displays in America	106
	Gentlemen's furnishings compared	111
7	**Enacting Status**	116
	Genteel households	118

The calibration of social status	121
Chancery court and chocolate pots	123
'Most genteel and hospitable receptions'	124
Devil Palling and 'his Kitchen where he generally sits'	126
'The finest couple that has ever been seen'	129
'A very Courteous & Elegant manner'	130
'Suitable to the fortune and dignity of a Nobleman'	133
8 Social Strategies and Gentlemanly Networks	**137**
Gentlemen and the structure of society	139
New men and their networks: land, commerce, and professional service	141
Gentlemanly networks and public life	146
Mercantile values and property rights	148
Imperializing projects	150
9 Conclusion	**154**
Notes	159
Select Bibliography	201
Index	225

List of Maps

2.1　Small classical houses built in Gloucestershire, 1658 to c. 1720　　14
2.2　Small classical houses built in Gloucestershire, c. 1720 to c. 1750　　15
2.3　Location of small classical houses built in America　　17

List of Figures

1.1	Paradise (now Castle Godwyn), Gloucestershire, c. 1730s	2
1.2	Stenton, 1723–1730, Philadelphia, Pennsylvania	3
2.1	Country house and gentlemen's house building, 1680–1770, by decade	13
3.1	Lower Slaughter Manor, 1656–1658, from a 1731 plan	27
3.2	Poulton Manor, c. 1690	29
3.3	Warmley House, c. 1750	30
3.4	Wotton, c. 1707	31
3.5	Nether Lypiatt, c. 1710	32
3.6	Sandywell, Glos., c. 1704, with 1720s wings	32
3.7	Pitchcombe House, Glos., c. 1743	34
3.8	Bigsweir House, Glos., c. 1755	34
3.9	The Governor's Palace, Virginia, c. 1710–1715	35
3.10	Wilton, Virginia, c. 1753	36
3.11	Cote, c. 1720	37
3.12	Frampton Court, 1731–1733	39
3.13	Redland Court, 1732–1735	39
3.14	Jeremiah Lee Mansion, Marblehead, Massachusetts, 1766–1768	41
3.15	Bishopsworth Manor, c. 1720	49
3.16	Stenton, 1723–1730, near Philadelphia	50
4.1	Detail of Benjamin Donn, 'Bristol and its environs' showing the location of several houses mentioned in the text	59
4.2	Scull and Heap map of Philadelphia, 1777	62
4.3	Fairford Park from Atkyns, 1712	64
4.4	Paradise (Castle Godwin), c. 1741	65
4.5	Old Frampton Court, c. 1650	67
4.6	Old Frampton Court, landscape plan	68
4.7	New Frampton Court, 1731–1733	69
4.8	New Frampton Court, landscape plan	69
4.9	Detail of de Wilstar survey, 1746	70
5.1	Plan of Nether Lypiatt, c. 1710	76
5.2	Plan of Bishop's House, 1711	78
5.3	Plan of Royal Fort, 1758–1761	79
5.4	Stapleton Court, Glos., rear façade, early-eighteenth century	80
5.5	Wotton, c. 1707, from Atkyns, 1712	81
5.6	Entry Hall with arched doors leading to main stair at Stenton, Philadelphia	83
5.7	Cote, chimneypiece with pilasters	85
5.8	Buffet cupboard, Stenton, Philadelphia	86

5.9	Back or service stair at Stenton, Philadelphia	88
5.10	The study at Frampton Court, c. 1840	93
6.1	Cote, c. 1720, ground floor, with inventoried contents, 1739	99
6.2	The Hall at Cote	100
6.3	Drawing of a 'chest of drawers' made for William Palling by Henry Viner, 1733–1734	104
6.4	India-back chair, early 1730s	105
6.5	Stenton ground floor with inventoried contents, 1752	108
6.6	Logan tea service, #1959–151–9–11 and 1975–49–1–2	109
6.7	Desk and Bookcase, c. 1730	110
6.8	Stenton first floor with inventoried contents, 1752	111
7.1	Clutterbuck coat of arms, Frampton Court	116
7.2	Stock plate from one of the firearms owned by William Palling	128
7.3	Portrait of James Logan, an 1831 copy by Thomas Sully after the original by Gustavus Hesselius, c. 1730	131
7.4	Title page of Cato Major, translated by James Logan and published by Benjamin Franklin	132
7.5	Chinese armorial teapot, c. 1750	134
8.1	The rear elevation, outbuilding and landscape of Fort Johnson, New York, 1749, from the *Royal Magazine*, Oct 1759	138
8.2	Johnson Hall, New York, 1763	139

List of Tables

2.1	Builders by background	18
2.2	Builders by age and background across the period	19
2.3	Gentlemen builder and owner JPs, 1736–1762	21
6.1	Comparative values of household furnishings, £, and inventoried spaces, Gloucestershire gentlemen's houses	112
6.2	Percentages (%) of goods owned by gentry and high status tradesmen in England	113
6.3	Percentages (%) of goods recorded in higher value inventories, average from four counties, Maryland and Virginia	113

List of Colour Plates

I 'A handsome House'. Stenton, 1723–30, near Philadelphia. Courtesy Stenton, NSCDA/PA, photo by Jim Garrison
II Painswick garden by Thomas Robins. By kind permission of Lord Dickinson
III Pitchcombe House, late-eighteenth century. Private collection
IV Fairhill, Stenton, NSCDA/PA
V Stenton Floor Plan with first finish coat paint colours, c. 1730. Drawn by Mary Agnes Leonard
VI Yellow Lodging Room at Stenton, with Queen Anne, or India-back, side chairs and Logan maple high chest (centre) and dressing table (left). Courtesy Stenton, NSCDA/PA, photo by Laura Keim
VII The range of ceramics owned by the Logans is documented in Stenton's archaeological collection. Stenton, NSCDA/PA, photo by Laura Keim
VIII Richard Clutterbuck, by Samuel Besly, 1741. Author, courtesy of Mr and Mrs Rollo Clifford

Preface

Research related to this book began when I became the director of Stenton, a historic house museum in Philadelphia, Pennsylvania. This double-pile, hipped-roof, brick house was built between 1723 and 1730 by James Logan, a colonial administrator and merchant. Arriving with academic training in British history, I was struck by Stenton's similarity to small elite houses in other parts of the British world. Immersing myself in the history and objects at the site, it seemed to me that there were several scholarly holes to fill. First, early American historiography had rarely situated Stenton in the broader context of the British empire or the Atlantic world even though it was the house of a leading colonial official. Second, the extraordinary eighteenth-century collections provided an unsurpassed opportunity to connect a number of themes linking history and material culture. Third, as a remarkably early (for Americans) and well-preserved building, Stenton's architecture and furnishings had been studied in detail. When compared with British domestic architecture, however, it had invariably been related to larger English country houses. Finally, it was clear that various historiographies that drew these topics together – British and American, as well as architectural, political, economic, social, and cultural history – overlapped but did not necessarily communicate.

In the United Kingdom, it was a joy to undertake research in Oxford to place houses like Stenton into a larger British framework. My initial investigations suggested that little work had been done on this sort of house in Britain, offering substantial room for the development of that aspect of my interests. Having now circled back around to my starting point in America, this book represents the results of over a decade of transatlantic labour. It examines a group of small classical houses and their owners in the eighteenth-century British world in order to explore architecture, material culture and social status.

Such an undertaking would not have been possible without the assistance of large numbers of people. In Oxford, I am grateful to many friends and colleagues for discussing my work and for generously sharing their own. Dr Perry Gauci in particular offered extensive comments and read numerous versions of this book, and Geoffrey Tyack weighed in on the architectural aspects of the project. Special thanks are due also to Julie Farguson, Erica Charters, Huw David, Oliver Cox, and Benjamin Heller, who offered much good advice and many helpful suggestions along the way. Paul Slack, Joanna Innes, Ben Heller, and Harry Smith kindly read drafts of several chapters. Mike Weaver and Annie Hammond introduced me to the world of Paul Strand – a far cry from gentleman's houses – whilst offering always convivial encouragement and support. Anne Keene has been a great friend throughout.

Outside of Oxford I have been equally fortunate. Nicholas Kingsley was tremendously helpful in offering advice at the start of this project. James and Annabel Ayres kindly offered accommodation, suggested many good insights, and asked

penetrating questions. Professor Roger Leech shared generously of his own work. Other who have contributed to my thinking include Judy Anderson, Zara Anishanslin, Michele Anstine, Toby Barnard, George Boudreau, Adam Bowett, Guy Chet, Andy Foyle, Johanna Gurland, Bob Harris, Karen Harvey, Dallett Hemphill, Bernie Herman, Julian Holder, Olivia Horsfall Turner, Helen Jacobsen, Seth Koven, Lynn Lees, Karen Lipsedge, Elizabeth McKellar, Catherine Molineux, Dennis and Debbie Miller Pickeral, Kay Ross, Jay Robert Stiefel, Sheena Stoddard, Patrick Tierney, Susie West, Lisa White, William Whyte, Richard Wilson, and David Young. Daniel K. Richter helped to inspire this endeavour. I am grateful to Philip Zimmerman for his aphorism, which became a mantra. Members of the Delaware Valley British Studies seminar helped to improve the work, as did the anonymous reviewers for Palgrave Macmillan. Jen McCall and Jade Moulds at Palgrave Macmillan have guided this book adroitly to completion. Colleagues in the Rowan University History Department welcomed me warmly to their ranks as I was finishing this book. Mary Agnes Leonard, who helped with a number of image issues, is a gem amongst designers.

The many generous owners who kindly gave me access, showed me their properties, shared their collections, and answered my many questions have been at the core of this project's success. With nearly two hundred houses in the study, they are too numerous to list, but my gratitude is profuse. I reserve a special word of thanks for the owners at four houses central to my study. Ron Collins, David Ryder, the Society of Merchant Venturers and residents at Cote welcomed me on a number of occasions. At Frampton Court, Mr and Mrs Rollo Clifford have allowed me extraordinary access to their house and collections. I am most grateful to them and to their staff. In particular, I thoroughly enjoyed spending time with Rose Hewlett and Jean Speed, whose shared passion for research and history has been an inspiration. Michael and Robert Little have also been extraordinarily generous. Finally, The National Society of the Colonial Dames of America in the Commonwealth of Pennsylvania, who have lovingly cared for Stenton, the remarkable house that inspired this project and appears frequently in these pages, have been hugely supportive.

Archivists, librarians and museum curators are a blessing to every scholar, and I thank the staff at all the institutions I visited, most particularly the Gloucestershire Archives, especially Vicky Thorpe, the Bristol Record Office, Hannah Lowery at the University of Bristol Special Collections, and Paul Driscoll at South Gloucestershire Council. David Mullin was especially helpful at the Museum in the Park, Stroud. In America, Jim Green and Connie King stand out for making the Library Company of Philadelphia a welcome research space, and Nicole Joniec helped with images. Bruce Laverty at the Athenaeum of Philadelphia was a great resource, particularly with images. I am also grateful to staff at the Lewis Walpole Library, especially Maggie Powell, Susan Odell Walker, and Ellen Cordes, the Historical Society of Pennsylvania, the Winterthur Museum and Library, and the Yale Center for British Art.

Several organizations have generously helped to fund this study. The Ernest Cook Trust Research Bursary awarded by the Society of Architectural Historians

of Great Britain enabled my doctoral research. I also benefitted from a McLean Contributionship Fellowship at the Library Company of Philadelphia and the Historical Society of Pennsylvania, a grant from the Miss Irene Bridgeman Research Fund of the Bristol and Gloucestershire Archaeological Society, a fellowship from the Winterthur Museum and Library, the Charles E. Peterson Fellowship at the Athenaeum of Philadelphia, and the Roger W. Eddy Fellowship at the Lewis Walpole Library. The NSCDA/PA has generously provided funds for the images.

My final thanks are reserved for my family. Thomas L. Evans offered helpful comments on an early but important piece of writing. Cheryll and Wayne Hague always provided encouragement, as well as a lovely respite for thinking and relaxing. Cathy and the late Brian Keim were supportive beyond any parental duty. Maglet and Will have endured endless dinner table conversations about houses and collections, and Kasia, Sofie and Sarah were wonderful additions to our household during the writing process.

Finally and most especially, all historians should be blessed with a muse. I am eternally grateful that Laura Keim, my lovely and darling Turtle, has been mine.

List of Abbreviations

Atkyns	Sir Robert Atkyns, *The Ancient and Present State of Glostershire* (London, 1712)
BCGAM	Bristol City Gallery and Museum
BCL	Bristol Central Library
Bigland	*Historical, Monumental and Genealogical Collections toward a History of Gloucestershire*, 3 vols (London, 1789–1887, reprint Gloucester, 1989–1995)
Bodl.	The Bodleian Library, Oxford
BoE: C	*The Buildings of England: Gloucestershire I: The Cotswolds* (London, 2002)
BoE: VF	*The Buildings of England: Gloucestershire II: The Vale and the Forest of Dean* (London, 2002)
BRO	Bristol Record Office
BRS	Bristol Record Society
CHG I	N. Kingsley, *The Country Houses of Gloucestershire: Volume One 1500–1660* (Cheltenham, 1989)
CHG II	N. Kingsley, *The Country Houses of Gloucestershire: Volume Two 1660–1830* (Chichester, 1992)
Colvin	H. M. Colvin, *A Biographical Dictionary of British Architects, 1600–1840*, 4th edition (New Haven and London, 2008)
GA	Gloucestershire Archives
HSP	Historical Society of Pennsylvania
LCP	The Library Company of Philadelphia
LWL	The Lewis Walpole Library
NMR	National Monuments Record
NSCDA/PA	The National Society of The Colonial Dames of America in the Commonwealth of Pennsylvania
ODNB	*Oxford Dictionary of National Biography*
PAGB	Andrew Foyle, *Pevsner Architectural Guide: Bristol* (New Haven and London, 2004)
PHG	W. R. Williams, *The Parliamentary History of the County of Gloucester* (Hereford, 1898)
Rudder	Samuel Rudder, *A New History of Gloucestershire* (Cirencester, 1779)
Stenton, NSCDA/PA	Stenton, The National Society of the Colonial Dames of America in the Commonwealth of Pennsylvania
TBGAS	*Transactions of the Bristol and Gloucestershire Archaeological Society*

VCH: G *Victoria Country History: A History of the County of Gloucester*, 9 volumes to date (1907–2010)
Winterthur The Winterthur Museum and Library

1
Introduction

Shortly after William Townsend died in 1754, a sales advert appeared for a house he owned known as Paradise (Figure 1.1):

> To be Sold in the county of Gloucester A MODERN-BUILT HOUSE, with four rooms on a floor, fit for a Gentleman, with all the convenient Offices and Outhouses, at Paradise, about a Mile from Painswick, and five from Gloucester, pleasantly situated on the Side of a Hill, which affords beautiful prospects; with 34 acres of Arable, Pasture and Wood Lands, the greatest Part adjoining to the House, and 50 Sheep Commons on Painswick Hill; all Freehold, and the Lands of the Yearly Value of about 35L.[1]

This intriguing description defined a 'modern-built house...fit for a gentleman'. The recently constructed house, probably completed in the 1730s, had eight principal rooms, four per floor. It stood close to a prosperous village and not far from a thriving commercial centre, the seat of the diocese. It benefitted from a pleasant situation, enjoyed a beautiful prospect, and stood amidst a small estate of farm land, pasture and woods. An unnamed but implied group of labourers accomplished the work of the house and small estate in a range of service buildings. The property, however, produced a relatively meagre income of £35, hardly enough for a gentleman to live on, suggesting that the estate owner had secured his living another way.

Paradise is a telling example of small classical houses built throughout Britain and its North American colonies in the late-seventeenth and eighteenth centuries.[2] Its forty-five foot wide façade, with five bays set off by a segmental pediment and an *oeil-de-boeuf* window, has been described as a fine example of West Country 'mason's Baroque'.[3] Like many houses on both sides of the Atlantic, it is uncertain who designed and constructed it; one historian suggests a local craftsman, another opts for a regional architect.[4] Despite its advertised description as a house with four rooms to a floor, physical evidence indicates that the classical façade was added to part of an earlier structure, a feature found in many similar houses. Townsend, a 'gentleman clothier' who amassed a fortune manufacturing cloth in the Stroudwater valleys of the Cotswolds, occupied a contested social borderland between rising middling sorts and the landed gentry of England.

2 The Gentleman's House in the British Atlantic World

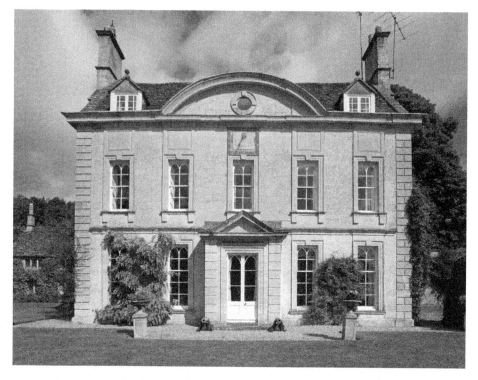

Figure 1.1 Paradise (now Castle Godwyn), Gloucestershire, c. 1730s
Source: Country Life Picture Library.

An ocean away, James Logan had died a few years earlier. As the colonial representative for the Penn family, proprietors of Pennsylvania, Logan lived the last twenty years of his life at Stenton, a brick, hipped-roof house he completed five miles from the burgeoning port of Philadelphia (Figure 1.2).[5] Situated on a small estate of about 500 acres, Stenton represented the culmination of Logan's years in the colony. After a long career as a Provincial Councillor, merchant, fur trader, Mayor of Philadelphia, Indian negotiator, Chief Justice, and finally acting Governor in the 1730s, Logan settled down at Stenton to a genteel life that mixed books and politics on his modest estate.[6] The substantial dwelling provided spaces for public and private activities, ranging from large-scale conferences with Native Americans to intimate discussions with figures like Benjamin Franklin. Fashionable goods, some from London, others from provincial England, still others made locally, established the Logan household at the leading edge of style in the colony. Stenton was yet another 'modern-built house, with four rooms on a floor, fit for a gentlemen'.

This book examines 'gentlemen's houses' like Paradise and Stenton, which developed as a significant architectural type across the British Atlantic world from the late-seventeenth century. It is in effect an object study, a detailed exploration of a particular kind of object, in this case a house. It is primarily concerned, however,

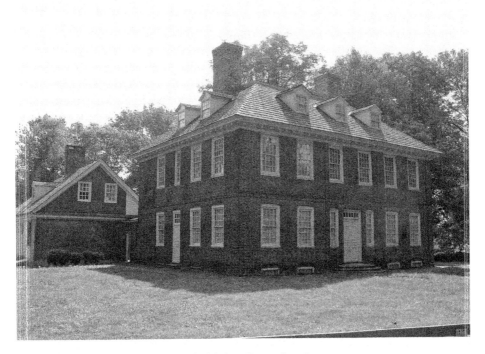

Figure 1.2 Stenton, 1723–1730, Philadelphia, Pennsylvania
Source: Courtesy Stenton, NSCDA/PA.

with status in the eighteenth century. As a result, it examines a group of small classical houses and how they functioned for the people who inhabited them.

By taking this 'material culture' approach I seek to contribute a fresh perspective to larger questions that animate debates about the eighteenth-century British world. The century after 1680 was a time of profound change for Britain. This period witnessed the remaking of the political system, the creation of new financial institutions, British imperial growth, expanding trade and a 'consumer revolution' that saw people purchasing and using more goods, the dramatic reshaping of England's towns in an urban renaissance, and the rise of polite culture. Historians disagree, however, about how these developments unfolded and their implications for Britain's social structure.[7]

The connections between these important social processes and small classical houses are too striking to ignore. Often viewed as commonplace because of their standard form, the importance of small classical houses and their owners has been largely neglected.[8] To enter the gentleman's house is to penetrate the complex lives of people like William Townsend and James Logan who experienced these great changes. Building a gentleman's house represented a calibrated strategic action, and gentlemen builders and owners employed their houses in precise ways across a range of settings to project power and define status. When considering building, James Logan noted that his wife feared, 'I should build too fine'.[9] It is the idea of

what 'too fine' might look like, or what constituted a house 'fit for a gentleman' that is a main theme.

Studying small classical houses in conjunction with their owners illustrates how buildings shaped identity throughout the British Atlantic World. Understanding what a 'gentleman's house' was is crucial to this book. These houses can be defined through the basic design building blocks of *form* and *function*. In terms of *form*, small classical houses shared a series of characteristics: all were freestanding houses built or remodelled in a classical style in the late-seventeenth and eighteenth centuries. Their main façades measured between forty-five and seventy feet wide, with five or occasionally seven bays of windows. They stood two and one half or three storeys tall and had double-pile (or two-room deep) floor plans, with a hall and grand stair. Increasingly during the eighteenth century British society acknowledged this house form as 'fit for a gentleman'.

These compact, classical boxes were centrally important because of their *function*. Naturally, gentlemen and their families lived in other types of houses, and this study makes no claim to analyse the many older manor houses and other forms of building that the genteel inhabited. But over the period covered by this book, especially from the 1720s, the small classical house form came to fulfil a specific function, namely as a suitable residence for a gentleman and his household. In other words, they increasingly came to offer floor plans, room arrangements and interior finishes that enabled the performance of genteel status. Although I use the two terms – small classical house and the gentleman's house – somewhat interchangeably, I tend to employ 'small classical houses' when suggesting their specific form, and gentleman's house, or occasionally the genteel house, when describing their function. In turn, what follows demonstrates how architecture functioned as a social strategy by also considering 'building status' in two senses. First, it investigates how buildings conveyed meanings, and what those meanings were; that is, the *status of buildings*.[10] Secondly, it explores how the individuals associated with these buildings used them to construct social position and identity; in other words, the *building of status*.

First and foremost, then, this book is concerned with status and social mobility in the eighteenth-century Anglo-American world. Through a new reading of evidence from gentlemen's houses, it seeks to contribute to discussions about how Britain achieved stable but dynamic expansion in the eighteenth century. This study is prompted by the argument Stone and Stone made more than twenty-five years ago that ownership patterns of large country houses indicated the level of social mobility in England had been exaggerated.[11] Their claim has been criticized extensively, especially on the count that they neglected smaller houses that were the most likely arena for social interchange between urban merchants, professional men, and landed elites.[12] Little effort has been made, however, to evaluate the smaller houses even they admitted might tell a different story. This study is such an effort, and by examining a different size house it reaches different conclusions, offering instead an answer that highlights measured, incremental development.

This social and cultural reading of gentlemen's houses combines histories of architecture, landscapes, and objects to unite subjects often treated separately. Architectural analyses have contributed to conflicting accounts of elite social

development in Britain and its colonies. The history of eighteenth-century domestic building in England has focused overwhelmingly on the country house.[13] But as Peter Guillery suggests, 'houses are principally interesting because people lived in them', and recent scholarship has highlighted the meaning of buildings as an important avenue of investigation in architectural history.[14] Nevertheless, how people lived and worked in houses and how their social relationships developed in relation to space remains largely unexplored.[15] Consideration of architecture, interiors, furnishings, and landscapes positions small classical houses at the centre of analysis in the first instance rather than people.[16] Despite the persistent view that land was the main indicator of elite status, the small classical house emerged in the second quarter of the eighteenth century as an important symbol of membership in Britain's governing class. Regardless of surrounding acreage, a key question these objects pose is what sort of owner did this particular type of house acquire? As will be argued, a discernable shift occurred where the construction and furnishing of a small classical house became a distinct marker that confirmed the social standing of house-builders.

Evidence from small classical houses prompts reassessment of the nature and pace of social change in the eighteenth century. Filled with possessions and standing in cultivated landscapes, small classical houses provided a setting for transatlantic elite identity formation by reinforcing power, prestige and a shared culture of gentility. The construction of a classical house resulted from conscious choices made by genteel owners inhabiting the permeable boundary between the middling and upper reaches of British society.[17] By adopting a form of 'polite' architecture, gentlemen-builders were laying material claim to a position above a 'polite threshold'.[18] Discussions of social status and class have typically emphasized the pre-eminence of the land-owning elite, although a significant body of work has examined the important role of the 'middling sort' in eighteenth-century society.[19] As Amanda Vickery has highlighted, however, there was no profound cultural gulf between the middling and upper reaches of British society or between colonial and provincial elites.[20] The polite collaboration between the landed gentry and the upper elements of bourgeois society formed, 'the closest thing to a governing class in Georgian England'.[21] The same can be said for Britain's empire, where those inhabiting this social borderland provided much of its governance and administration.[22] Associating houses with owners develops a more detailed picture of this porous social stratum in the eighteenth-century British world.

Studies of consumption, material life and manners have suggested such a close connection, and yet the 'creation and spread of an international gentry culture' has been underappreciated'.[23] Investing in property, constructing houses, and furnishing interiors constituted three of the most significant acts of consumption amongst eighteenth-century elites. Few works, however, seriously engage with buildings as a form of consumption.[24] The eighteenth century's rampant consumption aligned closely with changes in relations between metropole and colonies. An 'Empire of Goods', a new world of material culture resulting from increased commercial ties with Britain, provided possibilities for Americans to fashion themselves in innovative ways.[25] Assessing gentlemen's houses as an aspect of the 'consumer revolution' reveals their pivotal role in status construction.

Although primarily concerned with social status, this account of small classical houses grapples with a number of ways people constructed their identities. Within the household, spatial arrangement and room function contributed to the formation of gender identities.[26] The eighteenth-century British world was a hierarchical and patriarchal society, and in most instances the owners were described, either by themselves or others, as gentlemen, although women, as well as other kin and household relations, were included in the definition of a 'house fit for a gentleman'.[27] Genteel women actively engaged in furnishing and conducted sociable routines. The complex interaction between men and women in the domestic setting, contingent on time, space and status, has become the accepted paradigm in discussions of the domestic interior.[28] This book suggests that men played prominent roles in fashioning domestic space, from architecture to interiors to furnishings, and used it to project identity for themselves and their households.[29] In gentlemen's households both men and women shaped efforts to define and convey status.

A transatlantic perspective focused on genteel houses also helps to re-conceptualize how and in what ways people shaped identity. The houses at the centre of this study have been examined in much greater detail in America than they have in Britain.[30] Largely as a result, discussions of the Georgian mansion in the American colonies and English country houses have compared the architectural equivalent of apples and oranges.[31] American houses like Stenton bear only passing resemblance to the larger houses of the greater gentry and aristocracy in Britain. One British architectural historian commented that the Virginia plantation mansion, Rosewell, 'looked more suited to Hanover Square than a tobacco plantation' but we may ask in what ways was it more appropriate to one than the other?[32] Material culture scholars have occasionally drawn more relevant parallels between American and British examples. Graham Hood grasped the transatlantic essence of who built houses like these, describing the Governor's Palace in Virginia as 'of a type built for rural gentry and urban merchants in late-seventeenth and early eighteenth-century England'.[33] Likewise, a recent assessment of the Governor's Palace as 'a fairly modest gentry house by English standards' is close to the mark.[34] Nevertheless, a study of a particular building type in different parts of Anglo-America suggests that students of the British world, whether in America or the British Isles, have much to learn from one another. The creation of British national identity in the eighteenth century went hand in hand with the development of Georgian architecture, which reduced or subordinated regional differences.[35] Individuals living in provincial England and the American colonies, for example, could be at once American, provincial, and British. Indeed, in the century after 1680, *colonial* Americans came to identify firmly with symbols of British culture, becoming *provincial* Britons in the process. In this way, a small classical house served as one universal 'symbol of British culture'.[36]

Across the Atlantic World, race also structured the lives of genteel owners, as well as those they directly or indirectly enslaved. Trade in goods that enabled the slave trade, ownership of vessels that carried enslaved people, or investments in plantations that employed slave labour all produced wealth that purchased houses, furnishings, and property.[37] Indeed, identity for many Atlantic World gentlemen, especially in the American colonies, existed in direct relationship to enslaved

peoples. Moreover, many of the individuals covered in this book had ties that stretched well beyond English county or American colony. Their interconnected networks of trade and personal relations highlight the utility of a transatlantic study.[38] In order to connect these webs, the relationship between prosperous provincial port cities like Bristol, Philadelphia, Boston, Charleston and Liverpool and their rural hinterlands loom large in this account.[39]

It is important to make clear how this way of looking at buildings differs from the approaches other studies have adopted. This is not a study of country houses, a category that is notoriously difficult to define. Wilson and Mackley suggested two alternative measurements, the size of the estate or the size of the house, and also distinguished between the 'country house', the 'house in the country', and other forms of housing such as the villa. Mark Girouard argued a country house was the 'headquarters from which land was administered and organized'.[40] Although some small classical houses functioned as country houses, many did not. A few were rural retreats, but most filled roles as primary residences distinct from the villa of common conception.[41] Like Paradise and Stenton, with their small properties producing limited income, most small classical houses came closest to the idea of a house in the country.

The range of settings in which small classical houses were built demonstrates their adaptability whilst indicating their importance in building status. Although landholding and ornamental landscapes visually highlighted social position, the immediate surroundings of the gentleman's house usually displayed a mixture of the ornamental and functional.[42] Found in village and country settings alike, small classical houses embodied connections between urban commerce and landed society, encouraging exploration of the influences between provincial and colonial cities and the surrounding countryside. Because small classical houses appeared in various situations, the house and its contents took on enhanced importance as status markers. The country estate projected power and authority, but the eighteenth century saw the breakdown of land as the absolute measure by which an individual could lay claim to genteel status.[43]

The interrelationship between spatial arrangement, interior decoration, possessions, and people conveyed messages about social positon as well. Gentlemen builder-owners set themselves off as genteel not only in the form of their house but also in how it was organized, finished, and furnished. The history of domestic interiors has focused on noteworthy interiors, great houses, and outstanding objects on the one hand, or smaller buildings, traditional craftsmanship, and interiors and material goods in middling households on the other.[44] Although all these studies contribute to understanding spatial arrangement and furnishing, there is no detailed consideration of the gentleman's house interior. As this study reveals, genteel owners were largely immune to emulation of the aristocracy.[45] Although they would periodically purchase fashionable luxury items, their overall furnishing strategies were incremental, and their possessions exhibited a mix of old and new goods. It is this sense of balance, even moderation, that is the hallmark of the objects and people at the heart of this study.

Unified through size, style, plan, and furnishings, the gentleman's house is a tool for assessing social mobility in the eighteenth century. The analysis that follows

articulates in greater detail how a 'modern-built house...fit for a gentleman' functioned as an arena for changing forms of politeness, gentility, and sociability. It breaks new ground especially in its in-depth evaluation of gentlemen's houses in Britain. The core of the book is a detailed case study of over eighty houses and their builders and owners in the county of Gloucestershire, complemented by more than a hundred houses and the genteel families that lived in them in other parts of the British Atlantic World. The next chapter introduces the 'gentleman's house', chronicling when and where houses were built, as well as the backgrounds of builders and owners. As will be shown in Chapter 3, gentlemen's houses displayed an array of styles in a classical idiom, all of which were compact, economical and adaptable. Gentlemen builder-owners rarely sought to replicate larger country houses, although their small classical boxes were also distinct from dwellings of middling people. The interplay between buildings and their location in Chapter 4 reveals that the construction of a house appropriate to a gentleman, rather than acquisition of a large landed estate, increasingly became a decisive act that confirmed status. Chapters 5 and 6 set out how spatial arrangements, interior finishes, and furnishings constructed the stage set that enabled builders and owners to play roles in genteel society. Chapter 7 illustrates that once a gentleman built his house, its space became the scene of constant, repeated, varied routines and activities that reinforced claims to gentility. The final chapter considers how the domestic setting empowered genteel builders and owners to participate in an overlapping series of networks. Efforts to construct and maintain regional, national, and transatlantic relationships represented the outward manifestation of the gentleman's efforts to stake out position in the social order.

This analysis of architecture and material culture breaks down static categories and generates a social group based on their most important material choice: the form of house they built or owned. Both the houses neglected by Stone and Stone and the social stratum discussed by Vickery remain curiously underexplored. The process of integration of commercial and landed elites can be sketched out through their common material choices and shared connections. This book demonstrates that the small classical house constituted a significant venue for change, presenting a measured picture of social mobility. It was neither a tale where men of business made no attempt to purchase a country house and join the landed elite nor one where middling merchants and others undertook an 'ascent into the realm of the gentleman' replete with large estates, country houses and art collections.[46] In this picture, new men could compile a modest fortune, develop a range of networks over time, pick the right moment to rein in or retire from business activities, purchase a small estate or piece of property, and build a polite house that was economical to construct and maintain. That house accommodated a household with a handful of servants, and was furnished accordingly with selected new and fashionable objects to complement older pieces. Gentlemen's houses served as centres for sociable routines such as letter writing, visiting, tea drinking, and book collecting that reinforced and developed further networks. In this way, the gentleman's house struck a balance between dynamism and stability, typifying incremental social change in the eighteenth-century British Atlantic world.

2
The Gentleman's House in Context

Throughout Britain and its empire from the late-seventeenth century, people looking to secure their position began to construct small classical houses. Their proliferation over the course of the century from 1680 is a central feature of the architectural and cultural expansion of Britain.[1] Before embarking on a detailed analysis of the material culture of gentlemen and investigating the strategies they employed to build status, this chapter describes the houses and people at the heart of this study. Because small classical houses have received scant attention in Britain, a key sample of eighty-one small classical houses built before 1780 in Gloucestershire, as well as an associated group of 134 genteel builders and owners, is central to the analysis. Building on this cohort is a considerable literature that documents small classical buildings in other parts of Britain and its North American colonies. From this investigation of nearly two hundred houses and families in the British Atlantic World, patterns emerge that yield significant insights into the interplay between architecture and social status.

The first section of this chapter highlights the geography, socio-economic diversity, and widespread connections of Gloucestershire and Bristol in order to draw comparisons with other areas of Britain and the American colonies. The second section sets out a chronology of the construction of 'gentlemen's houses' and maps their distribution in Gloucestershire and elsewhere in the British Atlantic world. The final section develops the link between artefact and person through an examination of the builders and owners associated with 'gentlemen's houses', describing their backgrounds, life-cycle, professional and business activities, office-holding and religious affiliation.

Identifying some of the basic characteristics of houses and owners outlines their development and suggests several important themes. Early builders in England were almost exclusively from the lesser landed gentry, but in the 1720s a significant shift occurred in the number of building campaigns, the location of new houses, and the owners who built them. Construction in areas that were hubs of trade, commerce and administration, such as port cities like Bristol and in the cloth manufacturing district of the Stroudwater Valleys, highlighted this change. After the 1720s, the builders and owners of gentlemen's houses came from an

increasing mix of gentry, professional and mercantile backgrounds and comprised a flexible and dynamic segment of society. These findings articulate with greater specificity the permeable boundary between the gentry and commercial and professional worlds and provide a basis for analysing the qualities and interactions of these houses and their owners in subsequent chapters. This shift signals heightened social mobility from the second quarter of the eighteenth century for those who built houses of this sort.

Gentlemen's houses in the west of England

Social and economic conditions in Gloucestershire reflected processes at work elsewhere in British Isles, such as the continued prevalence of agriculture, early industry and textile manufacturing, domestic and international trade, political diversity, and relations between a few great landowners, the gentry, and commercial elites. Of the eighty-one small classical houses built in Gloucestershire during the period, eleven are demolished or destroyed, leaving seventy houses (86 per cent) extant. As the next chapter makes clear, numerous permutations of the small classical compact box dotted the landscape. Whilst not completely exhaustive of small classical houses built in the county between 1680 and 1780 – some may have been destroyed or altered – this group comprises a substantial representation of the form.[2]

This group of buildings and owners in Gloucestershire has numerous strengths. Two early county historians, Sir Robert Atkyns (1712) and Samuel Rudder (1779), published volumes that provide useful comparison at either end of the period, which help to assess change during the course of the eighteenth century.[3] Individually, many of these houses have not been studied extensively, while as a group they have not been assessed at all.[4] Investigating a significant number of hitherto neglected houses and drawing upon considerable and largely unexplored documentary and material evidence rewards their study amply.

The geographic, social, and economic diversity of Gloucestershire opens up further avenues for treatment of material culture and social status. The county served as a point of intersection in the west of England, bordering eight other counties and stretching from the Midlands in the north to the West Country in the south, and nearly linking the Home Counties to Wales from east to west.[5] Samuel Rudder noted the remarkable variety of landscapes, with 'three grand divisions of Coteswold, Vale, and Forest'.[6] The Cotswold hills run from north east to south west, dominating much of the landscape of the county, with a sharp escarpment on their western edge. Beyond this escarpment, the Vale is the low-lying area focused around the River Severn. In the western reaches of the county, nestled between the Severn and the River Wye, the Forest of Dean was a distinct region often more closely associated with Wales than with England.

Gloucestershire was largely a rural county, but important centres of economic activity existed by 1680. The north Cotswolds had a traditional focus on sheep and wool while the commercial centre of Bristol became increasingly important in the eighteenth century.[7] The Forest of Dean relied heavily on its coal and iron

production as well as timber.⁸ The cloth producing areas of the Stroudwater valleys were central to Gloucestershire. In 1757 Bishop Pococke noted that Stroud was, 'a sort of capital to the clothing villages', whilst by 1780 the value of the cloth trade to the county was on the order of £600,000 per annum.⁹

The social composition of the county differed by region. By the late-seventeenth century, three great aristocratic landlords, the Berkeleys, Beauforts and Bathursts, were concentrated in the south. Despite the presence of these aristocratic families, from the fifteenth to the nineteenth centuries Gloucestershire was one of the most gentrified areas of England.¹⁰ The Cotswolds and the Vale were 'the residence of many of the nobility and gentry'. The Forest of Dean and the Vale above Gloucester, however, had fewer large landowners and more yeomen farmers resulting in few gentlemen's houses built during this period.¹¹

The eighteenth century saw substantial growth in communication and transportation networks that facilitated economic and cultural interchange between different parts of the county and beyond, although for much of the century travel remained arduous, even dangerous.¹² The city of Bristol was better served than most places, with trunk roads leading to Bath and thence London and the road to Gloucester turnpiked by 1727.¹³ Water transport could be dangerous but provided conduits for trade and travel. Bristol was at the centre of a regional system that linked the ports of the Bristol Channel and Severn Valley with southwest England, the central and west Midlands, the Welsh Borderlands and south Wales. This network of coastal and river trade has been largely obscured by the focus on overseas trade.¹⁴ Improvements to water transport opened new possibilities.¹⁵ Frampton Court, Richard Clutterbuck's new classical house built between 1731 and 1733, benefitted from the River Avon being made navigable to Bath beginning in 1727, allowing elegant Bath stone to travel up the Avon and Severn to Frampton.¹⁶ Such connective tissues slowly unified the county's socio-economic system, which stretched from London to Wales.

This study moves well beyond the county borders in multiple ways. Gloucestershire was central to several 'socio-economic regions' associated with other counties. The county was naturally porous; people, including builders, architects and craftsmen, traversed boundaries and influences quite easily shifted across them. Around the fringe this porosity meant that gentlemen could easily look beyond the county in constructing networks. Cultural fashions and influences did not stop at the county's borders. In the north Cotswolds, distinct building practices emanated from Warwickshire.¹⁷ In the seventeenth century Roger Pratt's Coleshill (then in Berkshire, now in Oxfordshire) served as a model for several early Gloucestershire houses. Bristol's environs included substantial portions of both Gloucestershire and Somerset.¹⁸ Although few gentlemen erected small classical houses in the Forest of Dean, one who did, James Rooke of Bigsweir, had larger estates in adjacent Monmouthshire in Wales than in his own county.¹⁹

Much of the region enjoyed especially close links to Bristol, which connected the west of England and other parts of the world. The influence of Bristolian riches and culture stretched widely.²⁰ Bristol grew substantially in the eighteenth century; its population in 1670 was about 20,000, whilst not quite a century later

it had more than doubled to 50,000 people. In the second quarter of the eighteenth century it moved from the third to the second largest city in England.[21] This growth took place when Britain generally was experiencing demographic stagnation, a testament to Bristol's robust economic and social life. Although some contemporary observers opined that 'Bristol exhibited little taste or sophistication', visitor impressions of Bristol were mixed, and Daniel Defoe and others particularly noted its energetic mercantile activity.[22] During the eighteenth century it became the 'metropolis of the west'.[23] As a major port city, Bristol connected the county to a web of trading activity that stretched to the shores of Africa, the West Indies and North America. Bristol's increased role in the Atlantic slave trade drove much of its expansion following the loss of monopoly by the Royal African Company in 1698.[24] The amount of wealth employed in house-building from slave trading sources is difficult to determine, but slavery underpinned or supplemented a number of families and their economic resources in some way.[25]

Gloucestershire's socio-economic diversity and connections beyond the county permit insights into commercial and landed efforts at building status. Bristol's growth as a commercial port influenced its architectural development in many ways, although the city remained somewhat backward-looking when it came to architectural fashion.[26] This attitude highlights the conservatism of many mercantile and professional elites. As will become clear in subsequent chapters, such a staid approach to building had important implications for many gentlemen's houses. The engines that drove economic expansion in Gloucestershire and Bristol helped to provide the wherewithal for gentlemanly construction throughout the British Atlantic world. In this way, the county presents a broad canvas on which to paint a picture of 'gentlemen's houses' and their genteel builders and owners.

Gentlemen's houses in the British Atlantic world: when and where they were built

The Gloucestershire sample compares usefully with other areas of the British world. As the focus of the first extensive evaluation of small classical houses in Britain, Gloucestershire as a case study enables detailed comparison of its houses and owners with others throughout Britain and North America. In particular, this study also highlights Philadelphia in the middle colony of Pennsylvania. Genteel building took place, especially from the second quarter of the eighteenth century, in similar ways in myriad places.

A key undertaking is to understand better the location and chronology for the 200 or so houses covered in this study. On the basis of architectural style, physical examination and documentary evidence, it is possible to date the majority within a decade of construction. For Gloucestershire, building dates for sixty-nine of eighty-one small classical houses (85 per cent) can be comfortably ascertained, whilst the remaining twelve (15 per cent) have been assigned to the most likely decade of building. For North America, more precise dating is possible, mostly as result of intensive study of many houses by architects, architectural historians and others.[27]

A comparison of small, classical house-building activity with studies of country house construction fit gentlemen's houses into the overall picture of elite building

patterns. Figure 2.1 compares country house building with the construction of gentlemen's houses in Gloucestershire. Crucially, it demonstrates that significant numbers of small classical houses were built in the second quarter of the eighteenth century at a time when the numbers of specifically country house building campaigns in various parts of England fell.[28] Moreover, this robust period of gentlemanly house-building from the 1720s to the 1750s signalled an important process at work in terms of the kinds of houses being built and the identity of builders. After 1770 a building boom across England was mirrored in the American colonies up to the American Revolution. Kingsley suggests that fortunes made in Bristol and the Stroud valleys from about 1730 provided income for country house construction in the county but his data reflect a marked decline in building campaigns in the immediate decades after 1730, somewhat at odds with the idea of new men purchasing estates and building country houses.[29] The spike in gentlemanly house-building in the 1730s illustrated here offers new evidence to support Kingsley's general argument and provides a timeline that highlights the dynamism of rising commercial elites and their efforts to confirm status in material terms distinct from those further up the social hierarchy. Although Wilson and Mackley point to 'many shadings of rank and wealth' they also reinforce the 'highly emulative social structures' of landed and mercantile elites alike.[30] The pattern of gentlemanly building suggests that it is necessary to temper the idea of emulation when assessing how genteel builders and owners constructed their status.[31]

When overlaid with the geographic location of gentlemanly building and an analysis of owners, a refined picture of links between building and social status begins to emerge. Mapping house construction in Gloucestershire

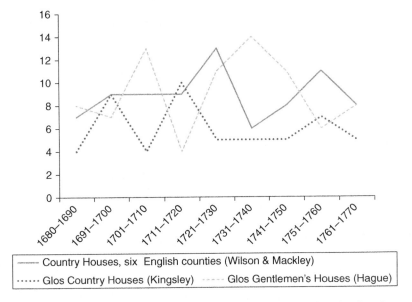

Figure 2.1 Country house and gentleman's house building, 1680–1770, by decade

Source: Calculated from author's figures; Wilson and Mackley, figure 2 and table 4; and extrapolated from Kingsley, 8.[32]

reveals a dramatic shift in the location of gentlemanly building projects over the period (Maps 2.1 and 2.2). Most importantly, their geographic distribution over time identifies a watershed in the 1720s. Before the 1720s, gentlemanly building was concentrated in the north and eastern sections of Gloucestershire. From the 1720s, however, a major move occurred south and west, with building especially prominent around Bristol and in the Stroudwater valleys. This coincides with the chronological shift shown in Figure 2.1. When looking at building in Gloucestershire by date and location, the conclusions are marked: before the 1720s, builders constructed houses in the north and east of the county. After the 1720s, houses appeared far more frequently in the south of Gloucestershire and around Bristol.

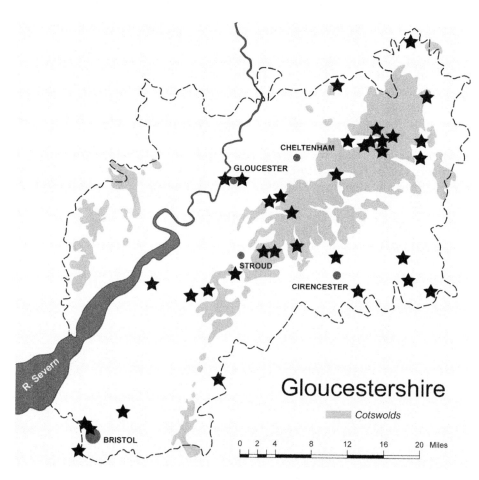

Map 2.1 Small classical houses built in Gloucestershire, 1658 to c. 1720
Source: Drawing by Mary Agnes Leonard.

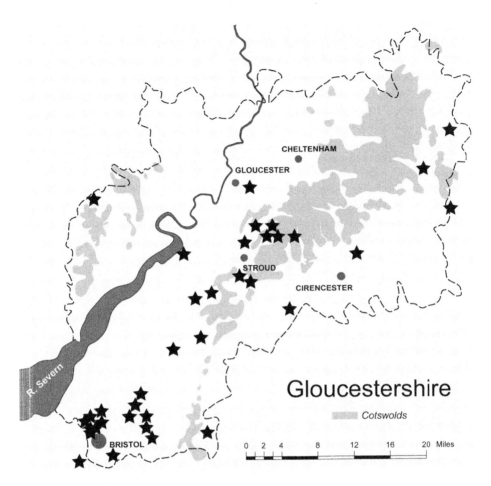

Map 2.2 Small classical houses built in Gloucestershire, c. 1720 to c. 1750
Source: Drawing by Mary Agnes Leonard.

As a result of this temporal and geographic mapping, two house types emerge which have counterparts in other areas of the British Atlantic world. The first, mostly situated in the northern part of the county, can be termed the *gentry house*. As a group, these houses appeared earlier, with almost all being substantially built by 1720 with landed fortunes accumulated by several generations of gentry families. The central and south Cotswolds, mostly although not exclusively in the Stroudwater Valleys and the area around Bristol, saw a concentration of a second type, what can explicitly be called *gentlemen's houses*. Houses built by 'gentlemen clothiers' and genteel merchants and professional men comprise much of this group. Gentlemen clothier's houses nearly all arose after 1730, part

of the expansion of gentlemanly housing funded through a combination of the cloth trade, professional earnings, and investment in land. At the same time, there was a veritable explosion of small classical houses around Bristol, which illustrates the interrelationship between commerce and gentlemanly building, particularly highlighting the important period of the second quarter of the eighteenth century. Although not all houses in this study fit neatly into either of these types, the categories help to organize the development of the gentleman's house type over the period between 1680 and 1780.

Building patterns elsewhere in the British Atlantic world broadly reflect those seen in the west of England. Eshott House, an early classical house built about 1700 near Alnwick in Northumberland by a minor landed family, typifies the gentry house, although its later acquisition by the family's lawyer offers an instructive case that I return to in the conclusion.[33] The sketchbook of painter Samuel Buck illustrates nearly forty small classical houses in Yorkshire.[34] Near Liverpool, merchants began building similar houses slightly later, as the city became increasingly important as a hub of trade.[35] One study of Liverpool slave traders suggests that some built or acquired country houses away from the city, but more built in the countryside around the city.[36] As early as the seventeenth century, and especially from the middle of the eighteenth century, merchants near Leeds built Georgian houses in the north Leeds villages.[37]

In the American colonies, too, colonists erected small classical houses (Map 2.3). American examples reflected the adaptability of the small classical house seen in Gloucestershire. William Penn's construction of Pennsbury Manor in the 1680s, described as a 'great and stately pile' in 1698, set the trend for gentlemanly building in Pennsylvania, which slowly expanded in the first few decades of the eighteenth century, and then exploded in the second quarter of the century.[38] A sample of twenty-five Virginia mansions and their families traces the building activities of the 'native elite' especially after 1720.[39] Around Boston and in western Massachusetts puritan New Englanders erected classical houses in significant numbers.[40] In Kent County, Delaware, mansion construction became widespread around mid-century, with three surviving from before 1740 but twenty-two from 1740 to 1776.[41] Well to do Charlestonians often acquired plantations in South Carolina and built within ten miles of the South's largest city.[42]

An uptick in gentlemen's houses in the 1760s and 1770s highlights another important moment. Provincial cities like Bristol and Philadelphia had begun building classical townhouses early in the eighteenth century, followed in the American colonies and around ports like Liverpool, but new men increasingly built small classical houses as a mark of status.[43] In America this building boom signalled a high point in the process of 'Anglicization' that drew together colonial Americans and provincial Britons.[44] As the century progressed, examples of sizeable Georgian houses appeared in provincial towns, a feature of the English urban renaissance described by Peter Borsay. The proliferation of small classical houses by 1780 made them something of an architectural norm, commonly built in urban, suburban and rural settings.[45] These chronological and regional variations also correspond to differences in situation and the social background of owners, points to be discussed further in subsequent chapters.

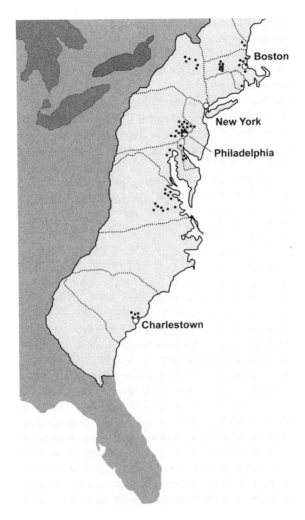

Map 2.3 Location of small classical houses built in America, 1680–1780, covered in the text
Source: Drawing by Mary Agnes Leonard.

The gentlemen who owned them

Architecture and people are largely inseparable, in the way that stage sets without actors have little meaning. Having established a timeline for building and identified the location of gentlemen's houses throughout the British Atlantic world, the final section of this chapter investigates the builders and owners these houses acquired. One basic fact unites the individuals in this study: sometime in the late-seventeenth century or eighteenth century they undertook to build or acquire a small classical house.

Genteel owners categorized according to their houses comprised a range of people hovering between the middle and upper strata of society.[46] Many were

merchants or had mercantile connections; a number were members of the landed gentry; a very few were peers. Frequently, they embraced more than one of these categories, depending on lifecycle. Thus the building form helps to assess in greater detail *who* was operating in this interstitial place and *how* they performed their social, cultural and material roles.

For eighty-one houses in Gloucestershire, it was possible to identify likely builders for sixty-eight, providing a useful cross-section of the backgrounds of those who erected a small classical house. In 57 of 68 cases (84 per cent), we can distinguish between builders coming primarily from landed backgrounds and those who were involved in the professions or commercial activity and assign them to one of four categories: peers, gentry, professions or mercantile. Table 2.1 highlights the chronological and geographic break evidenced in house-building trends. It indicates that before the 1720s, the landed gentry and peers built the majority of gentlemen's houses (15 of 22, or 68 per cent). Between about 1720 and 1780, a majority of builders (18 of 35, or 51 per cent) came from mercantile backgrounds. When professional men are included, the figure rises to 26 of 35 (74 per cent).

Elsewhere, some variations to this timeline are evident, although the overall trend is much the same. In the American colonies, for example, the distinction between the gentry as primarily landowners, professional men engaged in administration or educated employment, and merchants employed in trade, has tended to be viewed as largely regional in nature. Nevertheless, despite in some instances owning huge estates, Virginia planters made much of their money not only from trade in tobacco, but also other activities that demonstrated their commercial acumen.[47]

The point in their lives when gentlemen built their houses is an important factor in understanding the process of building status. Several life moments were critical, including marriage, inheritance, and retirement.[48] Marriage or inheritance shaped the household, providing resources to build or rebuild a house. Martha Vandewall, née Goldney, brought recently acquired property to her marriage to Nehemiah Champion in 1742.[49] Shortly thereafter they began building a new house, Clifton Court.[50] Inheritance enabled the construction of small classical houses, with 43 per cent of identified builders in Gloucestershire inheriting the property they built on. Inheritance was also an important juncture for Virginia planters.[51]

An overemphasis on marriage and inheritance, however, might underplay initiatives taken later in life by gentlemen. Building a house was a key moment

Table 2.1 Builders by background

	Pre-1720	Post-1720	Total
Gentry	13	8	21
Professions	5	8	13
Mercantile	2	18	20
Peers	2	1	3
Total	22	35	57

Table 2.2 Builders by age and background across the period[52]

Age, by decade, of builder	Number of builders	Background
20–29	2	1G, 1M
30–39	6	4G, 1Pr, 1M
40–49	6	4G, 2M
50–59	12	3G, 4Pr, 5M
60–69	2	2M
70 +	1	1Pr
Total	29	

Key: G, gentry; Pr, professional; M, mercantile.

for gentlemen, but in the case of builders it was not always linked to marriage or inheritance. The age of Gloucestershire builders at the time they constructed their houses can be determined with some certainty in twenty-nine instances. Assigning these building projects to a particular decade of life develops a picture of when in the life-cycle gentlemen built their houses (Table 2.2). By comparison with gentry houses, professionals and merchants – the primary inhabitants of what I have called the gentleman's house – generally built houses later in their life-cycle, although there are some regional differences. Nearly three-quarters of these builders commenced construction after the age of forty, at an average age of about forty-six. Although this did not preclude the infusion of money as a result of marriage, wedlock seems not to have played as significant a part in building decisions as seen elsewhere. Second or later marriages could sometimes be important in this context, as with the Champions.

Perhaps more importantly, retirement from active engagement in trade or public affairs served as a major impetus.[53] Paul Fisher, for example, built Clifton Hill House about the time of retiring and at least seven builders were at that life stage. One Liverpool merchant, John Okill, commenced construction when he was 84, and evidence from Liverpool similarly suggests later building.[54] In her study of twenty-five Virginia mansions, Barbara Mooney noted that Virginia native elites built at a younger age than seen elsewhere, with the average builder being in his mid-30s. Although leading Virginians built earlier than their counterparts in England, their efforts were usually facilitated by a generous inheritance or an ample dowry at marriage.[55] By waiting for an infusion of cash from inheritance or a dowry, however, southern builders displayed a similar judiciousness in their deployment of resources on building projects. In Pennsylvania, James Logan noted that he wished to 'purchase a plantation to retire to' in 1714, when he was about forty, but did not begin construction on Stenton until a decade later.[56] In Kent County, Delaware, mansion construction became widespread from 1735, in line with the number of 'gentlemen' listed in probate records. There were three gentlemen before 1740 but fifteen between 1740 and 1775. The Ridgeley family of Delaware, for example, was built on 'three generations of aspiration' but by 1748 when Nicholas Ridgeley added a three-bay brick house to an earlier structure at the age of 56, he had held numerous

positions in government, including justice of the Court of Common Pleas, and judge of the Supreme Court.[57]

On balance the landed gentry and southern plantation owners undertook building somewhat earlier in life, whilst professionals and especially merchants waited until later. Exceptions naturally occur. One of the two builders in their twenties was Henry Brett, a member of a Warwickshire gentry family, but another was Joseph Harford, scion of a Quaker merchant family, who began Stapleton Grove near Bristol in 1764 at the age of 23, albeit funded by a generous inheritance.[58] Conversely, septuagenarian James Rooke of Bigsweir House was a retired military officer who had come into the estate upon marrying his third wife, a member of a local gentry family. Overall, however, builders of small classical houses waited until somewhat later in their lifecycle before undertaking expensive and time-consuming construction projects, first building the real, social and cultural capital that enabled them to achieve success. This deferred process of house-construction suggests that the act of building was a conservative choice made from a position of financial responsibility.[59]

When moving beyond building to ownership more generally, a total of one hundred and thirty-four gentlemen owners of Gloucestershire houses can be identified during the period, including the sixty-eight builders above. Tracing ownership reveals who lived in these houses, when they lived there, how often the houses changed hands, whether this was through sale or inheritance, and what this says about evolving social status. Ownership reflected a clear gender divide: only eight of the 134 owners (6 per cent) during this period were women; 94 per cent were men. With one unusual exception, Ann Hort of Cote, women's ownership resulted from being widowed and was of relatively short duration.[60]

Of the one hundred and thirty-four changes in ownership, seventy-eight transfers were made through inheritance (63 per cent), and forty-six through purchase (37 per cent). Related to purchase, there are few examples of genteel families selling houses as a result of acute financial problems. For example, the sale of Paradise took place in 1755 immediately following the death of clothier William Townshend, an instance of family disposing of an unneeded secondary house.[61] The few transfers by sale indicate that a fairly high degree of stability characterized the owners of this style and size house, at least for several decades after they secured ownership. Gentlemen builders and owners for the most part made measured choices in their acquisition of small classical houses.[62]

Material possessions were one marker of status but involvement in public life, economic means, religious affiliation, and cultural values illuminated a gentleman's place in the social hierarchy as well. Peers stood at the top of landed society, but they played a limited role in the erection of small country houses. Over the first four decades covered here, most builders and owners stood in the ranks of the minor landed elite, whereas later builders and owners more often came from professional and mercantile backgrounds. Consideration of some of the most important variables related to gentlemen helps to set the stage for further evaluation of social status.

Engagement in public life helped to denote status, and most owners of gentlemen's houses appeared only rarely and episodically at the national level. A few landholders like the Whitmores of Lower Slaughter Manor occupied positions solidly in the gentry, and were members of the House of Commons, magistrates, and holders of county offices, with contacts beyond the county. Membership of the Commons served as one indicator of social standing. Throughout the period, few truly self-made men were able to enter parliament, but rather their families had been climbing for two or three generations, testing their suitability to enter the ruling elite.[63] Gloucestershire's gentlemen infrequently ascended to high political circles, with only twelve of 134 known builders and owners elected Members of Parliament.[64] None of the members served with particular distinction or held high office. If they appeared at the national level at all, gentlemen builders and owners tended to sit on the bottom rung of the political ladder.

Genteel builders and owners played more active roles in the administration of counties and colonies, living on between £250 and £1,000 per year.[65] In Gloucestershire over the period, nine gentlemen (7 per cent) served as High Sheriff, mostly avoiding what was considered an onerous post.[66] Service as a county magistrate also marked standing. The number of justices appointed for Gloucestershire more than doubled between 1680 and 1702, and had quadrupled by 1761, and at least twenty-eight builders and owners served as Justices of the Peace (21 per cent).[67] A further twenty-nine owners of small classical houses were almost certainly JPs, had close family associations with justices, or occupied other prominent positions on the county level. Taken together, at least fifty-seven of 134 builders and owners of gentlemen's houses (43 per cent). Between 1736 and 1762, for example, about 200 individuals were listed in Commissions of the Peace on five separate occasions.[68] On each occasion, identified gentlemen builders and owners constituted a modest proportion of the Commission, as seen in Table 2.3.

The commission for 1746 shows that seven of twelve gentlemen-owner JPs hailed from minor gentry families, although several, like Richard Clutterbuck of Frampton Court, had mercantile and professional associations in their background. There was still a bias toward land-owning JPs, although it was certainly possible to hold such a post without being a member of the gentry. By comparison with the seventeenth century, the position of JP was relatively more open in the

Table 2.3 Gentlemen builder and owner JPs, 1736–1762[69]

Year	Number of gentleman owner JPs
1736	10
1740	4
1746	12
1754	12
1762	12

eighteenth century, and not entirely the province of landed elites.[70] Fewer than half of known gentlemen builders and owners served as JPs. As many as 57 per cent of identified owners were not magistrates, but it is apparent that Gloucestershire gentlemen who possessed small classical houses were engaged in important ways in county-level service.

Small classical house owners fulfilled other political roles. In America, many served as legislators. At the highest level of colonial society, someone like William Penn had a large estate and was proprietor of Pennsylvania. Several other builders and owners held high political posts in the colonies, including the inhabitants of the prototypical colonial mansion, the Governor's Palace in Williamsburg, Virginia. Thomas Hutchinson served as deputy governor and then Governor of Massachusetts in the 1760s and early 1770s. James Logan, described by one historian as 'a sort of under-secretary for all affairs', sat on the Provincial Council, served as mayor of Philadelphia for a year, and later served as acting governor.[71] Isaac Royall, Jr was a JP, deputy to the General Court of Boston, a member of the Provincial Militia, and on the Governor's Council in Massachusetts for twenty-three years.[72] Sir William Johnson, one of a few gentlemanly house owners to hold a baronetcy, served on the New York Governor's Council, as a leading military officer, and on the frontier as Superintendent of Indian Affairs.[73] Leading owners in Virginia oversaw provincial government, served on church vestries and oversaw large plantations with significant slave populations.[74] Of the twenty-three Virginia elites covered by Mooney, twenty served as JPs, although fourteen served before or about the same time as building their mansions, an indication that they had already secured reputable places in Virginia politics and society.[75] Like the House of Commons, the Virginia House of Burgesses was a more elite, colony-wide entity, and seventeen out of twenty-three 'native elites' in Mooney's study sat in the Burgesses. Nine of these held office about the same time as or after constructing their house. Appointment as a Councilor, the highest and most prestigious office, was infrequent, and only one in six Virginia elites was appointed after house construction. Most other owners of small classical houses at one time or another held posts that provided the administrative leadership for their respective regions. Seven prominent 'River God' families in western Massachusetts filled many of the JP appointments between 1692 and 1774, and all the highest ranking military commissions.[76] Involvement in county or colonial affairs further helps to calibrate where gentlemen builders and owners stood in society. These figures suggest that small classical houses served as a tool for confirming status, rather than as an aspiration towards status.

Gentlemen builders and owners played significant roles at the local level as well, or claimed status in ways that were not strictly based in the institutions of county or colonial government or judiciary. Local affairs attracted Thomas Goldney, Paul Fisher and John Hodges, for example, who were active in the administration of St Andrews' parish, Clifton, near Bristol. Quaker wine merchant John Andrews of Hill House paid rates there and was also noted by a county political operative as being 'the head of the Quakers at Bristol'.[77] Andrews, Fisher, Goldney, and John Elbridge played pivotal roles in the creation of the Bristol Infirmary in the 1730s.[78]

James Logan established the Loganian Library upon his death in 1751 to benefit the people of Philadelphia. Those who were substantial local landowners, which included a high percentage of owners before 1720, exercised persuasive power and authority over tenants, indentured servants and enslaved labourers. Owners of the smallest classical houses, like Poulton Manor or Bagendon Manor, tended to be minor gentry focused on the parish.[79] The occupants of gentlemen's houses occasionally served as clergymen, although this varied by region. In Gloucestershire only three owners were men of the cloth, whereas this was more typical in New England. This evidence suggests that at least in terms of architecture, the idea that the rector and the local squire were hardly distinguishable may be overstated.[80] The relative frequency of church monuments indicated that gentlemen-owners held places as prominent residents of their parish. Where office-holding did not delineate social standing, the interface between houses, owners, and parish and county involvement becomes more important as an indicator of status.

Many genteel builders and owners after the 1720s relied upon resources derived largely from mercantile or professional activity to finance their gentlemen's houses. The demographic and economic development of provincial cities closely linked to the construction of gentlemen's houses. Between 1709 and the American Revolution, Bristol's inward trade, measured by shipping tonnage, had doubled, whilst Newcastle's had trebled, and Liverpool's had more than quintupled.[81] The connections between Bristol's commercial growth, the acquisition of property, the building of individual houses, and the related social strategies employed by leading Bristolians to build their social status remain underexplored.[82] New men from Bristol and other commercial areas like Stroud helped to account for the roughly 40 per cent of the major *country house* building campaigns in Gloucestershire between 1660 and 1830 that were carried out by men who purchased their estate rather than inherited.[83] In Gloucestershire gentlemen builders across the period were more likely to buy rather than inherit the property on which they constructed their gentleman's house.[84] This pattern suggests that gentlemen's houses, rather than country houses, were more likely sites for commercial and professional men to deploy their resources.

Provincial and colonial cities like Liverpool, Leeds, Newcastle, Glasgow, New York, and Charleston experienced similar expansion. The proliferation of small classical houses in Philadelphia's hinterland coincided with the city's growth in the eighteenth century. Leading Quaker merchants in Pennsylvania 'reared a structure of aristocratic living comparable to that of the Virginia planters, the landed gentry of the Hudson Valley, and the Puritan merchant princes of Boston'.[85] Boston, too, remained a substantial provincial town, although its population levelled out by mid-century at about 16,000.[86] Economic activity likewise expanded. The economies of North America played a pivotal role within the imperial system, providing opportunities for the accumulation of fortunes and the construction of a genteel life.[87]

Whilst participation in public affairs and economics were clearly indicators of status, other factors were less important considerations for those building gentlemen's houses. Religious affiliation seems to have had little influence on house

design or the accumulation of possessions. The majority of gentlemen-owners in Gloucestershire were practicing members of the Church of England, with indications of regular attendance at church and burial according to its rites. Eleven (8 per cent) can be identified as non-conformists: one Presbyterian, James Lambe of Fairford Park,[88] and ten Quaker merchants from Bristol. Beginning in the 1720s, commercial and early industrial developments were important factors in building gentleman's houses for Quaker mercantile elites. The Champion family and Thomas Goldney, for example, were investors in the early metal manufacturing processes at Coalbrookdale as well as in brass mills near Bristol.[89] Across the American colonies, despite the religious heterogeneity of Puritan New England, Quaker Pennsylvania, Catholic Maryland, and Anglican Virginia, leading figures easily adopted the small classical house as a dwelling of choice.

Religion played a more significant role in the construction of social networks, especially for Quakers.[90] Much of their interaction took place within kin networks and the Society of Friends. Other Quakers who established handsome lifestyles as gentlemen in the second quarter of the eighteenth-century included Nehemiah Champion, Thomas Goldney II, John Andrews at Hill House in Mangotsfield, Joseph Beck at Frenchay Manor, Joseph Harford at Stapleton Grove, and William Champion at Warmley.[91] These relationships were often based on family connections and Quakers were simultaneously somewhat insular and worldly.[92] Their houses demonstrate that members of the Society of Friends did not differ markedly from non-Quaker gentlemen. In Pennsylvania, dominated by the Society of Friends until the mid-eighteenth century, Quakers accumulated riches and materials goods, and James Logan pointedly noted in 1741 that his fellow Quaker merchant grandees in Philadelphia, 'are as intent as any others whatever in amassing Riches, the great Bait and Temptation to our Enemies to come and plunder the Place'.[93] Despite purportedly deep differences in outlook, genteel conformists and non-conformists were remarkably similar in their material possessions. Economic success enabled Quaker gentlemen to build small classical houses and engage in material display on a significant scale. That a number chose to do so indicated their desire to confirm their status in a visible way. Religious denomination had little influence on the design of houses, and there was no great distinction between gentlemen's houses on the basis of religious belief.

Despite multiple pathways to signify standing, gentlemen builder-owners enlisted a common material culture to delineate their place in the community. In Gloucestershire there was a move from small classical houses built almost exclusively by landed gentry before the 1720s to a house-building more reliant on established mercantile and professional wealth in the second quarter of the eighteenth century. These chronological and geographic shifts point toward two house types: the gentry house and the gentleman's house. Moreover, this trajectory occurred in other parts of the British Atlantic World, with some regional variation and some differences in timing.

It is possible to advance two arguments to be developed more fully in subsequent chapters. First, from the 1720s, new men, often described by historians as aspirational, began to build these houses with increased frequency. But many

gentlemen from the commercial and professional mileu of Bristol and other port cities around the Atlantic World as well as nascent manufacturers like the gentlemen clothiers of the Stroudwater Valleys or merchants in Leeds, were not necessarily aspiring to an increased level of status. Through construction or acquisition of a 'house fit for a gentleman', they more often sought to confirm, display and reinforce status already conferred by wealth or offices. The difference here was between, 'I want to arrive and this will help me' and 'I have arrived and this reinforces the point'. As a result, in the second quarter of the century small classical houses emerged as a marker of elite status that revealed the dynamic nature of British society and pointed toward a substantial degree of social mobility.

3
Building Status

In 1656 Richard Whitmore signed an agreement with master-builder Valentine Strong to construct a manor house in the village of Lower Slaughter, unwittingly putting in motion an architectural and social process that would have far-reaching effects over the next century.[1] The five-bay coursed-stone manor house stood on a raised basement, with quoins, a hipped roof, and three dormers, all surmounted by a turret or lantern (Figure 3.1). It displayed little ornamentation save for a broken pediment over a first floor centre door. Like so many similar small classical houses to come, the interior arrangement contained four rooms on the ground floor and bedchambers above, a straightforward double-pile plan. It is not clear who was responsible for the design; the contract records that the house was built in line with 'one moddell or plattforme by him lately received from the said Mr. Whitmore'.[2] More than likely, Whitmore and Strong collaborated on the design and construction. The resulting manor house was a statement of Whitmore's status that exhibited all of the features that distinguished gentry houses from those of yeomen.[3] Criteria like overall size, a double-pile floor plan, high ceiling heights, and 'superior' features like multiple parlours, some heated second floor chambers, moulded stone for mullioned windows, doorways and fireplaces, panelling, and grand staircases differentiated gentlemen's houses in architectural terms from houses lower down the scale and placed them above the 'polite threshold'.[4]

Building a gentleman's house was a momentous strategic choice. Choosing a type of house, deciding on a style, committing the resources to construct it, and seeing through the sometimes lengthy building process pointed toward a complex undertaking that delineated social status. To understand how building a gentleman's house functioned as a social strategy, it is necessary to consider both the status these buildings held as a particular architectural form as well as how the construction of such a house reinforced status. This chapter traces architectural styles, discusses the processes of design and construction, and evaluates the economic implications associated with constructing a gentleman's house.

Building Status 27

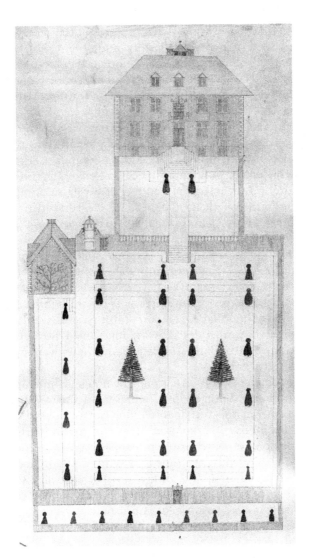

Figure 3.1 Lower Slaughter Manor, 1656–1658, from a 1731 plan
Source: Gloucestershire Archives, D45/P2.

Architecture: form and style

Small compact boxes like Lower Slaughter may have originated as a metropolitan form, but it is apparent that with his new house Richard Whitmore made his mark on the county of Gloucestershire.[5] There was nothing else like it by 1660, and it represented a bold, innovative step by someone confident of his social position, and assured in his taste. Described as 'a neat handsome Seat', Lower Slaughter Manor

served throughout this period as the house of a substantial gentry family who had 'very great Estates in Glostershire, Shropshire, and other Counties'.[6] It took some time for small classical houses to become an obvious choice for Gloucestershire gentlemen, but by 1680 the British world began to see more frequent construction of the classical, double-pile house that carried on for the next century and beyond as a suitable residence for a gentleman and his family.

The transition in geographic location and owner background over time illustrates that the small classical house after 1730 was a socially safe, traditional choice made by newcomers often from non-landed backgrounds. Classical architecture was linked with the idea of politeness, hence polite architecture was classical in form.[7] Architecture, however, has played less of a role in accounts of 'the rise of polite society' than it might have done.[8] Architectural historians have often equated the epitome of classicism with Palladianism from the 1710s until at least the 1750s, influenced by the designs of Inigo Jones.[9] Even contemporaries identified classicism with Jones. In 1765, for instance, a British officer remarked that the Foster-Hutchinson house in Boston must have been designed by Inigo Jones or a successor.[10] Recent scholars, however, have recast Classicism as a 'pluralist not a singular phenomenon', suggesting multiple possible trajectories for architectural forms.[11] The blurring of boundaries was part of this process. Gentlemanly builders employed a range of classical styles between 1680 and 1780: William and Mary, Queen Anne, Baroque, Georgian, and Palladian. These overlapped in duration and within the classical vocabulary.

Examining gentlemen's houses as a group encourages a more inclusive reading of style. Medford House, built c. 1694, represented the 'textbook example of the slow transition from the vernacular Tudor Cotswold style to Queen Anne classical'.[12] An early house like Poulton Manor (c. 1690), with the segmental pediment over the door, or Dutch influence apparent in its sprocketed roof line, was decidedly old-fashioned by the time that William Champion built Warmley House, a standard Palladian house with a few baroque details in about 1750 (Figures 3.2 and 3.3). But they largely share a common architectural language.

Many gentlemen's houses combined and displayed vernacular or provincial expressions of style. Well into the eighteenth century, builders and craftsmen continued to construct older-fashioned buildings, and gentlemen's houses sometimes incorporated vernacular elements and demonstrated localized building characteristics. In the seventeenth century, cross windows as seen at Poulton were standard.[13] The kinds of windows were an indicator of status, particularly as sash windows relatively quickly replaced casement windows around 1700.[14] Nevertheless, genteel houses sometimes mixed sash and cross-window fenestration, a compromise that evolved as owners upgraded.[15] A late-seventeenth century depiction of Urchfont Manor in Wiltshire displays sash windows on the projecting three-bay frontispiece but casement windows elsewhere.[16] In Virginia, at least one late-seventeenth century house seems to have been built with sash windows.[17] In details like window type and arrangement, small classical houses could mix architectural styles whilst they expressed a

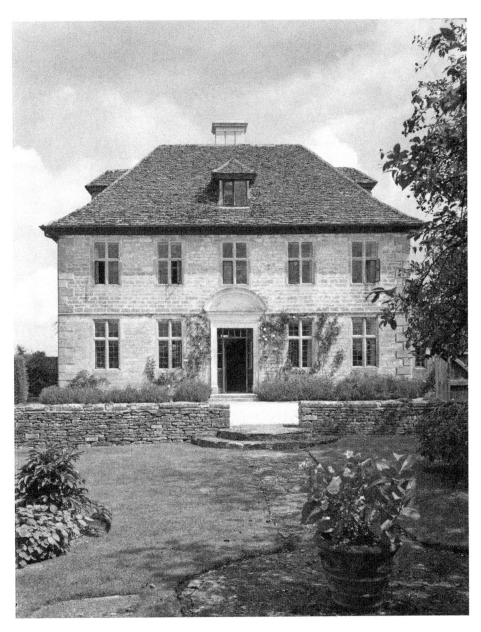

Figure 3.2 Poulton Manor, c. 1690
Source: Country Life Picture Library.

Figure 3.3 Warmley House, c. 1750
Source: Author.

level of architectural sophistication that readily communicated their builders' efforts to construct social status in line with the skills and capabilities of their master craftsmen.

The gentry house to the 1720s

Houses built by the landed gentry before the 1720s generally exhibited characteristics such as hipped roofs, raised basements, segmental pediments over doors, and transitional fenestration from cross mullioned windows to sash. Poulton Manor (c. 1690), about five miles east of Cirencester, is one representative version of the five-bay, double-pile structure that emerged as housing for lesser elites in England after the Restoration. The house displays classical interior ornamentation whilst drawing upon earlier building techniques in the exposed summer beams found in all the rooms, whether public or private spaces. A subtle building error on the facade – the quoins just below the belt course moulding are distinctly different sizes – indicates that the builder was not quite accurate with his measurements. Poulton Manor in some ways 'speaks more of an exalted yeoman than of the lord of the manor'.[18] Although almost nothing is known about its builder, Poulton Manor represented an early and

visible construction project that was an effort by that builder to lay claim to considerable status.

Other houses illustrate the architectural variations of this style. Wotton, near Gloucester, is an unusual example of brick construction in the west of England, built in about 1707 (Figure 3.4).[19] A handsome seven-bay house with modillioned cornice, Wotton had two flanking outbuildings that created a forecourt, and several ancillary structures.[20]

Nether Lypiatt (Figure 3.5), a dramatically vertical forty-six foot square box with hipped roof and five bays on a raised basement, was completed by 1717 near Stroud by Charles Coxe, MP for Cirencester and Gloucester.[21] The manor, described as '(locally) very advanced', was a likely inspiration for master clothiers to build in this style.[22]

Sandywell Park (Figure 3.6) displayed the five-bay hipped-roof form whilst also demonstrating the potential for remodelling in newer or more elaborate styles. In 1712, Johannes Kip illustrated the house surmounted by a balustrade and cupola, accompanied by an impressive landscape, with allees, pools, parterres, and a gated forecourt.[23] Henry Bret (or Brett), 'descended from the ancient Family of Brets of Bret-Hall in Warwickshire', purchased the Sandywell property in 1704, where he had 'a neat pleasant seat at *Sandywell*, and a new built house, with pleasant

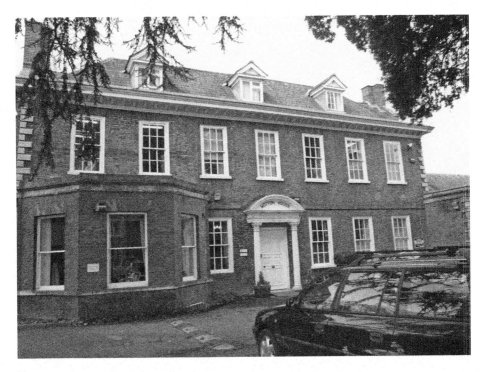

Figure 3.4 Wotton, c. 1707
Source: Author.

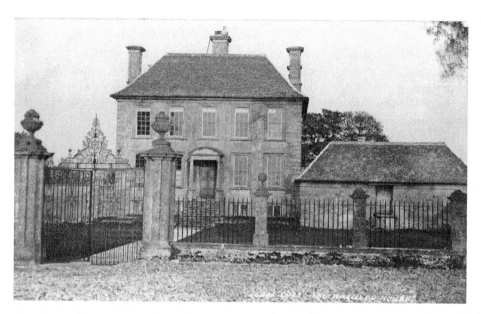

Figure 3.5 Nether Lypiatt, c. 1710
Source: Museum in the Park, Stroud, 2007.183.2184.

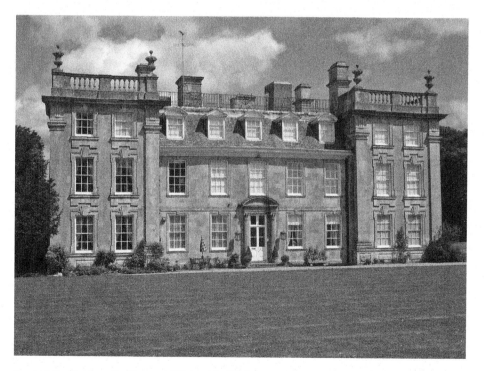

Figure 3.6 Sandywell, Glos., c. 1704, with 1720s wings
Source: Author.

Gardens, and a Park'.[24] As initially built, Sandywell was on an architectural scale with other five-bay, hipped-roof houses, but by 1712 Brett had sold the house to Francis Seymour-Conway, 1st Baron Conway of Ragley Hall. Lord Conway substantially enlarged the house, adding two-bay, three-storey wings to either side of the existing structure but incorporating the symmetrical façade of the Brett house as its core. In turn, Lord Conway's son sold the house and estate in 1748 to Thomas Tracy. The Tracys were an old Gloucestershire family and Thomas was MP for Gloucester from 1763 to 1770.[25] This process highlights the acceptability of a five-bay house for a minor gentry landowner, as well as the needs and desires of the aristocracy.[26]

Elsewhere in Britain and its colonies, members of the gentry built in the compact classical idiom. Samuel Buck's sketches of Yorkshire houses between 1719 and 1724 left a remarkable visual record of country houses large and small.[27] The drawings, many finely executed, others mere sketches, show at least 245 individual houses, about forty of which are small classical houses that would fall into the category of gentry house type. Usefully but not unusually, Buck in most instances noted who the house belonged to, and frequently referred to these houses as 'seats'.

In the late-seventeenth and early-eighteenth century, builders of gentry houses came from the ranks of elites who possessed landed estates or colonial plantations.[28] Richard Whitmore's background as the son of an MP with estates in Shropshire positioned him well to adopt this new style for his manor house at Lower Slaughter.[29] Andrew Barker, builder of Fairford Park in the early 1660s, was summoned by the Heralds in 1682/1683, held a prominent position in county society, and had close attachments to London.[30] Both Lower Slaughter Manor and Fairford utilized the Strong family as builders, and Fairford Park particularly may have drawn inspiration from Roger Pratt's famous house at Coleshill nearby. Dumbleton Hall was the seat of Sir Richard Cocks, the MP for Gloucester from 1698 to 1702 noted for his independent, even eccentric, personality.[31] Wotton was the seat of Thomas Horton, esq., whose father-in-law was MP for Gloucester from 1710 to 1713.[32] All represent families of the lesser gentry or above, whose main reliance was on landed income. Additional houses about which little is known, such as Kempsford Manor, may have been small-scale efforts by those on the cusp of local gentry status to build in a fashionable idiom.

The double-pile, hipped roof form continued to be built in a few isolated instances into the 1750s and by others than the gentry. Thomas Palling of a Stroud clothing family completed Pitchcombe House (Figure 3.7) in the 1740s. Late in life Major James Rooke, a retired member of a noted military family (a relation, Admiral Sir George Rooke, had been the captor of Gibraltar in 1704), built Bigsweir House (Figure 3.8) on the Welsh border overlooking the River Wye, probably in the 1750s.[33] Rooke married a member of the locally noteworthy Catchmay family, through which he inherited the estate.[34] This example of a substantial building campaign by a retired soldier at the age of seventy in an out of date style is a curious example.

The classical five-bay form suited leading elites in the American colonies. Early examples include Pennsbury Manor (1680s) in Pennsylvania and the Trent House

Figure 3.7 Pitchcombe House, Glos., c. 1743
Source: Author.

Figure 3.8 Bigsweir House, Glos., c. 1755
Source: Author.

(1719) in New Jersey. Perhaps the best and most influential example was the Governor's Palace in Williamsburg, Virginia, constructed between 1710 and 1715 (Figure 3.9).[35] Subsequently the brick, hipped roof design also appeared in single-pile houses such as Indian Banks and Ampthill. By 1730, Virginia planters began to construct double-pile, hipped roof brick houses as a matter of course. William Byrd II (1674–1744) wrote in 1729 that in 'a year or 2 I intend to set about building a very good house'.[36] Clearly the Byrd family achieved this with one of the most impressive Virginia plantation houses, Westover, completed between 1750 and 1751. Another example, Wilton, now moved to the city of Richmond, originally stood in Henrico County outside Richmond (Figure 3.10). It was the country seat of William Randolph III, another wealthy Virginia planter who had the means and taste to build a large country house on some 2,000 acres acquired in 1747.[37]

As a relatively new and even somewhat controversial effort at building status, gentry houses represented a fashionable choice for a relatively traditional group of elites. In choosing to construct compact boxes, gentry builders were going somewhat against the grain. Roger North had regretted that 'not only in the city and townes, a compact model is used, but in all country seats of late built...to the abolishing of grandure and statlyness'.[38] North's account of these houses as 'late built' suggests that contemporary commentators still considered the compact box a new form, but one increasingly employed for 'country seats'. Between 1680 and the 1720s established gentry families and those with large estates in the American colonies chose to build in classical styles using plans that were architecturally novel. Confident in their position, the landowners in counties and colonies

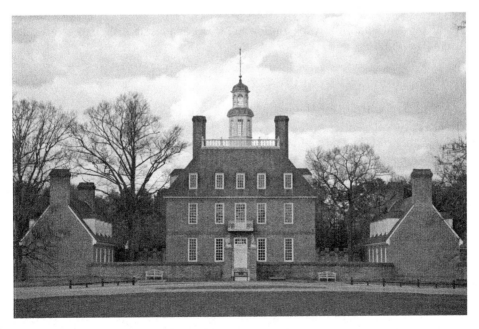

Figure 3.9 The Governor's Palace, Virginia, c. 1710–1715
Source: Alamy BBPACJ.

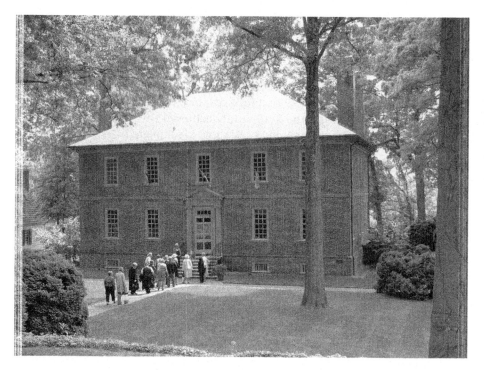

Figure 3.10 Wilton, Virginia, c. 1753
Source: Author.

adopted a somewhat innovative option in houses as a result of their already established position.

Gentlemen's houses from the 1720s

From the 1720s throughout Britain and its North American colonies, a more diverse group of gentlemen-builders began to construct small classical houses. The building trends detailed in the previous chapter suggest that in Britain small classical houses were built in the middle decades of the century with more frequency than larger country houses. Increasingly, genteel houses served as elite housing for prosperous merchants and professional men. The flexibility of the form suggested the elastic social status of the builders and owners.

Small classical houses increasingly appeared in the south and western parts of Gloucestershire, particularly around Bristol and in the cloth-making district near Stroud. Like other provincial cities, Bristol was part of the urban renaissance during the late Stuart and early Hanoverian period that saw towns became centres of leisurely activity and luxurious consumption, not to mention architectural facelifts.[39] From 1700 developments such as Queen's Square, begun in 1699, St James's Square, Dowry Square and houses along Prince Street set the standard

for brick urban planning and classical design.⁴⁰ These urban efforts soon had their equivalent in the villages and countryside outside the city. More than twenty small classical houses were built near Bristol between 1680 and 1770, all but two after 1720. Amongst the builders were Bristol merchants and professional men, including six Quakers.

One house that typifies the chronological transition in the 1720s, the geographic shift from building in the northeast of Gloucestershire to southwest, and the changing status of builders and owners from gentry to mercantile and professional men is Cote in Westbury upon Trym. A copiously documented but almost entirely ignored example, Cote and its owners will be a focus throughout the remainder of this book. As a result, a brief sketch is warranted. In 1705 Thomas Moore, a leading Customs official, bought 'the Cote house + lands' situated some two and a half miles from the centre of Bristol for £615.⁴¹ Some time later, Moore or his heir, John Elbridge, set about building a substantial new house (Figure 3.11). The date of the house is uncertain.⁴² The two-storey house is of Pennant rubble stone with a hipped roof, two chimney stacks, and five bays, with a deep modillioned cornice and flush sash boxes, two distinctive features prohibited by the 1707 and 1709 Building Acts in London but slow to be introduced elsewhere.⁴³ The raised parapet, however, suggests an early deference to another provision of the 1707 Act. The segmental stone arches over the windows also indicate an early-eighteenth-century date. If Moore built the new house at Cote, he probably did

Figure 3.11 Cote, c. 1720
Source: Author, courtesy of Society of Merchant Venturers.

so before 1721, when his wife Rebecca died. The double-pile floor plan offered a commodious dwelling that allowed for controlled circulation through the house for Moore, his family, visitors, servants, and workmen. Although other gentlemen building or renovating houses at this time made use of the existing structure, in this instance it is likely that any surviving building was removed and a new service wing built.[44]

Cote offers a particularly rich introduction to the acquisition, construction, and maintenance of a gentleman's house. John Elbridge, a leading Customs official, inherited the house from his cousin Moore in 1728.[45] Thomas Moore and John Elbridge seem to have had an unusually close partnership; John is recorded as living with Thomas and his wife in 1696, and also erected a splendid monument in St Peter's Church to Moore after his death.[46] It is possible that Elbridge was responsible for the new building; before 1739 he had given up his house nearer to Bristol and may have 'moved into the splendid house at Cote which he had rebuilt'.[47] Elbridge, a colonial son of a merchant, worked diligently in professional service, acquired a gentleman's house, and lived handsomely but not extravagantly despite great wealth. In this way, Cote and Elbridge typify gentlemen's houses and their owners across the Atlantic world.

Other gentlemen near Bristol deployed their commercial resources in the construction of small classical houses. The village of Clifton was a focus for gentlemanly building in the middle of the century. The poet Henry Jones wrote in 1767 of these houses, 'There, princely piles in classic taste express'd/In *Grecian* garb, *Roman* grandeur dress'd/A line of palaces o'erlook the town/That with a jealous pride the prospect crown'.[48] Bishop's House (1711), of limestone ashlar with a one-bay banded frontispiece, segmental portico and balustraded parapet, is the earliest gentleman's house in Clifton.[49] Several similar buildings were constructed in Clifton between 1720 and 1750, including Clifton Wood House for Robert Smith (1722–1728), Goldney House for Thomas Goldney II between 1720 and 1730, Clifton Court for Nehemiah Champion (1742–1743) and Clifton Hill House for Paul Fisher (1746–1750). Architect Isaac Ware remarked that Fisher's house would be 'handsome though not pompous' and built for 'convenience rather than magnificence'.[50] These attributes could be ascribed to most gentlemen's houses.

The geographic shift in building in Gloucestershire coincided with the stylistic changes throughout England. By 1730, Bristol had developed a distinctive provincial architecture that melded baroque form and ornamentation and Palladian design, and spread throughout the region.[51] Two gentlemen's houses from the 1730s exemplify this stylistic melding: Frampton Court (Figure 3.12), built for landowner and customs official Richard Clutterbuck, and Redland Court (Figure 3.13), for retired London grocer John Cossins. In about 1730, Richard Clutterbuck asked almost unknown architect Thomas Fassett to produce designs for a new house in Frampton-on-Severn. Fassett first drew an uncomplicated five-bay, hipped roof house, which clearly did not suit Clutterbuck's taste, and then a grander Palladian design, complete with attached outbuildings and connecting arcades.[52] Clutterbuck seemingly rejected both of Fassett's designs and the end result was likely the work of a Bristol architect.

Figure 3.12 Frampton Court, 1731–1733
Source: Author.

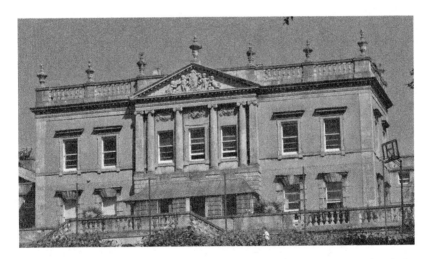

Figure 3.13 Redland Court, 1732–1735. Originally a five-bay house, the single bays on either end of the main block were added later
Source: Author.

Frampton Court shares design features with Redland Court, the only documented house completed by John Strahan, the leading practitioner of the provincial mix of baroque and Palladian that one rival architect referred to as 'Piratical Architecture'.[53] By 1735, retired London grocer John Cossins had erected Redland Court on a small estate near Bristol.[54] A link between the two houses can be established through Bristol Customs official John Elbridge. Richard Clutterbuck served

apprentice to Elbridge in the early 1720s and took on the post of Searcher of the Port, whilst Cossins was one of the executors of Elbridge's will.[55] This makes it circumstantially likely that John Strahan played some part in the design of Frampton Court. That Strahan's designs might be seen as backward-looking emphasises these houses as local efforts to balance the fashionable and the traditional.[56] They confirmed the status of owners like Clutterbuck and Cossins, at the same time that they hinted at a degree of aesthetic and social uncertainty.

By 1730 some consensus had been reached about the size and scale suitable for a gentleman's house. Houses exhibiting a blend of classical styles began to be sprinkled throughout Britain and its colonies, which demonstrated the stylistic flexibility of the compact box. William Townsend's Paradise, Dudbridge House for Richard Hawker, and Onesiphorus Paul's Hill House further illustrate the growth of clothier's fortunes and the concomitant building campaigns.

By the middle of the century, a few examples of more fully fledged Palladian buildings appeared, although many gentlemen stuck to designs with a provincial flair that had worked for a quarter century or more. Alderley Grange brought together developing architectural styles and new wealth generated by the growth of Bristol. The oldest sections of the house date to 1608, but in 1744, William Springett, having secured an advantageous marriage, set about building an appropriately scaled classical house suited to his position as an entrepreneurial Quaker merchant from Bristol seeking to establish himself as a country gentleman.[57] Built in the country with commercial wealth abetted by a clever connubial alliance, Springett and his house illustrate the archetypal interpretation of a new man making a linear move from trade to land.

Throughout the eighteenth century, members of the landed gentry continued to build small classical houses. In the mid-eighteenth century, George Whyrall added a classical front to an older house in the Forest of Dean following a fire.[58] Thomas Chamberlayne, who became Dean of Bristol in 1739, remodelled Broadwell Manor in the north Cotswolds, probably in the 1740s.[59] It is one of the few small classical houses built as domiciles for the clergy. Gloucestershire's gentry produced relatively few military and naval families.[60] As with the clergy, only a handful of houses had military associations.

As in England, this adaptable architectural style was increasingly used for both country and town dwellings in the American colonies. America was 'overwhelmingly a wooden world', and as a result large houses there were made of wood as well as stone and brick.[61] In New England, Archibald Macphaedris erected a five-bay house in Portsmouth in the 1710s, setting a standard that continued throughout the century in houses like the Jeremiah Lee mansion built in the 1760s in Marblehead, Massachusetts (Figure 3.14). From the 1750s, genteel families in western Massachusetts – the so-called River Gods – adopted a regional inflection of the small classical house seen elsewhere, often with a gambrel roof, decorated doorways and painted exteriors. The Ephraim Williams house, for example, may have been 'dated, rather rustic and a trifle vulgar' but still functioned as a genteel house.[62] Philip Ludwell III, a member of the Virginia Governor's Council, built the Ludwell House in Williamsburg that reflected the fashion for hipped roof

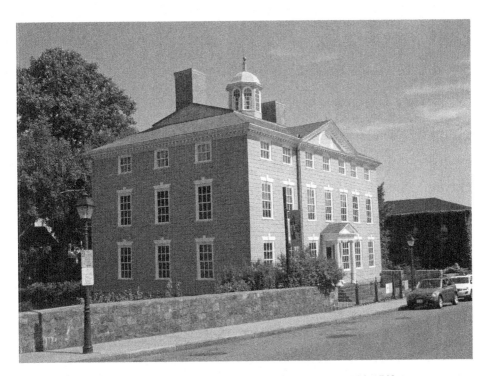

Figure 3.14 Jeremiah Lee Mansion, Marblehead, Massachusetts, 1766–1768
Source: Author.

brick. When he died in 1767, he left an estate valued at £11,442, making him one of the richest men in Virginia, and one who was pleased to build and own a house in the prevailing genteel style of the day.[63]

Commenting that he was 'about purchasing a plantation to retire to, for I am heartily out of love with the world', James Logan began Stenton in the 1720s. In late 1728 Logan told Thomas Penn that he was soon 'to retire with my family into the countrey, where I have for sometime been building a handsome house, tho' very leisurely.'[64] Given its relationship to other provincial houses in the British Empire, Stenton should be interpreted as an English gentleman's house in North America, another example of provincial and colonial interpretations of national architectural styles that were effective in building status in local and regional locations.

From the 1720s, small classical houses more often acquired owners who have frequently been described as merchants and professional men who had money to spend but not much taste. One historian, for instance, described Bristol as 'prosperous but unsophisticated'.[65] Although there may be some truth to these accounts, a close examination of gentlemen's houses suggests a somewhat different picture.[66] By the mid-eighteenth century, the compact classical house had become a standard choice for gentlemen builders. The houses could be dressed

up in various guises, but their form and scale conveyed a sense of restraint and solidity. By building houses like those above, new men were selecting a conventional form of house that helped them to avoid critique as the *nouveau riche*. Some gentlemen builders may have been showing off, but most were doing so after they had already reached a stage where success in their activities had been secured. Rather than provincial and sub-par, this range of classical styles should be understood as essentially conservative choices that confirmed status for genteel owners. Examining the intersection of architecture and status makes apparent that genteel builders were exercising moderation and taste in their construction efforts.

The building process for gentlemen's houses

Erecting a gentleman's house usually took a minimum of a year or two and in some cases building went on for even longer. Frampton Court, for example, took two years between 1731 and 1733.[67] This instance was fairly efficient; Clifton Hill House near Bristol commenced in 1746 but was still being finished, at least on the interior, in the early 1750s.[68] James Logan began Stenton in 1723, halted and resumed construction, and finally moved to the house in 1730. This was less time than it often took to construct a grander country house but was nevertheless a serious commitment of time and energy, and there were often complaints about the building process.[69]

In building their houses, gentlemen frequently incorporated existing structures, built on previous foundations or cellars, and reused building materials.[70] Economies were often employed with an eye toward saving on costs but presenting an appropriate image. A house as elegant as Frampton Court was built largely of locally-produced brick, probably reused from the earlier building. The main block was then faced in elegant Bath stone, with the two wings rendered and scored to simulate stone.[71] This economy achieved the desired outcome as one visitor remarked, 'The building is of stone, is rather heavy, but has a magnificent appearance'.[72] Richard Clutterbuck also recycled panelling from his father's house, albeit in tertiary spaces on the first floor. When he built his new stables at Lower Slaughter Manor, General William Whitmore received a £7.10 deduction for 'Old Stones'.[73]

Evidence often suggests an ongoing process of building, rebuilding and altering. Brownshill Court was built in 1760, and then an entirely new entrance front was created by about 1790.[74] A similar course took place at Hill House near Stroud, the 'beautiful villa or seat...erected a few years ago', by Sir Onesiphorus Paul soon after his acquisition of the estate in 1757.[75] Between 1784 and 1792, Paul's son made substantial additions to the house, including two-storey wings and canted bays, which cost the considerable sum of £7,185 5s 8d.[76] Indeed whole houses might be used in this way. Lord Conway's work at Sandywell Park incorporated the earlier five-bay, hipped roof house into a significantly larger composition through the addition of baroque wings in the 1720s.

These gentlemanly design and building processes involved several individuals. Most gentlemen's houses were not designed by an architect, but under the direction

of an informed builder owner or master craftsman.[77] For much of this period the distinction between provincial architects and master craftsmen was somewhat ambiguous. Valentine Strong, from a family of builders in east Gloucestershire and Oxfordshire, possibly undertook the design as well as masonry at Lower Slaughter Manor, and worked at Fairford Park just before his death in 1662.[78] John Bryan, a mason from Painswick principally noted for tombs and church memorials, has been credited with the main façade of Paradise.[79] Perhaps a dozen gentleman's houses in Gloucestershire can be plausibly attributed to provincial architects, but only one was designed by an architect accorded national recognition, Clifton Hill House by Isaac Ware. Despite the lack of a national architect, the other eighty gentlemen's houses were equally successful in enabling owners to build status. Tracing the architect frequently rests on stylistic attribution, and surviving building accounts most often suggest design by a master-builder or other craftsman. Thomas Paty, from a family of Bristol masons and architects, worked on Clifton Hill House and Royal Fort primarily as a carver but also as an architect, and also executed drawings for one family in Philadelphia.[80]

The work of designers was transmitted further by local craftsmen. A handful of men were paid sums ranging from £13 to £102.18.8½ for work at Frampton Court in 1733, and family tradition has it that the exquisite joinery in the house was the work of Bristol craftsmen.[81] Visual comparisons suggest that the staircase at Frampton Court, for example, is strikingly similar to one at Eastbach Court in the Forest of Dean. Despite being an innovative building in colonial Virginia, it is not clear whether the Governor's Palace took its design from formal sources or locally influenced ideas.[82] As late as 1765, Thomas Nelson of Virginia noted that he had designed a two-storey brick house in Yorktown by himself.[83] The anonymous nature of many master craftsmen and workmen should not obscure their obvious important role in fashioning and erecting gentlemen's houses. Great architecture they might not be, but compact classical boxes still stood out as houses fit for gentlemen.

For gentlemen builders, provincial urban centres provided inspiration and expertise, and port cities encouraged transmission across the Atlantic. Architects and craftsmen from Warwick and Bristol designed several of the larger and more significant houses, and other houses display details illustrating influence emanating from these regional centres.[84] Geography contributed to this process, as did personal connections. The north Cotswolds particularly saw influence from Warwick, especially the Smith family of architect–mason–bricklayers, who worked at Sandywell in the 1720s and built Barrington Park of 1737 for Lord Talbot.[85] John Strahan's work at Redland Court is one of several houses he may have had a hand in designing. Painswick House, built in the mid-1730s for Charles Hyett, has also been attributed to John Strahan on the basis of style,[86] as has Frenchay Manor, although George Tully has also been credited with the latter. Tully likely designed Hill House in Mangotsfield for John Andrews.[87] An associate of Strahans, William Halfpenny, made a name as a second-rate architect based in Bristol by about 1730. Best known for publishing a slew of architectural pattern books and manuals, he willingly mixed styles and became something of

a figure of architectural mockery.[88] Although little actual work can be attributed to Halfpenny, he was involved in the construction of Redland Chapel, picking up the work after Strahan died, and may also have designed Clifton Court and the Gothick orangery at Frampton Court.[89]

Architectural pattern books and building manuals had limited influence at this level of building in England and America, and subscription lists and gentlemanly libraries indicate that gentlemen builders did not own many copies.[90] Most of the well-known pattern books were not available until well into the eighteenth century. Halfpenny's first book, for example, appeared in 1724.[91] Some houses built in the west of England after 1730, such as Broadwell Manor and Winson Manor, clearly drew upon James Gibbs's *A Book of Architecture* (1728).[92] Gibbs's work may have been especially useful as a source for disseminating floor plans to gentlemen-builders, with much of the book devoted to elevations and plans of the 'middling-gentry size, more often than not seven bays wide'.[93] But Gibbs did not write until the late 1720s, by which time many of the houses in this study were already built and could serve as practical models for others wishing to construct similar houses.[94]

Few architectural plans survive for small classical houses and although their design, level of sophisticated detail, and overall craftsmanship argues in favour of a reasonable level of knowledge in the direction of building works, it is unlikely that an architect had an active hand in more than a small percentage of gentlemen's houses. Elsewhere in the British Atlantic, a mixture of architectural knowledge with vernacular building traditions was likewise the norm.[95] The remainder drew upon the expertise of master craftsmen, possibly although not conclusively utilising pattern books or builder's manuals.[96] In less urban-centred areas like Virginia, the lack of highly qualified craftsmen provoked complaints.[97] Moreover, gentlemen builders lacked a detailed knowledge of building practices. Although they may have had views on the appearance of their house, as evidenced by Richard Clutterbuck, it was primarily left to them to exercise economic control over the building process.

The economics of building

Although the expenditures incurred in building a gentleman's house bear little comparison with the sums spent by larger landowners on their country houses, they far exceeded the capital available to most in British society.[98] House construction or purchase was the single most significant act of consumption most people undertook.[99] Nevertheless, genteel building did not break the bank. Architectural pattern books, such as those published by William Halfpenny, set out surprisingly modest estimates. Halfpenny offered designs for several five-bay houses without office wings between £511 and £910. Another plan 'for a house 56 feet in the front, with proper offices' totalled £2,598.[100] Although it is necessary to be wary of the calculations of architects, especially those of an active self-promoter like Halfpenny, these costs indicate what a gentleman builder might expect to spend when undertaking new construction.

Building records are rare and often incomplete, but construction projects in provincial England and the American colonies approximate Halfpenny's estimates for compact, classical houses. In practice, a house built in the 1670s like Ryston in Norfolk cost £2,800, while a century later Heacham Hall (2,700 square feet) cost £4,128.[101] Stoneleigh Abbey in Warwickshire was rebuilt for £3,330, an astonishingly modest sum for a fifteen-bay classical house.[102] Clifton Hill House (1746–1751) cost Bristol linen draper Paul Fisher at least £4,204, including payments totalling £1976.1.10 to mason/architect 'Thomas Patty'.[103] In the 1760s, Edward Machen spent £2,500 to rebuild Eastbach Court after a fire.[104] In the early 1770s timber merchant, shipbuilder and occasional slave trader John Okill built Lee Hall near Liverpool, described as a 'large capital mansion house', expending by its completion nearly £3,000.[105] At the higher end of gentlemanly house building, Crowcombe Court was built in two campaigns that totalled £5,913.[106]

Costs incurred by American builders over the eighteenth century were similar, factoring in local currency and labour costs. The colony of Virginia erected the Governor's Palace in Williamsburg, a model for later Chesapeake planters' mansions, with an initial appropriation of £3,000, although in 1710 the legislature allocated an additional £1560, 'a farther Sume of Mony for The Speedy perfecting of The Governors house'.[107] In the 1760s, Cliveden near Philadelphia cost the Chew family £4,718 (including £650 for the land), which was the equivalent of £2950 sterling. Building costs for nearby Mt Pleasant were comparable.[108] Appraisers valued Jeremiah Lee's elegant mansion in Marblehead, Massachusetts at £3,000 Massachusetts, or £2,500 sterling, in 1775.[109]

A genteel family could therefore expect to spend between £2,000 and £5,000 on a small classical house.[110] Such expenditures incurred in building a small classical house bear little comparison with the sums spent on country houses by aristocratic landowners. Nevertheless, their compact form, size, and limited exterior and interior ornamentation placed them above a polite threshold, striking a balance between an impressive architectural display and a reasonably affordable and easy to maintain structure.[111] The tendency of builders from commerce and the professions to undertake construction later in life indicates that their choice was made from a position of financial responsibility. As a result of their business background, merchants especially may have been more cognizant of building costs than landowners, prompting them to wait before investing in a gentleman's house.[112] Even supposedly profligate southern plantation owners displayed judiciousness in their deployment of resources on building projects. Tellingly, the most successful planter in Virginia, Robert 'King' Carter, lived relatively modestly until building his large brick house in about 1720, when he was well into his fifties.[113]

The argument that planters and other southern elites did not overextend themselves, at least insofar as expenditure on material goods is concerned, is at odds with the model of aristocratic emulation often propagated in discussions of the colonial gentry.[114] Mooney suggests that some Virginia planters overstretched their resources, although building costs are difficult to measure. Arlington, a large eighty-foot by sixty-foot house from 1670 cost £6,000, while Sabine Hall

was estimated at £1,486 local currency. Elite planters' dowries indicate a standard of wealth similar to prosperous English merchants, suggesting that the classical houses of Tidewater Virginia did not unduly stretch most owners.[115] Likewise, the few transfers of small classical houses in Gloucestershire by sale as a result of acute financial problems suggest that a fairly high degree of stability characterized the owners of this style and size house.[116] The 'River Gods' of western Massachusetts spent limited resources to build their clapboard mansions.[117] Material culture and architecture can therefore be recast from one of 'prodigious amounts of money' being spent on 'aristocratic facades' to suggest a more incremental and measured process.[118] Some genteel owners did overextend themselves. Thomas Carr of Eshott Hall in Northumberland experienced keen financial difficulty ultimately selling up to his lawyer, Thomas Adams, who held many of his debts.[119] But this was an exception to the generally careful economic management of many elites.[120]

Maintaining a gentleman's house also required regular expenditures and occasional improvements. After the death of her husband in 1725, Elizabeth Whitmore of Lower Slaughter Manor embarked on repairs to modernize the manor house and its décor, spending £150.19.11 for such items as 'Slatting the house', 'the plumers bill', and 'Collering', or painting, various elements.[121] Thirty years later, the roof was again under major repair, as a bill records, 'For Repairing the Roof of the Great House and taking Down old Cealings and the old Plastering of the Walls and Riding out the Same and Stoping Hols in the Barn and Stables and taking Down the Old Landrey and Work at Mr Marshals'.[122] Elizabeth's son, General William Whitmore, undertook reconfiguration of both the back and best staircases in the manor house, the former done in a combination of oak and deal, the latter solely in 'Flanders oak'.[123] In the 1740s and 1750s, William Whitmore was usually spending between £500 and £600 per annum on expenses to maintain the house and estate.[124] Outbuildings demanded attention, and Whitmore built new stables costing £493.18.10 in the 1760s.[125] Near Bristol, retired grocer John Cossins undertook a steady stream of work in the 1730s and 1740s, first building Redland Court, then a handsome chapel for about £1,610.5.9½, and then moving back to add small wings to the house.[126]

How to pay for such projects was a central question for builder-owners. Sources of income combined estate rents, the sale of crops, and proceeds from trade and office-holding. Although it is difficult to calculate the income enjoyed by gentlemen, it was substantial by many measures. The Whitmore estates at Slaughter and Norton near Cheltenham were valued at £321.16.1 but were only part of their extensive landholdings.[127] Charles Hyett had income as a lawyer, held the Constableship of Gloucester Castle worth £109.16.0, and had property in Gloucester and in the county. By 1780, the Hyetts held estates valued at £1,120.6.6. Resources from a profession, office-holding and property had enabled the family to acquire a small estate, build a gentleman's house, create a noteworthy garden, and continue to develop their estate further.[128] Richard Clutterbuck had an estate as well as salary and fees as Searcher of the port of Bristol.[129]

New men often built their houses from business proceeds. In Bristol, gentlemen first made money in trade and then deployed it for a suitable house. Many

Americans as well profited from their commercial ventures in ways that enabled them to erect houses befitting genteel living. Significant early buildings in the Delaware Valley include the cupola-surmounted William Trent House (1719). William Trent owned an interest in over forty ships, exporting such products as tobacco, flour and furs while importing wine, rum, molasses and dry goods. He also traded in African and West Indian slaves and indentured servants from the British Isles. In 1714, Trent acquired 800 acres in New Jersey and began construction of a large brick dwelling house overlooking the falls of the Delaware River. In late 1721, the Trent family left Philadelphia to take up permanent residence in their new country house. While a resident in rural New Jersey, Trent was elected to the Assembly, commissioned a Colonel of one of the militia regiments and also became New Jersey's first resident chief Justice in 1723, clearly signalling the status embodied by his house.[130] Trent's contemporary James Logan made a substantial fortune in shipping and the fur trade, and then embarked on the construction of Stenton. Planters' incomes in Virginia came not only from tobacco but from a range of sources, and they had extensive connections with merchants in Britain.[131] The small estate at Paradise produced only £35 per annum, making it clear that the buyer would need other resources.

A number of gentlemen's houses were built largely or in part as a result of involvement in the slave trade.[132] John Elbridge amassed a fortune of some £80,000 by his death in 1739, with a portion of that coming from a moderately sized sugar plantation in Jamaica.[133] Other gentlemen engaged in the slave trade directly or through investments they had in sugar plantations, activities utilizing enslaved labour, or the provision of goods to the Africa trade. Somewhat later, gentlemen's houses around Liverpool cropped up funded in part by slave activities.[134] Many, if not most, American gentlemen's houses existed because of enslaved labour. The economy of the Chesapeake, based on the institution of slavery, fuelled building projects for Virginia planters.[135] Mid-Atlantic and New England gentlemen's houses, too, profited from enforced servitude and the international trade that made it possible. At Stenton, James Logan held a handful of enslaved people, enumerated in his will, and kept careful track of shipments of slaves in his account books.[136]

William Palling, who rebuilt his house at Brownshill Court in about 1760, offers a final glimpse at the income available to a prospective builder. Palling, from a Painswick family that had been engaged in the cloth trade for several generations, carefully recorded the value of his estate, which went up consistently between 1755, when he set the value of his whole estate at £4,387 and 1763, when it was £5,520.[137] For a gentlemen-clothier like William Palling, who was also noted as having an estate of about 'eight hundred pounds per annum', in 1760, an investment of a few thousand pounds to build a small classical house does not seem to have caused any extraordinary financial hardship.[138]

Such an undertaking seemed to be in keeping with other gentlemen. Few builders or owners experienced economic distress related to house cost, or sold up as a result of over expenditure. Small classical houses were a flexible, economical choice that neither broke the bank nor overstretched the resources of their genteel

builders. This finding broadly agrees with Wilson and Mackley, Rothery and Stobart, and Walsh that the amount of debt and its deleterious effects on building and estate ownership has been overstated.[139] The economics of gentlemanly construction offer another indication that gentlemen were making considered decisions in using a flexible, economical style in building.

Interpretation of meanings: gentlemen's houses as architecture

In their size, scale, and design, gentlemen's houses differed significantly from grander houses built throughout the British Isles during this period. Such larger country houses projects are especially well-documented and occasionally inspired gentlemen's houses, but genteel emulation of grander architectural projects has been overemphasized.[140] There was a clear sense throughout the British Atlantic world of what was appropriate for the genteel and what was too grand. The building of gentleman's houses was not a process of re-creating grander country houses on a smaller scale. Although small classical houses might take cues from great houses, they form an important and distinctive category of their own, a significant indicator that the people who inhabited them did as well.

Two larger country houses in Gloucestershire illustrate some of the substantive differences between these grand residences and those of the gentlemen in this study. Dyrham, the seat of William Blathwayt, was one of the largest building projects undertaken in Gloucestershire between 1680 and 1780. The garden front extended one hundred thirty feet, more than double the width of most gentlemen's houses. In effect, the main block consisted of two separate single-pile fronts, one fifteen and the other thirteen bays wide, built ten years apart, designed by different architects, and comprising two nearly distinct ranges of rooms. The interior was highly decorated, with numerous rooms adorned with carving and gilding, panelling, gilded leather, textile wall coverings, and japanning. In turn, the number, quality and cost of the elaborate furnishings far outstripped those possessed by owners of smaller classical houses.[141]

The eighteenth-century house in Gloucestershire that garnered the most attention as a model for other local architects-builders was Edward Southwell's Kings Weston.[142] Designed by Sir John Vanbrugh, the scale of this seven-bay house is also beyond the small classical houses in this study.[143] The influence of Kings Weston has been identified with several Bristol architects such as John Strahan, who in turn spread their ideas beyond the city through work at several houses.[144] Yet Vanbrugh's effect on Bristol's architecture has been overstated. Merchants might look to smaller gentry houses for building examples, 'but not to a gargantuan villa breathing "expense" from every massive architrave and ponderous cornice'.[145] Bishopsworth Manor (c. 1720), located five miles from Bristol, exhibits some direct influence from Kings Weston. A small hipped roof house, Bishopsworth (Figure 3.15) was built for Anne Smyth, an unmarried daughter of the Smyth family of Ashton Court.[146] The house is modest in size and built onto an older structure. Although displaying handsome proportions, some baroque ornamentation, and adorned with Vanbrughesque chimney stacks, Bishopsworth Manor

Figure 3.15 Bishopsworth Manor, c. 1720
Source: Author.

Figure 3.16 Stenton, 1723–1730, near Philadelphia
Source: Stenton, NSCDA/PA, photo by Jim Garrison.

is far from being a work of homage to Vanbrugh. Beyond Bishopsworth, no other gentleman's house signals direct influence from Kings Weston.

Most gentlemen builders and owners after about 1730 were uninterested in aspiring to significantly higher status by constructing or acquiring a large country house, but rather more intent upon consolidating their standing with a new, elegant house 'fit' as it were 'for a gentleman'. Emulation therefore had strict limits, and gentlemen sought to build in a style and on a scale that was deemed appropriate for them and by them, on the basis of cultural and economic choices. Indeed the concept of emulation is slightly misleading; most men of gentlemanly status could not hope to construct a vast pile. The reverse was also true. Melton Constable in Norfolk, a house of the rectangular, hipped roof form but on quite a grand scale, was criticized as 'suburban' and unsuited as the principal seat of a large landed estate.[147] By the late-seventeenth century it was becoming clear that the style, scale, and plan of buildings suggested status with great specificity. Some gentleman's houses combined high style designs or ornamentation with vernacular features that demonstrated cost-saving measures or the limits of design by master builders. Owners in the late-seventeenth and eighteenth-century British world built as they were able, elaborating where they could but following form, plan, and style that fitted into an established hierarchy.

Contemporary chroniclers like Sir Robert Atkyns and Samuel Rudder, an amateur architect and critic like Roger North, visitors, poets and others offer intriguing references to small classical houses. Although these buildings did not draw the attention that larger houses did, what people said or wrote about them indicated

their importance. Repeated descriptions of these houses use terms such as 'handsome', 'neat', 'new built', and 'good'. Later in the century, Samuel Rudder employed similar language to describe small seats of gentlemen-owners. Cote was, 'a good house, with suitable estate, pleasantly situated', whilst Redland Court was, 'one of the most elegant houses in this part of the country'.[148] James Logan referred to Stenton as a 'handsome house' and similar descriptions abound of gentlemen's houses set in the American landscape (Figure 3.16 and Plate I). A vein of thinking in the 1760s and 1770s in America, however, gravitated toward plainness and simplicity. Benjamin Chew desired urns with little or no carving especially from England for his new house, Cliveden near Philadelphia, and Robert Beverly requested that his mansion, Blandfield, be 'in a plain neat Manner'.[149] As late as the 1790s, architect Benjamin Latrobe, conducting a survey of Norfolk, Virginia, commented that the houses of 'private Gentleman' were 'plain and decent, but of the fashion of 30 Years ago. They are kept very clean and independent of papering, which is not universal, fitted up much in the English style'.[150]

This is not to say that new men were unaware of lineage and claims to higher status. In finishing their houses and memorializing for posterity, a number of gentlemen displayed coats of arms on the physical structure.[151] Only the grandest gentlemen or those looking to attain decidedly higher status made an attempt to suggest status akin to the aristocratic landed elites in this way. John Cossins had his coat of arms placed in the tympanum of the south side of his new house, as well as on the main gate and side gate to the estate. Clifton Hill House had a cypher and its date of construction in the tympanum on one side, the coat of arms of the Fisher family on the other. Richard Clutterbuck had a grand coat of arms emblazoned on Frampton Court as the culmination of construction. For some gentlemen, the coat of arms was an overt statement of position and lineage. Onesiphorus Paul, one of the 'gentlemen clothiers' who 'now pass for gentry' also incorporated his coat of arms into his new gentleman's house near Stroud.[152] In 1730, Logan wrote to his brother in Bristol, alluding to their gentrified ancestors that prompted him to name his house Stenton after the ancient village in Scotland where their father had been born.[153]

Georgian society had a remarkable ability to balance dynamic growth and stability. The construction of gentlemen's houses embodied a series of choices made by genteel Britons about taste, investment, and claims to authority.[154] House-building was a visible, symbolic, and calculated act undertaken in a measured way. Between 1680 and 1780, the small classical house went from being thought inadequate for a country seat by Roger North to being mocked as a pretentious 'Cit's country box' by poet Robert Lloyd.[155] These interpretations of the compact box design must be measured against reality. In examining small classical houses it is evident that the more disparaging claims about such houses (and their owners) were overdrawn. Compact boxes were initially a choice of landed elites. Later new men adopted the compact classical box because it was adaptable, convenient, and economical, which converted this style of house from the pioneering choice of an established group to a more conservative choice for a range of owners frequently originating from newer, non-landed backgrounds. The construction of a 'house

fit for a gentleman' represented a sober response by newcomers to the needs of status.

New men were not challenging large landowners, or seeking to build large country houses. They quite reasonably constructed dwellings that made clear their genteel position without incurring financial hardship, without seeking to emulate the greater gentry or the aristocracy, and without seeking substantial aggrandizement. As a result, the building of a gentleman's house was one important step in a slow, incremental process of social mobility. These houses allowed gentlemen to build status step by step, brick by brick, or stone by stone.

4
Situating Status

Building a house fit for a gentleman presupposed land for it to sit on. The example of Paradise in Gloucestershire highlights important issues related to the settings of individual houses, their connections with urban and rural environments, and the character of their immediate landscapes and gardens. As a property, Paradise did not serve as a country house subsisting on rents from land. Its income of £35 per annum was insufficient to guarantee the independent existence of the gentleman it sought for an owner. At the same time, the house resulted from William Townsend's manufacturing of cloth, a trade centred in the Stroudwater valleys but which had important, indeed necessary, links with the great commercial centre of London.[1] Without these links and the resulting financial resources, the house would not have existed. Paradise had its aesthetic merits as well. The house's 'West Country baroque' architecture likely took its cue from Bristol. It was 'pleasantly situated' with a 'beautiful prospect', providing an agreeable place of residence for a genteel owner. Factors of location, property, setting, and urban connection all helped to make Paradise 'fit for a gentleman'.

The small classical house form was geographically sprinkled around Britain and its American colonies. Early in the period, gentry houses were primarily situated on and supported by landed estates in Britain and America. Clear associations existed with land. Later, a greater variety of settings were to be found, particularly near port cities and other areas of commercial activity, such as the Stroud valleys, which saw gentlemen's houses situated across rural, village and suburban settings. The settings of gentlemen's houses brought together urban and rural environments. Evaluating how builders and owners used their gentlemen's houses prompts reconsideration of categories like the villa, the country house, and the house in the country. The immediate surroundings of gentlemen's houses constitute another theme of this chapter. Builders and owners erected houses on land ranging from sizeable estates with quite elaborate gardens to a few acres with simple, tidy landscapes. Several stood in conspicuous locations in villages. Others were contiguous to places of work. These specific settings, and the landscapes and gardens around them, offer indications about function and status.

The construction of small classical houses in urban, suburban and rural settings demonstrated their capacity to project status in a range of places for both landed and non-landed elites. The situation of the gentleman's house was important, conveyed meaning, but was highly variable. Land very much mattered, and was a virtual *sine qua non* for social and political power at the highest echelon.[2] Nevertheless, this did not preclude those propertied men who held smaller estates, or little land at all, from joining the governing class of Georgian Britain on something like their own terms.[3] Possession of a landed estate was not essential for acceptance into gentlemanly ranks. Throughout the British world, small classical houses, whether at the centre of a large estate or located closer to a city, town or village, was a signal feature of genteel status.[4]

The diversity of situations: change over time

Space has increasingly come to be accepted as socially produced, which is to say that it is imbued with meaning through the social practices of the people who create, use and encounter it.[5] The situation of the houses in this study conveyed social and cultural messages to the people who interacted with them. In the more geographically confined built environment of eighteenth-century Britain, even a small gentleman's house was a significant physical presence that might dominate the local landscape. According to one account, Robert Carter's Nomini Hall in Virginia could be seen at a 'Distance of six Miles'.[6] Indeed, a defining characteristic of gentry houses was that they were meant to stand out in the landscape, whereas yeomen's houses blended into their surroundings.[7] This emphasizes the importance of topography and the relationship of small elite houses to location and setting.

Although gentlemen's houses were modest by comparison with the larger houses of the aristocracy and greater gentry, they appear in contemporary written and visual depictions. The occasional but infrequent visual images of gentlemen's houses in county histories and other books are an indication of their perceived status. Only fourteen of eighty-one houses surveyed in Gloucestershire (17 per cent) were depicted in the volumes of country house prints.[8] Atkyns's *Ancient and Present State of Glostershire* incorporated many of Leonard Knyff's and Johannes Kip's drawings of country seats, which confirmed the centrality of houses in a physical and ideological sense.[9] When their drawings were produced in the early-eighteenth century, compact classical houses were relatively innovative dwellings built by landowning gentry families. The published eighteenth-century views of gentlemen's houses nearly all show substantial landed estates with ample gardens. Comparison of the drawings in Atkyns with those in Rudder illustrate changing fashions in landscape: Kip and Knyff depicted extensive formal gardens with parterres and allees, whilst in Rudder's views from the 1770s formality had been swept away, replaced by an undulating naturalistic landscape.

Examining the location and situation of gentlemen's houses helps to interrogate ideas about space, distance and topography. Through maps people experienced and represented their world, and the period covered by this book saw

dramatic changes in the accuracy of cartographic practice.[10] Maps are critical to situating gentlemen's houses and provide a guide to changing built and natural environments in the Atlantic world.[11] Estate surveys, for example, were aesthetically pleasing as well as functional, suggesting they were meant to be seen, even displayed, at least to those who had an interest in the property concerned: stewards, tenants, or other landowners. Surveys documented the acres that supported houses, an important purpose for the small classical houses situated on estates. The relationship between house and setting was highly dependent on the amount of land on which the house sat. Throughout the period, landed estates remained a main source of income for gentlemen builders and owners. Such landholdings provided income to sustain a genteel lifestyle. Landed estates were the norm for gentry houses until the 1720s. Indeed before 1730, only a handful of small classical houses were *not* built on a landed estate by established members of the gentry.

Whereas grander country houses were often 'too big for their estates', this seems not to have been a significant problem for builders and owners of small classical houses.[12] One thousand acres and the income that went with them, made up from farming, rents and other investments, was usually a minimum threshold to sustain a country house for the minor gentry.[13] Few estates associated with houses in this study numbered much over that number. In 1704, Henry Brett purchased the Sandywell estate of indeterminate size, but probably not more than a few hundred acres, and quickly built a house.[14] Perhaps as a result of the limited acreage, the estate was mortgaged for £1,300 in 1708 and then sold to Lord Conway in 1712, who added additional property.[15] In 1748 Thomas Tracy bought Sandywell for £17,250.[16] Other families acquired enough property to settle comfortably as minor gentry. One estate with a small classical house, Bigsweir estate in Gloucestershire and Monmouthshire, numbered just under 1,000 acres in 1787.[17] By about 1730, Gloucester attorney Charles Hyett owned several hundred acres in the county and purchased the Painswick estate in 1733, completing the house over the next five years. Hyett played an active role in county affairs as a JP, chairman of the Quarter sessions nineteen times, Constable of Gloucester Castle, and MP for Gloucester from 1722 to 1727.[18] Hyett originally called his Painswick property 'Buenos Ayres' on account of its purportedly salubrious air (Plate II). Although he did not buy more than about sixty acres in the parish of Painswick, Hyett, and then his sons Benjamin and Nicholas, held small but widespread landholdings.[19] A survey of 1780 records eighteen small estates, with rents valued at £1,278.19.8.[20] By the end of the eighteenth-century, the Hyetts were reaping enough income from their estates to have solidified their position amongst the gentry of the county.[21] A 1768 survey of the Frampton Court estate shows land in Frampton parish totalling a little more than 345 acres, and it seems unlikely their total landholdings amounted to much more than 1,000 acres.[22] Estate income, however, combined with salary and fees from his customs post allowed Richard Clutterbuck to build a new house, do some reshaping of the landscape, and enjoy a handsome style of life.[23]

In America, where land was plentiful, the situation was somewhat different, and some colonials owned staggering amounts of property. Robert Carter I had an estate

of 200,000 acres valued at perhaps £129,000. Generally the value of American property, though, was limited and few Virginia planters enjoyed incomes similar to comparable landholders in Britain.[24] William Penn, proprietor of Pennsylvania, owned over 8,000 acres at Pennsbury Manor and wrote, 'The Country Life is to be preferr'd', so it was only natural that he should look to establish a country estate.[25] Several plans show sketches of Pennsbury, all of them reflecting a symmetrical design.[26] Many New York landholders also had enormous estates.[27] Sir William Johnson purchased 24,000 acres that became Johnson Hall in the Mohawk Valley of New York.[28] Nevertheless, a genteel lifestyle could easily be sustained by those building houses on much smaller plots. James Logan, for example, assembled 511 acres for his Stenton estate.[29] Like Paradise and Stenton, numerous gentlemen had modest estates with their classical houses as centrepieces.

By the second quarter of the eighteenth century, small classical houses were less frequently constructed on landed estates. Penelope Corfield noted the mistake many historians have made in classifying all gentlemen as landowners.[30] Between 1690 and 1740 land declined as the absolute criteria by which an individual could lay claim to genteel status.[31] Many gentlemen's houses that appeared after the 1720s were neither supported by a landed estate, nor even located at the centre of a significant piece of property. These owners increasingly drew upon substantial resources related to trade and commerce to support their building efforts. Land remained important, but merchants sought out diversification, with land being an obvious choice amongst several options.[32] Gentlemen merchants in Leeds, for example, acquired estates piecemeal for economic reasons rather than social and political advancement.[33] Only occasionally when buying land did new men build on it. Most often it was let to produce income.[34] New men spearheaded a process where classical houses situated on landed estates were superseded by gentlemen who built on much smaller pieces of property.

Much of the change after about 1730 in Gloucestershire can be attributed to increased construction of small classical houses by clothiers in the Stroudwater valleys and building around Bristol. In 1681, one traveller noted that in the Stroudwater valleys, 'you begin to enter the land of the clothiers, who in these bourns [are] building fair houses because of the conveniency of water'.[35] Houses erected by clothiers show a relationship between work, home, and status. Some were built in close proximity to woollen mills in and around Stroud, as millhouses 'often combined within the same building a mill and a clothier's residence'.[36] Many clothiers elected to retain their domicile near their work. It was only the most successful clothiers, such as William Townsend, Richard Hawker or Onesiphorus Paul who moved to a literal and metaphorical status elevated above their mills. One such family of 'gentlemen-clothiers' were brothers William and Thomas Palling, who each built a 'gentleman's house' between 1740 and 1760. By the early-eighteenth century, the family's cloth business in London paid handsomely, and 'most of their money was made here, rather than from their lands in Painswick'.[37] Over the course of the eighteenth century, however, they acquired additional property, seemingly from declining clothier and farming families. William, the elder, eventually came into much of the estate through inheritance from his uncle, whilst

Thomas went on to build Pitchcombe House.[38] By the early 1760s, William Palling of Brownshill valued his assets at £5,520, reaping handsome income from the cloth trade and land rents.[39] Although unusual, their experience of removal from mill site to small estate showed that mobility in situation was possible, and that construction of a small classical house functioned as an important tool for social mobility as well.

The influx of new money like the Palling cloth fortune changed the dynamic of gentlemanly building campaigns. As a setting for a gentleman's house, a landed estate was important but no longer paramount for those hoping to situate their status amongst the governing class. As French has pointed out, gentility did not necessarily equate to 'tokens of *landed* gentility'.[40] Landed and commercial elites could come together to form 'polite society', but gentility in the form of a classical house did not require the acquisition of substantial landholdings.

The function of gentlemen's houses: a 'beautiful villa or seat'?

The significant changes in the situation of small classical houses between the 1720s and 1780 underpinned the social strategies of urban-centred propertied men who were increasingly prominent in the eighteenth century. But what role did the small classical houses that gentlemen built near provincial cities play? Did they function as country houses, houses in the country, or villas? Houses like those in this study have been categorized in several ways. In the seventeenth century, 'the smaller double-pile house was appropriate as the centre of a small or suburban estate'.[41] But there was a difference between 'the true country house and the house in the country'.[42] Diarists in London, however, occasionally referred to their dwellings as 'country houses', even when they lived in relatively close proximity to the metropolis.[43] Wilson and Mackley suggest that the clear distinction between the country house and the house in the country did not to break down until the mid-nineteenth century when 'new money flowed into the countryside'.[44] This process, however, began as early as the 1720s throughout the British world, highlighting the underappreciated fluidity of small classical houses. Consideration of gentlemen's houses built by new men develops a different picture of how these houses were used and what they meant.

Another frequent reference to small houses is to call them villas, a term which has both architectural meaning in terms of size, scale, and design, and social meaning in how it was used.[45] One contemporary author described the villa as a seasonal residence, the 'little House of Pleasure and Retreat, where Gentlemen and Citizens betake themselves in Summer'.[46] The villa was a place of 'retreat or retirement', or 'a house that mediated between town and country and excluded all that was unpleasing of either'.[47] But there was a 'marked variation' from the early-eighteenth to the early-nineteenth century, when the villa shifted from an 'aristocratic diversion' to a 'family home in continual occupancy'.[48] Moreover, Roger North noted the distinction between 'The country model, and that of a suburb villa'.[49] But small classical houses often served as a full-time residence for genteel families, belying their description as villas. As the following discussion

will make clear, particularly after the 1720s gentlemen's houses more closely resembled a house in the country than a villa or a true country house.

The distinction between urban and rural environments often obscured important inter-linkages.[50] Although rural communities might be resistant to urban values and cling tenaciously to customs and traditions, gentlemen's houses formed an important link between town and country.[51] Provincial cities in Britain and America sought to appropriate politeness as a balance to the competing claims of commercial and manufacturing activity.[52] Because of its robust trade, some accounts of Bristol were not favourable to the city, especially juxtaposed with the new building and lovely landscape of nearby Bath. Alexander Pope and Horace Walpole emphasized the dirty, uncouth and commercial nature of the city, but others were kinder.[53] In the 1710s, John Macky described a pleasant city, with 'a fine Stone Bridge', 'a very noble Square', and the 'little Country Seats' of the city's merchants 'in the adjacent eminences'.[54] Later in the century, one visitor remarked that Bristol was not 'near so bad a place as report has taught me to expect it'.[55] Accounts of other provincial cities exhibited similarly mixed perspectives, some commentators lauding development, some finding these cities backward. In 1761, the *London Magazine* described Philadelphia as 'one of the finest plans of a town that is now existing'.[56] Scottish provincial towns received mixed reviews, as did the burgeoning port of Liverpool.[57] One commentator noted that in South Carolina, 'the people live very Gentile and very much in the English taste'.[58]

Topography and setting provide keys to understanding the relationship between these houses, provincial cities, and the surrounding countryside and region. Eighteenth-century Bristol, for example, occupied much less land than it does now, and from the early years of the century successful merchants and city leaders began to construct noteworthy houses in nearby hamlets and villages.[59] Over one-quarter of the gentlemen's houses built in Gloucestershire were situated within the eleven miles of Bristol's environs.[60] This level of building reinforced the wealth available in Bristol in the eighteenth century, and illustrates the range of building choices made in a relatively confined geographic area.

Bristol's population growth resulted in a slow expansion of the area occupied by the city. Benjamin Donn's map of 1769 showed the medieval centre still formed the core of the city, but also identified a number of 'Seats and Noted Houses' around the city, including a number of houses in this study (Figure 4.1). Although Bristol had grown, its urban concentration had only just begun to climb the hills north and west of the city.[61]

Clifton village, the site of several gentlemen's houses, remained well outside the urban fabric of Bristol and at a markedly higher elevation, with a road leading nowhere – an isolated settlement that was close to but distinctly separate from the urban centre of Bristol.[62] Its 'very pleasing prospect' over the city, combined with 'the fine air, have induced many gentlemen to build and reside there'; their houses 'grace the summit of the hill'.[63] The houses built in Clifton displayed the wealth generated by Bristol whilst illustrating efforts by affluent merchants to remove themselves in some way from the City.[64] Rudder described the 'very

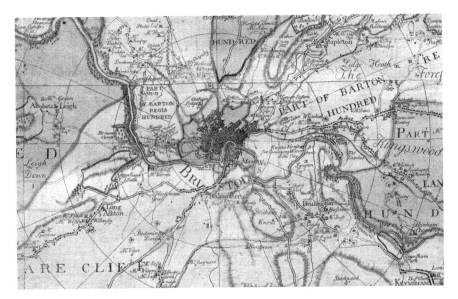

Figure 4.1 Detail of Benjamin Donn, 'Bristol and its environs' showing the location of several houses mentioned in the text
Source: Courtesy Bristol Record Office.

handsome houses, with freestone fronts and proper offices, upon Clifton Hill'. Thomas Goldney III had 'a handsome house here, with fine gardens, a grotto of shell-work and a canal with fountains supply'd with water by a fire engine'.[65] Henry Jones particularly admired Goldney's landscape and garden: 'a minor *Stow* on *Clifton's* crown we find'. Clifton was able to avoid the aspersions cast on commercial Bristol, being a place 'Where art, where nature leads the soul along/ And taste and commerce crown the copious song'.[66] Although close to the city, Clifton functioned as a separate village, albeit with a concentration of gentlemen's houses that distinguished it from other villages in and around Bristol. This process of removal, of engaging with but separating from the world of trade, made Clifton particularly noteworthy, but typical of the other villages near port cities throughout the Atlantic world.

Although only a mile or so distant from Bristol, Clifton's elevation separated it from the city; this distance meant that those who built houses there were not settling in suburbia, but were choosing something rather different. Many of the houses built by prosperous merchants and professionals did not function as villas, part-time residences, or retreats.[67] Houses like those in Clifton – Goldney House, Clifton Court, Clifton Hill House, Clifton Wood House – served as primary residences for their owners. Thomas Goldney II and III, for instance, made their Clifton house their primary dwelling, despite owning property elsewhere in Bristol.[68] Nearby, Paul Fisher's Clifton Hill House is frequently described as a 'Palladian villa'.[69] But when architect Isaac Ware's *A Complete Body of Architecture* featured elevations and plans of the house, it was described not as a villa, but as a 'Country

Seat without columns'.[70] Like many gentlemen's houses, Clifton Hill House was not a semi-rural retreat for its builder. Completed only a year or two before Fisher's sixtieth birthday, it was intended to be his main residence. After building and furnishing Clifton Hill House, Fisher lived there from the early 1750s until his death in 1762.[71] Naturally, the house allowed access to the city, where Fisher kept a hand in his business and public affairs. In setting up house, becoming active in parish affairs and charitable activities like the Bristol Infirmary, and reducing his role in business, Paul Fisher had reached a point in his life where such a house confirmed status. Likewise, merchants in Liverpool were not eager to abandon their commercial lives, and many only acquired houses outside the city later in their careers.[72]

This process was repeated by other gentleman builders and owners who undertook to solidify their social standing. Nehemiah Champion, a leading figure from a noteworthy Quaker family of metal manufacturers, and his third wife, Martha, daughter of Thomas Goldney II and sister of Thomas Goldney III, built Clifton Court soon after their marriage in 1742.[73] Nehemiah and Martha Champion likely resided at Clifton Court, across the village green from Fisher, in the few short years between its completion and Nehemiah's death.[74] The Champion's house, probably designed by William Halfpenny, the lightly regarded Bristol architect who indulged in buildings and books on the Gothic and chinoiserie, can be juxtaposed with the more correct Palladian rectitude of Fisher's Clifton Hill House designed by Isaac Ware. The distinction architectural historian Michael Jenner made between Clifton Court as a country house and Clifton Hill House as something less grand seems difficult to sustain on the basis of architectural style alone.[75] In terms of function, these houses were remarkably similar, and it was how they were used that distinguished them both as gentlemen's houses.

Few small classical houses near provincial cities were situated on estates that provided enough income for genteel living. Most were more akin to 'houses in the country'. The Cote estate a few miles from Bristol illustrates the interplay between a small estate, a gentleman's house, and various sources of income. By 1706, Thomas Moore had invested a total of £2,470 in a small estate.[76] Contemporary documents frequently referred to Cote as the house 'over the Down', signifying distance and removal from the environs of the city.[77] Other gentlemen's houses stood separate from the city, an important factor in the creation of a sense of space and distance. A little more than a mile from the burgeoning commercial port, the Redland Court estate had produced just enough to sustain a minor gentry family into the early-eighteenth century. The house and estate were sold in 1732 to Johns Cossins, a wealthy London grocer, at which time it 'ceased to be regarded as a source of income'.[78] Almost immediately Cossins diverted his grocer's fortune into a small but elegant gentleman's house designed by architect John Strahan, which had a long tree-lined drive perhaps a quarter mile long.[79] The estate remained substantial until sold in 1799 by order of the Court of Chancery, but it had not for some time functioned as a proper country house.[80]

Bristol merchants made varying choices in situating their houses. John Andrews, a wealthy Quaker wine merchant, purchased a small estate and built

Hill House near Mangotsfield four miles from Bristol. He became one of the 'principal Proprietors of Lands in this Parish', supported in part by estate holdings in Gloucestershire, Wiltshire, and Somerset, the rents of which totalled £470.[81] Despite having a small estate and house in the country, John Andrews retained a residence in Bristol.[82] Joseph Beck, one of Andrews' trustees, acquired a small piece of property near Frenchay and built a quirky but elegant house which may have served him primarily as a part-time residence, one of the few instances of a small classical house built for such a purpose.

In North America, expanding cities also propelled development. Around Philadelphia, a map by surveyors Scull and Heap identified 'the most Remarkable Places on this Plan', including gentlemen's houses, as well as noting other residences for the city's elite (Figure 4.2).[83] The village of Germantown, five miles northwest of the city, became home to several genteel families, including James Logan's full-time retirement house at Stenton and Pennsylvania justice Benjamin Chew's mansion, Cliveden, in the 1760s. Near Boston, Governor Jonathan Belcher told Isaac Royall, Sr that 'when you have done what you intend at Medford, it will be a fine Estate for a Gentleman to live on'.[84] Charleston, the largest city in the American southern colonies, had a concentration of plantations within a ten mile radius of the city.[85] Charleston's successful urban economy altered the balance between urban and rural. Whereas there might have been a clear progression from merchant to planter before 1740, after that date it was more of a mix and 'the countryside was servicing the purposes of the town'.[86]

The question of how small classical houses functioned for gentlemen builders and owners extended beyond urban environments. Stroud clothier Onesiphorus Paul built a house described as a 'beautiful villa or seat', an indication of the pliability of both concepts, as well as the house form.[87] After a long career in trade, Paul purchased the small estate in 1757 as a place to reside, swiftly followed by his elevation to a knighthood (1760) and then a baronetcy (1762).[88] In turn, his son, Sir George Onesiphorus Paul, used the house as a country house and primary residence, increasingly devoting his time and energy to Gloucestershire affairs, where he became a noted prison reformer.[89]

Building patterns and use suggest that small classical houses fulfilled specific functions for genteel builders and owners.[90] In whatever situation they occupied, gentlemen's houses were primarily about confirming status and serving as residences: they provided a genteel, adaptable house in rural or semi-rural environments, allowed the display of architectural and decorative taste, and enabled sociability. Especially before 1720, many were built as small country houses. A few small classical houses served in part as retreats from the urban environment. Rarely is the term villa encountered in reference to the houses in this study. More frequently, they are termed 'mansion' or simply 'house' usually with an adjective like 'handsome'.[91] After the 1720s, many more were essentially houses in the country. A number were residences in villages not far from port cities. Small estates close to provincial and colonial cities provided several needs but they were not merely villas. Erected later in life by gentlemanly builders, gentlemen's houses were often central investments that served as a primary residence or as a small country seat,

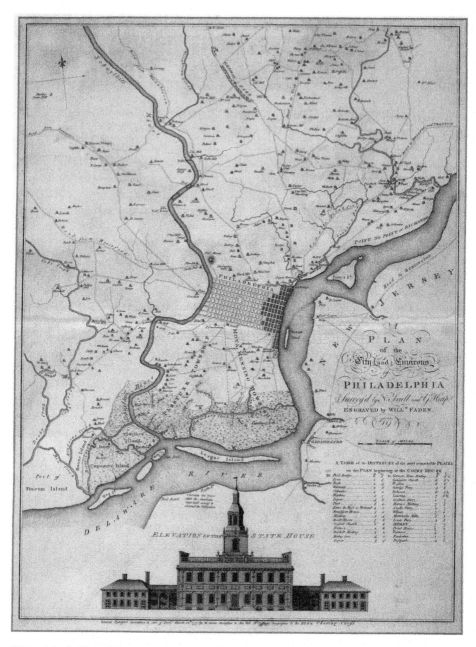

Figure 4.2 Scull and Heap map of Philadelphia, 1777
Source: Courtesy Library Company of Philadelphia.

rather than a site of retreat. Although the suburban villa became increasingly common at the end of the eighteenth century, between the 1720s and 1780, the houses built by new men were often neither villa nor country house. They were in many ways an amalgamation of the two, much like the owners themselves.

The surroundings of a gentleman's house

The relationship of gentlemen's houses to their immediate landscapes varied greatly in much the same way as their situation. Although an increased desire for isolation characterized the elite in the seventeenth and eighteenth centuries, this was not a course taken by many gentlemen builders and owners.[92] Major efforts to shape the grounds and gardens around a gentleman's house indicated some combination of interest, taste, wealth, and a wish to project power. The immediate settings of gentlemen's houses provide further indications of their practical and status-building functions.[93] Although Girouard has commented that 'a close connection between house and farm was entirely at variance with the English tradition' his stricture applies to larger country houses.[94] Moreover, despite the claim that the genteel house 'turned its back on the barns, animals, the farm laborers', what is striking about most gentlemen's houses is the close juxtaposition of the ornamental and the functional.[95] Gentlemen's houses throughout the Atlantic world displayed some form of shaped landscape or ornamental garden, but many also stood in close proximity to farming, cloth-production, industry or other work activity. Such diverse surroundings indicate that for genteel families no great inconsistency existed between gentility and utility.

Gentry houses before 1715 often exhibited extensive formal gardens, although throughout the eighteenth century some owners undertook development of their landscapes. At Fairford Park, the Lambes remade the formal gardens depicted by Kip in 1712 (Figure 4.3). According to Rudder, 'Mrs Lamb's seat' at Fairford had been 'modernized and much improved by the late Mr. Lamb', and included a deer-park, well-laid-out gardens, pleasant serpentine walks, viewing openings from several seats and buildings, and a vista terminated by an obelisk.[96] By the mid-eighteenth century the earl of Talbot's 'small park' at Barrington Park included, 'an elegant three-arch stone bridge, a Gothick Temple with ogee arches, a domed pigeon house, and a circular Roman Doric temple'.[97] Likewise, new owner John Dolphin transformed the landscape at Eyford House after he purchased it in 1766.[98]

In a few instances after the 1720s, gentlemen's houses had gardens that were more elaborate. Painswick garden, designed between 1738 and 1762 by Benjamin Hyett, departed from the sober provincial Classicism typified by the house built by his father to a more light-hearted landscape in the rococo style.[99] In 1748, Thomas Robins painted the house and garden, which shows a striking composition of walks and buildings (see Plate II). Bishop Pococke commented in 1757 that it was 'a very pretty garden...on an hanging ground from the house in a vale, and on a rising ground on the other side and at the end; all are cut into walks through wood and adorn'd with water and buildings, and in one part is

64 *The Gentleman's House in the British Atlantic World*

Figure 4.3 Fairford Park from Atkyns, 1712
Source: Athenaeum of Philadelphia.

the kitchen garden'.[100] Rudder drew attention to Hyett's Painswick House, but not Paradise, an illustration of the distinction between a family seat of the minor landed gentry and a clothier's house that may have been let, or was possibly even unoccupied at the time.[101] The sophisticated Painswick garden seems to have been about playfulness, even debauchery, but in social terms the process of its creation helped to confirm the Hyetts as not only owners but shapers of the Gloucestershire landscape.[102]

More typical of gentlemanly landscapes was Pitchcombe House. A late-eighteenth-century painting of the house depicts a service yard cordoned off from the main house by a low wall (see Plate III). A handsome Chinese-style fence defines the front of the house and a dovecote stands behind. The grounds are simple, tidy, and pleasant but certainly not elaborate, and there do not appear to be any formal gardens.[103] Situated in a small village, Pitchcombe reflected Tom Williamson's contention that 'the gentleman's mansion was, in many ways, a yeoman's farm writ large'.[104]

Elsewhere, Poulton Manor (c. 1690) was surrounded by a wall with piers at its entrance, and its garden opened into fields; 'beyond this the house never appears

to have had any more elaborate gardens'.[105] The gardens at Redland Court, one of the grander houses examined here, had gardens that were neither large nor elaborate, 'kept in excellent order, and the green-house is stored with a well-chosen variety of curious exotics'.[106] Paradise (Figure 4.4) had only a small, formal

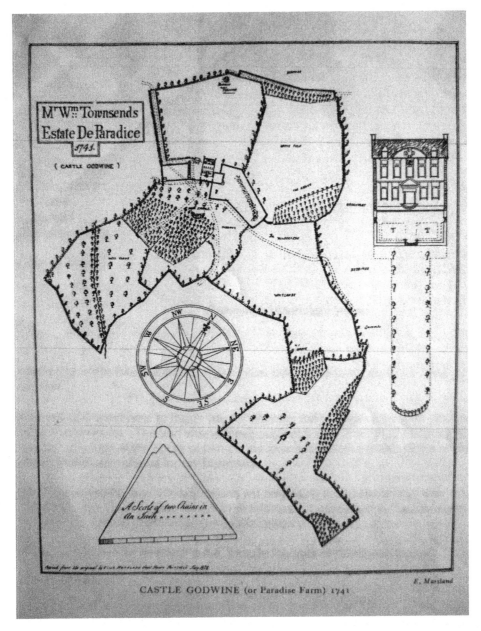

Figure 4.4 Paradise (Castle Godwin), c. 1741

forecourt garden, although it was 'pleasantly situated on the Side of a Hill, which affords beautiful prospects'.[107]

Houses like the old and new Frampton Courts offered an impressive exterior face to their village. William Clutterbuck's country seat built in the 1650s, old Frampton Court, was surrounded by an ample forecourt, high walls and an imposing gate. Large, strikingly vertical trees perhaps forty years old and just coming into maturity, highlight and frame the façade (Figure 4.5).[108] The plan shows several adjacent service buildings which accommodated the functions that enabled displays of social status to be carried out. Servants were often housed in the garrets of these houses, with storage and some work spaces in the cellars. Proximity to important outbuildings like stables is a relatively forgotten feature of the house setting.[109] Earlier houses characteristically had ancillary spaces behind and in some instances detached from the main house, with a somewhat irregular plan for kitchens, laundries, stables and barns. Frampton Court of 1650 had small service extensions behind, as well as a 'kitchin court', a 'coal house' and a 'Little house', possibly a necessary or storage. The barn and stable asymmetrically flanked the 'Outward Court' at the front of the house.[110] Although symmetry was sought on the main façade, less attention was paid to symmetrical arrangements on the sides and at the back of houses (Figure 4.6).

This arrangement is markedly different from the attached, balanced service wings at Richard Clutterbuck's new Frampton Court built in the early 1730s. More emphasis on the landscape meant an architectural transition in importance from one to two facades, reserving the prospect over the landscape for the owner. The exterior therefore affected the peopling of interior spaces, a point to be explored more fully in the next chapter. During the eighteenth century, Palladian designs introduced symmetrical service wings (or offices). At Frampton Court, the landscape was remade when the old house was torn down and the new house built, eventually incorporating a Gothick orangery as a focal point but without elaborate gardens.[111] Despite this, in the late-eighteenth century the Frampton landscape was 'very regular and neat, in the old Style of Gardening' (Figures 4.7 and 4.8).[112]

Modest formal gardens were planted on the small plots of Clifton mansions (Figure 4.9).[113] One major exception was Goldney's outstanding garden (marked X), which was described as a 'minor Stowe on Clifton's crown'. Various visitors enthused over the garden. In the 1760s, the duchess of Northumberland praised Goldney's efforts whilst noting that they were 'formal but not ugly'. Mrs Delany particularly admired the view from the terrace, from which 'we saw everything in the utmost perfection'.[114] The grotto at Goldney's House exerted a powerful influence on shell work and garden design, including a visit from the literary sophisticate Elizabeth Graeme Ferguson of Pennsylvania.[115] Goldney, however, seemed motivated more by science and aesthetics than politics in creating his garden over a period of more than thirty years.[116]

The combination of ornamental and utilitarian landscapes was seen throughout the British Atlantic world. In Pennsylvania, William Penn created a garden and landscape as a fitting setting for his fine manor house in keeping with his status as Proprietor of the Colony.[117] In 1707 John Oldmixon called it 'a very fine seat...both

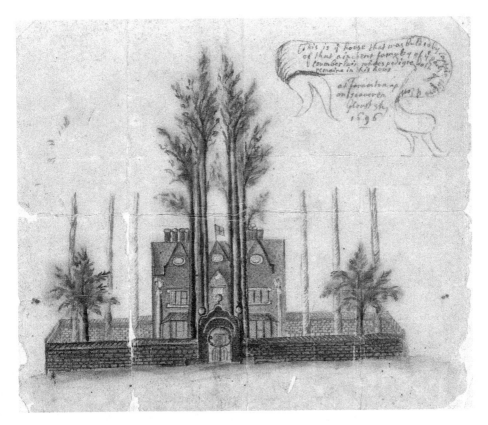

Figure 4.5 Old Frampton Court, c. 1650
Source: Courtesy Gloucestershire Archives and Mr and Mrs Rollo Clifford.

in its nature and Situation, as well as its improvement'.[118] Oldmixon also recounted how on a visit in 1702 (hosted by James Logan), Lord Cornbury, governor of New York, was 'extremely pleas'd with the House, Orchards and Gardens'. In 1755, Thomas Graeme of Graeme Park, another country seat outside Philadelphia, boasted about the 150 acres that surrounded his house, claiming that 'as a piece of beauty and ornament to a dwelling I dare venture to say that no nobleman in England but would be proud to have it on his seat or by his house'.[119]

But it was more often the case that 'few of the provincial gentry could afford the formal gardens that graced the largest mansions'.[120] Although Bushman argues that classic and formal gardens became standard for Georgian mansions after 1725, one of the earliest country seats in Pennsylvania, Fairhill (1712–1717) displays a representative landscape.[121] Fairhill, a significant estate of over 800 acres for Isaac Norris, Sr (1671–1735), who was born in Surrey, emigrated to Jamaica, and eventually became a wealthy merchant and member of the ruling elite in Pennsylvania, reflected the small gentry houses of England. A 1770s sketch of the house (Plate IV) provides a view of the physical context of the shaped

68 *The Gentleman's House in the British Atlantic World*

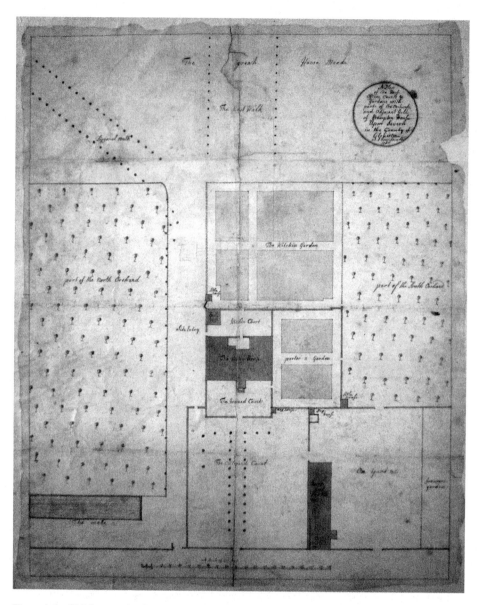

Figure 4.6 Old Frampton Court, landscape plan
Source: Courtesy Gloucestershire Archives and Mr and Mrs Rollo Clifford.

Figure 4.7 New Frampton Court, 1731–1733
Source: Author, courtesy of Mr and Mrs Rollo Clifford.

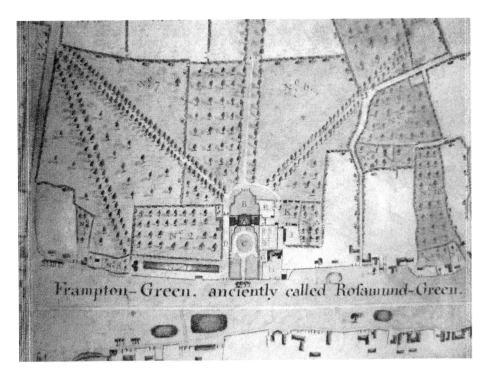

Figure 4.8 New Frampton Court, landscape plan
Source: Courtesy of Mr and Mrs Rollo Clifford.

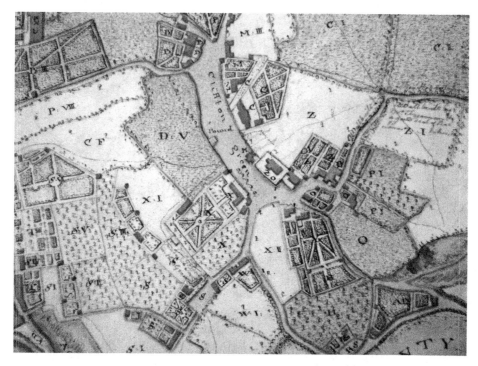

Figure 4.9 Detail of de Wilstar survey, 1746
Source: Courtesy Bristol Record Office.

landscape, ancillary buildings, and the simple setting of the mansion house in colonial America. Norris was not above some considerable expenditure, especially when it came to the symbolic act of crowning his house with suitable display: 'Another thing is a whim, but thou must get it for me. That is a weather-cock for the top of my turret'.[122] In a similar vein, the Ephraim Williams house in Massachusetts shows a side service area and outbuildings in close proximity to the house.[123] Isaac Royall's houses had a cobbled courtyard, with slave quarters and ten outbuildings in close proximity to the mansion.[124] Nomini Hall in Virginia had a simple landscape with little ornamental planting, in keeping with many houses elsewhere.[125] Sales advertisements for estates sold in Virginia also point to the well-tended, improved but basically utilitarian landscapes.[126] As in England, a combination of show and practicality characterized most gentlemen's houses in British North America.

For the genteel, how to balance labour and politeness remained an issue. According to Josiah Tucker, gentlemen clothiers in Gloucestershire, for example, established themselves 'so high above the condition of the Journeymen [that] their conditions approach much nearer to that of a Planter and a Slave in our American colonies'.[127] Tucker's contemporary comparison draws clear associations between work and gentility in England and America. Like Stroudwater clothiers, genteel

planters in southern colonies, reliant on the system of slavery, lived in close proximity to their enslaved workers. But not until the late-eighteenth century did plantation owners consciously seek to obscure the relationship between gentility and slavery.[128] For much of the eighteenth century these two aspects of life could be closely related.

One noteworthy landscape brought together work and beauty: William Champion's Warmley, with its curious mixture of aesthetics, status, manufacturing and industry. William, son of Nehemiah Champion of Clifton Court and hence related by marriage to the Goldneys and other Quaker families, acquired a small property five miles from Bristol as a commercial investment and erected his house, gardens and mills at Warmley in perhaps the most unique setting in Gloucestershire.[129] The large complex he established was a science and technology marvel in the processing of zinc, the smelting of copper, and the manufacture of brass goods. This integration of production on one site was a novel step, and included '15 copper furnaces, 12 brass furnaces, 4 spelter or zinc furnaces, a bater [battery] mill, or small mill for kettles, rolling mills for making plates, and cutting mills for wire'.[130]

Immediately adjacent to the manufacturing works Champion built a five-bay, three-storey residence (see Figure 3.3). As one clandestine visitor noted, 'The spelter works was built right in front of Mr Champion's windows...He is so fiery in his surveillance that the workers will hardly whisper his name'.[131] The house faced north overlooking a pleasure garden that included a thirteen-acre lake with an enormous statue of Neptune, an echo pond, boathouse, Gothic summerhouse, walled garden, and a substantial grotto. Although thoroughly dedicated to his role as an entrepreneurial man of science, Champion created an attractive symbol of status in his house, where the manufacturing parts of the estate served as an expansive 'service yard' to the south and behind the house.

Proximity of work and domesticity was not a new concept, but Champion's innovative development at Warmley took the idea in a new direction and on a substantially greater level. Indeed, his mills may have held attraction on account of their ingenuity, rather than disgust at their noise and filth. 'Mr Champion's copper-works are well worth seeing', Arthur Young commented in 1768.[132] The garden physically and metaphorically brought together Champion's roles as inventor and gentleman. The site thus comprised an unusual example of industry, landscape and architecture, a 'utilitarian arcadia'.[133] Such an industrial aesthetic or 'art industrial' landscape brings into sharp relief the multiple identities of a man like Champion. Humphrey Repton's later remark about 'exposing the *Genius of the place* to all the horrors of fire and steam, and the clangour of iron chains and forcing pumps', captures the contested nature of many gentlemen's landscapes.[134] In gardens, too, gentlemen owners staked out their own adaptable position in Britain's hierarchy. In an extreme fashion, Warmley displays many aspects of location that characterised gentlemen's houses. The setting on a small estate combined work and politeness. There were gardens that ornamented the landscape, but the setting was particularly highlighted by a compact classical box that served as the primary residence of the owner.

Between 1680 and 1780 the situation of small classical houses changed considerably, as the relationship between land, building and social status shifted. Gentry houses on small estates predominated until about 1720. Land remained important, but after the 1720s, clothiers, merchants, government officials, professionals, linen-drapers, lawyers, and an occasional military officer undertook building projects in a range of situations. Gentlemen's houses stood on enough land to provide physical distance between houses and their occupants and the rest of society, but this varied considerably. Many minor gentry continued to build small classical houses and occasionally surrounded them with shaped landscapes and fashionable gardens. Increasingly, however, houses of this type were sited on smaller landholdings, sometimes incorporated into village settings. They should not, however, always be interpreted as villas. In their function as primary residences, they drew together urban and rural environments. Nascent industry, small estates, and polite life often came together closely. In these venues new men carved out their place not by acquiring land but by constructing 'modern-built houses'.

Late-eighteenth-century writers and surveyors depicted the houses and estates of genteel owners with little distinction about estate size. Contemporary maps mostly delineate houses, not estates. The houses were the important distinction for gentlemen, whether situated on large estates or only a handful of acres. Reasserting architecture as a critical form of property reinforces the social strategy of house-building and furnishing. To that end, it is possible to move inside the houses and explore the production of space once the privileged threshold between interior and exterior was crossed.[135]

5
Arranging Status

The architecture, cost, exterior decoration, and situation of gentlemen's houses all conveyed significant messages about their residents, but it was on the interior that some of the most important aspects of status played out. The next two chapters develop a better understanding of how gentlemen's houses were laid out and decorated, what rooms they contained, how the function of rooms changed over the period and, perhaps most importantly, how they were furnished with objects that constructed everyday life and social behaviour. Gentlemen's houses had multiple functions and rooms were flexible. As centres of domestic life, showpieces of display, and theatres for status construction, they put objects into action repeatedly to reinforce the social position of their owners. Spatial organization and floor plans provided the 'medium through which society is reproduced'.[1] The interrelationship between spatial organization, interior finish, furnishing arrangement, and the ways people interacted with these spaces helped to define social status.

This chapter focuses on building and finishing a house as a key social strategy by examining how gentlemen-owners constructed, arranged and decorated their interiors. First, the chapter assesses the size of 'gentlemen's houses' in more detail, and then goes on to analyse floor plans, considering how people conceptualized and used space in this particular sized dwelling. Finally, it explores ways in which interior appearance and the level of finish in rooms conveyed important messages about their value. Locations, access, and interior finishes helped to establish the hierarchy of spaces.

The space of their houses defined gentlemen. Brief glimpses at grander country houses and houses lower on the social scale reveal that gentlemen's houses were distinct in their size, plan, arrangement, and finishing of space. The great success of the small classical house form was its inherent flexibility. Gentlemen builder-owners adapted the compact four-rooms-per-floor plan to meet their specific needs. Several variations of floor plan, however, signalled that spatial arrangement could be flexible and adapted in different ways. There was no linear evolution from one plan of gentleman's house to another, although how rooms were used did vary. These houses combined generic adaptability with individual choices made by

genteel builder-owners. This adaptability enabled the social functions of houses to change and shift over time. By mining interiors for their meaning and coded values, this chapter situates the 'gentleman's house' within the broader context of ideas about spatial arrangement in the eighteenth-century British world.

The size and arrangement of gentlemen's houses

Building size and arrangement is one measurement of elite housing and in this regard small classical houses bear little resemblance to large country houses. The greater number and variety of rooms in larger country houses reflected a grander scale and more elaborate finishing. Gentlemen were not eager to replicate larger houses. By almost every measurable – cost, size, volume, number of spaces, use of space, or decoration – the gentleman's house stands above the threshold needed to maintain a genteel life but well below the level of the great houses of the gentry and aristocracy.

To gauge social mobility, historians have employed various calculations to link domestic space with social status. Stone and Stone used a formula that assigned one unit to every hundred square feet of floor space for *living* quarters.[2] On the basis of this formula, they analysed country houses of fifty units or greater, although most of the houses they assessed were significantly larger than this. As an investigation into social mobility, their study set the bar very high.[3] By comparison, the typical small classical house covered in this study was a rectangular box of fifty feet by forty feet, or 2,000 square feet per floor. Applying the Stone and Stone criteria, most 'gentlemen's houses' throughout the British Atlantic world are between thirty and sixty-five units, and the majority fall between forty and fifty.[4] Additionally, despite claims that five-bay houses in colonial British America were built on a much more substantial scale than equivalent houses in England, a new assessment makes clear that small classical houses in America exhibited no substantial difference in size and scale from their British counterparts.[5] Another feature of space almost entirely neglected is that of volume. Space in three dimensions offers another way of characterizing how rooms conveyed status. Rooms with similar dimensions in plan could vary considerably in their height.[6] Few 'gentlemen's houses' in this study had, for instance, double-height halls or saloons, as found in larger houses.[7] This meant lower cost for gentlemanly builders accompanied by a concomitant lack of grandeur.

The size of gentlemen's houses combined relative affordability with enough space to differentiate function, achieve higher degrees of room specialization, accommodate a range of consumer goods and furnishings, oversee servants to do work, and remove kitchen smells and the threat of fire. In other words, they were ideally suited to enable genteel displays of status for a combination of wealthy merchants, professional men, and landed elites. The domestic space available to genteel owners dictated various features of their social status.

How that space was arranged was critical. Building plans signal the importance of rooms and their intended use. The relationship between exterior appearance and interior arrangement in symmetrical Georgian buildings is not entirely

clear. Ayres states that 'The regular and inscrutable facades of the eighteenth century masked a consistency of plan but a great diversity of interior treatment'. Conversely, Bernard Herman suggests that exteriors reflected local conditions whilst interiors were relatively generic throughout the British Atlantic world.[8] These ideas, which highlight the interchange between external appearance, construction material, floor plans, and interior finish, are not wholly incompatible, and it is possible to test and develop them in relation to gentlemen's houses.

Most eighteenth-century houses grew out of their plans. The compact plan typical of gentlemen's houses appeared in a range of variations.[9] Girouard traced dramatic changes in floor plans from the seventeenth to the eighteenth centuries in larger country houses. By the mid-eighteenth century, the 'formal house', characterized by a series of sequential, increasingly private chambers that created an enfilade emanating from a centrally-located salon, was supplanted by the 'social house', with rooms organized around a central staircase for more flexible social entertaining.[10] By about 1770, this replacement of an axial or linear concept of space with one based on circular movement represented a move away from 'ceremoniousness, formality and grandeur' toward 'comfort, convenience, and accessibility'.[11] Direct comparison between large country houses and small classical houses, however, can easily be overstated. Girouard assessed one small house, Nether Lypiatt Manor, with 'matching sets of apartments', but Nether Lypiatt's modest size and room arrangement stretches the definition of the 'formal' house nearly beyond recognition (Figure 5.1).[12] Comparing Nether Lypiatt to a larger house hosting multiple apartments in enfilade fails to account adequately for the individual character, spatial arrangement, and inherent flexibility of smaller houses and their plans.

A recent study charting the development of compact country-house planning suggested that the six rooms on a floor plan highlighted in James Gibbs's *A Book of Architecture* was 'adopted, with minor variations, in many hundreds of houses built country-wide throughout the eighteenth century'.[13] Robert Beverly of Virginia based Blandfield (1769–1772), a house seventy feet across the front, on a plan from Gibbs, but with key alterations that circumscribed the ease of movement around the ground floor.[14] This plan as built highlights a desire for spatial segregation that belies the 'social house' concept proposed by Girouard. The Gibbs-based Blandfield, however, is still larger than the houses considered here.

The compact, double-pile plans of most Atlantic world gentlemen's houses most closely approximate what Gomme and Maguire call the 'square pile'.[15] In America, more study has been given over to 'the classic Georgian plan of four rooms on a floor divided by a stair passage from front to back', but far less attention has been paid to this plan in Britain.[16] The more accurate description of a typical 'gentleman's house' would have been four *primary* rooms on the ground floor. In addition to four main rooms, many houses had several smaller ancillary spaces. The floor plan usually included a hall for entry, a space for a stair enabling vertical access, and at least three further rooms intended for various sociable or household functions. As many as five or six spaces might normally be contained in the main

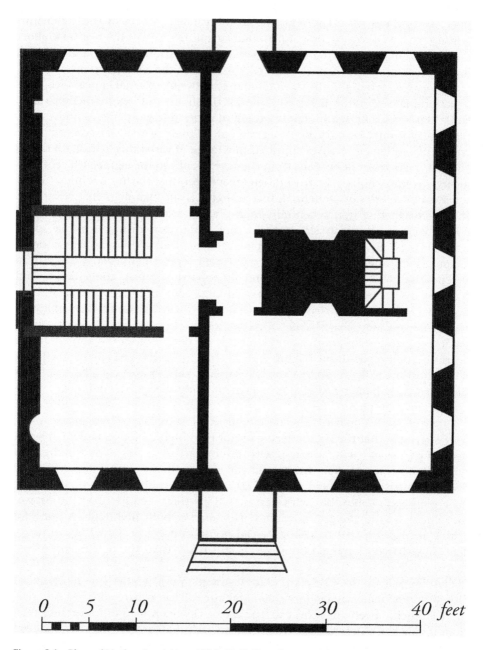

Figure 5.1 Plan of Nether Lypiatt, c. 1710. Hall directly entered with stairs offset
Source: Drawn by Mary Agnes Leonard.

block on the ground floor of the typical five-bay classical house, with perhaps fifteen to twenty spaces in total, including chambers and garret spaces above the ground floor. The basement or attached offices or wings accommodated additional rooms for storage and service functions.

Between 1650 and 1750, the number and kinds of rooms, as well as specific building features, differentiated houses of landowning gentry families from those of yeomen in Gloucestershire, where the gentry had an average of twelve rooms and yeomen seven-and-a-half.[17] In Glamorganshire in Wales, 'secondary' gentry families lived in houses with an average of 9.43 hearths, whilst 'tertiary' gentry families owned houses averaging 5.55 hearths.[18] These figures offer guidance about the relationship between the size of buildings, the number of rooms associated, and different social groups.

In practice, gentlemen's houses varied in how their space was laid out. A number of house plans in Britain resulted from incorporating part of an earlier building. This was less typical in the American colonies, although examples of reworked or altered buildings did exist, such as Chalkley Hall in Pennsylvania, which was built in 1723 and then had a large classical three-storey brick section added in 1776.[19] Houses designed by architects, such as Frampton Court, Redland Court, and Clifton Hill had more regular plans.

Floor plans that can be reliably reconstructed for gentlemen's houses suggest several variations across the Atlantic world. The hall was a universal feature governing access, and its development in many ways demonstrated the reluctance of gentlemen to give up the idea of the Great Hall.[20] Earlier houses, such as Nether Lypiatt (Figure 5.1) included a heated hall entered directly from the outside, which was also seen in Virginia at Rosewell (1726–1737) and Shirley (1738).[21]

A second variation had central halls that functioned as both a room and passage. In the main hall at Wotton (1707), highlighted by a stone floor, one immediately encountered a panelled staircase with an open string and turned balusters, although no fireplace, making it unlikely that this space was intended to function as a place of frequent sociability. A combined stair and hall feature, usually unheated, is shared with Hill House (1730s) near Bristol.[22] In some cases, these could be divided. Stenton in Philadelphia, completed by 1730, had a heated centre entry hall with arched double doors leading to the main stair behind. A third and widespread plan had a centre hall that served primarily as a passage, as appeared at Bishop's House (Figure 5.2) in Clifton, and in Virginia at the Nelson House (1729), Sabine Hall (1738), and Westover (1750–1751).[23]

A house of the early 1760s that points toward the suburban villa, Royal Fort near Bristol, has a floor plan more characteristic of larger houses: an entrance hall and large centred saloon behind, with drawing room and parlour on one side of the hall, and another parlour and staircase on the other side adjacent to the service wing (Figure 5.3). This is similar to the double-pile saloon plan found in a few Virginia planters' houses.[24]

The compact double-pile plan offered an arrangement that was economical and flexible. Although 'ready access and an easy flow through the house' were characteristic of these houses, such floor plans presented an ample opportunity

78 *The Gentleman's House in the British Atlantic World*

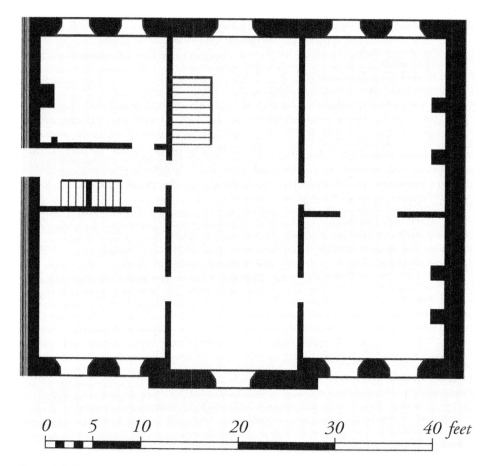

Figure 5.2 Plan of Bishop's House, 1711. Centre hall serving primarily as a passage with stairs to rear. The most common floor plan in small classical houses
Source: Drawn by Mary Agnes Leonard.

for segregating and governing movement through space.[25] By comparison with smaller vernacular buildings, the number of spaces allowed for various points of ingress and egress dependent on function, as well as room specialization that created multiple levels of segregation. Equally, such arrangements created a sense of permeability.

Uniting exterior and interior, the arrangement of windows was an important feature that defined the symmetrical appearance of these buildings and dramatically affected practical conditions such as light and air.[26] Fenestration in the eighteenth century was largely about light and sight: how light entered rooms in the day hours and illuminated spaces for work or recreation, and how an individual could see out from their house, for a range of practical and aesthetic reasons. In the early part of the period, internal space often dictated window positioning.

Arranging Status 79

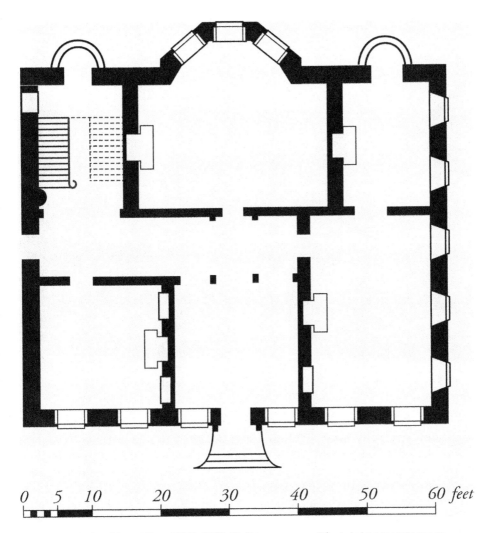

Figure 5.3 Plan of Royal Fort, 1758–1761. Hall as passage with stair in separate space
Source: Drawn by Mary Agnes Leonard.

Houses built before about 1730 exhibit regular arrangements of windows on the main or show façade but often a rather more haphazard arrangement on the other facades (Figure 5.4). The fenestration is disrupted on the rear facade by diagonally arranged windows located to provide light and a pleasing internal arrangement for the main staircase in the house.

As the symbolic importance and fashion of a symmetrical façade increased, floor plans increasingly accommodated the regular exterior arrangement of windows. By the mid-eighteenth century, polite architecture demanded greater regularity.

Figure 5.4 Stapleton Court, Glos., rear façade, early-eighteenth century
Source: Author.

Beginning especially after 1730, architect-designed houses such as Frampton Court, Redland Court, and Clifton Hill House displayed greater degrees of symmetry in keeping with reigning Palladian design ideas, which imposed 'considerable restrictions on the disposition within'.[27]

Landscapes and gardens affected space arrangement, and views sometimes defined a room's place in the spatial hierarchy. Best rooms tended to be located to take advantage of prospects, whether those overlooked a small country estate or the city and quays of Bristol, whilst consciously avoiding service areas. The most finely finished room at Wotton house, unusually located on the first floor at the rear of the house, afforded views over formal gardens to the city of Gloucester with its striking cathedral, an interesting example of the rural incorporating the urban (Figure 5.5).[28] The best bedchambers at Frampton Court faced the garden and wider parkland, rather than the village and its green. At Goldney House in Clifton, the 'Best Room southwards' overlooked Thomas Goldney's famous garden and the view over Bristol beyond.[29] Mt Pleasant in Philadelphia has the most lavishly decorated room on the first floor, overlooking a river view.[30] Although these houses may not have been associated with large estates, their use of borrowed landscapes was a clever and sensitive response to their environment.

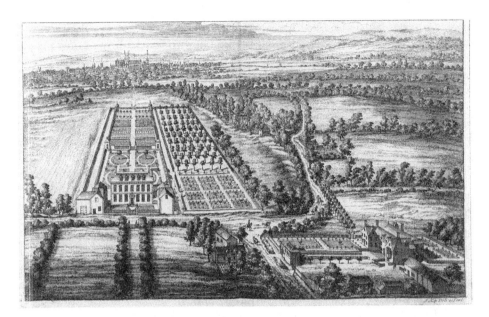

Figure 5.5 Wotton, c. 1707, from Atkyns, 1712
Source: Athenaeum of Philadelphia.

Despite being smaller than the Gibbs ideal, gentlemen's houses with four rooms on a floor could signify ample status. Notions about arrangement of space in the small classical house were central to how they functioned on both a practical, day to day level and as a symbolic manifestation of social position. Households tended to use individual rooms throughout the period for overlapping functions. Their adaptable basic layout provided a number of rooms but without the high degree of specialization found in larger houses. These flexible houses reflected the flexible status and varied situations of their owners.

Interiors and spatial hierarchies

The sales advert for Paradise from 1755 describing, 'A MODERN-BUILT HOUSE, with four rooms on a floor, fit for a Gentleman, with all the convenient Offices and Outhouses', presents questions about the arrangement of the typical gentleman's house. What were the four rooms on each floor? Where were they located and how did they interrelate? What were the 'Offices and Outhouses' mentioned, and what was their relationship to the main house? If the plan of rooms governed how genteel households interacted with space, how families used the rooms and what their houses looked like on the interior provided further indicators of social status.[31] Changes in room function over time render determining the use of spaces or even room names with certainty a difficult process. Architectural evidence such as the position of a room within the building and its aspect, the

level of interior finish, and its interaction with other spaces allow exploration of a room's intended use. These features also guide our understanding of how people used a room on a daily basis. Households expressed status spatially and access to personal space and the ability to govern such spaces related directly to position within the domestic hierarchy.[32]

In the late-seventeenth century, the four main rooms in small classical houses most often included a hall and two parlours. For example in 1688, Lower Slaughter Manor had a 'Hall', 'Great Parlour', and a 'Little Parlour'.[33] The fourth space varied: sometimes a 'buttery', or service room such as a kitchen. Later, when the hall developed into more of a passage, it was often not counted as a separate room, even though it functioned as an important space governing vertical and horizontal movement through the house.[34] On the ground floor, in addition to the Hall, there might be two or three parlours, with perhaps a dining room or kitchen occupying the fourth space. Although this totals five rooms, the number of principal ground floor rooms remained the same: four.

By the middle of the eighteenth century, the typical gentlemen's house in the British world contained a hall and stair, a best parlour, a common parlour, and a final space, occasionally a third parlour, study or other room.[35] In the Chesapeake it was typical until the late eighteenth century to have one or more 'chambers' containing beds on the ground floor, an interesting regional variation of room use in the four-room-per-floor plan.[36] By the 1770s, however, Nomini Hall in Virginia had two dining rooms, a study and a ballroom on the ground floor.[37] Still, the development of the compact plan in the second quarter of the century signalled the fourth space as a 'back room' or 'little parlour'. The four main rooms on the first floor invariably served as bedchambers. In the late-seventeenth century, chambers were often named in relation to the ground floor room that they stood above, as in the 'Parlor chamber', 'Passage chamber' and 'Hall chamber' at old Frampton Court.[38] Bedchambers frequently included subdivided smaller rooms such as closets or cabinets that meant that more than four individual spaces existed. These were particularly noteworthy as private spaces within the household.[39] Second storeys or garrets, in most instances the domain of servants' rooms, were smaller, tucked under the eaves, and more numerous. Sometimes these rooms served as chambers for children, other members of the family or visitors.

Two spaces in particular defined a genteel house and set it off from those lower down the social scale: grand staircases and parlours.[40] Both rooms were important components of the highest-style colonial architecture and governed social behaviour. Every gentleman's house invariably included a main staircase. The location of the stairs was an impressive and important feature of these houses. The size of the staircase, the amount of space it took up in a dwelling, and its construction and ornamentation all set it apart as a status symbol that governed movement through spaces, especially vertically. Stairs rising around three sides of a well, like those found in all gentleman's houses, took up three to five times as much space as the spiral stairs found in the dwellings of much of the population.[41] Stair location within houses varied and there was no clear pattern of arrangement over time or location. Stairs of this sort were comparatively difficult to heat and

expensive to build. Most often, they were complemented by secondary staircases that could be used for service functions or personal access by members of the household.

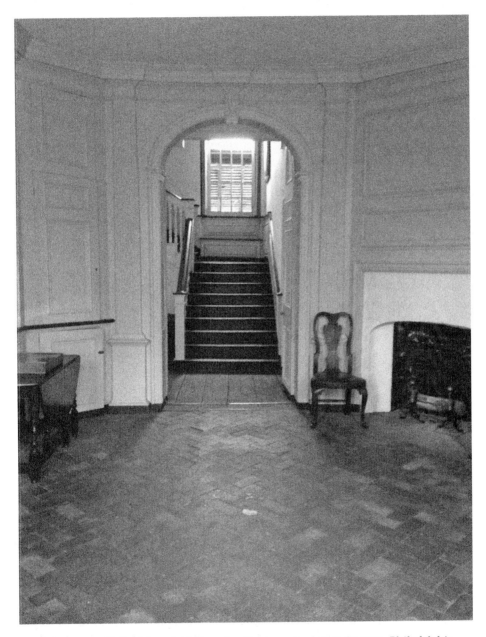

Figure 5.6 Entry Hall with arched doors leading to main stair at Stenton, Philadelphia
Source: Stenton, NSCDA/PA.

Staircases framed by arches emphasised their central importance, and were a feature of nearly all of these houses (Figure 5.6). Houses could be updated to accommodate fashion and introduce the functions of primary and secondary staircases. At Lower Slaughter, William Whitmore undertook building work to modernize the interior, including the installation of a new staircase.[42] Ornamentation of a staircase could add to its impressiveness. At Clifton Wood House, 'the finish of the main stairs, with marquetry inlays, and the provision of a separate servants' stair, set this house apart from almost all others built in Bristol in the first half of the eighteenth century'.[43] The amount of floor space occupied by staircases, the effort that went into creating them, their ornamentation, and their visible position in most gentlemen's houses combined to make them a central feature of genteel dwellings.

As an important space of civility, the parlour allowed owners to set themselves apart from their social inferiors by their architectural detail and finish. Lower status inventories frequently list beds in parlours along with other furniture, but this practice was less common in England after 1700, though it continued in parts of America.[44] Houses owned by gentlemen made this transition more quickly, although it was common to retain bedchambers on the ground floor in many Virginia plantation houses. Several parlours might be found in the gentleman's house, an indication of the range of daily household activities. Thomas Goldney had a 'Common Best sitting Parlour' and a 'Common sitting small parlour' to go with the handsomely finished 'Mahogany parlour'.[45] In the eighteenth century, Great Parlours, often with the house's most elaborate decoration, transitioned from multi-use rooms – main meals, for instance, being taken there – to being almost exclusively about show, display and sociability. Parlours might still be used for meals, especially the fashionable service of tea, as depicted in contemporary illustrations.[46] Other parlours, sometimes referred to as 'common', 'little' or 'back', were for everyday use.[47]

Parlour spaces throughout the period were most often fully panelled, although this began to change after about 1740. Fireplaces in public rooms, highlighted by columns, panelling, overmantel pictures and marble surrounds, served as focal points that emphasized the social hierarchy of spaces.[48] Pilasters particularly accentuated fireplaces as seen in numerous Atlantic world houses (Figure 5.7). These could be further set off by figured tiles, such as the floral arrangement comprised of Bristol tile at Frampton Court or blue and white Delft tiles at Stenton.[49] Such decoration offered indications of intended use and where and how status was meant to be conveyed. Parlours, as evidenced by the frequency of decorative buffet cupboards often with shell motifs and fitted ledges for display of valuable objects, conveyed ideas of politeness and civility (Figure 5.8).[50]

The evolution of room use meant the removal of practical functions to other parts of the house. Service spaces formed a critical part of a gentleman's house design. In larger houses, there was no predominant place for kitchens, and within the compact plan over time kitchens migrated from basements to external structures to attached pavilions.[51] Girouard comments that 'the 1680s saw the beginning of the practice of moving the kitchen out of the main block

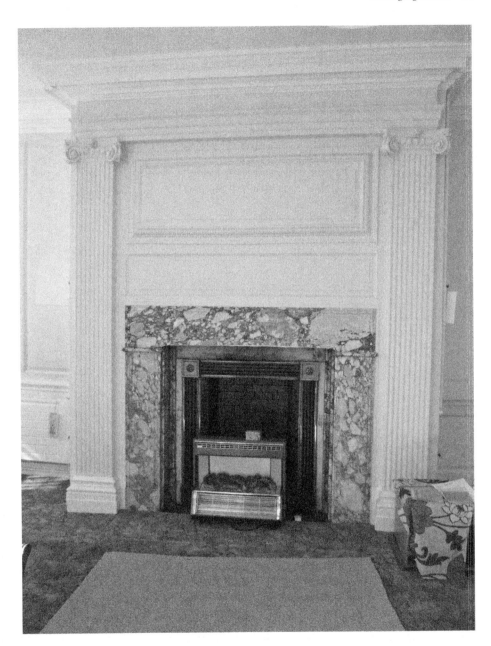

Figure 5.7 Cote, chimneypiece with pilasters
Source: Author, courtesy of Society of Merchant Venturers.

86 *The Gentleman's House in the British Atlantic World*

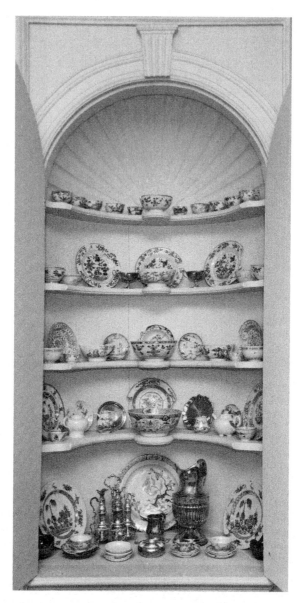

Figure 5.8 Buffet cupboard, Stenton, Philadelphia
Source: Courtesy of Stenton, NSCDA/PA, photo by Laura Pearson.

and putting it in a separate pavilion'.[52] For various reasons, early in the period a few gentlemen's houses contain kitchens in the main block.[53] Basements were used for other service functions although occasionally they housed cooking facilities. In Gloucestershire, only two houses, Lower Slaughter Manor and Bourton

House, had kitchens in basements, although Johnson Hall and the Trent house in America had them. Smaller, earlier houses like Poulton Manor and The Chantry featured kitchens as an integral part of construction, as did Bishopsworth Manor (c. 1720). Sometimes this resulted from the classical part of the house being added to an existing building, as at Bicknor Court, where a fire prompted rebuilding of part of the house and a classical refronting for the whole, probably in the 1750s.[54] As late as the 1740s, a house like Pitchcombe still had a kitchen incorporated into the design for a new house. Despite this example, increasingly kitchens resided in detached service buildings, wings or offices. This was true in the American colonies as well, where by the early-eighteenth century kitchens had mostly removed to other buildings.[55]

Kitchens in service buildings (some the remnants of earlier buildings) became the norm for most gentlemen's houses during this period although the location of these outbuildings could vary. Service buildings were sometimes located on either side of the front courtyard, although they were frequently also removed to back courtyards. The architectural arrangement of service buildings reached a sophisticated form in the Palladian composition of main block, attached offices and linking hyphens, which multiplied the possible ways in and out of the building. Frampton Court's well-designed wings, or offices, meant that the 'service areas' of the property could be located in the offices, allowing the back façade of the house to overlook a new landscape.[56] These designs at once attempted to create status by segregating service functions at the same time that they opened many more possibilities for entry and ceded some control over access.

In providing for the service needs of gentlemen's households, the introduction of back stairs in larger houses was an important change in the late-seventeenth century.[57] Gentlemen owners adopted this innovation somewhat languidly. Late-seventeenth century houses such as Lower Slaughter Manor and Poulton did not include a service stair in their design. Bishopsworth Manor, while exhibiting an elegant façade, included a kitchen in the main block and no service stair, an indication of its modest intended use as a house for a single daughter of the Smyth family.[58] By 1720 most gentlemen's houses incorporated a back stair, whether as part of a design for a new house or adapted from an older house (Figure 5.9). The presence of back stairs emphasizes service functions even in houses of relatively modest size and reinforces that greater formal separation between family and servants increasingly became the genteel standard.[59] Nevertheless, in genteel households there was still an almost unavoidable relationship between the two, and this growing divide can be overstated. Architectural features were important indicators of social attitudes.

Other service spaces enabled the smooth functioning of a gentleman's house. Physical evidence and reference to cellars in inventories indicate owners mostly used them for storage. Servants Halls provided space separate from the family for servants, whilst kitchen 'garrats' were sleeping quarters for servants.[60] Brewhouses were common until the early-eighteenth century, when they tended to disappear. In 1730, old Frampton Court had Little houses – likely privies – and a coal house. Storehouses, woodhouses, summerhouses, coach houses, and garden houses also

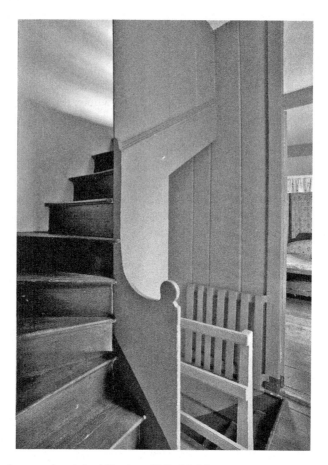

Figure 5.9 Back or service stair at Stenton, Philadelphia
Source: Courtesy Stenton, NSCDA/PA, photo by Will Brown.

appeared, demonstrating the spaces desired or required by genteel households. Such structures enabled the storage of food and fuel, sociability out of doors, the maintenance of gardens, even the storage of the high status coach.[61] They comprised the 'convenient Offices and Outhouses' where the work necessary to support a genteel house took place.

Interior finishes

Interior finishes conveyed important meanings for gentlemen and their audiences. Although interior finishes are well-documented for larger houses, studies of smaller gentleman's houses are lacking. Because few are publicly owned or have had extensive research, technical investigation that can yield interesting results is virtually unknown for small classical houses in Britain.[62] On the contrary, studies

of interior finishes and fittings are highly developed in America. Although indications of original finish choices for gentlemen's houses are scarce, documentation can be pieced together with surviving physical evidence to provide insights into decorative choices made by gentlemen builders and owners. Moreover, American examples provide key evidence, given 'the degree that British-made ironmongery, pigments, wallpapers and molding planes used to fashion architectural trim', were imported into the American colonies.[63] Many of the same raw materials shaped and decorated gentlemen's houses on both sides of the Atlantic, and all of the British North American colonies.

Decorative treatments evolved over the course of the period, and colour and texture could be achieved in various ways: wood panelling or joinery, painted walls, tapestry hangings, other textiles, and wallpaper. A combination of these decorative features created colour and pattern on floors, walls and ceilings. Entry into gentlemen's houses was usually through the hall that was often floored with stone but occasionally with wood, which was more prevalent in America. Wood flooring was typical of other rooms in these houses. Painted and decorated floors were virtually unknown in Britain and do not seem to have featured in gentlemen's houses, although in America some genteel owners used painted floor cloths to simulate stone or textiles.[64] Parquet flooring was used in houses like Frampton Court and Clifton Wood House on the stairs, but this was uncommon.[65]

Wood panelling was common to better rooms in most grand houses until about 1750.[66] Gentlemen's houses invariably had at least one panelled parlour, although subsequent decorating campaigns have obscured whether panelling in most houses was originally painted and, if so, what colour. Chesapeake planters especially began to utilize wainscot after 1730, although examples exist before this date.[67] In a few cases the wainscoting remains unpainted, although panelling was likely not as dark as experienced today.[68] A buffet cupboard at Frampton Court, exposed to limited oxidation as well as not having fallen prey to Victorian staining, retains a lighter and warmer tone compared with other wainscoting in the house. By the early-eighteenth century, oak panelling was common in better spaces, and left unpainted.[69] Cote (c. 1720) exhibits a range of oak panelling, from relatively provincial panelling in the hall, with no frieze supported by the capitals, to well-built in the Great Parlour, with the presence of a drip on the cornice, a small feature denoting a high level of craftsmanship.[70]

In the seventeenth century wainscoting was sometimes grained, although when left unpainted, as was frequently the case in gentleman's houses, the choice of wood was important as a way of highlighting the natural grain.[71] Gentlemen's house interiors in Britain occasionally incorporated re-used panelling and materials. Eastbach Court has decorative panelling from the sixteenth or seventeenth century in what was likely a back parlour, and panelling from the previous house can be seen in first floor closet spaces at Frampton Court. Bourton House has sixteenth-century panelling in several first floor rooms and the attics.[72] Panelling in gentlemen's interiors could be striking, as seen at Goldney house in Clifton where Thomas Goldney II likely installed a 'Mahogany Parlour' in the 1720s.[73] Elaborate Grinling Gibbons-style carving over the fireplace was probably taken

from another building and installed here when the room was built. If indeed this room dates to the 1720s, it represents a fairly early use of mahogany, perhaps a testament to Bristol's role in the transatlantic trade and Goldney's ready access to such goods.[74] Elaborate panelling in American houses like Stenton, Wilton (1750–1753), Carter's Grove (1750), and Westover (1750–1751) undercuts the notion that American houses were unsophisticated, but rather suggests they were old-fashioned or traditional. A 1777 floor plan of Fair Hill in Pennsylvania, built in the 1710s, still noted several rooms according to the wood presumably used for panelling.[75] In addition, relatively few gentlemen's houses had paintings inserted into overmantels.[76]

Panelling slowly declined in the eighteenth century on the basis of status and geography.[77] First, oak was superseded by painted softwoods, followed by a change in preference to stucco for grander rooms.[78] In gentlemen's houses in Gloucestershire, evidence suggests that this decline began about 1750. Although Isaac Ware discussed the relative merits of stuccoed, wainscoted and hung walls in *A Complete Book of Architecture*, workmen did not erect any panelling at Clifton Hill House (1746–1752) in the late 1740s.[79] From the 1750s, interior decoration appeared that reflected rococo fashion, such as plasterwork at Clifton Hill House, Nibley House (1760s) and especially stunningly at Royal Fort (1758–1761). American houses also largely abandoned panelling in favour of stucco or plasterwork.[80] These houses begin to mark a stylistic change and significant departure in genteel attitudes to interiors.

Valuable work has been done on the use of colour in domestic spaces from the late-seventeenth through the eighteenth-century in England and paint analysis has also played a significant role in the analysis of domestic interiors in America.[81] Neutral house-paint was the norm in the post-Restoration interior, and interiors often reflected what Roger Pratt called the 'natural colour' of building materials like stone and timber. The result generally was a 'white ceiling being set above a white, stone colour, drab, brown or occasionally marbled wainscot'.[82] In large houses like Dyrham Park, the cheapest paint was used in common areas, with the more expensive decoration in bedchambers, and the most lavish finishes in closets.[83]

Into the eighteenth century, paint colours might be bold, but because few original paint schemes survive in gentlemen's houses in Britain, it is difficult to say with certainty how exactly paint was employed. William Salmon listed paint colours and prices in 1734, offering guidance about what was both costly and fashionable.[84] These paints cover a spectrum from off-whites and cream, stone, oak to deeper (and more expensive) browns. Most costly were golds, olives, blues, reds and then finally green. Insights into gentlemanly colour choices can be drawn from genteel houses in North America, where paint analysis has identified interior colours from the first half of the eighteenth century.[85] In the 1730s, for example, Stenton had a hall dado painted moderate yellow. The fully-panelled great parlour was a medium grey, as was the partly-panelled common parlour behind (see Plate V).[86] Such colours are reflected by contemporary conversation pieces depicting English interiors, although these pictures tend to reflect a somewhat higher level of interior finish than that found in gentlemen's houses.[87]

Although there was no universal standard for colour symbolism, a hierarchy of colour originating in Stuart heraldic standards existed in grander houses that placed red or crimson as the highest colour, followed by green and then blue.[88] Owners utilized yellow fabrics, but yellow painted rooms appeared rarely before 1740.[89] Gentlemen's houses did not adhere strictly to this schema. Rooms listed in inventories were sometimes delineated according to paint colour, as was likely the case with the 'Stone Parlour' at John Elbridge's St Michael's Hill house near Bristol.[90] Elbridge's bedchambers there, however, derived their room names from the fabric of their bed hangings, tapestries, and curtains.

Textiles played a particularly noteworthy role in colour schemes. As the most expensive category of domestic good after precious metals, textiles constituted a visible way of adorning a room with colour at the same time that they conveyed messages about the intended importance of the space.[91] Before mechanization, a relatively small privileged group were able to use fabric to any degree for decoration.[92] In the seventeenth century, hung textiles provided colour and pattern to walls. At Lower Slaughter Manor, Richard Whitmore had a 'Purple Cloath bed imbroidered with Slipps', an elaborate and highly unusual use of textiles.[93] In the early 1730s, Richard Clutterbuck adorned the walls of a bedchamber at Frampton Court with tapestry hangings, possibly those left to him by his father.[94] James Rooke seems to have hung tapestries in the hall at Bigsweir House as late as the 1750s.[95] Fabric used for bedhangings and window curtains constituted an expensive display.[96] At Cote, for instance, four of five bedchambers on the first floor had window curtains, which can be ranked according to their fabric and colour, as suggested by inventory values.[97] The most expensively furnished bedchamber had a mix of colourful textiles, with the predominant colours yellow and green.[98] The second most expensive bedchamber details a room decorated in crimson throughout.[99] It is unknown what colour Thomas Goldney's 'upper Yellow Room' was painted, but it took its name from the yellow worsted bedhangings and curtains.[100]

During the eighteenth century the upholder or upholsterer became a major figure in interior decoration in grander houses, but, as was the case with architects, it is unclear what relationship gentlemen builders and owners had with this burgeoning profession.[101] Since many gentlemen builder-owners in Gloucestershire and elsewhere relied on wealth generated in the textile trade, they may have been especially conscious with respect to such a status display. It is possible to speculate that providing expensive cloth to customers enabled 'gentlemen clothiers' like Thomas and William Palling, Richard Hawker and Onesiphorus Paul, a linen draper like Paul Fisher, or merchants such as James Logan, to employ costly textiles to adorn rooms in houses as a mark of status.

Wallpaper increased in fashion throughout the eighteenth century, although how quickly it became widespread remains a subject of debate.[102] There is little to suggest, however, that gentlemen's walls were adorned with it until the 1750s, and even then it was not typical.[103] Although paper would have been available to builder-owners, their preference seems to have been for more conservative taste in interiors. Not until 1771, for example, did Richard Clutterbuck record wallpaper

in his account book.[104] In the same year, Robert Beverly, builder of Blandfield in Virginia referred to wallpapering as a 'foolish Passion' despite ordering large quantities.[105] A remarkable example of English wallpaper in America was found at Jeremiah Lee's mansion in Marblehead, Massachusetts, which in some ways proves the exception to the rule.[106] Indeed in the 1790s, architect Benjamin Latrobe noted that wallpapering of houses of 'private Gentleman' in Virginia was 'not universal'.[107] Gentlemanly taste on the whole seemed to have included a continued predilection for panelled walls and textile hangings.

Until well into the eighteenth century, ceilings were not lavishly adorned, although again exceptions do occur. The ceiling in what was likely the Great Parlour at Lower Slaughter Manor is a remarkable piece of craftsmanship, but similar examples in gentlemen's houses are rare. This may be a result of elaborate decorative ceilings becoming less common in the late-seventeenth century. Most were smoothly plastered with little ornamentation and in several instances, builder-owners took little effort to conceal structural timbers such as summer beams. By 1750, applied plaster decoration began to re-emerge as a feature in new houses. Nibley House, rebuilt by George Smyth, has plasterwork from the 1760s. Redland Court and Clifton Hill House had work done by Thomas Paty of Bristol, and plasterer Thomas Stocking may have been responsible for fine rococo decoration at Royal Fort.[108]

Special decorative schemes such as japanning, graining, marbling and gilding appeared frequently in larger houses, but not in small classical houses. A thirteen-bay house like Dyrham Park, for instance, had a closet with woodwork that was entirely decorated with japanning.[109] Such finishes were rare in small classical houses until well into the eighteenth century, and emphasizes the restrained taste of gentlemen.[110] Although handsome parquetry and inlaid staircases were seen at Frampton Court, Eastbach Court and Clifton Wood House, and in the mahogany parlour at Goldney House, few gentlemen's houses display evidence of japanning or gilding. Subsequent decorating campaigns may have obscured examples, but it was unusual that gentlemen builders and owners employed such finishes for entire rooms with any frequency. To add such elements to their interiors gentlemen builders and owners opted instead for individual exotic furnishings. This was likely a factor of both cost and status, as will be discussed in the next chapter. Gilt leather screens, japanned chests and other individual objects were the province of gentlemen.

The themes of spatial arrangement and interior finish between 1680 and 1780 are illustrated by the interior decoration at Frampton Court in Gloucestershire, an example of cutting-edge, even aspirational, design for gentlemen. In 1730, Richard Clutterbuck demolished the house where he had grown up and where his father had lived. The new Frampton Court displayed Palladian planning, with a main block, hyphens and wings housing offices. On the interior, the domestic spaces on the ground floor were hierarchically arranged and exhibited craftsmanship of high quality. The stone-floored centre hall with a fireplace served as a space for segregating and directing encounters in the house. In the hall, the walls have deal wainscoting, while two rooms that likely functioned as parlours have

exquisitely joined oak panelling decorated with ionic and Corinthian pilasters.[111] The ground floor rooms are ranked according to the classical orders, which visitors encountered when moving from the hall to the other public chambers on the ground floor. The panelling and joinery in these rooms is particularly fine, and indicates a major effort to display and impress. Skilled joiners from Bristol were likely employed in its construction, implying substantial urban and rural interaction.[112] A small study or library was situated off the Hall in the design of the new house (Figure 5.10). This had built-in shelving, which seems to have been part of the original fabric of the room.[113]

Off the hall, inlaid stairs provided vertical access. In several closets on the first floor, workman reused seventeenth-century panelling from the previous house. The best rooms on the ground and first floors overlook the gardens. The offices included a kitchen in one wing, where the service stair climbed from the basement to the first floor, with a winding stair up to the garrets. The other wing housed the laundry, baking facilities and possibly an apartment. Taken as a whole, Frampton Court exhibited an effort at display that was at once confident, bold

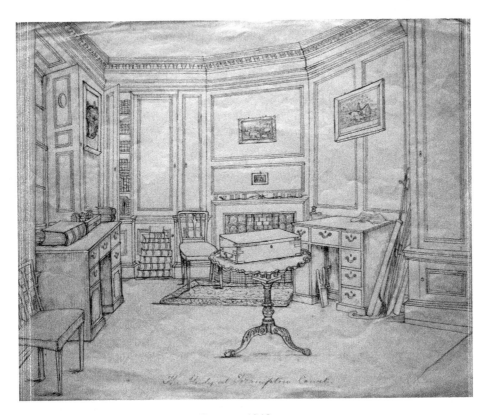

Figure 5.10 The study at Frampton Court, c. 1840
Source: Courtesy of Mr and Mrs Rollo Clifford.

and attractive, but also suggested a show mounted by a builder not entirely certain about his status.

Throughout the British Atlantic world, men like Richard Clutterbuck used architecture and interiors to reshape their status at the same time that they were structuring houses to be lived in. The compact, double-pile plan remained a standard but flexible form used by rising commercial men and lesser landed gentry to achieve the segregation of space necessary to sustain the role of a gentleman. Although their spaces were less differentiated than those in larger houses, compact plan houses were flexible, affording space for public, private and service functions.[114] Ample space accommodated work and 'convenient Offices and Outhouses' were critical to a genteel way of life.

By the second quarter of the eighteenth century, public rooms of the ground floor were increasingly prominent, and typically included a hall, several parlours of greater or lesser degrees of refinement, and perhaps a pantry or service passage. Decoration and architectural finishes introduced new fashions and urban craftsmen into an environment that retained conservative features such as wood panelling. Occasional ostentation that appeared in the form of overmantel paintings and pilasters was offset by plainer finishes in most rooms, with no clear nod to fashion in features like colour usage. By about 1750, interior decoration became somewhat more elaborate, although gentlemen-owners undertook few extensive decorating schemes until quite late in the eighteenth-century. When genteel owners wanted to add something exotic to their household, they did not create a japanned room. More likely, they acquired a japanned piece of furniture, or, in the case of Richard Clutterbuck, a set of Chinese armorial porcelain. The site of considerable change in the presentation of gentlemen's houses was in the selection and arrangement of furnishings.

6
Furnishing Status

The legal battle over Bristol Customs official John Elbridge's will opened with a contretemps about a small classical house and its furnishings.[1] Despite an extraordinary inheritance of more than £10,000, Elbridge's niece Rebecca Woolnough and her husband accused his executors of illicitly seeking to sell the possessions at Elbridge's house, Cote. Although the executors offered to compensate Mrs Woolnough with furnishings from another house Elbridge owned near Bristol, she insisted there were 'some few pieces of furniture' that she was bent on having for herself. Appraisers drew up an inventory, which the Woolnoughs called 'an Imperfect Schedule' because it aggregated several of the best rooms rather than valuing individual objects. Although the household contents at Elbridge's two dwellings were worth similar amounts – £290.8.10 and £303.12.8 respectively – the Woolnoughs insisted that 'the furniture over the Down are of much greater Value'. Throughout the proceedings, Rebecca Woolnough displayed both emotional attachment to the goods at Cote house and a keen sense of their worth. In her desire to lay claim to 'some few pieces of furniture' she highlighted how individual pieces could be pivotal within the domestic setting. Such multi-layered reactions indicate how and in what ways objects displayed status for genteel people.

Furnishings mattered. Their monetary and coded cultural values gave precise indications of their importance. Using inventories and other records, it is possible to populate the spaces discussed in the last chapter with objects in order to reconstruct genteel owners' furnishing patterns. Yet too often planning and interior decoration are treated separately.[2] The interplay between interiors and furnishings conveyed signs about genteel identity. Drawing these aspects of domestic space together probes further into the gentleman's environment, identifying the objects that filled gentlemen's houses and helped them to construct status. Furnishings were mobile and, by comparison with building renovations, relatively affordable, meaning that they could be frequently changed or acquired over time. This enabled genteel owners to keep up with fashion more easily, although they did not always do so.

Gentlemen builder-owners set themselves off as genteel not only in the form, arrangement, and finish of their house, but most especially by precisely how it was furnished. As Amanda Vickery has put it, 'gentility found its richest expression in objects'.[3] Taking account of household possessions, scholars have proposed two basic models for understanding the material relationship between social groups. For some, emulation guided these relationships, with those lower down the social scale seeking to ape those higher up in important ways.[4] Bourdieu, however, has argued for an alternate view of differentiation, where different social ranks exhibited consumption practices in specific ways unrelated to a concept of 'taste' from above. These contrasting views have structured much of the writing about society and consumption in the eighteenth century.[5]

Within this framework, investigations of the domestic interior have analysed household possessions from several vantage points.[6] There has been increased attention to the rising demand for goods, underpinned by several studies that have aggregated large numbers of inventories to trace the change over time of the numbers of people's possessions.[7] Social historians have employed material culture to understand facets of urban and middling life.[8] Decorative arts scholars, meanwhile, have focused on well-documented and visually significant high-style interiors, whilst only a few have examined traditional craftsmanship and the interiors of smaller dwellings.[9]

Although these studies have charted consumption patterns and the availability of goods to people in Britain and America, analysis of objects in the household can be pushed further. The dispute about John Elbridge's will highlights, for example, the interplay between men and women as they furnished domestic space. Although the 'house over the Downs' belonged to Elbridge, it was telling that some of the objects were acquired by and associated with a woman. As Vickery has noted, architecture mostly remained the domain of men, whereas 'interior decoration fell to the distaff'.[10] As will be seen in this chapter, however, gentlemen in the Atlantic world as well as women did much to fashion domestic space.[11]

Recent investigation has begun to reveal a more complicated story of consumption 'not simply driven by fashion'.[12] Between 1680 and 1780, the number of household possessions increased dramatically.[13] Gentlemanly interiors offer a guide to these changes, which reflect consumption patterns, taste, fashion, conservatism, and expense. Genteel households injected stylish elements by mixing newly-acquired goods with old-fashioned furnishings. Without pushing the analogy too far, possessions were mobile in a way that reflected the mobility of gentlemen. There was a clear sense of what were 'best' objects, as Rebecca Woolnough demonstrated with her precise desire for specific items of furniture. The number and quality of their possessions distinguished them from even moderately prosperous middling members of society; at the same time they made little effort to acquire and display furnishings in the way or at the level of the aristocracy. Instead, furnishings represented precisely-attuned means for genteel owners to display their status.

Several kinds of objects held particular significance for gentlemen and their families, including plate (or silver), textiles, wearing apparel, paintings and prints, and books. Invariably, silver and other precious metals formed the most valuable component of a gentleman or woman's personal possessions, although significant numbers of such possessions were restricted to the very wealthy.[14] Despite an overall drop in prices from the late sixteenth century, textiles remained the most costly goods in gentlemen's houses with the exception of precious metals.[15] Goods like pictures and books were important material indicators, although between 1675 and 1725, only one-third of the gentry and higher status trades and professions owned pictures.[16] Their libraries suggest that gentlemen were moderately knowledgeable about arts and architecture, but not in the category of gentlemen-scholar amateur architects.[17] Gentlemanly owners had small painting collections, and portraits could also visibly advance status, although these tended to appear in small numbers.[18] Reflecting the continued conservatism of many gentlemen's houses, display of arms and armour were not uncommon. John Elbridge had a 'Pyke' in his Hall and William Palling of Brownshill Court had an arsenal of weapons stockpiled at his house.[19] Into the late eighteenth century, older forms of display, with overtones of power and control, remained aspects of domestic space in gentlemen's houses.

Several houses offer especially illuminating records of genteel furnishing activities in Britain. In the first half of the period, a series of inventories document the changing consumption of the Whitmores, a Cotswold gentry family of long-standing residence at Lower Slaughter Manor. In the 1730s, John Elbridge's Cote displayed the furnishing choices of a Bristolian gentlemen who had a range of investments. Two gentlemen from mid-eighteenth-century Clifton, Thomas Goldney III and Paul Fisher, illuminate the interaction between interior space, furnishings, and wealth radiating from commercial pursuits in Bristol. At Frampton Court, Richard Clutterbuck's account book and surviving objects map furnishings acquired after the construction of the new Frampton Court in the early 1730s, highlight the role that fashion played in interior decoration. Each of these houses helps to illustrate important aspects of the gentleman's house, whilst contributing to a broader understanding of the changes in the gentlemanly household during the late-seventeenth and eighteenth centuries. Comparison with furnishings in several colonial houses further reveals the shared material culture of genteel society in Anglo-America.

Genteel displays in Britain

At Lower Slaughter Manor, Richard Whitmore's 1688 inventory offers a look into the house of the minor landed gentry in the late seventeenth century.[20] Bedrooms were central to domestic display, including the first floor 'Best Chamber', which included a bed arrayed in purple cloth embroidered with slipps.[21] On the walls hung tapestries depicting 'the Story of King Solomon and the Queen of Sheba'. A set of chairs, one with arms, a couch, and curtains on the windows completed the

ensemble. Valued at £60 by the appraisers, Whitmore's best chamber must have been an impressive space for a late-seventeenth-century figure. Despite having four main spaces on the ground floor, Lower Slaughter Manor contained only three identifiable public rooms: the 'Little Parlour', 'Hall', and 'Great Parlour'. By comparison with the bedchambers, these rooms housed relatively low value objects. The exception was the Great Parlour, which contained fourteen chairs, as well as three 'Turkey Carpetts', a looking glass and a silver toasting fork.[22] The fourth room may have been one of the 'chambers' listed, possibly the 'Chamber over the Kitchen' (which was in the basement).[23] The presence of a bed chamber on the ground floor was a practice that became archaic in gentlemen's houses over the ensuing century, although it hung on especially in colonial Chesapeake houses.

Important changes in furnishing took place at Lower Slaughter over the next fifty years. In 1725 following William Whitmore's death, the appraisers began their inventory in the Hall, perhaps reflecting a different attitude about the relative importance of spaces.[24] The ground floor rooms displayed many of the same furnishings, but generally appraised at lower values. In the 'Bigg Parlour', however, appeared 'One stand, Tea table, one Hand tea table, & a Sett of China', an indication that the Whitmores were one of the few gentry families to acquire China and utensils for hot drinks by 1725.[25] The bedchambers remained the most valuable rooms in the house, although these too had declined in value. Private spaces like closets offer further insights into the interests and preoccupations of an owner of a gentleman's house. Although often associated with women, men also utilized closets throughout this period as spaces for contemplation, business, or reading.[26] Mr Whitmore's 'Closett' evinced a devotion to monarch and family, including sixteen miniature pictures 'of the late King' and 'of Mr Whitmore's family', silver and gold medals of Queen Anne and the late King, and silver medals of the 'present King and Queen'. One object had the 'family arms Engraved and let in gold', whilst three snuff boxes, one of gold, another of tortoiseshell with a gold rim, and a silver rimmed one, stood next to a toothpick case. Money, 'six gold rings', a 'side saddle' and a 'Sable Muff and Tippett' rounded out the intimately ostentatious display, the latter two objects suggesting the space may have been shared with Mrs Whitmore.[27]

Lower Slaughter conveys the impression of a relatively conservative member of the squirearchy. By the 1730s, however, Elizabeth Whitmore had directed a household refurbishment, repairing the manor and acquiring stylish objects not found in the house during her husband's time, including several tables made of mahogany, a newly fashionable wood. Whereas William retained one of the ground floor rooms as a bedchamber, his widow removed the bed and installed a 'burrow and book case' valued at the substantial sum of £10, as well as an easy chair, indicating a space of study and comfort.[28] Other bedrooms were slated for refurbishment, as indicated by a £40 'worked bed and quilt with two pieces of damask to line the same Unfinished & not Sett up'.

Buying new possessions rather than rebuilding a house was both affordable and had immediate visible impact. This was a major attraction for genteel owners.

The increased presence of china indicates a turning point in display and dining habits, where William's pewter was supplanted by Elizabeth's china. Three dozen knives and forks appeared in the 'Butler's Pantry'. Easy chairs were found in two rooms, including the 'Little Parlour'. The 'Great Parlour' now contained an 'India Japan'd Chest', coffee mugs, and a 'TeaPott' of 'blew and white China' for use in formal entertaining.[29] The transformation undertaken by Elizabeth Whitmore, with pewter and cane chairs out, blue and white china and mahogany in, mirrors a broader change in fashion taking place in many genteel houses throughout the Atlantic world.[30] This account offers further evidence to support the importance of women's roles in furnishing the domestic interior.[31] The furnishing of genteel houses was a complex interplay between husbands and wives, trades people and purveyors, and Lower Slaughter illustrates the careful balance between building and furnishing, à la mode and old-fashioned, which was characteristic of small classical houses and their genteel owners.

The inventory that so exercized the Woolnoughs led to John Elbridge's Cote near Bristol being the most copiously documented gentleman's house in Gloucestershire, offering a matchless opportunity to understand the furnishings of a leading Bristolian gentleman and government official.[32] A brief tour of Cote illuminates how Elbridge arranged space and used rooms (Figure 6.1).[33]

On the ground floor, the Hall (Figure 6.2), unpainted but fully-panelled in handsome oak wainscot, governed entry to the house. This room had a 'Large

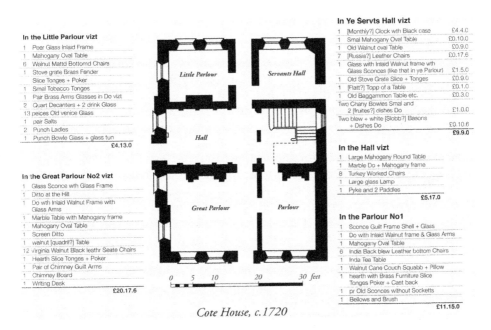

Cote House, c.1720

Figure 6.1 Cote, c. 1720, ground floor, with inventoried contents, 1739
Source: Drawn by Mary Agnes Leonard.

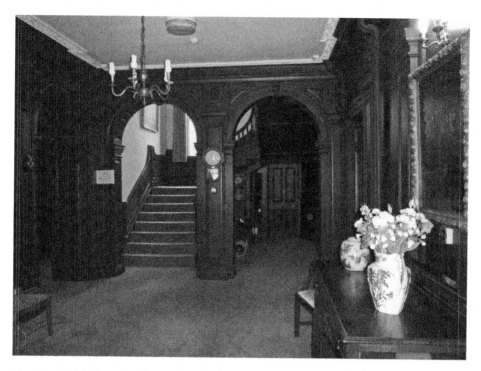

Figure 6.2 The Hall at Cote
Source: Author, courtesy of Society of Merchant Venturers.

Mahogany Round Table' and '8 Turkey workd Chairs', a durable fabric which had its peak popularity in the late-seventeenth century for middling rank homes.[34] These rather old-fashioned chairs designated a respectable but somewhat utilitarian space. A set of double arches set off the stair, while various routes moved visitors horizontally or vertically from public to more private spaces.

On the ground floor the 'Great Parlour' had oak panelling highlighted by large ionic pilasters and heavily figured marble around the fireplace, complemented by flanking cupboards at either side of the chimney breast. The furniture included several sconces, one of glass the other of inlaid walnut, a 'Marble Table with Mahogany frame', '1 Mahogany Oval Table', '12 Virginia Walnut Black leathr Seate Chairs', and a 'writing desk'. Three tables and twelve chairs made from various woods combined with handsomely decorated lighting fixtures and a writing desk to create a room that was a centre of sociability and perhaps some business.[35] Pictures, listed separately on the inventory, also likely hung here. Valued at £20.17.6, this was the most expensively furnished room on the ground floor.

The 'Parlour' behind was less formal. This room contained a 'Walnut Cane Couch' (or day bed), '1 India Tea Table', a single 'Mahogany Oval Table', and 6 'India Back' chairs with 'blew [blue] Leather' bottoms, that is slip seats. Injecting ornamentation was a 'Guilt frame Shell + Glass'. Fashionable India back chairs and

a day bed indicated use for both repose and polite entertainment, a space of less formality but more privilege. In addition, leather served as upholstery in these two ground floor rooms. Because meals were likely taken in one or both of these rooms, this was a practical alternative for more stylish chairs. Across the Hall, the 'Little Parlour' also had panelling floor to ceiling. A table and seating furniture covered in simple matte bottoms, and its equipment of 'tobacco tonges', decanters, glasses and punchbowl suggest a room used for intimate male camaraderie.[36]

The fourth space on the ground floor at Cote was likely 'Ye Servts Hall'. This room, heated with a small corner fireplace, was well-furnished for the use of Elbridge's staff. A looking glass with sconce arms is especially noted as being 'like that in ye Parlour', an indication of the relative ranking of objects in the house. Several objects are noted as being 'old', perhaps cast-offs previously used in other parts of the house. A costly 'Monthly Clock with Black case' regimented the time, which the servants might have spent at the 'Old Baggamon Table'.

Two routes were available to the first floor. The main stair led to five bedchambers on the first floor. Whilst ascending to these rooms, visitors and servants alike would pass the 'Eight-day Clock with fine Japan Case + Glass Front', worth £9 that stood in the staircase, at once one of the most visible and most expensive single items in the house. Because upholstery was a sign of wealth, bedchambers were typically the most finely decorated rooms in late-seventeenth- and early-eighteenth-century England.[37] In genteel households, the best bed was the most important and expensive object, not on account of its wood but because of the fabric that adorned it and this was true at Cote.[38] Architectural features such as panelling and deep cornices suggest that the two finest rooms were located directly above the Great Parlour and Parlour. The most highly decorated room, with furnishings appraised at a substantial £50, was located at the front of the house and enjoyed ready access to the main stair. The bed was adorned with chintz fabric with yellow satin which was replicated in the elaborate window curtains. Additional furnishings, including a 'Chint[z] Quilt Lined with green silk', two dressing tables, a 'Double Jappan case Drawers', and '10 India Back Chairs with worked Seats', indicated that this space easily served to entertain – and impress – visitors. The presence of chintz is particularly intriguing. By the eighteenth century, East Indian fabrics, especially calicoes and chintzes, had caught the fancy of Europeans and challenged the products of European woollen manufactures.[39] In England, this 'calico craze' resulted in an almost complete ban on East Indian fabrics in 1721, a victory for the wool trade.[40] Curiously at Cote, chintz, illegal to import, served as a fashion statement for one of Bristol's leading Customs officials. The next most expensively furnished space was also a bedchamber on the first floor. This chamber, fully-panelled, probably in oak,[41] contained a bed with a Crimson silk counterpane, two 'setts of Crimson Camblet window vallions Cornishes + 2 squabbs',[42] a 'walnut case Drawers', six fashionable 'India Back chairs with Camblet Seats and 2 Elbow Ditto', and three pictures, valued at £38 8s. 6d. The eight chairs had crimson seat upholstery matching the windows, whereas a somewhat outmoded 'sett of Guilt Leather hangings' costing £5 5s. adorned the walls.[43]

These two rooms could be seen. Although removed from the main floor rooms designed for reception, privileged visitors might be shown up the staircase and into one of the bedchambers, there to be dazzled by the architectural features, the range of goods on exhibition, the sumptuous textiles at the windows and on the beds, and the ample furniture to accommodate chosen people of significance or import. Adjacent to the best bedchamber was a 'Closet' containing '1 Walnut Desk and Bookcase', which seemingly stood alone in the room. The form of the desk and bookcase suggests books, of which Elbridge had a modest collection of seventy volumes. The collection displayed a combination of religious and instructional literature, together with some history, poetry, and plays including titles such as *The Whole Duty of Man*, *The Gentleman's Calling*, and *The Gentleman Instructed*.[44] The books offer a guide to gentlemanly reading habits and assert the closet as a private space for combined writing and study for the customs official.

For servants, a steeper climb up the narrow back stair led to the garrets, where five chambers housed members of the household or perhaps visitors. At the bottom of the back stair, access to the service wing was easy. A 'Servants Hall', 'Best Kitchen', and 'Back Kitchen' with three 'Garrats over ye Kitchen' enabled the work of cooking and cleaning to go on without interruption to the master of the house. The two cellars contained ample storerooms for food, work implements, and various liquids: 'syder', beer, and wine. Immediately adjacent to the service wing, a Coach house stood in a small service yard framed by walls and gates. The areas for service mirrored the compact, efficient arrangement of the grander spaces of the 'gentleman's house'.

Cote typifies gentlemen's houses at an important juncture in the second quarter of the eighteenth century. The rooms and objects indicate how these houses functioned as social spaces. For a person with a fortune of nearly £80,000, John Elbridge owned a house that was handsomely but not ostentatiously decorated. He kept furnishings relatively up to date, possibly due to his niece's influence, but there was no attempt to refurbish the house completely. A range of fabrics make clear that Elbridge saw his bedchambers as places to display his taste. No carpets or curtains are recorded on the ground floor, indicating the greatest efforts at display were to be seen in the bedchambers above.[45] He was not bound, however, by formulaic colour hierarchies. In several cases, the best furnishings were restricted to privileged visitors. Of the three sets of 'India Back' chairs, purchased within the decade prior to Elbridge's death, two were in the best bedchambers and one was in the 'Parlour'. The presence of imported wood such as walnut from Virginia, mahogany from the Caribbean, and oak from the Baltic, as well as proscribed chintz textiles, highlighted Elbridge's connections with overseas trade. As at Lower Slaughter, where the Whitmores had an 'India Japann'd Chest' in the Great Parlour,[46] the staid possessions of a gentleman had a spice of the exotic.

Records from two Clifton residences offer benchmarks about the costs of furnishings in relation to building and the range of goods gentlemen possessed in the third quarter of the eighteenth century. Linen draper Paul Fisher expended over £325 to furnish Clifton Hill House; notes and receipts from 1744 to 1752 list the supplier, date, and cost of the goods. Since Fisher spent about £4,200 on his

new house, the furnishings amounted to roughly 8 per cent of building costs.[47] This admittedly crude measurement provides a guideline to gentlemanly investments in both furnishings and houses.

Thomas Goldney III's 'dwellinghouse Outhouses and Gardens at Clifton' offers another perspective on the domestic interior. Goldney is most noted for creating an outstanding garden, but the house has been less thoroughly explored. Like many gentlemen's houses, Goldney Hall had a 'new part' and an 'old part' of the building.[48] The 'new' building was two and one half storeys, with four rooms on each floor and a total of twelve spaces. The Goldney inventory provides detailed descriptions of furnishings, although no values. In the 'Best Room Southwards', a bedchamber that overlooked the garden, there was a 'Mahogany Bedstead Fluted Pillars half silk yellow damask furniture feather Bed', an extravagant assemblage, side by side with five chairs with checked coverings. Such informal fabric coverings seemed oddly juxtaposed with expensive silk, although they were a common utilitarian covering for the silk underneath. Between the time of Elbridge's inventory in 1739 and Goldney's thirty years later there had been a marked evolution in the use of the bedchamber for sociable purposes. The lower cost of textiles meant that by the middle of the eighteenth century beds functioned less as showpieces.[49] By the 1760s, Goldney also had carpets on the floors in some rooms, including two bedchambers and three parlours.[50] For Elbridge, born in the seventeenth century, the bedchamber still fulfilled a public function; for the eighteenth-century man, Goldney, it did rather less so.

Sociability had migrated to other rooms. Thirteen spaces in the 'Old part of the Building' were private rooms and service spaces. The 'Study' contained objects for private interaction with companions interested in learning and the natural world: a mahogany writing desk, a pair of globes, several pieces of 'Virginia Walnut' furniture, several 'Landskip' paintings, numerous prints, '1 Large Box for viewing pictures perspectively', probably some form of zograscope, and a 'Camera Obscura'.[51] A group of visitors in 1764 mentioned the Camera Obscura, which clearly gave them pleasure as it allowed a view of 'the whole Country & the Objects around'.[52] In the new building, the principal rooms on the ground floor included 'the Common Best sitting parlour', 'the common sitting small parlour fronting the north', a 'Hall' and 'best Stair case', and the magnificent, and still intact, 'Mahogany parlour'. The 'Mahogany parlour' not only displayed an impressive tea table, but richly carved panelling and fine joinery, '10 Half Crimson silk armed Chairs', '2 White Marble tables and carved Gilt frames', '2 pier Glasses in carved Gilt frames', several items of silver and portraits of Mr Thomas Goldney and his father. This room was a splendid exhibition for a Bristolian gentleman. Indeed, the range and quality of Thomas Goldney III's possessions illustrated the elevated material status of commercial elites who by 1770 had become an established part of British genteel society.

Individual household furnishings also provided indications about how status was displayed, especially in relation to the concept of 'taste'.[53] In the early 1730s, William Palling commissioned a 'chest of drawers' made of Bannut tree, a local Gloucestershire name for walnut (Figure 6.3). This piece, recorded in a description

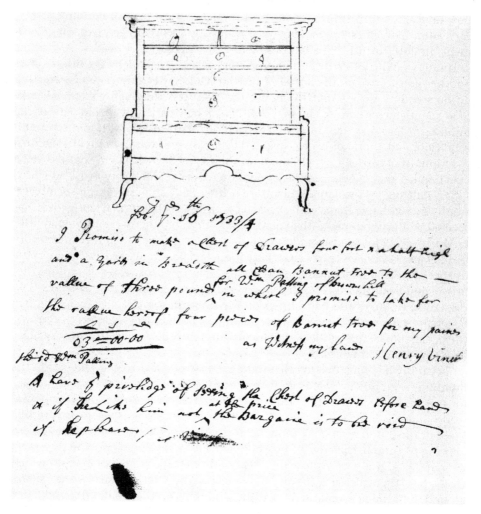

Figure 6.3 Drawing of a 'chest of drawers' made for William Palling by Henry Viner, 1733–1734

Source: Courtesy Gloucestershire Archives and the owner.

and sketch made by cabinetmaker Henry Viner, indicated a knowledge of current style and an effort to secure new furnishings.[54] But this form of furniture was unpopular in London, illustrating a balance between fashion and conservative provincial craftsmanship reflected in other gentlemen's houses.[55] About the same time, Richard Clutterbuck likely bought new furniture to adorn his substantial new house, Frampton Court, including a set of ten side chairs and two matching settees, with compass seats, India backs and cabriole front and back legs terminating in claw and ball feet (Figure 6.4). Although chairs were prevalent in all households by the mid-eighteenth century, their number, form and value mattered.

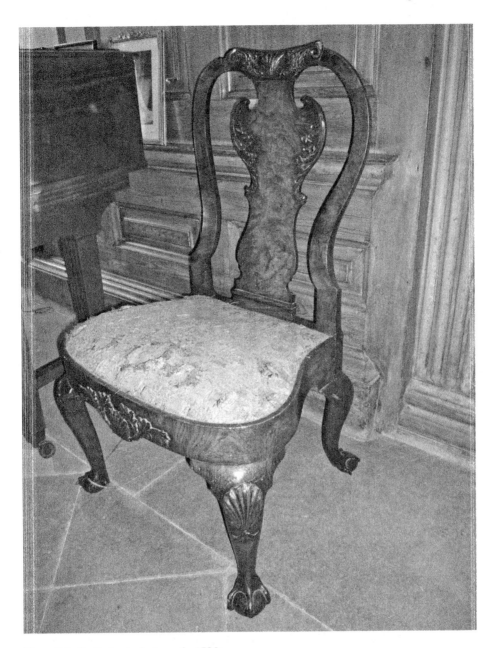

Figure 6.4 India-back chair, early 1730s
Source: Author, courtesy Mr and Mr Rollo Clifford.

There is no documentary evidence linking the chairs with the construction of Frampton Court, but family tradition holds that they were acquired by Richard Clutterbuck. Previously dated to the period of George I, recent scholarship almost certainly confirms that these chairs were contemporary with the construction of the new Frampton Court in the early 1730s.[56] The Frampton chairs exhibit the claw and ball foot, a motif introduced about this time, on all four legs, indicating the chair's high level of status. Whilst not the finest or most decorative chairs available in the second quarter of the eighteenth century they were distinguished by their figurative wood and new form.[57] Dating these chairs effectively and exploring their provenance marks them as material representations of Richard Clutterbuck's efforts to display status and illustrates the consumption behaviours of gentlemen builders and owners. This type of chair was, 'made in very large numbers by both metropolitan and provincial chair-makers' and available throughout provincial England, Wales, and the British colonies.[58] In this way, these chairs represent a furnishings shift about 1730 that coincided with the architectural transition that announced merchants and professional men as owners of small classical houses.

Other utilitarian and decorative objects reinforced this point. Richard Clutterbuck stayed abreast of fashion. He recorded specific instructions for a bookcase to be built in 1771.[59] Like other gentlemen's houses, however, the furnishings of Frampton Court were not entirely *au courant*. An older chest with the initials 'RC', and date '1639' suggested Richard's Clifford lineage whilst displaying out-dated taste. One bedchamber had walls covered with a late-seventeenth- or early-eighteenth-century Aubusson tapestry, an older form of décor.[60] A set of Chinese armorial porcelain was complemented by a range of quotidian pewter dishes and serving pieces made in Bristol and London in the 1740s and 1750s.[61] Despite the acquisition of fine porcelain, Clutterbuck and his household frequently took meals off far more commonplace objects. In another material manifestation of the status of gentlemen, however, even on these pewter dishes one finds the Clutterbuck crest. The show created by new furnishings was counter-balanced by older pieces of furniture.[62]

Genteel displays in America

As should come as little surprise, Americans echoed British tastes to acquire and use furniture, silver, ceramics, and glass, albeit flavoured with local and regional influences. By the 1680s, the level of material goods began to change for wealthy colonials, and during the first quarter of the eighteenth century, the number of household possessions accelerated considerably.[63] Although increasingly objects acquired by the genteel colonials were made in North America, imported goods from Britain continued to play a significant role up to and after the American Revolution.[64]

Despite the attention paid to the effects of the Consumer Revolution in the colonies, like their British counterparts, genteel American families took a basically

measured approach to furnishing their houses. In 1710, the Virginia Burgesses agreed that 'the sume of two hundred and fifty pounds shall be expended and laid out in buying necessary standing and ornamental furniture' for the new Governor's Palace in Williamsburg.[65] Not all Virginia's elite shared this standard; in 1715, planter Robert Beverly lived, 'well, but though rich, he has nothing in or about his house but what is necessary', including 'instead of cane chairs, he hath stools made of wood', a reminder that even the wealthy might be slow to change their décor.[66] By about 1750, however, high value inventories in the Chesapeake region exhibit widespread ownership of many higher status goods, seemingly surpassing even parts of provincial England. By the 1760s, a later Robert Beverly of Blandfield was eager to order china enough to serve '2 Genteel Course of Victuals'.[67] The number and value of goods varied between urban and rural areas, which reflected similar processes in Britain. Owners of furniture in York County, Virginia, for example, favoured walnut and mahogany, while such woods less frequently appeared in the backcountry.[68] There was little time lag in the dissemination of goods from metropole to colony; as William Eddis wrote from Maryland in 1771, 'The quick importation of fashion from the mother country is really astonishing'.[69] Consumption in the lower South, especially South Carolina, was characterized after the middle of the eighteenth century by a level of conspicuous consumption not seen elsewhere, largely fuelled by the wealth of the South Carolina elite.[70]

Gentlemen's houses built throughout the middle and northern colonies displayed both variation and consistency. In the hinterlands of western Massachusetts, the 'River Gods' owned dated and countrified furniture by Boston standards, a sort of 'shabby gentility' that was in contrast to coastal genteel families. Nevertheless, ownership of an average of thirty chairs represented an ample number for polite sociability.[71] In 1729, Archibald Macphaedris, who built a small classical house in Portsmouth, had 'Furniture in the house....£180' and '134 oz. of plate....£100'.[72] Ten years later, Isaac Royall, Sr, whose father had been a house painter, had high value 'amenities' like linens, table wares, clocks, carpets and books as part of the inventory of his Georgian house in Medford, Massachusetts, amounting to about £127.[73] Thomas Hutchinson, whose governor's residence was destroyed by a crowd in 1765, recorded a highly-furnished house with furniture worth £445.3.0.[74] Sir William Johnson constructed two gentlemen's houses on the New York frontier and was a substantial patron for cabinetmakers and merchants, placing regular orders for goods like locally-made furniture, 'new fashioned' Queensware, and ceramics from the Philadelphia firm Bonnin and Morris.[75] Although he was in a position to purchase all new furniture for his new house, Johnson Hall, Sir William instead adopted the gentleman's approach of buying new furniture to go with old.[76]

In Pennsylvania, James Logan kept up a predilection for English goods, although his furnishings reflected a mix of British and Philadelphia wares. A 1752 inventory documents a lifestyle closely in line with genteel houses in

108 The Gentleman's House in the British Atlantic World

In the Back Dining Room

	£	s	d
1 Maple Desk	2	15	--
1 Couch & Bed & Cushion	1	15	--
2 Walnut Tables	1	17	6
10 Leather Chairs [8 shillings per chair]	4	--	--
1 Armed Chair with Cushion	--	17	6
1 pair of Iron Dogs w[i]th Fire Shovel & Tongs	1	5	--
1 pr. of Bellows	--	4	--
1 Looking Glass	2	5	--
Corner Cupboard	--	10	--
Tea Table	--	5	--
a Pewter Press / Contain[in]g / vizt	1	--	--
2 doz. & 3 [27] dishes	10	2	6
5 doz. [60] plates [1 shillings 6 pence per plate]	4	10	--
4 p[air] Brass Candle sticks [2 shillings 6 pence per stick]	1	--	--
3 old water plates & 1 Basin	--	15	--
	33	1	6

In the Lodging Room

	£	s	d
6 Cane Bottomed Chairs [7 shillings, 6 pence per]	2	5	0
1 Case of Drawers	2	10	0
A Bed & Furniture Belonging to it	12	0	0
An Eight Day Clock	8	0	0
A Looking Glass	3	10	0
A Dressing Box and old Walnut Dressing Table	0	5	0
1 p[ai]r of Iron Dogs with Fire Shovel & Tongs	0	10	0
	29	--	--

In the Parlor

	£	s	d
10 Black Leather Bottomed Chairs [12/6]	6	05	00
an Easy Chair	3	00	00
a Scrutore	7	00	00
1 Large Looking Glass	8	00	00
1 pr. Brass [Fire] Dogs with Fire Shovel, Tongs, Fender & ca	1	05	00
In the Buffet and Closets a Quantity of China	10	10	00
2 broken Cases of Knives and Forks	1	10	00
329 Oz. of Plate	148	01	00
	185	11	00

In Ye Hall and Entry viz

	£	s	d
1 Large Black Walnut Table	1	10	0
8 Leather Bottomed Chairs [10/]	4	0	0
A Tea Table	0	10	0
1 Large Black Walnut Table & Stand	1	10	0
	7	10	0

Stenton – Ground floor (1723-30)

Figure 6.5 Stenton ground floor with inventoried contents, 1752
Source: Drawn by Mary Agnes Leonard. Currency is £ Pennsylvania.

England and elsewhere in British North America (Figure 6.5).[77] The fully-paneled Stenton Parlour housed Logan's 329 oz. of plate (i.e. silver), including a fine London-made tea service, in a decorative buffet cupboard (Figure 6.6). A desk and bookcase (or 'Scrutore' as it is called on the Logan inventory) exhibited distinctive Philadelphia craftsmanship, yet with its ogee top, mahogany primary wood, mirrored door panels and sophisticated interior it closely resembled similar objects seen in contemporary interior domestic scenes of the British gentry (Figure 6.7).

On the first floor above (Figure 6.8) was the Yellow Lodging Room, a chamber that combined public and private functions reached by a dramatic climb up a grand and commodious staircase and entered through a pair of double doors. Its furnishings included a 'Yellow Worsted Damask Bed with curtain, Window Curtains & bed cloths, &ca', worth £30, comparable to beds in some of the secondary rooms listed on inventories from larger English country houses between

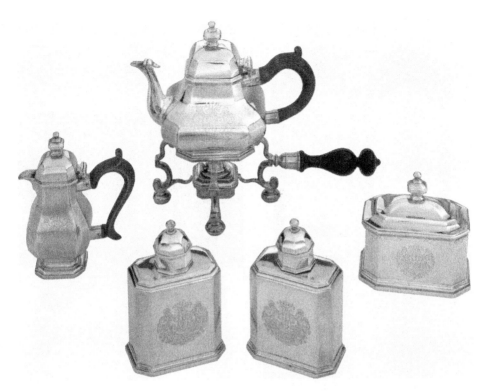

Figure 6.6 Logan tea service, #1959–151–9–11 and 1975–49–1–2
Source: Philadelphia Museum of Art.

1700 and 1750.[78] Embedded hooks in the ceiling suggest the bed had a suspended tester (or 'Flying Tester'), much in keeping with significant beds of the early eighteenth century.[79] The Yellow Lodging Room also contained two 'Sconce glasses with Brass Arms', at £10, which would have created a dazzling setting with the yellow wool damask and warm colour of the maple furnishings of the room (see Plate VI).

Although not necessarily acquiring the most magnificent, most beautiful, or most costly objects, gentlemen purchased to the level that they could, and obtained a mixture of fine new furnishings while continuing to utilize older, less stylish objects, often moved to back rooms. At Stenton, items such as '3 old Cane Chairs' and '1 pr of old Walnutt Drawers' in 'ye Nursery and Small adjoining Room', reference a style of chair that was out of date and unfashionable by the 1750s and a chest of drawers made from a wood that had been largely superseded by mahogany for the finest cabinetmaking and joinery in urban centres like Philadelphia.[80]

The presence of numerous chairs and kinds of ceramics also attests to the Logans' efforts at display and sociability, as do the number of dishes and

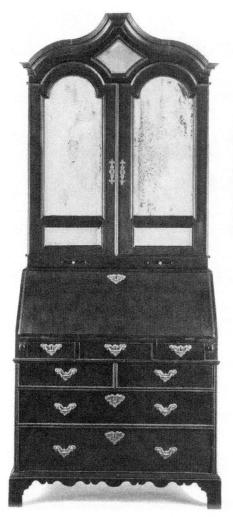

Figure 6.7 Desk and bookcase, c. 1730. Possibly the one that belonged to James Logan.
Source: Stenton, NSCDA/PA, photo by Gavin Ashworth..

serving pieces on the inventory. The house contained a range of upholstered pieces of furniture, such as a set of '10 leather chairs' listed at 8s. a piece in the Back Dining Room, and a £3 fully upholstered easy chair.[81] Stenton had a total of seventy-four chairs, ranging in value from 27s. 6p. in the Yellow Lodging Room – these had worsted damask bottoms – to 12s. 6p. for leather-bottomed chairs in the Parlour to '3 old cane chairs' at 3s. in the Nursery. Surviving archaeological fragments further confirm the quantity and quality of the Logan's possessions. The ceramics and glass represented virtually every type

Furnishing Status 111

In the Nursery and Small Adjoining Room	£	s	d
2 Beds with Bedsteads & Bed Cloths & Curtains	14	0	0
5 old Chairs wth Worsted Bottoms	1	10	0
1 Small Box of Pine Drawers	0	4	6
1 small Bed wth Bed stead & Bed Cloaths	3	10	0
3 old Cane Chairs	0	9	0
1 p[air] of old Walnutt Drawers	0	12	6
1 small Swinging Looking Glass	0	10	0
1 p[air] small fire Dogs wth Shovel & Tongs	0	7	6
1 Close Chair	0	10	0
	21	13	0

In the "Bleu" Lodging Room	£	s	d
1 Bed wth Callico Curtains, Bed Cloaths & ca	12	10	0
7 Cane Chairs & 1 Armed Ditto [chair]	4	0	0
1 Black Walnutt Stool	0	7	6
1 Dressing Table	0	17	6
1 Looking Glass	4	10	0
1 Tea Table wth 6 China Cups & Saucers and 1 Small Bowl	1	0	0
1 pair Iron Dogs wth Brass Heads, 1 p fire shovel and tongs	1	5	0
	24	10	0

In the Yellow Lodging Room	£	s	d
1 Yellow Worsted Damask Bed w[i]th Curtains, Window Curtains & Bed, Cloaths & ca	30	00	00
12 Maple Chairs w[i]th Worsted Damask Bottoms [1 7 6/per chair]	16	10	00
Old Brass Chimney Furniture w[i]th Shovel Tongs and Fender	1	5	00
1 Maple Chest of Drawers & Table	7	00	00
2 Sconce Glasses w[i]th Brass Arms	10	00	00
1 old Tea Table w[i]th a Broken Set of China	1	7	6
	66	2	6

In Ye White Lodging Room (and Closet Passage)	£	s	d
1 White Bed with Curtains, Bed Cloaths & ca	12	10	0
10 Old Cane Chair @10/	5	0	0
1 Chest of Drawers	2	0	0
1 pr. of Iron Dogs with Five Shovels & Tongs	0	10	0
1 Dressing Table	0	10	0
1 Looking Glass	2	10	0
7 Small China Sugar Dishes & 2 large Bowls	1	5	0
1 Black Walnutt Chest	1	10	0
6 Damask Table Cloths	3	0	0
2 ½ doz[en] Napkins @2/	3	0	0
14 Diaper & Huckaback Ditto [Napkins] 7/6	5	5	0
1 doz[en] & 9 Diaper Ditto [Napkins] 1/6	1	11	6
	38	11	6

Stenton – First floor (1723-30)

Figure 6.8 Stenton first floor with inventoried contents, 1752
Source: Drawn by Mary Agnes Leonard. Currency is £ Pennsylvania.

of ware available to an Atlantic world gentlemen – stonewares, earthenwares, creamwares and Chinese export porcelain. Archaeological objects from Stenton record consumption locally in Pennsylvania, throughout the British Atlantic and, in the form of China ware, from Asia (see Plate VII).[82] Taken together, the value of household furnishings at Stenton, £242 sterling, was in line with other Atlantic world gentlemen.

Gentlemen's furnishings compared

How do the furnishings of Atlantic World gentlemen's houses compare to other houses in England? Room arrangements, interior finishes and furnishings indicate that genteel owners stood very high in the socio-economic hierarchy, likely in the top 10 per cent of wealth in the population.[83] As Table 6.1 shows, the owners of English houses possessed household goods worth perhaps £300, a figure consistent with genteel houses in the America.[84] These figures indicate that the scale of furnishings in gentlemen's houses with four rooms on a floor

Table 6.1 Comparative values of household furnishings, £, and inventoried spaces, Gloucestershire gentlemen's houses[85]

	Richard Whitmore, 1688, Lower Slaughter Manor	William Whitmore, 1725, Lower Slaughter Manor	Elizabeth Whitmore, 1735, Lower Slaughter Manor	John Elbridge, 1739, Cote	John Elbridge, 1739, The Fort House	Paul Fisher, 1744–1752, Clifton Hill House	Thomas Goldney, 1768, Goldney House
Value	274.16.8[a]	260.10.6[a]	199.17.0	290.8.10	303.12.8	326.17.11	No values
No. of spaces listed[b]	23	21	15	24	23	N/A	25

[a] Silver included in calculation.
[b] Excluding outbuildings.
Source: GA/D45/F2: Inventory and valuation of goods of Richard Whitmore of Lower Slaughter, 31 January 1687/1688; GA/D45/F3: Inventory and copy will of William Whitmore of Lower Slaughter, 1724–1725; GA/D45/F4: Inventories of goods, linen, etc. belonging to Elizabeth Whitmore of Slaughter House, 1724–1735; BRO/AC/WO/10/19: 2 April 1739, Inventory of the goods of John Elbridge at his house at Stoke, Westbury (Cote House); BRO/09467/12/b: 'Notes + Receipts for Furniture + c at Clifton, 1744–1752 (Bundle 13)'; UBL/DM1398/A: 'Copy Inventory of furniture and effects at Goldney House, 1768'.

was fairly consistent between the 1680s and 1770s. Despite changes in values, the availability of goods, and the number of furnishings, a gentleman might expect to furnish his house with objects costing a few hundred pounds. This amounted to about 10 per cent of building costs. The number and value of furnishings might be somewhat higher for those near urban areas, as in the case of Elbridge and Fisher, but this might be a matter of individual choice rather than geography. Other genteel owners might occasionally spend less, but only on rare occasions significantly more than these figures reflect.

Between 1675 and 1725, mean inventory values in England were respectively £320 for the gentry and £193 for trades of high status, including clergy and professions.[86] Despite overall growth in the possession of goods in the first half of the eighteenth century, higher status objects such as books, clocks, pictures, window curtains and china were relatively uncommon and slow to spread, even among the gentry, high status trades people, and leading colonials.[87] Tables 6.2 and 6.3 document the possession of these goods by different social groups in England and the Chesapeake in the first half of the eighteenth century.

Owners of gentlemen's houses demonstrated a high level of acquisitiveness, as they possessed objects in all these categories, with a few exceptions. Richard Whitmore, for example, who died in 1688, did not own china or utensils for hot drinks. In America, the rising trajectory of consumption reflected Britain, but regional distinctions underscored both the variability and standardization of experience presented here. In northern urban centres like Boston and Philadelphia, wealthy merchants largely drove new tastes in consumer goods, whereas in the Chesapeake the rural gentry did more to set the standard.[88] Until the mid-eighteenth century, meanwhile, South Carolinians, despite being wealthier than their

Table 6.2 Percentages (%) of goods owned by gentry and high status tradesmen in England

Social status	Books	Clocks	Pictures	China	Utensils for hot drinks
Gentry (1675–1725)	39	51	33	6	7
Trades of high status, clergy, professions (1675–1725)	45	34	35	11	7
Gentlemen (Kent 1700–1749)	46.2	69.2	n/a	n/a	23.1
Gentlemen (Cornwall 1700–1749)	26.7	33.3	n/a	n/a	20

Source: Weatherill, table 8.1; Overton et al., table A4.1.

Table 6.3 Percentages (%) of goods recorded in higher value inventories, average from four counties, Maryland and Virginia

Inventory value and date	Books	Clocks	Pictures	Fine earthenware	Utensils for hot drinks
£226–490 (1723–1732)	79	14	10	27	22
>£490 (1723–1732)	87	41	36	31	43
£226–490 (1745–1754)	77	16	14	45	51
>£490 (1745–1754)	85	43	38	69	81

Source: Carr and Walsh, 'Changing Lifestyles and Consumer Behavior in the Colonial Chesapeake', tables 1–4.

northern compatriots, held a relatively lower proportion of their wealth in consumer goods. The residents of South Carolina made widespread use of high status goods such as tea and vessels for its consumption by the 1730s, but the explosion of goods seen from mid-century is almost entirely attributable to the conspicuous consumption of wealthiest members of South Carolina society, including gentlemanly house owners.[89] Throughout the Atlantic World, builders and owners who possessed small classical houses equipped them with a range of handsome goods that reinforced their genteel status.

Yet if these statistics are a reminder of how many material possessions belonged to gentlemen-owners, there was still a substantial gap with country houses of the greater gentry and aristocracy. Larger houses naturally contained more objects but the quality and cost of furnishings often far surpassed those of gentlemen-owners.[90] The 2nd earl of Lichfield socialized with one genteel Gloucestershire family, the Rookes, but his domestic possessions at Ditchley Park in Oxfordshire far outstripped their possessions. Ditchley had forty-one rooms, a dozen or more ancillary spaces, and contents, excluding silver, totalling £1489.5.0, or nearly five times as much as a typical gentleman's house.[91] The most expensively furnished bedchamber was valued at £137.5.0; seven bedrooms contained furnishings worth between £30 and £52, comparable to John Elbridge's or James Logan's best bedroom. On the ground floor, the comparison becomes even more stark, where

Lichfield's Drawing Room had furnishings worth £143.13.0 and his Great Room £195.10.6. The parlours of gentlemen simply could not hold their own against such spaces. With the plate included, the contents totalled a staggering £3,000, or about ten times as valuable as a gentleman's possessions.[92] At Stoneleigh Abbey in Warwickshire the Leighs, a middle-ranking gentry family, practiced conspicuous consumption episodically, but spent nearly £7,000 on household refurbishment between 1764 and 1767.[93]

The difference in the number, cost, and overall level of furnishing between gentlemen's houses and those of the greater gentry was apparent in other ways. Another great house, Kiveton in Yorkshire, inventoried in 1727, had two apartments 'more for shew than conveniency'.[94] Gentlemen, by contrast, had less room to spare for rooms and furnishings simply about 'shew'. Small country houses elsewhere in England were more comparable in their size, arrangement, and furnishings, but even these often had more possessions and higher values. Likewise, the wealthiest merchants, such as South Sea Company officials, had significantly higher numbers of goods worth more.[95] Individual objects told similar stories. On one occasion, Lady Elizabeth Germain purchased a fine inlaid desk in France 'from the Dauphin for 100 guineas' for Drayton House, Northamptonshire.[96] Compared to Lady Betty's buying binge, Elizabeth Whitmore's efforts at Lower Slaughter Manor seem positively staid.

In most instances, gentlemen made little effort to replicate aristocratic consumption practices. As Deborah Cohen noted for the nineteenth century, 'Aristocrats, though often conspicuous consumers, did not secure their status by their household possessions'.[97] Possessions meant more to the genteel. Objects enabled them to participate in genteel society, inject taste into the domestic environment, and display their fashion sense in a way that was relatively economical. Their choices were not always governed by resources. Sometimes it was a matter of taste and preference. John Elbridge or Robert Carter I had the means to decorate their houses more lavishly, but instead elected to furnish them with objects that did not cost vast sums of money. Carr and Walsh contend that conspicuous consumption appeared throughout the American colonies by the 1760s 'although not to the degree practiced by the English aristocracy'.[98] This should come as no surprise. Of course well-to-do colonial Americans did not consume like aristocrats. Neither did their counterparts amongst the genteel in provincial Britain.

Architectural finishes and room furnishings provide multiple additional layers for understanding those who lived in gentlemen's houses. In country houses, 'insufficient attention has been devoted to the strong thread of conservatism' in decorating, and the same could be said of small classical houses.[99] As with their building campaigns, gentlemen furnished their houses in measured and economical ways. Throughout the period they accumulated an array of objects distinct in its composition from those lower and higher in society. Although there were exceptions, gentlemen did not normally procure the highest standard, best, or most expensive objects available. Genteel owners acquired new luxury goods as signifiers of fashion, especially after about 1730, while often simultaneously retaining older objects and traditional forms of social interaction. This process

took place over time, as they judiciously inserted appropriate objects into their domestic surroundings. The result was a mixture of fine furnishings, often situated in public spaces, with older, less stylish objects usually found in back rooms.

As Charles Carroll of Annapolis remarked, 'What is decent & Convenient, You ought to Have, there is no end to a desire for finery of any sort'.[100] Fashionable India Back chairs could co-exist with a walnut cane couch, or a handsome green bed might stand in the same room with an 'old' case of drawers and dressing box, and 'old' quilts and blankets. Seeking neither to differentiate themselves from the aristocracy nor to ape their consumption practices, most families consumed in order to reinforce genteel credentials. Gloucestershire gentry, Bristolian gentlemen, Stroudwater clothiers, Southern planters, New England merchants and 'River Gods', and Pennsylvania Quakers all staked out their position through the furnishing of small classical houses.

7
Enacting Status

In 1723, William Clutterbuck of old Frampton Court folded a piece of paper, melted a dab of red wax onto its back, and sealed it with an impression of his family coat of arms. A decade later, a stone mason, perched high on scaffolding, carved the same coat of arms in the tympanum of the new, fashionable house recently constructed by William's son Richard. In about 1750, a Chinese painter held a piece of porcelain in his hand, stroke by careful brush stroke applying the Clutterbuck arms onto a tea pot. That serving vessel together with at least a

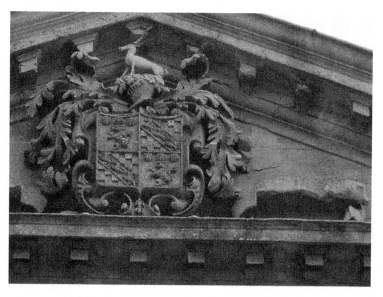

Figure 7.1 Clutterbuck coat of arms, Frampton Court
Source: Author.

hundred other similarly painted objects would shortly make a voyage half way around the world to grace the tables and cupboards at Frampton Court.

These three actions and the objects associated with them represent important attempts to enact status in eighteenth-century Britain. The most prosaic of these, the sealing of a letter, played an important role as an oft-repeated practice in knowledge and status communication.[1] It was a personal act of security and privacy almost certainly conducted in the confines of William's study or closet. The building of a house was an omnipresent assertion of status and power. Embellishing it with the family coat of arms was a final visible reminder of family lineage and authority. The acquisition of porcelain signified participation in a global consumer network and a fashionable world of goods, but could also be closely admired and even touched for those privileged to come within the setting of the gentleman's house. Possession or lack of such a material good constituted a distinct marker of status.

It was through object-actions like these that people laid claim to gentility, acted out their status, and shaped their identities. Houses, landscapes, interiors and furnishings allowed genteel owners to put social practices in motion.[2] In other words, these houses served as vehicles for a range of activities, displays and symbols that conveyed ideas of status within and beyond the household. The last four chapters have considered in turn the architecture of gentlemen's houses, their situation, the arrangement and decoration of interior space, and their furnishing. But theatres, sets and props without the action of the play are hollow. With the stage set designed, how genteel owners enacted the drama of status becomes the central question. From the kitchens and parlours of their own houses in this chapter, to involvement in local, national and imperial affairs in the next, genteel owners employed strategies that defined status and identity for their families, and within wider networks.

The domestic environment of the gentleman's house involved social and cultural interactions between and within families, friends, visitors and servants. Building a gentlemen's house most often confirmed status, but the performance of status was a recurring process. Gentry houses such as Lower Slaughter Manor demonstrate how elements of fashion could be injected into traditional landed life. Members of society from the commercial and professional worlds of Bristol or the cloth-making districts of the Stroudwater Valleys confirmed their status within an established social hierarchy through a series of measured choices. This process, however, had decidedly different manifestations, and small classical houses displayed behaviour ranging from the crude to the polite to the occasionally aspirational. Social status for those on the cusp of the elite was both privileged and contested. William Palling's Brownshill Court and Sir Onesiphorus Paul's Hill House offer contrasting examples of the gentlemen-clothier's house and its central role in enactments of status. Likewise, gentlemen's houses in America exhibited the permeability of social and cultural boundaries for British elites, whilst also highlighting distinctions between genteel owners and others. On the American frontier, a leading colonial figure like Sir William Johnson could assert gentility through his house and belongings. Jeremiah Lee's elegant house

in Marblehead, Massachusetts is an example of conspicuously deployed wealth in a New England port town. Finally, Richard Clutterbuck's efforts to enact status in his small, elegant Palladian mansion displayed an effort at aggrandizement seen infrequently in gentlemen's houses. Clutterbuck's socially assertive choices contrast with the more typical activities of other genteel owners.

The enactment of status could be a repetitive act, a specific event, or an everyday occurrence. They might be recorded in a letter or diary, referenced in an account book, or represented by an object whose use can be explored. Most telling are those enactments that highlight how genteel owners grappled with status within the domestic setting. These activities trace social strategies over time and geography, particularly identifying what is distinctive about genteel individuals and their environments.

During the eighteenth century, the concept of politeness emerged as a central force in the construction of genteel status. From the seventeenth century, gentility was the key variable in status construction for 'the middle sort'.[3] As Margaret Hunt contends, however, politeness and good breeding were ideas landed families conveyed to their children but were not vital to middling male socialization compared to traits like thrift, hard work and business-related skills. Instead, middling 'prudential virtue' emphasized rational self-discipline over refinement.[4] There was, however, no necessary incompatibility between politeness on one hand and hard work and business sense on the other. One of the forces of change in gentlemanly houses was the ability of genteel owners to express both ideas. The construction of gentlemen's houses after the 1720s resulted from unity of polite intention and thrifty acumen. At the same time, this was not universal. It is evident that owners of these houses straddled a line between different social strata, urban and rural environments, and polite and impolite. As Langford reminds us, most people were neither polite nor commercial, although for propertied members of society, polite living and commercial consumption characterized the eighteenth century.[5]

For gentlemen, status enactments struck a balance between a celebration of polite ideals and the contested reality of life within personal and family networks. Their houses were largely about putting gentility into action, but behaviour even in gentlemen's houses was not always shaped according to polite strictures. It is here then that we see both the importance of gentility in the form of house, possessions and the behaviour that they help to construct, as well as a field of play where the concept of gentility became more malleable over time. How that process played out in the domestic setting is the topic of this chapter.

Genteel households

For the landed elite, great country houses served as centres of administration for estates, focal points for the display of power, and places of hospitality, leisure and sport.[6] To that end, grander houses of the aristocracy had, 'a titanic social capacity'.[7] Gentlemen also exerted power through their control of space, and small

classical houses fulfilled many of these functions as well but in different ways and on a less elevated social level. More often for gentlemen owners after about 1730, these houses served as year-round residences, or at least the primary location of their domestic life, and the regular presence of gentlemen enabled them to play a more active role in local affairs and administration. Even where they might have multiple residences, as was the case with gentlemen who owned houses in provincial cities, the scale of distance and time between city residence and gentleman's house was much smaller than if they had been travelling to London. James Logan could easily move between Philadelphia and Stenton in an afternoon, and owners with houses outside other provincial cities could do likewise. London could be a forbidding place, as when John Elbridge expressed extreme reluctance to travel from Bristol to the metropolis, despite pressing business in the capital.[8] Particularly for gentlemen who maintained a primarily local power base, a small classical house as a primary residence made sense in many ways.

How then did the status of these owners play out on a daily basis; in other words, how did gentlemen enact their status? Houses were organized on multiple levels: as homes for families, as places of business transaction, as locations of sociability, and as complicated symbols of power and hierarchy. The houses are guides to the structure of households. As spatial position, architectural finish, inventories, and other records indicate, a hierarchy of rooms within the gentleman's house shaped experience for the owner, his family, other members of the household such as servants, and visitors.[9] Numerous people interacted with the interiors of these houses, although gaining access to the house itself and individual spaces varied according to station, relationship to the owner, the purpose of a visit, and timing. The domestic setting was private, but within it space was fluid and privacy relational, based on such factors as who controlled the space, at what times, and in what circumstances.[10]

The 'household family' included all persons living under the same roof, whether relations, servants or others.[11] Hired, indentured or enslaved servants were an omnipresent group for genteel owners, and may have seen most of the house as they traversed space in performance of their duties.[12] The four rooms per floor of a gentleman's house included various spaces in attics, basements, attached offices or outbuildings that accommodated servants and the activities that they undertook.[13] Their floor plans suggest that separation of servants and masters began to take place by the early-eighteenth century.[14] Back stairs went some way toward enforcing segregation. The ample space available for servants in genteel houses meant that there was a capacity to maintain physical distance and separation between family and servants. With the difference that enslaved Africans fulfilled many service roles, the Governor's Palace compound in Williamsburg, Virginia, 'must have seemed a microcosm of English life'.[15] A 'modern built house' allowed for modern forms of social organization.

Control of space was 'a complex interrelation of age, status and sex'.[16] The gendered nature of the household has been recently reconsidered and, as will be seen, men and women of varying status could control access to and within the household.[17] Although Judith Lewis argues that 'only a woman can turn a house into a

home', men controlled the money that built these houses, and much of the action that went on within them.[18] The male presence structured relationships within these houses and between the house, its occupants, and the external world. Accounts of domestic space in the gentleman's house help to trace the transition from 'rough-and-ready seventeenth-century man' to 'refined eighteenth-century man'.[19]

Social and gender hierarchies shaped sleeping arrangements and seating plans at meals. Until the mid-seventeenth century, separate bedchambers for servants were highly unusual, although that had changed in gentlemen's houses by the early-eighteenth century.[20] Gentlemen's houses allowed for more segregated space. Cote had five garret rooms in the main house with good but not lavish fixtures in each. Elbridge maintained ample space for a number of servants, including a 'Servts Hall', 'Best Kitchen', 'Back Kitchen + Cellars', a separate 'Cyder Cellar', a 'Woodhouse', and 'Coach house'.[21] The three 'Garrets over ye Kitchen' were almost certainly for servants – all are relatively low value rooms and two contain multiple beds, including an 'Old Turn up Bedstead'. The Servants Hall contained a monthly clock, walnut and mahogany oval tables, and seven leather chairs, an indication of the number of servants. The display of fashionable goods was less important in what Weatherill calls 'back-stage' or service spaces.[22] In these rooms individuals encountered many objects described as 'old' with much lower associated values. Nevertheless, the ample provision of space and equipment for use by servants set gentlemen's houses apart from most British households.

Kitchens led the way in domestic technological innovations in the eighteenth century and the service areas of gentlemen's houses were well-equipped.[23] The kitchen was also a primary centre of household activity.[24] John Elbridge's kitchen displayed an array of jacks, kettles, saucepans, stewpanns, roasting racks, chafing dishes, and even a 'chease toaster' that suggest a good diet and ample staff to prepare it.[25] Thomas Goldney's kitchen in 1768, located in the older part of the building, contained a 'double flap't table', leather, wooden- and cane-bottomed chairs, a common jack, and considerable amounts of pewter. Such wares for preparing, serving and consuming food articulate the level of potential sociability in genteel households.

Employing servants in particular numbers and ways carefully calibrated gentlemanly status. Within households, servants were omnipresent and had close and complicated relations with their masters. In America, enslaved people comprised a large segment of the population, especially in southern colonies. Enslaved domestics worked in close proximity to their masters, often sleeping in kitchen outbuildings.[26] Northern families had slaves as well, and there were enslaved workers at Isaac Royall's house in Massachusetts, Johnson Hall in New York, and Stenton in Pennsylvania. In most instances, it seems that a few trusted servants were intimately involved in the operation of gentlemen's houses, supplemented by kin or friendship networks. Regular bequests to servants indicated their importance and the mutually dependent relationship between master (or mistress) and servants.[27] Quaker wine merchant John Andrews gave five and ten guineas apiece to his

servants Thomas Jeff and Francis Cowles. Charles Coxe of Nether Lypiatt made provision for his 'Domestick servants who shall live with me at the time of my decease', as well as defining his household broadly by leaving an annuity to the wife of one of his executors 'in Consideration of her Service and Attendance on me during my frequent Indispositions'. William Springett of Westend House provided for his servant 'so long...as he shall live and behave dutiful and Obedient to my said wife'. In his will, Elbridge left money to three servants: 'my servant Anne Evans' received £100, 'my servant George Avery' received £30, and 'my other servt Richard Drew' received £10. The Logan family of Stenton had a long-standing relationship with Dinah, an enslaved African manumitted in 1777 but who remained a part of the Logan household.[28] William Palling of Brownshill kept only three servants, 'two maids and a man'.[29] Thomas Goldney had two chambers specifically for servants. One contained a bed and '6 old chairs' and an 'old' table and stool. The other had two beds, suggesting at least three servants.[30] Beyond a few primary servants with some individual identity, a supporting cast of unnamed servants, as well as a host of occasional contracted labour and short-term staff, kept genteel households running.[31]

These accounts construct a picture of the gentlemen's household. Despite Mark Girouard's quip about the introduction of back stairs from the late-seventeenth century meaning the gentry walking up stairs need not meet last night's faeces coming down, there was close interaction between all people in the household.[32] The number of rooms available in the gentleman's house made some semblance of privacy possible, particularly in small rooms like closets, but genteel families and servants working for them alike had limited recourse to private space and activities.[33] The complex dynamics of the genteel household were keys to how status was enacted.

The calibration of social status

Status was created in many ways. Landed gentry families with small estates played main roles in their immediate community. Even their relatively modest houses stood out in the landscape and presented a focal point for local activity and action. In England, landed gentry living off small estates were the first to build small classical houses and it is important to consider the way that they performed their social position. The Whitmores at Lower Slaughter, for example, were unusual for their continuous occupation of the manor house. Richard Whitmore's lavishly furnished house attests to the significant status the family claimed from an early date by building innovatively and furnishing conservatively. Gentry families like the Whitmores were not immune to change and followed fashion as well as seeking improvement in living space. Despite the family's ancestral base in Shropshire, their efforts to maintain and enhance Lower Slaughter Manor were achieved through building works, stair renovation and refurnishing. Large numbers of individuals were employed in lengthy building works that projected their power and status to the populace. Elizabeth Whitmore's efforts at refurbishment placed her in an important position as the 'Lady of the Mannor', as

she is referred to in several accounts, as well as 'Madam Whitmore' and 'my Lan Lady'.[34]

Gentry landowners may have spent more time away from their country houses than commercial and professional owners.[35] Charles Coxe seems not to have inhabited Nether Lypiatt Manor consistently, but travelled frequently to London and on his judicial circuit.[36] John Cossins of Redland Court spent significant time in the capital.[37] William Whitmore, an army officer, was frequently absent from the Lower Slaughter estate in the middle years of the eighteenth century, kept a house in London, and was often abroad with his regiment.[38]

A hierarchy existed within the Lower Slaughter Manor entourage and Whitmore regularly left the Manor in the good care of his lawyer friend, Richard Jervis. Richard Jervis, as Whitmore's attorney, general factotum and friend for many years, handled much of the business of the estate.[39] The subtle relationship of local tradesmen to the Manor House was reflected in the letter written by a local grocer or dry goods dealer to 'the Gentlewoman who is Housekeeper at George Whitmore's Esqr, Slaughter' noting that, 'I shall be glad to obey any Commission in serving the family with anything in my way whenever called upon'.[40] In their capacity as a leading family, the Whitmores expected deference, even obedience. In one letter related to elections, William made clear that he expected his wishes to be followed, with an unspoken but implied threat: 'I shall very much resent if any person that I have an interest in should vote against you'.[41]

In the early 1770s, the Whitmores had their servants in livery, although it is not clear how early this practice began at Lower Slaughter, and it seems not to have been typical of most gentlemanly owners.[42] By that time as well, there was more intercourse between Lower Slaughter and London. In the 1770s, bills from London stationers, jewellers and goldsmiths, and musical instrument-makers reflect heightened levels of fashionable consumption.[43] A prominent gentry family involved in national affairs in London, the Whitmores illustrate some of the trends seen amongst the gentry: early projects to build small classical houses, involvement in local affairs, some connections to the metropole, and efforts to keep up with material changes.

Once small classical houses began to be constructed in America, similar although not identical patterns emerged. At Pennsbury, William Penn attempted to recreate the gentry lifestyle he knew in England.[44] Although he spent limited time in Pennsylvania, when he was there he primarily resided in Philadelphia, only occasionally venturing out to live on his estate, despite his view that, 'The Country Life is to be preferr'd'.[45] Virginia planters, meanwhile, primarily lived on their estates, since no urban centre existed to attract their attention. Although they looked to the capital in Williamsburg for inspiration, their plantations functioned much as estates in England, replete with copious hospitality.[46]

Although urban and rural gentry espoused a common social identity, each might define and manifest it in a different way.[47] Historians often claim that merchants were '"commonly ambitious of becoming country gentlemen", not of perpetuating their businesses', but the motivations of those engaged in mercantile

pursuits were complex, and it is evident that many merchants did not choose one over the other.[48] Some merchants wanted only to make money, others to enter the world of the genteel. Only a few truly sought to become country gentleman. In many instances, these motives were combined in some way. Gentlemen's houses near port cities like Bristol, Philadelphia, Liverpool or Boston typify a mix of business and countrified pursuits. Small classical houses mostly built after the 1720s represent the new wave of social growth seen amongst commercial and professional elites in the eighteenth century. Few merchants completely abandoned their business or removed themselves entirely from the city to a country house. In their domestic spaces, middling and gentry values and identity met and interacted.

Chancery court and chocolate pots

Complex social interactions unfolded in John Elbridge's houses near Bristol, highlighting the intersection of male homosociability, objects, and status. Elbridge had distinguished himself as a capable Customs official, and his penchant for hard-work, diligence, and competence made him a leading figure in the professional and commercial worlds of Bristol.[49] In his domestic sphere, concepts such as service and gentility combined with objects to cross various thresholds in a complicated web of personal relationships. A particularly revealing case was that of Elbridge's servant Henry Bodman. Bodman, the son of a pilot, became apprentice to Elbridge in 1718. After his term expired, he worked as Elbridge's Clerk at the Custom House and as a personal secretary. He then remained one of Elbridge's most trusted lieutenants until 1738, when on Elbridge's recommendation Bodman was appointed as Deputy Customer at Bristol. Despite this new office, Bodman continued to live with Elbridge and 'assisted him in the nature of a Clerk and Cash keeper in the Business of his offices and his private affairs to the time of his decease'.[50] When Elbridge died in 1739, some Bristolians were astonished to find that he had left a substantial sum to Henry Bodman. As one noted: 'I am now determined to inform you what I am sure will amaze you. In short, it is the manner Mr Elbridge (of whose death I don't question but you have heard) disposed of his fortune'. The letter especially noted the glaring omission of Thomas Elbridge, John's nephew, who received what was considered a meagre inheritance.[51]

The bequest illustrated the complex relations within the domestic setting. Several deponents in the resulting Chancery case averred that Elbridge had 'a Great Value for' Bodman. Apprentices added words of praise, commenting that Elbridge had treated Bodman, 'as if he had been a child of his own'. One deponent stated that Bodman served as Elbridge's 'Companion rather than his Servant in somuch that he always dined with him at his Table and drank Chocolate with him in the morning before he went to the Custom house'. Another suggested that during the latter part of Elbridge's life he made Bodman 'his principal Companion'.[52]

The case revealed the fine gradations of the social hierarchy. Bodman's role in the household and Custom House was not enough to be accepted as an equal or gentleman in some circles. John Elbridge's slighted nephew, Thomas Elbridge, made clear his feelings about Bodman's position. When Bodman first came to live with Elbridge, Thomas claimed, he 'was a Ladd or youth' employed 'in going on Errands and other Servile offices in his Family'.[53] Some of the most disparaging comments about Bodman came from the lower orders. One servant remarked that Bodman, 'did use to attend to him to and from the Custom house with a Candle and Lanthorne Clean his Shoes and waite at Table' but claimed that Elbridge, 'never Shewed him...any other or Greater degree or Marks of favour Than are usually Shown by humane Masters to Wiling Servants'. Another servant from Thomas Elbridge's household echoed these stories, recalling that Bodman 'occasionally waited and attended on the said Mr Elbridge when he had company at his Table in the nature of a Servant and used Sometimes to ride out with his said Master and carry his Great Coat and do little offices about the house'.[54]

Domestic space was an important setting for social interaction on multiple levels, and Bodman's relationship illustrates the interplay that sometimes existed in gentlemen's houses between servants and their masters. By the early-eighteenth century, a shift in social attitudes meant that 'it had become demeaning for a gentleman to be a servant'.[55] At the same time, however, it had become increasingly possible that a servant like Bodman might become a gentleman. Apprentices from the Custom House might be on a par, but factors such as family attachment, social background, and personal relations made a significant difference to the social rise of a gentleman. Although Bodman never achieved the glittering success or wealth acquired by John Elbridge, he nevertheless illustrates the contested identity of the provincial gentleman.[56] Living in Elbridge's house, being treated like a favoured child, serving as a cash keeper, being listed as a friend, dining at his table, even sharing a morning pot of chocolate, were all coded actions that defined Henry Bodman and created his status.

'Most genteel and hospitable receptions'

Shared codes of genteel behaviour across the British Atlantic world were especially important in enacting status. Genteel families often embraced intellectual and cultural pursuits that informed and shaped identity. Gentlemen's reading and travel experiences contributed to and reflected their understanding of taste and style. Those with genteel pretensions in America often sent their children to England for schooling, and occasional visits reinforced connections.[57] James Logan of Stenton visited England twice after removing to Pennsylvania; his return the second time in the 1720s coincided with the construction of his house, suggesting metropolitan inspiration. Later his son and grandsons travelled to England for education. A few gentlemen owners in England, such as Benjamin Hyett, G. O. Paul, and Thomas Goldney II, left travel journals or accounts recording European tours.

The travel journal of Thomas Goldney II displays the interest but somewhat limited sophistication of gentlemanly thinking about architecture and furnishings.[58] In 1725 Goldney undertook a month and a half tour on the continent, visiting the Austrian Netherlands, the Spanish Netherlands, Holland, France, and several German cities. Three themes emerge from his journal: an interest in religion, art and architecture, and food and drink. Throughout his journey he remarked extensively about the buildings that he saw, commenting in some detail about the style, materials, craftsmanship and design. At the same time, his lengthy journal entries do not exhibit a great deal of technical knowledge about architecture or interiors. Nevertheless, his attention to aesthetics and cultural life positioned his family to participate in genteel life and rituals. Goldney noted for instance the 'Blew Tyles' in Holland similar to ones that adorn fireplace surrounds in his Clifton house.[59]

When his son Thomas Goldney III inherited Goldney house in 1731, it served as a focal point for genteel sociability. The gardens – Goldney's 'minor *Stow* on *Clifton's* crown' – attracted much comment at the time and have drawn the attention of subsequent historians.[60] But polite display extended beyond the garden alone. Elizabeth Graeme Ferguson, a visitor from Pennsylvania, described a 1764 visit to Goldney's house at Clifton:

> Lady Charlotte Finch and Lady Juliana Penn, called on me to go & breakfast with one Mr Goldney, an eminent Quaker of an antient Family, his house is on Clifton Hill, about a mile from the Hot-wells, & is allowed to be one of the finest Views in Engld. – we breakfasted with great elegance & had a most genteel and hospitable Reception.[61]

Ferguson's description of her visit can be matched with objects recorded in Goldney's house to reconstruct her procession around the house and grounds.[62] As with most visitors, the garden formed the highlight. Even as a bachelor gentleman with 'two maiden Sisters', however, Goldney knew how to entertain. The new section of Goldney House was the focus for sociability. In the house, Ferguson traversed the Hall, with its 'Derbyshire marble' and 'Italian composition' tables, as well as a 'pillar Dutch tea table History painted', on her way to the 'Mahogany Parlour', the likely site of breakfast. Here Goldney's things dazzled her, as they were meant to do: her description of 'a very fine Sett of english China on a Silver Tea Table' accords with Goldney's inventory of a 'Silver tea table on a carved Mahogany stand with a fine Sett of Worster China'. As they ate and drank, 'two fine fruit pieces by a celebrated Hand' drew Ferguson's attention. These fruit paintings by Tobias Stranover (1684–1756), a noted decorative painter in the second quarter of the eighteenth century, merited particular comment and aesthetic judgment.[63] It is even possible that Ferguson and her friends gained admittance to Goldney's study, a more private chamber where the 'Camera Obscura' she mentions was stored. Ferguson went away impressed by her 'polite Treatment' having spent a 'most agreable Morning'.[64] Thomas Goldney III had flawlessly enacted his status in a way comfortable and acceptable to the Atlantic world genteel.

Devil Palling and 'his Kitchen where he generally sits'

A mix of business and gentility was a significant characteristic of these houses, and the intermingling could take varying forms. Even in the late-eighteenth century, clothing manufacture was 'still considered as a lucrative and genteel employment' in parts of Gloucestershire.[65] From the 1720s, gentlemen-clothiers in the Stroudwater Valleys indulged in construction of small classical houses, building efforts that at once removed them from the immediate surroundings of their mills whilst maintaining a measure of proximity.

William Palling of Brownshill Court represented one version of the varied performance of status enacted by gentlemen-clothiers. For Palling the domestic setting was a venue for exercising authority over tenants, family, and friends. Despite most of their money being made in the cloth trade, the Pallings relied on land to provide 'status and stability'.[66] William Palling seems to have been an unpopular landlord and neighbour, referred to as, 'Devil Palling'.[67] This was not his only sobriquet. One contentious tenant referred to William as 'the Golden Palling' in a letter that highlights his house as a nexus of power that gave authority over others:

> The reason I did not come to your house last night was, a while ago you ask'd me several times to go to your house, and I did not go then. Tother day I swore over and over that I wou'd never go to your house till I had the money to bring with me.[68]

In this way, avoidance of Palling's house staved off the inevitability of paying money owed, although the tenant still associated the notion of obligation with the place of payment. Another tenant received notice that Palling would distrain his goods for failure to pay rent, unless 'you immediately wait on him'.[69] Such accounts emphasize not only the importance of the house as a point of contact, but also the personal nature of relations between gentlemen and those around them. It is this sense of physicality, simultaneously separate and close, that typified gentlemen's houses in particular.

Family and gender relations at Brownshill were also fraught with turmoil. After his mother's death, it fell to William to provide for the schooling of his two sisters, as well as doctor's visits and other care and upkeep, with the expenses paid 'out of their fortunes'.[70] This later proved contentious, as his sisters Sarah and Mary, and their respective husbands, brought a Chancery case against William. Amongst the claims they made was that William had kept Mary 'as a Meniall Servant and constantly employed by him in the lowest and most servile offices'.[71] For his part, William argued that Mary's husband was nothing but a fortune hunter eager to take her away from Brownshill. The family conflict indicated that polite behaviour was not necessarily the driving force for William's conduct.

Despite substantial wealth and investments in land, Palling made only intermittent efforts at gentility in his domestic affairs. Even in these classical arenas of politeness, older modes of interaction could carry on and overlap with newer polite

forms of sociability. A government report about Palling's activities provides an extraordinary description of his household and personal activities. In May 1758, a letter sent to the Excise Office in London noted that Palling had 'Conceal'd in his Dwelling House' a large quantity of guns, gunpowder and other weapons and was 'said to be a man of bad Principle, tho Vast Rich'.[72] The government evinced enough concern about this cache of weapons that they despatched a spy, Nathan Carrington, to investigate the report. Carrington found Palling, 'the greatest Oddity that ever existed', farming his own land about his House and keeping only three servants. Palling limited his social network, keeping 'no Gentlemen company', not even his brothers, with whom there was 'no great harmony'. Perhaps wary of unhappy tenants, when travelling 'to Gloucester or elsewhere on business, He always walks there with his Man Servant, who carries along with him a Brace of Pistolls, or a Blunderbuss, nay sometimes both'.[73] Carrington reported that whilst Palling 'drinks a great deal at particular times...when he has Company (which is never more than three at a time)' he amply provided for those he entertained, laying on 'two Legges of Mutton, two Rumps of Beef, and two large puddings or two large Apple Pies. And all sorts of Liquor in great plenty'. Palling's hospitality to a select few, however, did not extend to overnight stays, as 'He suffers Nobody to lie in his House, but himself, his Man and two Maids'. What was more, Palling clearly kept careful guard on his house and his belongings, 'even the Maids he does not trust with the Keyes of any of his Rooms (which are generally kept locked)'.[74]

On the pretence that he knew a distant Palling relation in Barbados, Carrington was invited into 'his Kitchen where he generally sits', an indication that the Kitchen, normally associated with service, could function as a space of sociability for at least some people of gentlemanly status.[75] Here Carrington noted 'a great Number of Arms for such a Place, and very clean and ranged in good Order' (Figure 7.2). Another guest on the occasion mentioned that Carrington, 'had not seen a Tenth Part of 'em, for that he had two or three Rooms above Stairs, which were as full as they could hold with all sorts of Arms and Ammunition', confirmation that indeed Palling had a huge store of weapons that adorned several rooms in his house and reinforced his reputation as a reclusive figure. Although Palling seems to have quite openly collected the arms, 'He and all his Family were always look'd upon, as very well affected to the present Establishment'. Carrington concluded that he could not say, 'How far it may be judg'd right for such a Number of arms and offensive Weapons to lie together'.[76]

Nothing seems to have been done about the collection. Carrington reported that Palling's house was, 'situated in a very retired Place in a Valley, and is Nothing better than a good Farm House'. But within two years, William Palling was at work constructing a substantial but old-fashioned classical dwelling.[77] What prompted this construction is unclear, but the new house provided ample storage for his weapons, and family accounts describe the rebuilding of the house and the display of arms into the nineteenth century.[78] William Palling's curious mix of classical architecture, provincial furnishing, arms collecting, and old-fashioned kitchen

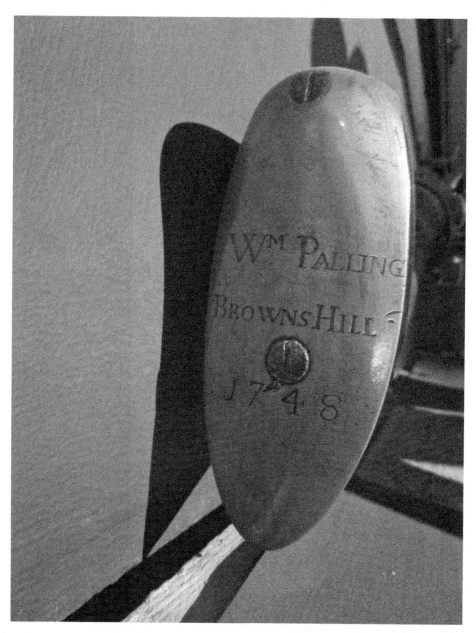

Figure 7.2 Stock plate from one of the firearms owned by William Palling
Source: Blunderbuss from the Wathen Collection at Museum in the Park, Stroud STGCM1987.356.

entertaining offer another complicated version of how gentlemen owners enacted status.

'The finest couple that has ever been seen'

Another gentleman-clothier offers a decidedly more aspirational view of the gentleman's house and its owner, a reminder that individual circumstances could differ substantially within the milieu of the small classical house. Not many miles distant from Brownshill Court, Onesiphorus Paul acquired the small estate of Hill House near Rodborough in 1757. It was clothiers like Paul that Defoe had in mind when he described as 'no extraordinary thing to have clothiers in that country worth from £10,000 to £40,000 a man, and many of the great families who now pass for gentry'.[79] Paul's social trajectory was steep, and he typified the rise 'from counting house to court house to gentleman'.[80] Like many other gentlemen after 1730, Paul actively engaged in the cloth trade, securing a patent for 'A method of preparing cloths intended to be dyed scarlet, so as more effectually to ground the said colors and preserve their beauty'.[81] In 1750 as a result of his success, Paul took breakfast with the Prince and Princess of Wales during their visit to Stroud.[82] About the time that he served as High Sheriff and was knighted in 1760, he constructed a gentleman's house in Rodborough, described as 'a beautiful villa or seat…situated on an eminence…with a pleasant prospect of the river'.[83] The timing of Paul's purchase suggests he was using a gentleman's residence as a way of certifying status, helped in his case by a baronetcy.

Not content only with building a house, Paul sought to convey his status in other ways. He left his wife, 'my best Chaise', suggesting the presence of more than one chaise.[84] He sent his son, who became Sir George Onesiphorus Paul, to Oxford and then on the grand tour. Accounts from the early 1770s show the expense Paul incurred for Hill House, as well as illustrating his son's somewhat profligate lifestyle. In 1769–1770, he provided his son an annual allowance of £1,000 per annum, and the following year he paid expenses for his London club, Boodles, of £4.4.0, his 'Taylor in full of all Demands 65.17.0' and 'Lost on the Turf' at Cirencester £11.11.0. By 1775, the Paul family's annual income was a substantial £2,107.17. There was £130 spent on a Townhouse, no doubt in London, and purchases of 'pictures' and 'plate' cost £140.5.0 and £190.2.0 respectively. 'Servants Wages' totalled £198.7.0, a considerable sum indicating a bevy of servants.

Playing the role of the gentleman could be a highly contested process. In 1762, for example, the London wit, George Augustus Selwyn, commented that 'Sir Onesiphorus Paul and his Lady are the finest couple that has ever been seen here since Bath was built. They have bespoke two whole-length pictures, which some time or another will divert us. His dress and manner are beyond my painting; however, they may come within Mr Gainsborough's'.[85] Selwyn's comment indicates a gentleman's efforts to portray himself socially and artistically as a fashionable member of society, but with limited success. After his father's death in September 1774, however, G. O. Paul became more careful with his expenditures,

settling into life as a leading member of the county, a J. P., and a prison reformer of national note.[86] After his death, the President of the Board of Trade remarked of G. O. Paul, 'I do not know any individual who gave me a better idea of a respectable English country gentleman'.[87] In the course of two generations, the Pauls had gone from clothiers to parvenus mocked by Selwyn to respectable country gents, along the way breakfasting with the Prince of Wales and building a gentleman's house for their enactments of status.

'A very Courteous & Elegant manner'

Many Atlantic world gentlemen built small classical houses near cities, which enabled them to enact status in similar ways. Genteel owners handsomely furnished their houses, where they combined personal and business affairs. Hospitality was a hallmark of gentlemen's houses in America as well, although the scale of entertaining varied. In Massachusetts, owners entertained smaller numbers of people than their counterparts in England or the southern colonies.[88] Virginia planters filled their houses with guests regularly. Nomini Hall in Virginia hosted dinners, suppers, dances and assemblies on numerous occasions.[89] In Pennsylvania, John Smith reported on frequent entertainments at Stenton, describing on one occasion how his family 'were treated in a very Courteous & Elegant manner'.[90] Stenton underpinned James Logan's political position in colonial affairs, and like many gentlemen's houses, its hierarchical segregation of space allowed it to function almost as a public building.

Intellectual as well as social, political and economic authority was on display at Stenton. For much of the eighteenth century, books were comparatively rare, even in houses of higher status, and interior spaces set aside for their storage and use were most often only found in larger country houses with greater room specialization.[91] Nevertheless, small classical house owners throughout the Atlantic world almost always possessed books. Occasionally these appeared in large numbers. By his death in 1751, Logan (Figure 7.3) owned 2,681 books valued at £900 Pennsylvania, certainly one of the largest and most scholarly libraries in North America. William Byrd's library at Westover rivaled Logan's in size if not quite in scholarship, Sir William Johnson collected actively, and Thomas Lee of Stratford Hall had a library worth over £260.[92] These libraries, however, are something of an exception that proved the rule. Logan's correspondence is filled with orders for books in many languages and discussions of the merits of particular editions and their ideas. Evincing an interest in Native American dialects, in 1711 he bought a Bible in Algonquin of which he complained, 'not one word agrees with any of our Indian'.[93] Logan conducted scientific experiments, produced an original essay on corn and, for his friend Isaac Norris of Fairhill, translated Cicero's essay on old age called *Cato Major*, printed by Benjamin Franklin (Figure 7.4).

Logan sought to display his knowledge actively, never more so than when a visitor came to Stenton. The library occupied the Yellow and Blue Lodging Rooms across the front of the house, which served as a grand library space also used for

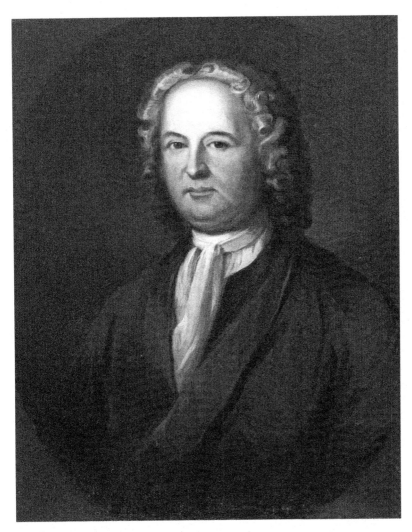

Figure 7.3 Portrait of James Logan, an 1831 copy by Thomas Sully after the original by Gustavus Hesselius, c. 1730
Source: Courtesy of the Library Company of Philadelphia.

sleeping and large scale entertaining. Franklin paid his first visit to Stenton in March 1732 to take James Logan's advice about the purchase of books for the incipient Library Company of Philadelphia. The young Franklin was impressed with Stenton and Logan, calling him 'a Gentleman of universal learning, and the best Judge of Books in these parts'.[94]

Another visitor, William Black, Secretary to Thomas Lee of Stratford Hall in Virginia, called at Stenton in 1744. Although more interested in Logan's pretty

M. T. CICERO's CATO MAJOR, OR HIS DISCOURSE OF OLD-AGE:

With Explanatory NOTES.

PHILADELPHIA:
Printed and Sold by B. FRANKLIN,
MDCCXLIV.

Figure 7.4 Title page of Cato Major, translated by James Logan and published by Benjamin Franklin
Source: Courtesy of the Library Company of Philadelphia.

daughter – 'I declare I burnt my lips more than once, being quite thoughtless of the warmness of my tea, entirely lost in contemplating her beauties' – Black also noted his genteel reception:

> After the tea table was removed we were going to take leave, but it appeared we must first view his library, which was customary with him to any persons of account. He had really a very fine collection of books, both ancient and modern.

After the library tour, Black remarked that, 'the old gentleman had been complimented on his fine taste'. Black called Stenton a 'beautiful house', and his knowledge of Stratford Hall and other Virginia houses gave him some claim to know.[95] After Logan died, Franklin recounted that Logan had, 'for the most part a life of business, tho' he was passionately fond of study'.[96] He actively collected books and exchanged letters with the great minds of Britain and Europe. In his intellectual accomplishments, administrative acumen, business success, and political guile, Logan defined himself as a member of the British Empire's governing class.

'Suitable to the fortune and dignity of a Nobleman'

Not all owners of small classical houses conformed to the picture of moderation presented in this study. Some indeed seemed to aspire to higher status. The specific tactics and strategies that opened this chapter were intended by the Clutterbucks to enhance their standing and exert their authority. Despite his small landed estate and privileged professional position, William Clutterbuck experienced a sense of the vulnerability endemic to middling families.[97] Clutterbuck looked both towards the cloth-producing areas in Gloucestershire – his maternal grandfather had been a clothier – and toward the port of Bristol, where he served as a prominent Customs official. Shortly after William's death in early 1728, his son Richard largely abandoned the professional and business worlds of Bristol to undertake the wholesale reconstruction of his father's house and his own identity. Whilst retaining his post as Searcher and the income that went with it, by 1731 Richard undertook an investment of real as well as emotional capital by building a new house at Frampton-on-Severn. Given the architecture of the house and the furnishings that Clutterbuck acquired, it is little surprise that in 1779 Samuel Rudder noted that Frampton Court was 'suitable to the fortune and dignity of a nobleman'.[98]

On the interior, Richard worked hard to create this sense. He acquired a set of Chinese armorial porcelain, the beautiful and useful hard-paste porcelain objects that carried English coats of arms (Figure 7.5). These pieces originated several thousand miles away in China, where between 1695 and 1820, artists turned out perhaps 6,000 sets of which 3,325 sets have been firmly identified.[99] At least two years were required between placing an order and receipt of the finished objects. Ownership of such material status symbols was highly unusual for gentlemen

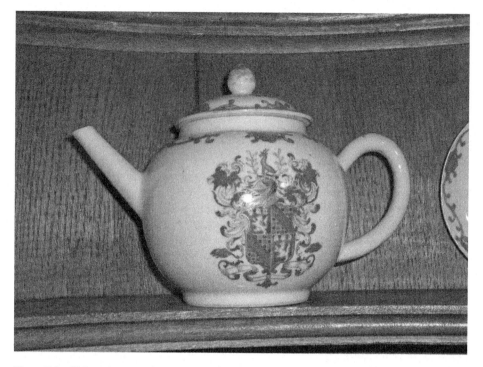

Figure 7.5 Chinese armorial teapot, c. 1750
Source: Author, courtesy of Mr and Mrs Rollo Clifford.

owners across the Atlantic world, and only a very few invested in sets of armorial porcelain. The Clutterbuck set probably dates from about 1750, just prior to the peak decade in the form's production, an indication that Richard was both indulging in as well as following fashion.[100] Sets of ceramics were not only about dining, but about show, housed in elaborate arch-top buffet cupboards, a typical feature in many Atlantic world gentlemen's houses, as well as adorning tables.[101] Chinese armorial porcelain was one of Richard Clutterbuck's dramatic and visible attempts to display and enhance his status.[102]

Entertainment at Frampton could be on a substantial scale, and Richard Clutterbuck spent generously but not extravagantly on food, drink, and material goods for Frampton Court. Over the mantel in the Hall a painting purchased in 1772, 'The Maid of the Mill', records a knowledge of fashionable opera. It is listed together with a 'Book of Architecture', an indication of a continued interest in building.[103] A 1741 portrait hung in the stair hall at Frampton Court reinforced Rudder's impression in a significant visual form (see Plate VIII). The portrait itself as well as its representation of what Richard wore and his personal objects offers subtle indicators of efforts to enact status. In his three-quarter length portrait, in contrast to the more sombre picture of his father that was also a fixture at

Frampton Court, Richard Clutterbuck is garbed in a handsome patterned red coat, his face slightly full but confident. His colourful and elaborately embroidered waistcoat highlights the white cuffs and ruffled cravat of his shirt. His right hand gently holds a pinchbeck-pommelled Malacca cane with mythological figures, which still survives in the Frampton Court collection. Pinchbeck, a brass alloy invented in the eighteenth century, was mixed to resemble gold closely, and it seems somewhat characteristic of Richard Clutterbuck to have chosen the flash without the cost.[104]

Such efforts at display, at once conspicuous and measured, said a great deal about Richard Clutterbuck's claim to status. Like most gentlemen-owners, his house combined old and new furnishings, materials, and modes of living. His elegant but provincial-styled house, handsome furnishings, remade landscape and decorative outbuildings all make this clear. One final account illustrates some of these themes. In 1773, Edmund Clutterbuck, a distant relation from Islington, Middlesex, paid a visit to Frampton-on-Severn, where he and his companions 'walked in the Gardens of Mr Richard Clutterbuck's mansion', especially admiring the Gothick greenhouse. Family ties, however, did not gain them entry into the mansion itself, as 'There happened to be company in the house on a visit, so it was not convenient for us to see the apartments'. As distant cousins, their access to the mansion was limited. They could however view Frampton Court, with its provincial mix of baroque and Palladian elements that Edmund Clutterbuck considered 'rather heavy, but has a magnificent appearance'.[105]

In enacting status, Richard Clutterbuck clearly sought to depart from his father's preoccupation with the business of the Bristol Custom house and set himself up as a country gentleman. A combination of fashion and tradition, economy and expenditure positioned him at the high end of gentlemanly owners but also reflected their particular ways of staking out their position in eighteenth-century society. Only on occasion did a figure like Richard Clutterbuck assert his personal sense of taste and style, impressing cousins and county historians with his effort to live like a nobleman.

Once a gentleman built a house, its space became the scene of constant, repeated, varied routines and activities that reinforced claims to gentility in many guises. Gentlemen's households included wives, sisters, sons, and daughters, as well as a handful of servants, a few of whom held special status. Gentlemen's houses were hubs for the community, playing important roles at the centre of local administration, economy, and society. In the spaces of these houses, men and women delineated their standing through actions that tied together material culture, domestic space and individuals. Gentlemen could employ objects to signify their taste and position, whether Thomas Goldney's fruit paintings, William Palling's arms, James Logan's books, or Richard Clutterbuck's pinchbeck cane. Some of these efforts demonstrated a concern with the polite: a hospitable reception with a silver tea table, the construction of a new more fashionable staircase to govern movement through a house, or the purchase of a set of fine china adorned with a family coat of arms. But politeness was not all that these houses were about.

Other actions demonstrated little regard for gentility, such as drunkenness in a kitchen or the alleged treatment of a sister like a menial servant.

Social status, however, was constructed in relation to others. It was dependent on internal and external evaluation, what the builders and owners considered their place in society and what others thought about hierarchy and rank in the seventeenth- and eighteenth-centuries.[106] The relationship of the genteel to those levels of hierarchy underscores the ways in which people who encountered these houses acknowledged owners and engaged with their display of status. The involvement of gentlemen builder-owners in local, regional, national, and imperial concerns uncovers how a 'modern-built house fit for a gentlemen' helped owners to articulate status precisely in the complex web of the British Atlantic world.

8
Social Strategies and Gentlemanly Networks

On the New York frontier, Sir William Johnson, the Irish-born colonial administrator and Superintendent of Indian Affairs, erected several gentlemen's houses in the middle of the eighteenth century. Although each was a compact classical box, they subtly illustrated Britain's colonial development. The first, Fort Johnson (1749), is a stone structure with a classical façade but irregular window arrangement on the back and sides, almost fortress-like in appearance (Figure 8.1). In 1763, Johnson constructed the clapboard Johnson Hall, a fifty-five foot by thirty-eight foot house with balanced facades and a striking Palladian window, a fashionable centrepiece for the massive estate he acquired during nearly twenty-five years of service in the colonies (Figure 8.2). In 1773, he gave his nephew, Guy Johnson, a piece of land where the following year the third small classical house, Guy Park, was erected.

Johnson's three gentlemen's houses in rural New York represented an imperializing project that illustrated the widespread networks that gentlemen developed throughout the Atlantic world. At Johnson Hall, as one memoir recounts, 'this singular man lived like a little sovereign; kept an excellent table for strangers and officers'.[1] On myriad occasions, Johnson hosted Native Americans on the grounds and in the hall, negotiating relations between the British Empire and their important allies, the Iroquois Confederacy. The balance Johnson Hall struck between civility and perceived barbarity did not suit everyone's tastes. Lord Adam Gordon noted that Johnson, 'has built a very comfortable house' that was 'generally crowded with Indians, mostly of the Five Nations, who are generally our friends when properly used'. Gordon stayed for some time, 'but no consideration should tempt me to lead his life – I suppose custom may in some degree have reconciled him to it, but I know of no other man equal to so disagreeable a Duty'.[2]

Gentlemen's houses provided centres of power that delineated their position within British society and beyond. Native American leaders and British lords could come together in the spaces of Johnson Hall, and it was connections like these that transformed houses and possessions into power and influence in the eighteenth-century British Atlantic world. Genteel families like the Johnsons operated within

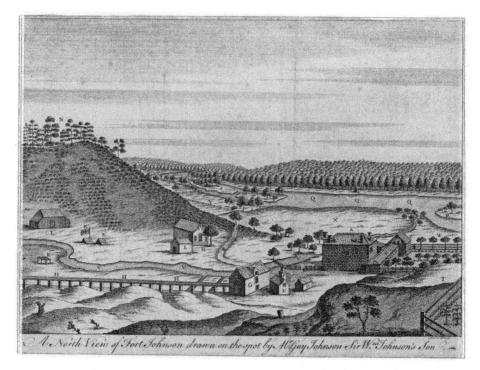

Figure 8.1 The rear elevation, outbuilding and landscape of Fort Johnson, New York, 1749, from the *Royal Magazine*, Oct 1759
Source: Courtesy of New York Public Library.

overlapping networks, from the domestic setting of their house, to local and regional communities, provincial urban centres, the capital of Britain's empire, London, and colonial borderlands. Efforts to construct and maintain relationships represented the outward manifestation of the gentleman's efforts to stake out position in the social order. These activities illustrate the role of gentlemen's houses in facilitating these networks.

This chapter re-constructs some of the networks within which genteel families operated. As outlined in chapter two, the owners of small classical houses hovered between the middle and upper reaches of society. Although they rarely held positions at the highest level of government, they regularly exercised authority at a regional or colonial level. Moreover, many gentlemen were deeply engaged in commercial, political, religious and knowledge networks throughout Britain and its colonies, and some moved back and forth between metropole and periphery. Considering various networks in which genteel builders and owners interacted amplifies the fine gradations of the eighteenth-century social order and offers guidance about the extent and process of movement into elite society.

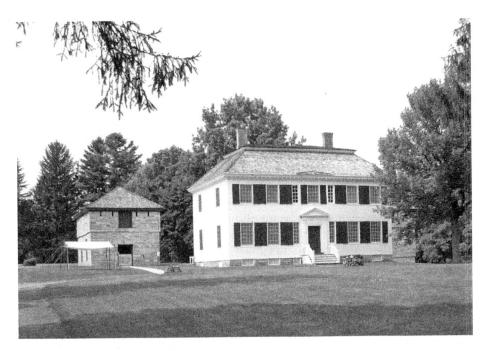

Figure 8.2 Johnson Hall, New York, 1763
Source: Author.

Actions and communications were strategic and well-planned. Although gentlemen without a small classical house could play a role in power networks, those with such a house were virtually certain to do so. A gentleman's house was a passport into the governing class, although it had its limits. Personal and kinship connections, professional affiliation, politics, religion, and economic interchange drew together upper middling sorts from provincial urban environments and gentry landholders in Britain and its North American colonies. From the 1720s, the entry of new men into the ranks of the genteel accelerated participation in elite networks. What emerges is an account of a social system where mobility was incremental, measured, contested and exclusive, but ultimately relatively open.

Gentlemen and the structure of society

To understand this process requires further consideration of the question posed earlier: what kind of owner did this type of house acquire? The material lives of gentlemen owners bring greater definition to social categories. Very little set the genteel off like their houses. A gentleman's house both constrained and elevated his ability to interact with others, served as a key factor in how

others perceived him, and governed how he interacted with social equals, inferiors and betters. In local settings this was especially the case, as the material object – the house – served as a constant physical reminder of the gentleman-owner.

A close cultural relationship developed between the gentry and commercial and professional elites throughout Britain in the eighteenth century, including in the West Riding of Yorkshire, north-east Lancashire, South Wales, the northeast, and the environs of London.[3] Nevertheless, the elusive relationship between upper middling and lesser landed society has continued to raise questions about how emulative behaviour was for newer or middling families and how much social mobility existed within British society. Before 1780, Richard Wilson argued, 'there was one ideal pattern of living, that manifested by the aristocracy', although historians who have examined the middling sort have highlighted efforts to stake out a separate and different mode of life from those above.[4] This study of gentlemen's houses argues that it is not necessary to see social identity as a case of either 'emulation' or 'differentiation'. The genteel owners considered here suggest the need to move beyond these models to examine status-building processes in more detailed and nuanced ways.

Gentlemen builders and owners held a complicated place in the social hierarchy, particularly related to the aristocracy. Great estates formed centres of gravity in the mother country, but by comparison with aristocratic seats, small classical houses were decidedly second-rate. At the Duke of Beaufort's seat at Badminton House, the five-bay Essex House served as a dowager house. In 1707, Charles Weston, descended from Shropshire gentry, built a house called the Chantry almost literally in the shadow of Berkeley Castle, an effort to confirm a degree of intimacy with a leading landed family.[5] With few exceptions, most gentlemen builders and owners did not have close intercourse with leading peers, largely because new men did not have established relationships with noble landowners.

Gentleman builders and owners therefore carved out social space for themselves in specific ways and specific places. The primary structure of local authority, the parish, served as the focal point for the 'middle sort' in seventeenth- and early-eighteenth-century provincial England.[6] The parish allowed a point of entry for the outsider from trade who might 'penetrate the "parish gentry", leaving it to later generations to advance to county or national level'.[7] This account of moving from parish to county gentry runs the risk of overstating the linearity of the process at the same time that it undersells the permeability of these categories. Certainly, gentlemen builders and owners often filled parish offices. Thomas Goldney, a Quaker no less, served as Churchwarden and on the Vestry for St Andrews Parish, Clifton, as did Paul Fisher of Clifton Hill House.[8] William Clutterbuck was deeply enmeshed in the selection of a new candidate for the living at Frampton-on-Severn, and his son Richard was credited with a major public works project, helping to drain the village green in Frampton-on-Severn.[9] But although gentlemanly life might be based in the parish, these involvements indicate a high degree of participation beyond its borders.

Gentlemen builder-owners frequently breached parochial borders by employing a genteel house to solidify claims to gentility. They stood on the rung of the social ladder that might be termed supra-parochial. In Gloucestershire, one in five identified owners served as a Justice of the Peace, nine served as High Sheriffs, and twelve were Members of Parliament. Militia rank served as an indicator of status for some: Captain William Clutterbuck, for instance, served under major landowner Colonel Colchester in a clearly delineated chain of command. The tone and content of William Champion's correspondence with 'Major Bragge', a key investor in the Warmley Company and owner of Cleve Hill, further signalled status arrangements.[10] Several gentlemen builders and owners held important roles in the Customs service, whilst a number of others had investments extending throughout the county and beyond, or were engaged in trade with contacts and networks in London and in Britain's colonies overseas.

Consideration of small classical houses destabilizes the distinction between 'parish gentry' and 'county gentry' and also between the gentry and new men of business and the professions.[11] Given their commercial involvements, professional service and engagement in politics, it would be inaccurate to reduce inhabitants of small classical houses to mere parish gentry. Gentlemen negotiated multiple locales, including the countryside, villages and provincial urban centres. The village was not the limit of a gentleman's horizons and it was provincial urban environments that defined the competitive social development of the middle ranks.[12] Social, religious, professional and business networks occasionally took gentlemen owners beyond the county boundaries to London and beyond the shores of the British Isles.

The inclusiveness of genteel society did not mean that hierarchy disappeared; far from it. The reality was that although there was commonality between upper middling and lesser landed elites, there was still, 'minute discrimination within the local elite itself'.[13] Architecture and material objects helped to construct social categories. Exploring the networks in which gentlemen operated provides a better understanding of how social processes unfolded.

New men and their networks: land, commerce, and professional service

Until the early-eighteenth century, small classical house owners mostly comprised landed gentry, and the networks that linked their houses were those of traditional landed society. After the 1720s, men whose income came from the professions, government service or commerce increasingly built small classical houses. This was an important moment. The eighteenth century was not only concerned with the possession of wealth, but how that wealth was obtained, invested, and displayed. In 1711, Jonathon Swift identified, 'a moneyed interest that might in time vie with the landed'.[14] Yet as late as 1814, Robert Southey, wrote that 'The commercial system has long been undermining the distinctions of rank in society. Mushrooms are everyday starting up from the dunghill

of trade'.[15] The figure of 'the wealthy Cit, grown old in trade' who 'now wishes for the rural shade' was the subject of considerable satire in the middle of the eighteenth century, and it would be easy to see some gentlemen owners fitting this image.[16]

Yet as Penelope Corfield pointed out, satirists directed most of their jibes at the vulgar displays of 'ultra-rich India "nabobs" and overseas merchants'.[17] These caricatures primarily mocked prosperous London merchants, and had limited significance when applied beyond the capital. Gentlemen builders and owners largely avoided such stigmatization, although figures like Sir Onesiphorus Paul occasionally came in for ridicule. Other merchants were criticized not so much for vulgar displays as for simple vulgarity. The 1742 edition of Defoe's *Tour* argued that merchants of Bristol 'tho' very rich, are not like the Merchants of London'.[18] Bristolians had 'inbib'd the Manners of those rough Gentleman' who frequented the city, like shipmasters, as result of which there was little gentility. In Philadelphia, a clear distinction existed between the majority of merchants and gentlemen.[19] Nevertheless, from the 1720s onward, most small classical house owners offered a counter-point to the idea of 'rough Gentlemen' and were examples of sobriety, responsibility, and modest taste.

For new men who built or acquired small classical houses in the eighteenth century, financial and business connections were particularly important in defining networks and delineating status. Bristolian gentlemen and the gentlemen-clothiers of the Stroudwater Valleys had closely intertwined connections within the county and beyond its borders. Contacts for gentlemen-clothiers ran a gamut of associations. Some gentleman clothiers, as Josiah Tucker noted, rose to great heights.[20] Onesiphorus Paul secured a patent for processing cloth that helped to make him exceedingly wealthy, and enabled him to send his son to Oxford, breakfast with the Prince of Wales, and take the waters at Bath.[21] But clothiers' contacts beyond the Stroud valleys rested primarily on correspondence with London cloth factors.[22] William Palling, as we have seen, despite being a rich clothier who built a gentleman's house, had few connections and lived a rather rough and reclusive life.

Networks evolved in several ways for gentlemen owners after about 1730, including their religious connections. The mercantile connections of Quakers particularly bound colonies and metropole.[23] Around Bristol and Philadelphia, members of the Society of Friends engaged in gentlemanly building after 1720. During the eighteenth century, religious dissenters became a more accepted part of society and prominent Quakers balanced their evolving religious convictions with economic and social success. Thomas Goldney II, whose parents had been devout members of the Society in the 1670s, strayed significantly from Quaker ideals.[24] Goldney built a handsome house, acquired many fine possessions, and invested in the Woodes Rogers privateering expedition of 1708–1711, an endeavour that provoked the disapprobation of the Meeting. He also spent time in prison as a result of troubles that arose from financial mismanagement in the Customs house. He bought expensive gifts in London, took a grand tour in the 1720s, kept a coach and horses and likely rebuilt Goldney House, which included a magnificent

panelled and carved mahogany parlour.[25] His son, Thomas Goldney III, lived a privileged, even opulent, life, indulging in an extravagant garden, handsome interiors, and beautiful furnishings.[26] Across Clifton Green, Thomas Goldney III's sister and brother-in-law, Martha and Nehemiah Champion, constructed a substantial building, Clifton Court, in the 1740s.

In the area of science and early industry, Quaker gentlemen engaged in mercantile activity that contributed to the wider, urban-dominated network of knowledge. The Goldneys and Champions were involved in Abraham Darby's innovative iron works at Coalbrookdale.[27] Soon after starting his Warmley Company works near Bristol, William Champion, the son of Nehemiah Champion, erected Warmley House on his estate, dominated on one side by a growing and impressive industrial concern and on the other by a garden featuring a grotto, echoing pool, lake and statue of Neptune.[28] The Harfords had substantial interest in iron production.[29] In Pennsylvania, James Logan invested in the Durham iron furnace in the 1720s, one of the earliest industrial concerns in the American colonies.[30] The Goldneys and Logan also had a strong scientific interest in botany and gardening, transatlantic connections that mixed business and the dissemination of knowledge.

In a similar way, business partnerships drew together mercantile elites and landed gentry, although within these arrangements hierarchy was evident. William Champion secured funding for his Warmley Company from Norborne Berkeley (latterly Lord Botetourt and governor of Virginia) and Charles Bragge of Cleve Hill. This somewhat unholy alliance between a Quaker commercial man and the staunch Tory Berkeley suggests that economics could trump politics and religion in the construction of networks. The company caused bad feelings within Champion's family and with fellow Quakers. In one meeting, Champion's cousin, who operated the rival Bristol Brass and Battery Company, 'was so very angry' that he could hardly contain himself, 'without being in a violent Passion, and behaving Ungentlemen like'.[31] With the company beset by funding problems, Berkeley intervened at the highest levels of government for the company, to little avail.[32] Although Champion's Warmley works lasted only a short time because of financial difficulties, their company correspondence richly documents the multi-layered mixture of business, social standing and politics.

Mercantile and professional networks collided in government offices, such as the Custom house in Bristol, a nexus for a web of merchants, professionals, and even landed gentry. A source of patronage and frequent corruption, the Customs service nevertheless accounted for up to 25 per cent of the British state's income in the period between 1700 and 1760.[33] Officials were compensated through a system of salaries and fees chargeable on the public purse, making employment in the Custom house a potentially lucrative place for a rising man.[34] John Elbridge, as Deputy Controller of the Port of Bristol, connected individuals from a broad spectrum of economic, political, religious and social backgrounds. Elbridge owned part of a large sugar plantation in Jamaica, had family in New England, served as a Justice of the Peace, and became a major benefactor in Bristol. His position put him at the centre of activities related to the port, although this role alone does not

necessarily explain his expansive network of contacts. In the Customs house and elsewhere, the apprenticeship system offered the opportunity to gain experience, develop contacts, and establish, or assert, social position. As Deputy Controller of the Customs, Elbridge took in numerous apprentices over the next three decades, ranging from the sons of minor landed gentry to the sons of butchers, distillers and ropemakers.[35]

One apprentice in John Elbridge's office was Richard Clutterbuck, the young son of William Clutterbuck, Searcher of the port of Bristol.[36] The relationship between the Clutterbucks and Elbridge demonstrate complex links between landed status, government office, and commercial money in Atlantic world ports. In seeking his own appointment as Searcher, William had expressed an awareness of carefully defined status, saying he had a 'friend in ye Treasury' but, 'I'm unwilling to trouble people of that Quality about such a trifle'.[37] By the early 1720s William, Searcher for nearly thirty years, was a wily operator with a detailed understanding of how to work the system. He had semi-retired to his country seat, Frampton Court, where his frequent instructions to his son, Richard, introduced a series of strategic manoeuvres and reveal the range of tactics he employed to sustain his family's position. The Clutterbucks cultivated a number of people in order to build status, including the influential Elbridge. William frequently reminded Richard of what might be said to Elbridge and what was best left unsaid, 'If you think best to say any thing to Mr Elbr. be sure say nothing to him how you know of it'.[38] He was also not beyond subterfuge in the conduct of his business dealings, as he noted in another missive to Richard, 'I have enclosed a letter for Mr El open, which (if you approve) you may seal with a wafer but not your owne seal that he may not suspect you have seene it'.[39] William frequently reinforced that every detail mattered in this game of commercial intrigue and social position: 'altho' it is but a small matter, yet 'twas ye saying of a wise man He that despises little things shall perish by little & little'.

Richard Clutterbuck eventually left Elbridge's employ to become deputy to his father at the Custom house in Bristol, and in 1724, Richard travelled to London to secure appointment as his father's successor as Searcher, the culmination of William's grand strategy. William was particularly keen to impart guidance on dealing with Charles Carkesse, the head of the Custom service. Encounters with this formidable figure required subtlety, and William's richly detailed draft, including phrases stricken out, offered precise instructions to manage the affair:

> if you have not already spoken with him your best way is to go in an afternoon, when you may speak with him in private or to his house soon after dinner & ask him whither your Patent should pass through his office or not, if he tells you it should then ask him his fee & ~~tell him~~ thank him for his last kindness to you ... & that now since you have ye Patent you must desire that he will ~~let you have your favour~~ give you leave to write to him when you have occasion & that he will please to oblige you with his Favour & then put 5 Guin[eas] in his hand & desire him to accept of that small present.[40]

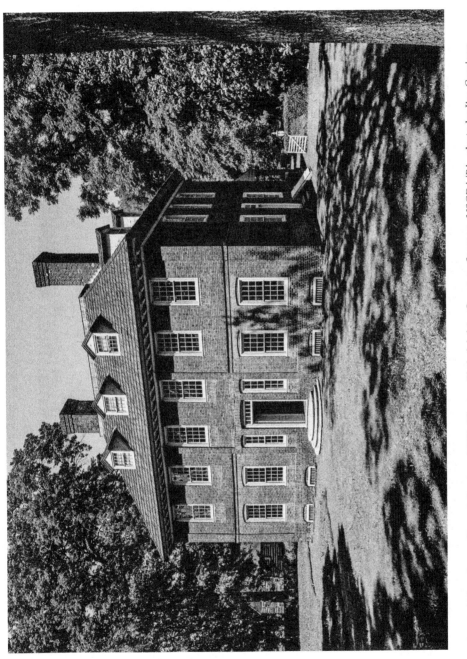

Plate 1 'A handsome House'. Stenton, 1723–30, near Philadelphia. Courtesy Stenton, NSCDA/PA, photo by Jim Garrison

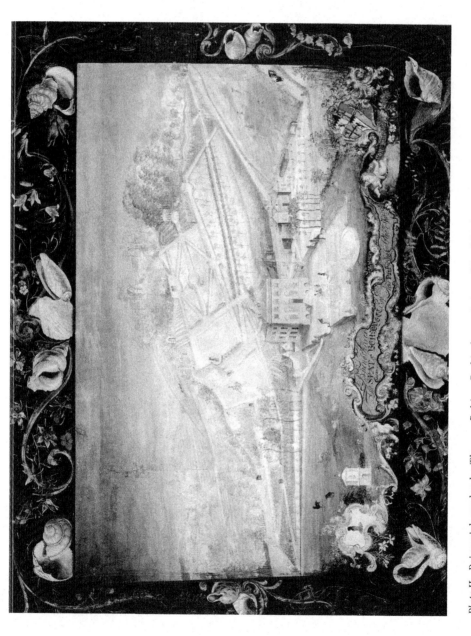

Plate II Painswick garden by Thomas Robins. By kind permission of Lord Dickinson

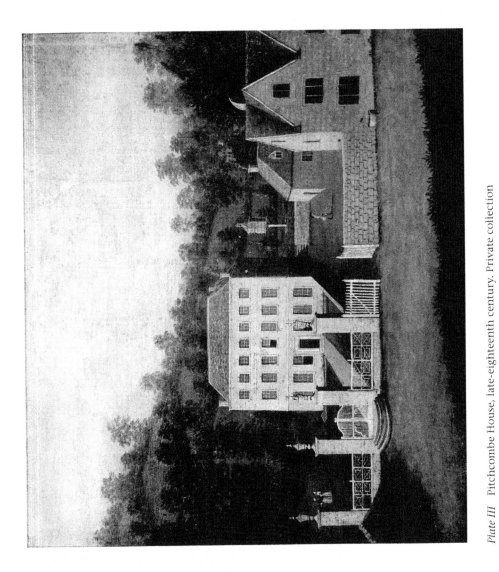

Plate III Pitchcombe House, late-eighteenth century. Private collection

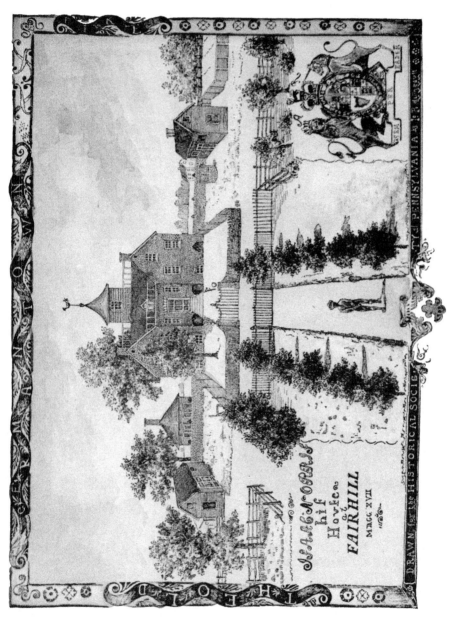

Plate IV Fairhill, Stenton, NSCDA/PA

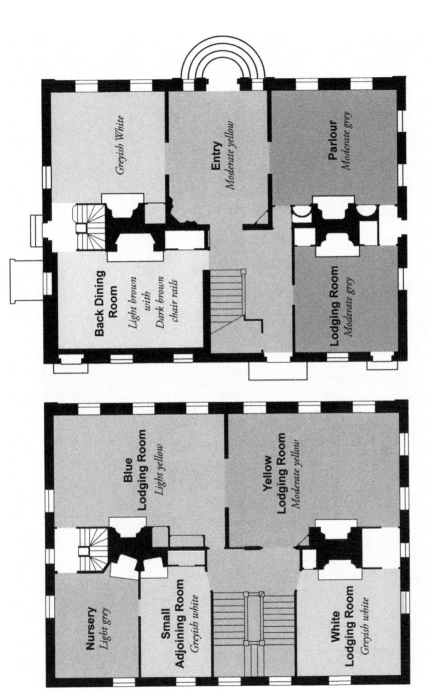

Plate V Stenton Floor Plan with first finish coat paint colours, c. 1730. Drawn by Mary Agnes Leonard

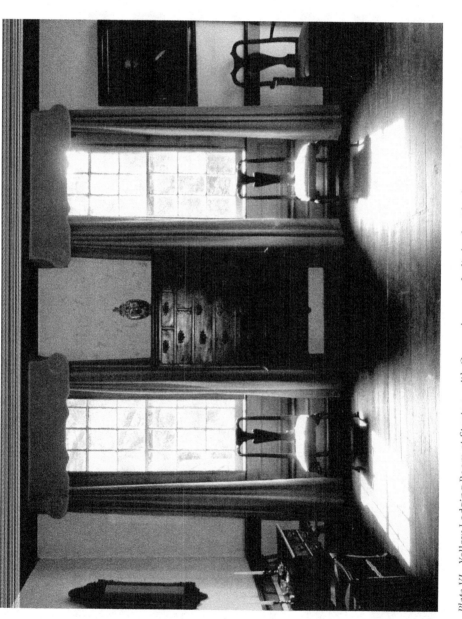

Plate VI Yellow Lodging Room at Stenton, with Queen Anne, or India-back, side chairs and Logan maple high chest (centre) and dressing table (left). Courtesy Stenton, NSCDA/PA, photo by Laura Keim

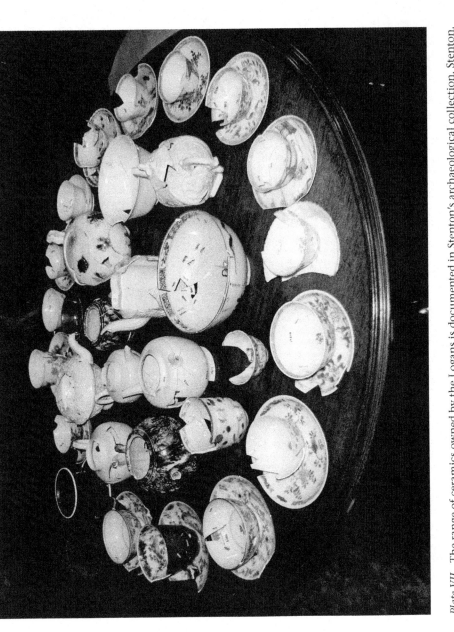

Plate VII The range of ceramics owned by the Logans is documented in Stenton's archaeological collection. Stenton, NSCDA/PA, photo by Laura Keim

Plate VIII Richard Clutterbuck, by Samuel Besly, 1741. Author, courtesy of Mr and Mrs Rollo Clifford

In an effort to assure status, William Clutterbuck weighed every word so as to convey the correct meaning and set the ideal scene for the transaction. It links location, timing, and action: Richard was to visit Mr Carkesse in the most propitious place at the most opportune time, probably at 'his house after dinner'; Carkesse was not to be told, but rather thanked; his favour was not to be demanded but given with leave; then he was to be given a 'small present' to ensure success.

Even after Richard had received the patent, William continued to devise ways of securing advantage, although his advice was less direct. In a draft of a proposed letter to be sent by Richard, William opened a letter to the Commissioners of Customs in London, 'Hon_d_. Sirs'. William noted, however, that, 'I know not whither this form or yours be best I mean Hon_r_ or Hoble but you know best how Mr El was wont to write & you had best to doe ye like'.[41] These few lines suggest the complexity and nuance of the relationship between father and son, between the Commissioners and their Customs agents, and between the powerful and influential former employer Elbridge and his clerk made good.

When Elbridge died in 1739, several members of his circle invested in his personal possessions sold at auction. Henry Bodman, Elbridge's trusted underling, acquired '1 Doz. Pewter plates' and a 'pair of brass candlesticks'. 'Mr Fane', likely attorney Thomas Fane, who acted as solicitor on behalf of Elbridge's executors, acquired a 'Silver knife fork spoon & case'. Gentleman's house owner John Andrews, a Quaker merchant who knew Elbridge, purchased a 'Horn tipt with Silver' for £1.[42] That John Andrews should purchase a small piece of John Elbridge's estate is a not surprising. Andrews and Elbridge were contemporaries who had widespread social and economic connections in Bristol and beyond. Elbridge was an Anglican colonial from New England with Bristol connections, while Andrews was a vintner and Quaker merchant. Despite these differences by the early-eighteenth century both were actively involved in the mercantile gentleman's world of Bristol. John Andrews played a pivotal role in civic and religious affairs and economic life. As early as 1706 he became one of the partners in Abraham Darby's Bristol Brass Works.[43] In addition, over the years Andrews served in various capacities in the Society of Friends, including Clerk of the Bristol Yearly Meeting in 1712, and was involved with the Pennsylvania mortgage in 1713.[44] Although a Quaker, he worked closely with John Elbridge.[45] Andrews followed Elbridge as Treasurer of the Bristol Royal Infirmary, one of the major initiatives that brought together members of the Church of England with non-conformists. Indeed, Andrews and Elbridge formed part of the small initial committee that met in December 1736 to discuss its organization.[46]

John Andrews's connections and trading networks included gentlemen in North America.[47] Utilizing his Quaker contacts not only in Bristol but with the colony of Pennsylvania, Andrews corresponded with James Logan, the influential proprietary representative. Their close relationship was based on shared business interests and personal connection. Logan relied on Andrews for shipments of wine, for handling some of his bills of exchange in Britain, and for offering credit assessments of potential business associates. One purveyor of the Stroud cloth

that was highly important in the North America Indian trade, Robert Eagles, was unknown to Logan, who wrote to Andrews, 'Pray favour me with some Accot of him'.[48] The interactions of gentlemen across the Atlantic reinforce the importance of honesty, worth, and credit arising from engagement in business activities and public affairs.[49]

The process of negotiating networks required gentlemen to be incredibly precise and calculated in their social communication. These networks enabled commercial and landed elites to interact in a number of ways, each participating in the governing class, but this did not mean that there were no impediments to social intercourse. Whereas the interface between these groups has been seen by some historians as a yawning gap and others as a zone of happy camaraderie, the reality was finely tuned in every detail.

Gentlemanly networks and public life

The political sphere was especially expressive of varying degrees of hierarchy. The metaphor of architecture in politics is a useful one; as Sir George O. Paul commented in relation to parliamentary reform, 'Before I begin to pull down my house, I will have fully considered and fixed on a plan for a new one'.[50] The building of houses was both a literal and figurative act that emphasized power that could be put into play in the political arena. The plain style of house adopted by numerous gentlemen across the Atlantic world stands in contrast to the far grander Palladian forms that prevailed in aristocratic Whig circles during the period especially between 1720 and 1760. If Houghton represented Whig oligarchs like Sir Robert Walpole – massive, expensive, and opulent – gentlemen's houses reflected an altogether more sober and industrious manifestation of architecture and politics.

In politics as in society, aristocratic and greater landed families dominated with the support and involvement of gentlemen. On the third and fourth tiers of the political world, gentlemen fulfilled key roles in the mechanisms of political life.[51] Despite infrequently standing for or being elected to Parliament, owners of small classical houses took an active interest in parliamentary affairs and played a role in parliamentary elections and national politics. Gentlemen owners did not drive the political machine, certainly at the county and national level. Instead they frequently exercised small nodes of 'interest', although they could influence those above them through the allocation of their opinions, support and votes.

The complex nature of politics and precise indications of standing within gentlemanly ranks are borne out by the correspondence of the Dutton family of Sherborne House, a substantial gentry seat.[52] In 1739, William Bell, Richard Clutterbuck's brother-in-law, asked Sir John Dutton, a leading Whig political figure, to serve as chairman of a newly formed Commission of Sewers and expressed his 'great pleasure' in 'the Whig Interest reviving'.[53] On at least two occasions, Dutton was warned to beware of Thomas Chamberlyne, owner of the five-bay Broadswell Manor, who had a foot in both Whig and Tory

camps.[54] The owner of another small classical house, James Lambe of Fairford Park, promised his support in the Whig interest.[55] Three gentlemen listed in 1733 as wielding political influence in Frampton-on-Severn included Richard Clutterbuck.[56]

It was natural for gentlemen to be canvassed for support during parliamentary elections. Quaker merchant John Andrews of Hill House near Bristol was prominent enough to be approached on behalf of Dutton in 1739.[57] Maynard Colchester, MP for Gloucester, asked William Clutterbuck's advice about political matters.[58] To Maynard's son, Henry, who looked to stand in 1717, William Clutterbuck wrote, 'ye Gentl (our sort of friends) are most inclined for you but they are unwilling to oppose ye Earl of B who is engaged for another Gentl'.[59] In 1720, Henry Berkeley, standing for one of the Gloucester seats, also asked for Clutterbuck's support.[60] As with many gentlemen looking to secure favour and position, William Clutterbuck exercised his influence to benefit himself and his family. In 1727 he wrote to Kinard De La Bere, MP for Gloucestershire, on behalf of his son-in-law, William Bell.[61] Nevertheless, regional politics could be highly problematic for a gentleman of Clutterbuck's position. Another intervention on Bell's behalf was, 'not very pleasing' to Lord Berkeley and Lord Ducie, leading aristocrats in the county.[62]

Power and influence could be exercised in different ways. Gift-giving remained an important form of social reproduction that helped to build and consolidate personal, political and business relationships.[63] To curry favour, William Clutterbuck often dispatched gifts to noteworthy neighbours. In response to some fish sent to Lord Ducie, Lady Ducie opened her letter of thanks with, 'My Lord loves salmon'.[64] William recognized the importance of gift-giving in lubricating the socio-economic gears of office-holding when he instructed Richard to provide a 'small present' when soliciting the post of Searcher at Bristol.[65] In turn, William received presents as well, such as the 'keg of sturgeon and two Sugar-loafs, tis a small present I desire you to accept of for your many favours I have received from you'.[66] Frequent exchanges of venison, salmon, fruit and other goods are noted between the Rookes and their aristocratic friends.[67] New men readily adopted this form of relationship-building. Clothier Daniel Packer regularly dispatched gifts such as cheeses to his factors in London, a custom followed after his death by his wife Mary.[68]

Many of the networks small classical house owners participated in were intertwined. In particular, the interplay of politics, religion, and business could be powerful. In response to a widow's request for him to serve as pallbearer for his 'good friend Mr Wintle', William Clutterbuck wrote that 'being informed that he is not to be interred according to ye Usage of ye xch of Engd...it may affect me in respect of my Office (for I never saw ye Act of Parlt) & therefore beg my Cozen to excuse me. I heartily sympathize with her'.[69] William Clutterbuck also conducted a long-running debate with a Dr Cradock about a new vicar at Frampton-on-Severn.[70] Cradock had written to William as 'the Chiefest Person of the place' and a 'Gentleman of Learning' to have his son appointed to the living. After a number of imploring letters, Clutterbuck had to write finally in exasperation, 'I humbly

desire that henceforwd you will not give your self ye trouble of writing anything more upon this subject, for my eyesight is not so good as yours or at least expect none from me'.[71]

Public affairs also saw gentlemen from both gentry and mercantile groups involved in charitable causes. Philanthropic leadership reinforced John Elbridge's social standing and transatlantic connections. Elbridge donated a brass chandelier and an oil portrait of himself to St Michael's church in Marblehead, Massachusetts where his sisters lived.[72] In Bristol, Elbridge established a charity school for impoverished young women and took a lead role in the provision of medical care for the poor of the city by helping to set up the Bristol Infirmary.[73] One minute book records that he covered, 'at his sole expense for all the Materials, workmanship linen and Furniture of the house, and fitting up and providing the medicine for the Apothecary's Shop' and continued to invest monies and paid for a new ward himself.[74] He was joined in this endeavour by a number of Bristolian gentlemen: Paul Fisher, John Andrews, Nehemiah Champion, and Thomas Goldney.[75] Richard Clutterbuck contributed twenty-one Guineas to become a Life Member of the Bristol Infirmary in 1751 and renovated the village green at Frampton-on-Severn.[76] In the 1770s, several gentlemen supported the Gloucester Infirmary.[77] William Harrington founded a hospital in Bourton on the Water. In Massachusetts, Isaac Royall, Jr gave £80 to a school in Charlestown in 1745 and left one hundred acres to support schools in Medford. Another 2,000 acres went to Harvard College, which was used to establish the Royall professorship of law.[78] At the end of his life, James Logan decided to give his magnificent library away, in order that others might enjoy its many scholarly fruits, a symbolic gesture intended to reaffirm his rank amongst the great and the good of colonial America. Logan's model in this was Thomas Bodley, benefactor of one of the world's great libraries, the Bodleian at the University of Oxford.[79] The performance of these sorts of public charitable functions reinforced that gentlemen owners played influential roles in both urban and rural affairs. This ability to negotiate multiple settings was one of their great strengths as a group.

Mercantile values and property rights

Despite the focus in this book on small classical houses, most genteel owners ultimately invested in property in some form. The ownership of land carried with it rights, responsibilities, and problems. Estate ownership presented a series of connections that both elevated status and challenged gentlemen. In 1767, William Whitmore had an acrimonious exchange through his friend and attorney Richard Jervis with John Dolphin, the new owner of Eyford House, who wrote to Jervis, 'He [Whitmore] has given so much Trouble, & seems so stiff'. Whitmore quickly retorted, 'In response to a Very Extraordinary letter of Mr Dolphin's which you showed me yesterday I desire you will please to acquaint him, as he has the character of a Gentleman I would not think him capable of breaking his word'.[80] Clothier and landowner William Palling of Brownshill did battle repeatedly with

tenants and neighbours. Land ownership was fraught with such headaches, and gentlemen often had to deal with them on a personal level.

Such problems were not restricted to landowning gentry or plantation owners, and new men and indeed women from commercial backgrounds became enmeshed in land ownership issues. Five years after John Elbridge's death, Cote came into the possession of Ann Hort, who went on to own the small classical house for nearly forty years.[81] As joint-inheritors of Elbridge's fortune, Mrs Hort and Elbridge's niece Rebecca Woolnough were together left responsible for administering the estates that were settled as part of his will. Until Rebecca died in 1761, they were two wealthy single women holding substantial property and functioning as prominent female players in the construction of social identity.

Affairs related to the estate demonstrate that the genteel status of wealthy widows did not always insulate them from legal and social challenges, sometimes from below. Thrust into the role of landowners, Ann Hort and Rebecca Woolnough encountered a range of difficulties. One dispute centred on a property they acquired from a locally noteworthy family that could not pay a mortgage held by Elbridge's estate. A great deal of wrangling ensued that involved local agents and people, other gentlemen, and even the Vicar. Their status as newcomers displacing long-standing, seemingly popular, and still prominent local landowners ensured that resentment was high and acceptance of their new status begrudging. Their instructions for the wholesale ejectment of tenants must have been highly disruptive, caused anxiety and anger amongst the rural populace, and undermined their standing in the area.[82] The conflict revolved around urban and rural values, local lineage, ancient ritual, the threat of the unknown, and distaste for something new.

For several decades, debate continued about the status of the new owners and their social responsibilities and obligations. The local inhabitants were clearly in a position to undermine the authority of the Woolnoughs and Mrs Hort, exploiting their knowledge of the local landscape in acts of resistance to owners that they might consider to be acting illegitimately. In 1747, seemingly in the absence of informal or moral authority, the new owners had to take measures to exert their formal control, circulating a series of notices against the illicit cutting of timber on their estates.[83] In 1749, Rebecca Woolnough received a letter from the vicar of Horsley church, claiming his right to four loads of firewood, imploring, 'That you would not debar me of that small addition to my small income, which I earn as hard as any labourer, the Duty being very great, and the clear value of my vicarage under 30L per Ann'. He followed this up a year later with a statement signed by three Witnesses saying that ministers of Horsley had always been entitled to firewood.[84] Responding with a lack of sympathy perhaps engendered by a decade of fierce struggle over estate issues, Rebecca Woolnough wrote her London solicitor for advice, arguing that, 'we were not obliged to let him have any', commenting that, 'You are sensible what great sufferers we are already'.[85]

It is not known whether the wood was granted or not, but such small but important rights and responsibilities did not go away and the uncertainty of local

status remained an issue. As late as 1776, another Vicar renewed the claim for the four loads of firewood, writing to the venerable Mrs Hort about it. Invoking the responsibilities of land ownership and the charity expected, the Vicar noted, 'The claim is trifling & insignificant to you – but important to me, the Living being so small'.[86] Although they could find no 'Deeds or papers we have that our Woods ever belong'd to the priory of Bruton, + therefore cannot admit yr Claim' Mrs Hort yielded to social and moral appeal of the Vicar, informing him that, 'from the Character we have of you + the living being small', they had decided to pay him, 'two Guineas upon New Years day, + we intend to continue the same'.[87] Nothing more is recorded from the Vicar, perhaps a suggestion that after a quarter century, local obligation had been fulfilled.

Imperializing projects

Gentlemanly builders often had widespread connections across the British Atlantic world. Imperial affairs attracted genteel owners, who provided much of the backbone for colonial administration and governance, and the empire offered provincial and colonial elites, 'a sense of belonging, identity and order'.[88] One of the earliest and most influential small classical houses was the governor's mansion in Williamsburg. Alexander Spotswood, appointed deputy governor in 1710, took up his post with the intention of exerting imperial authority. One way he accomplished this was in building campaigns around the colonial capital: the local college, the parish church, a debtor's prison and a magazine. The most symbolic project was the Governor's house, which stood as an empty shell when Spotswood arrived in Virginia. He moved to secure additional funding to complete the mansion, although his contentious approach cut across the grain of many planters. Like other gentlemen, Spotswood showed an inclination to display arms and armour, in this case an expression of government authority, and took up occupancy in 1715. The Governor's Palace and gardens were not wholly completed until the early 1720s, the wrangling to finish it a mixture of politics and architecture, with this small classical house at the centre.[89] By that time, Spotswood was actively engaged on his own private mansion on the Virginia frontier, again using architecture to impose control over local mining, manufacturing and frontier trade.[90]

The influence of American colonial governments and interests was limited at the highest levels in Britain, but foreign trade and merchants cared about America because American trade was particularly dynamic.[91] Merchants engaged in overseas trade in port cities – better organized and with good political contacts – demonstrated the most significant long-term interest in colonial American affairs, albeit with more influence over specific legislation than overall policy.[92] Isaac Royall, Sr, for example, lived for many years on Antigua and participated in the slave trade, sugar planting and rum distilling before removing to New England and building a gentleman's house.[93] Many other colonial gentlemen followed suit with their commercial involvements.

James Logan of Stenton maintained extensive transatlantic connections. Although Logan had once remarked that he was 'firmly resolved never to set

up a gentleman', and was prepared to, 'sit down and be content with ease and happiness instead of show and greatness', he made a fortune in the fur trade, invested in property, and built a substantial gentleman's house near Philadelphia that enabled him to play a leading role in colonial politics and administration.[94] Logan's ambivalent efforts to 'set up a gentleman' suggest a complicated, even confused, process of identity building. Many of his commercial contacts were in London, but Logan also maintained contacts with Bristol, where he had met Penn and where his brother lived. He actively corresponded with the city's Quaker merchant elite, including exchanges of botanical information with Thomas Goldney.[95] Extensive orders to Bristol merchant Nehemiah Champion of Clifton Court included nails for Logan's classical house, a large order for locks, 1,000 squares of window glass, and a clock jack for cooking, an indication that Logan in Philadelphia literally and figuratively looked to Champion in Bristol to build his status.[96]

Logan also participated in sophisticated knowledge networks in the Atlantic world. His brother was a prominent physician in Bristol and in September 1729, James wrote him that his wife had a mind to send their son, William, to England, being of the 'opinion that you may have better schools there'. Logan argued that, 'I am as capable to look after the education of my own children as any man that can be hired to it'. Nevertheless, his wife admonished him that as William, 'wants capacity so I may patience'. Indeed, James did not have high hopes for his son, 'I have given over all expectation of making any thing more of him than an honest farmer...for I have known many dull boys make ingenious and judicious men but the retentive power of memory after the mater is fix'd in it I think never improves'. In light of such sentiments, it is perhaps not surprising that when James asked his son, 'whether he would freely leave & venture on that voyage...he cheerfully answer'd Yes'. So in the end Sarah Logan won the argument, and Logan sent his young son off to Alexander Arscott's school in Bristol, writing soon after to Goldney, that if William, 'should happen to come in thy way if thou should [lent?] thy duty to him it would be obliging to a Parent who values himself on thy friendship'.[97]

The Logans remained tied to the metropole, at least insofar as education was concerned. Although arch Anglophobe Thomas Jefferson suggested in the 1780s that, 'England, once seen...as the only place to educate young gentlemen, now became the worst place to educate them for anything but careers of extravagance and vice', William Logan in turn sent his eldest son to Britain for his schooling.[98] When the eldest son died, his second son crossed the Atlantic on the eve of the American Revolution to study medicine and take the Grand Tour. For the Logans, success was still naturally measured in a transatlantic context.

The process of building empire and identity occurred in other small classical houses. Andrew Hamilton, owner of Bush Hill near Philadelphia, recorded an 'intercolonial network of civility' that linked together genteel families, and found expression in their house, possessions and behaviours.[99] At Johnson Hall, Sir William Johnson engaged in cross-cultural experiences in numerous gatherings with Native Americans, and a house filled with travellers, 'from all parts of America, from Europe, and from the West Indies'.[100]

The level of anxiety felt by colonial Americans trying to keep up with the mother country is a matter of debate.[101] For Americans, the uncertainty of status was typified by Logan, the self-described 'American bearskin merchant' who wielded considerable power in Pennsylvania from his seat at Stenton, but also wrote to the classical scholar Johann Albrecht Fabricius, 'from the wilds of Pennsylvania', and later told a London bookseller he was not to be put off 'as a common American'.[102] Strong ties between Britain and her colonies had developed over the course of a century. Colonials identified strongly with everything British.[103] Increasingly, however, colonial citizens saw themselves as a particular cast of Briton, the provincial Briton. This concept of Britishness came with a certain understanding about their place in imperial society, where colonials had close ties with other provincial parts and people of the empire. Participation in cultural and intellectual life encouraged provincials to assert their rights and privileges as British subjects, although they took considerable pains to assure, 'the mother country of their loyalty'.[104]

Ironically, some historians have identified the development of this closeness as a major cause of the American Revolution. Creole elites differed from their counterparts in Britain. In Maryland, for example, hard-headed and thrusting founders gave way to creole sons of more refinement and gentility, followed often by a third or fourth generation of pedestrian inheritors or dissolute wastrels. They developed a 'provincial consciousness' although they did not achieve cultural independence from the mother country.[105] Maryland elites did not do as much to retain their transatlantic connections as other colonial elites, such as the Quaker merchants of Pennsylvania. Maryland's 'provincial consciousness' was an outgrowth of a level of exclusion from the imperial gentry club, an important explanatory step on the way to 1775. Virginia planters, who came closer to the lifestyle of English landed gentry, also found themselves denied legitimacy and labelled as provincial upstarts.[106] The tension between old, landed society and new approaches to gentility that de-emphasized land and lineage, echoed trends seen in Britain. Virginians often found their transatlantic connections ineffectual in securing higher positions in the British Empire.[107]

Nevertheless, the claim that, 'English high culture remained the exclusive consecrating agency of taste and style for the colonial gentry', and that Britons evaluated provincial culture by whether it conformed to these standards confuses the relationship between the Virginia gentry (and colonial elites more generally) and genteel society Britain.[108] American elites continued to rely on models of British gentility and material fashion well after the Revolution, a point that reinforces that no matter how much colonial elites may have felt excluded from prevailing imperial power structures, they and their successors still shared a metropolitan view of what genteel standards were.

Although cracks began to emerge in the relationship between the American colonies and the mother country by the 1760s, colonial gentlemen continued to build in styles acceptable to genteel people around the British world. Small classical houses dotted the landscape around Philadelphia, Boston and other American ports, whilst Georgian mansions dominated the Virginia Tidewater and Piedmont,

as well as coastal South Carolina. All served as conduits for the expansion of British culture and authority. On one hand, some colonials became concerned about British consumer goods – the 'Baubles of Britain' – and their corrupting influence.[109] It is clear, however, that the construction of a small classical house facilitated participation in genteel networks right up until the break between Britain and America, and even after. By 1775, the gentlemen of Cantwell's Bridge, Delaware, 'felt obligated to construct worthy residences', confirming their participation in the transatlantic genteel world, whilst in Virginia, no specific political ideology attached to the mansions of planter elites.[110] The Revolution divided the occupants of western Massachusetts mansions, which had begun to appear in large numbers, as it did elsewhere.[111] Architecture was not a reliable guide to politics.

Unsurprisingly, one way to punish loyalists was to take away their Georgian mansion and goods. Thomas Hutchinson's house was the personification of the governor, with frustration taken out on his gentleman's house and furnishings.[112] Other Loyalists owners in America suffered similar fates. British troops commandeered Cliveden, the home of Benjamin Chew, and made it into a fortress during the Battle of Germantown in 1777. Colonial troops drove Sir John Johnson, William's son, from Johnson Hall in 1776 and the next year John Adams called the Johnson family, 'Rascals! They deserve Extermination'.[113] Whichever side owners of small classical houses ended up supporting does not detract from the fact that gentlemen's houses had functioned as agents of imperial power.

From the woods of rural Gloucestershire to the mills of the Stroudwater, in the halls of British Custom houses, and on the American frontier, owners of small classical houses grappled with status concerns at the same time they exerted their authority. The gentlemen described here built on household, local and regional power bases to extend their connections through commerce, kin and knowledge networks, government service, or politics. The on-the-ground experience for gentlemen builders and owners was often contested, but the interchange between mercantile worlds and the landed society was frequent and on-going. Across the Atlantic world participation in joint economic and political endeavours tied wealthier merchants with local landed gentry: provision of loans and mortgages, shared business interests, the burden of county and colonial administration, and knowledge exchange.[114] The precise strategies that gentlemen employed to negotiate their networks delineated the fine gradations of social status and identity. Social tension where it occurred was for the most part not the mockery of parvenus often portrayed but much subtler and more finely graded. The practical process of social mobility and the integration of commercial and landed elites can be sketched out through their common material choices and shared connections. A key factor in their ability to participate in these networks successfully was possession of a small classical house.

9
Conclusion

Eshott Hall, a local version of a five-bay gentleman's house, was probably built around 1700 twelve miles from Alnwick in Northumberland.[1] The Carr family had owned Eshott since the first part of the seventeenth century; the Georgia-born Thomas Carr, who had served as an army officer and Customs official, inherited the estate in 1770 and moved to England to take up his inheritance.[2] Despite his American roots, Carr had little trouble fitting into provincial society. Gregarious and outgoing, he served as a JP and was elected High Sheriff in 1778. But, constantly in need of money and recklessly extravagant, Carr became a living caricature of the dissolute gentry, including multiple wives around the Atlantic world.[3]

Carr's lawyer and confidante, Thomas Adams, footed many of the bills. Carr and Adams had a tumultuous relationship stretching back to the 1770s, soon after Carr arrived from America. Adams, a new man of the professions and business, became increasingly exasperated with Carr as time passed and debt mounted. As Adams wrote in 1791, 'since 1775 when my connections with him began I can scarcely be said to have enjoyed myself'. Adams further complained, 'his Character for Dissipation became such that no one would have any concern with him'. In the end, Adams felt that being 'soused over head and Ears in dirty Water by or with such a Gang of wicked People is rather too much'.[4] Heavily in debt, Carr changed his mind constantly about what to do about Eshott Hall, imploring Adams at one point, 'I wish to God you would (my Dear Friend) purchase it'.[5] That is what ultimately happened, as Carr sold the Eshott estate in 1792 to Adams for £34,000. After acquiring the estate, Adams made numerous improvements, but treated it more as an investment property, searching for a tenant who would take on this suitable 'mansion house...fit for a Gentleman'.[6]

The sale of Eshott Hall from landowner to lawyer was a striking metaphor for the transition of small classical houses and their owners described in this book. By 1780, the compact box had become a common, elegant, ordered form of dwelling prevalent across the social spectrum. The small classical house had established its staying power within propertied society. As Penelope Corfield points out, although the concept of the gentleman was more ambiguous by the

late-eighteenth century, that did not make 'the concept of gentility any less "real" or less culturally important'.[7] Small classical houses were a material form that signalled status in specific ways. They enabled gentlemen builders and owners to employ remarkably precise but flexible social strategies in a range of capacities, settings and venues whilst remaining above the all-important threshold of the genteel.

By considering 'modern-built houses, with four rooms on a floor, fit for a gentleman', this study has mined a particular type of house for what it says about social structure in the eighteenth-century British Atlantic world. I have tried to grapple with a series of questions: What can we learn about the melding of commercial and landed society in the eighteenth-century British world from a study of small classical houses? What type of owner did this particular form of house acquire? Where did owners of small classical houses stand in the social hierarchy? How possible was it for someone who made a respectable fortune in business to move into the governing class?

The small classical houses and their associated builders and owners considered here offer an alternative method for categorizing social groups and calibrating social status. Historians have focused their attention on other topics, seeking to define and evaluate larger country houses, restricting their gaze to the suburban villa, or investigating a particular social or economic group. Rather than examining occupation – such as merchant, lawyer or landowner – or wealth, I instead highlight ownership of a particular kind of object. Using a material culture analysis offers an opportunity to link social, cultural and architectural history. This study breaks new ground by incorporating furnishings into the broader picture of genteel architecture. Although politeness cannot be aligned with neat social boundaries, examining material objects helps to develop greater specificity about how social groups participated in the world of the polite.[8] An approach focused on houses presents a subtler, richer picture of social mobility in the eighteenth-century.

This book has maintained that the compact classical box has not been adequately examined, especially in Britain, making the utility of a study of this trans-Atlantic house form important and compelling. As Ned Landsman noted, during the eighteenth century colonial Americans became provincial Britons.[9] Very often the history of early America and eighteenth-century Britain have been treated separately, with the classical architecture of America considered as an appendage or afterthought of important architectural developments in the mother country. I suggest that gentlemen's houses in provincial Britain and colonial America share many similarities, in terms of architecture, material goods, and the social and cultural life that they enabled. Because Georgian mansions have been preserved, documented, and studied in greater detail in America, the rich vein of evidence available for these houses there sheds significant light on the British condition. For an important level of Anglo-American society, the small classical house represented a universally accepted symbol of gentility, offering an entry into the British governing class.

This reading of small classical houses in the British Atlantic world yields several key findings. In the late seventeenth and eighteenth centuries, small classical

houses served as primary sites of social change and transformation of the upper reaches of society. Before the 1720s, their builders and owners were most often already members of the landed elite, and these 'gentry houses' constituted a somewhat innovative choice by an established group of elite owners. In the second quarter of the eighteenth century, however, building status shifted dramatically. From about 1730, small classical houses began to acquire owners who reflected more diverse patterns of wealth accumulation, including substantial funds from professions, government service, and trade. Two important transitions accompanied this chronological turning point. The first was a geographic reorientation that saw these houses increasingly built near commercial centres and provincial and colonial port cities. The second was a peak of building activity, with a significant increase in the number of gentlemen's houses built between the 1720s and 1750s when far fewer larger country houses were under construction. Often erected later in the life of their builders, gentlemen's houses were not the cause of social mobility, but a near certain indicator that social mobility had occurred.

This transition signalled a cultural change that recast smaller classical houses from a new fashion in architecture to a socially-safe, conventional choice attractive to newcomers from non-landed backgrounds. Gentlemen's houses were a distinctive form that enabled builders and owners to confirm their gentility. The five-bay compact box simultaneously displayed characteristics of conservatism and change that echoed the restrained dynamism of their builders and owners. These houses combined fashionable and vernacular design elements, and offered simple but flexible floor plans that allowed for differentiated space and considerable sociability. Moreover, they were relatively cost-effective to build, furnish and maintain, emphasizing their propriety for genteel households looking to confirm their status without exorbitant expenditure. Moving from a new form adopted by established elite families to a more traditional form employed by new men, gentlemen's houses confirmed status. Emphasizing the *confirmational* over the *aspirational* nature of these houses recasts our view of gentlemen and their social status. In this way, a house such as Frampton Court, with a thrusting owner like Richard Clutterbuck, becomes the exception that proves the rule. John Elbridge and his 'house over the Down' near Bristol, or James Logan's 'handsome house' at Stenton, both acquired toward the end of a lifetime of dedicated labour, better represent the way small classical houses confirmed the position of their owners.

The construction of small classical houses projected status in urban, suburban, and rural settings for both landed and non-landed elites. The compact, classical box was a successful form because of its flexibility, enabling it to function as a small country house or an occasional villa, but most often as a 'house in the country' that mixed a rural setting with proximity to a city or town. Their gardens and landscapes frequently combined aesthetics with practicality, as seen most starkly at houses like Warmley, where William Champion's gentleman's house and pleasure garden stood contiguous to his manufacturing complex. Gentlemen's houses without estates served as important markers of status. They did not challenge or undermine the primacy of landholding but offered an alternate route

into the ruling elite. Indeed, a decisive factor increasingly became the possession of a house appropriate to status as gentlemen, rather than the amount of land per se. Possession of land remained important, but this house form indicates that acquisition of a large country house and estate was not necessary for an owner to play a significant role in polite society and its power networks. A smaller gentlemanly house would do.

Once constructed, gentlemen's houses were a forum for the display and enactment of status, functions governed by the floor plan, room use, and furnishings. Too often treated separately, understanding the careful coding of interiors and objects makes clear how genteel households fashioned power and status.[10] By comparison with middling homes, gentlemen's houses were lavishly furnished in terms of the number, cost, and quality of their possessions. Gentlemen did not for the most part, and in most cases could not, seek to emulate the aristocracy. More frequently, they decorated their houses and acquired goods that combined display with restraint, only occasionally purchasing objects like those higher up the social scale.

Throughout the British Atlantic world, gentlemen's houses functioned similarly. Colonial Americans made efforts to accommodate their enhanced position in the American colonies by creating an elite culture suited to their environment, but a view toward Britain played a critical role in shaping this elite formation. Even the cataclysmic event of the American Revolution did not undermine the notion that colonial elites shared a common culture with genteel society in Britain. As Cary Carson has noted, 'Independence involved no repudiation of the values that both Britons and Americans shared'.[11] Not long after the Revolution ended, genteel Americans made voyages back across the Atlantic to be inspired by architectural ties and consumer goods.[12] As Kariann Yokota has recently demonstrated, 'unbecoming British' was a long and complicated process.[13] For Americans and provincial Britons alike, the small classical house was a piercing cultural symbol.

By exploring material culture, this study has aimed to develop a more complete account of the social borderland between the middling sort and lesser landed elites in the British Atlantic world. This social stratum, discussed so effectively by Amanda Vickery in *The Gentleman's Daughter*, has largely defied further exploration.[14] As I have tried to demonstrate, small classical houses – the architecture of choice for many of this group – were a material form that enabled genteel builders and owners to employ remarkably precise but flexible social strategies in a range of capacities, settings and venues whilst remaining above the all-important threshold of the genteel. Their involvement in local and county affairs was extensive, and their networks frequently took them beyond the county or colonial boundaries to London and the British empire.

By the late-eighteenth century, relations between the lesser gentry and commercial families had become commonplace.[15] Using one type of house as a bellwether suggests that the decades following the 1720s were a period of social transition that saw the ties between these levels of society widen and deepen. Stone and Stone rightly pointed out that few gentlemen went from trade and commerce to large country house.[16] By looking at the smaller but still polite houses they

neglected, this book offers a revised narrative of social mobility in the eighteenth century, outlining how it took place, and charting a more convincing process. Rather than being linear and flashy – new men buying estates and building large houses – social mobility was most often cloaked in restrained garb.[17] New men in particular were conservative in their efforts. Gentlemen's houses adhered to a uniform type and plan, simple and straightforward in their architecture, spatial arrangement, and interior decoration. Gentlemen builders and owners combined fashionable furnishings with older objects, and spent considerable but not colossal sums on their material goods, generally acquiring a handful of high status objects that enabled them to display polite taste and engage in genteel sociability. On the whole they sought neither emulation of the aristocracy nor differentiation. Instead through their choices about housing and material goods they staked out a specific place in the social hierarchy. It is perhaps too much to argue that the lessons from small classical houses are a universal story in the eighteenth century. Nevertheless, they are indicative of a wider social phenomenon. Building and furnishing a gentleman's house marked absolute entry into the governing class in a way that was comfortable for many ranks of British society. This was the realistic character of social mobility in action.

This form of architecture highlights the slow, incremental nature of social change. Building status was therefore a step by step process taken by those whose lives reflected a conjunction of wealth, age, position, inclination, and taste. The gentleman's house in the British Atlantic world represented one of the largest and most significant of those steps taken during a lifetime. Exploring these structures has teased out James Logan's notion of what 'building too fine' meant. It has helped to make more sense of the sales advert for William Townsend's Paradise, explaining why a house with four rooms to a floor was fit for a gentleman, and how a small estate producing only £35 per annum could still suit someone whose income derived from other sources. It has demonstrated how such a house might be furnished, and the specific character of objects that conveyed meaning. What is more, the approach has put objects into action to show how gentlemen's houses were used, reconstructing the networks in which gentlemanly builders and owners participated and which precisely delineated their status. In the final estimation, this study has utilized material culture to re-evaluate social categories and enhance our understanding of an important segment of eighteenth-century British society. These overlooked gentlemen's houses illustrated the permeability of social and cultural boundaries in Britain and its colonies, and embodied many of the processes that enabled the British world's dramatic growth and prosperity in the eighteenth century.

Notes

1 Introduction

1. *Gloucester Journal*, 11 February 1755.
2. N. Cooper, *The Houses of the Gentry, 1480–1680* (London and New Haven, 1999), 244; G. Worsley, *Classical Architecture in Britain: The Heroic Age* (New Haven and London, 1995). Cooper calls rectangular, hipped-roof houses for the gentry 'ubiquitous' by the end of the seventeenth century.
3. C. Woodward, 'Castle Godwyn', *Country Life* (27 September 2007), 130–135, at 131. The house became known as Castle Godwyn in the later eighteenth century; D. Verey and A. Brooks, *The Buildings of England: Gloucestershire I: The Cotswolds* (London, 2002), 555.
4. J. Milne and T. Mowl, *Castle Godwyn: A Guide and an Architectural History* (Painswick, 1996), 6–7 suggests mason John Bryan. Dan Cruikshank posits architect John Strahan in Woodward, 'Castle Godwyn', *Country Life* (27 September 2007), 132.
5. Detailed analysis of Stenton's construction is in R. Engle, 'Historic Structure Report: Stenton' [hereafter HSR] (Unpublished MS for The NSCDA/PA, 1982).
6. F. Tolles, *James Logan and the Culture of Provincial America* (Boston, 1957). For a discussion of the word genteel and its associations, see R. L. Bushman, *The Refinement of America: Persons, Houses, Cities* (New York, 1992), 61–63.
7. For example P. Langford, *A Polite and Commercial People: England 1727–1783* (Oxford, 1989) emphasizes change and the middle class. J. C. D. Clark, *English Society 1660–1832: Religion, Ideology and Politics during the Ancien Régime* (Cambridge, 2000) advocates seeing Britain as an *ancien regime* confessional state with emphasis on aristocratic rule.
8. J. Summerson, *Architecture in Britain, 1530–1830* (New Haven, ninth edition, 1993), passim; Worsley, *Classical Architecture in Britain*, 10–12, 29–31, 169–173; Cooper, *Houses of the Gentry*; For North America, H. Morrison, *Early American Architecture* (Oxford, 1952); J. Deetz, *In Small Things Forgotten: An Archaeology of Early American Life* (New York, expanded and revised 1996), 156–158.
9. James Logan to Thomas Story, 9 November 1721, James Logan Letterbook, HSP, 209, quoted in Stenton HSR, 8.
10. W. Whyte, 'How Do Buildings Mean? Some Issues of Interpretation in the History of Architecture', *History and Theory*, 45 (May 2006), 153–177.
11. L. Stone and J. F. Stone, *An Open Elite? England 1540–1880* (Oxford, 1984).
12. E. Spring and D. Spring, 'The English Landed Elite, 1540–1879: A Review', *Albion: A Quarterly Journal Concerned with British Studies*, vol. 17, no. 2 (Summer 1985), 149–166, especially 151.
13. M. Girouard, *Life in the English Country House: A Social and Architectural History* (New Haven and London, 1978); J. Summerson, 'The Classical Country House in 18th Century England', in *The Unromantic Castle and Other Essays* (London, 1990), 79–120; H. Clemenson, *English Country Houses and Landed Estates* (London, 1982); C. Saumarez Smith, 'Supply and Demand in English Country House Building, 1660–1740', *The Oxford Art Journal*, vol. 11, no. 2 (1988); C. Christie, *The British Country House in the Eighteenth Century* (Manchester, 2000); D. Arnold, *The Georgian Country House: Architecture, Landscape and Society* (Stroud, 2003); R. Wilson and A. Mackley, *Creating Paradise: The Building of the English Country House, 1660–1880* (London, 2000).

14. P. Guillery, *The Small House in Eighteenth-Century London* (New Haven and London, 2004), 10; R. J. Lawrence, 'Integrating Architectural, Social and Housing History', *Urban History*, vol. 19, no. 1 (1992), 39–63; R. Stewart, *The Town House in Georgian London* (London and New Haven, 2009); B. Arciszewska and E. McKellar, (eds), *Articulating British Classicism: New Approaches to Eighteenth-Century Architecture* (Aldershot, 2004).
15. P. Borsay, 'Why Are Houses Interesting?', *Urban History*, vol. 34, no. 2 (2007), 338–346, at 346.
16. K. Harvey, (ed.), *History and Material Culture: A Student's Guide to Approaching Alternative Sources* (London, 2009); B. L. Herman, *Town House: Architecture and Material Life in the Early American City, 1780–1830* (Chapel Hill, NC, 2005); D. Hicks and M. C. Beaudry, (eds), *The Oxford Handbook of Material Culture Studies* (Oxford, 2010); R. Blair St George, (ed.), *Material Life in America, 1600–1860* (Boston, 1988).
17. A. Vickery, *The Gentleman's Daughter: Women's Lives in Georgian England* (New Haven and London, 1998); H. F. French, '"Ingenious and Learned Gentlemen": Social Perceptions and Self-fashioning among Parish Elites in Essex, 1680–1740', *Social History*, vol. 25, no. 1 (January 2000), 44–66; R. G. Wilson, *Gentlemen Merchants: The Merchant Community in Leeds, 1700–1830* (Manchester, 1971); T. M. Devine, *The Tobacco Lords: A Study of the Tobacco Merchants of Glasgow and their Trading Activities, c. 1740–90* (Edinburgh, 1975); P. Jenkins, *The Making of a Ruling Class: The Glamorgan Gentry 1640–1790* (Cambridge, 1983); Susan Whyman, *Sociability and Power in Late-Stuart England: The Cultural Worlds of the Verneys 1660–1720* (Oxford, 1999).
18. E. McKellar, *The Birth of Modern London: The Development and Design of the City, 1660–1720* (Manchester, 1999), 3. R. W. Brunskill, *Vernacular Architecture: An Illustrated Handbook* (London, 2000), 27–30; A. Green, 'The Polite Threshold in Seventeenth- and Eighteenth-Century Britain', *Vernacular Architecture*, vol. 41 (2010), 1–9. M. Johnson, *English Houses 1300–1800: Vernacular Architecture, Social Life* (Harlow, 2010), chapter 8. On politeness more generally, see L. E. Klein, 'Politeness and the Interpretation of the British Eighteenth Century', *The Historical Journal*, vol. 45, no. 4 (December 2002), 869–898, 870; P. Langford, 'The Uses of Eighteenth-Century Politeness', *Transactions of the Royal Historical Society*, vol. 12 (2002), 311–331.
19. On landed society, see G. E. Mingay, *English Landed Society in the Eighteenth Century* (London, 1963) and *The Gentry: The Rise and Fall of a Ruling Class* (London, 1976); J. Cannon, *Aristocratic Century: The Peerage of Eighteenth-Century England* (Cambridge, 1984); J. Rosenheim, *The Emergence of a Ruling Order: English Landed Society 1650–1750* (London, 1998). 'The 'Middling Sort' are Well-Covered', in J. Barry and C. Brooks, (eds), *The Middling Sort of People: Culture, Society and Politics in England, 1550–1800* (Basingstoke, 1994), M. R. Hunt, *The Middling Sort: Commerce, Gender and the Family in England, 1680–1780* (Berkeley, CA and London, 1996); H. R. French, *The Middle Sort of People in Provincial England 1600–1750* (Oxford, 2007).
20. Vickery, *The Gentleman's Daughter*, 14; J. Flavell, *When London Was Capital of America* (New Haven and London, 2010); N. Landsman, *From Colonials to Provincials: American Thought and Culture 1680–1760* (Cornell, 1997); S. Conway, 'From Fellow-Nationals to Foreigners: British Perceptions of the Americans, circa 1739–1783', *The William and Mary Quarterly*, third series, vol. 59, no. 1 (January 2002), 65–100.
21. Langford, *A Polite and Commercial People*, 76.
22. The subject of social status has preoccupied British historians of the long eighteenth century but has been largely absent in accounts of early America. K. Wrightson, 'Class', in D. Armitage and M. J. Braddick, (eds), *The British Atlantic World, 1500–1800* (Basingstoke, 2002), 304–305; S. Middleton and B. G. Smith, (eds), *Class Matters: Early North America and the Atlantic World* (Philadelphia, 2008).
23. C. Carson, 'The Consumer Revolution in Colonial America: Why Demand?' in C. Carson, R. Hoffman, and P. J. Albert, *Of Consuming Interest: The Style of Life in the Eighteenth Century* (Charlottesville, 1994), 483–697, 687. See also C. D. Hemphill, 'Manners and Class in the Revolutionary Era: A Transatlantic Comparison', *William and Mary Quarterly*, vol. 63, no. 2 (April 2006), 345–372.

24. Wilson and Mackley, *Creating Paradise*; J. Stobart, 'Gentlemen and Shopkeepers: Supplying the Country House in Eighteenth-Century England', *Economic History Review*, vol. 64, no. 3 (2011), 885–904, 899. On consumption, see J. White, 'A World of Goods? The Consumption Turn and Eighteenth-Century British History', *Cultural and Social History*, vol. 3 (2006), 93–104; N. McKendrick, J. Brewer, and J. H. Plumb, *The Birth of Consumer Society: The Commercialization of Eighteenth-Century England* (London, 1982); J. Brewer and R. Porter, (eds), *Consumption and the World of Goods* (London, 1993); A. Bermingham and J. Brewer, (eds), *The Consumption of Culture 1600–1800: Image, Object, Text* (London, 1995); C. Shammas, *The Pre-industrial Consumer in England and America* (Oxford, 1990); L. Weatherill, *Consumer Behaviour and Material Culture 1660–1760* (London,, second edition, 1996).
25. T. H. Breen, 'An Empire of Goods: The Anglicization of Colonial America, 1690–1776', *Journal of British Studies*, vol. 25, no. 4 (1986), 467–499.
26. A. Vickery and J. Styles, (eds), *Gender, Taste and Material Culture in Britain and North America 1700–1830* (New Haven and London, 2006); Special issue on Georgian interiors in *Journal of Design History*, vol. 20, no. 4 (Winter 2007); H. Barker and E. Chalus, *Gender in Eighteenth-Century England: Roles, Representations and Responsibilities* (London, 1997); A. Vickery, *The Gentleman's Daughter* and *Behind Closed Doors: At Home in Georgian England* (New Haven and London, 2009); N. Tadmor, *Family and Friends in Eighteenth-Century England: Household, Kinship and Patronage* (Cambridge, 2000); A. Flather, *Gender and Space in Early Modern England* (Woodbridge, 2007); J. Lewis, 'When a House Is not a Home: Elite English Women and the Eighteenth-Century Country House', *Journal of British Studies*, vol. 48 (April 2009), 336–363.
27. N. Tadmor, 'The Concept of the Household-Family in Eighteenth-Century England', *Past and Present*, vol. 151, no. 1 (May 1996), 111–140; K. Harvey, *The Little Republic: Masculinity and Domestic Authority in Eighteenth-Century Britain* (Oxford, 2012), 12–13.
28. Flather, *Gender and Space*, especially chapter 2. Vickery, *Behind Closed Doors*.
29. Harvey, *The Little Republic*. M. Finn, 'Men's Things: Masculine Possession in the Consumer Revolution', *Social History*, vol. 25, no. 2 (May 2000), 133–155; K. Harvey and A. Shepard, 'What Have Historians Done with Masculinity? Reflections on Five Centuries of British History, circa 1500–1950', *The Journal of British Studies*, vol. 44, no. 2 (2005), 274–280; K. Harvey, 'Men Making Home: Masculinity and Domesticity in Eighteenth-Century Britain', *Gender and History*, vol. 21, no. 3 (November 2009), 520–540; H. French and M. Rothery, *Man's Estate: Landed Gentry Masculinities 1660–1900* (Oxford, 2012), especially chapter 4.
30. Worsley, *Classical Architecture in Britain*, 169–173; D. Reiff, *Small Georgian Houses in England and Virginia: Origins and Development through the 1750s* (London, 1986); B. B. Mooney, *Prodigy Houses of Virginia: Architecture and the Native Elite* (Charlottesville, VA, 2008).
31. S. G. Hague, 'Historiography and the Gentleman's House in the British Atlantic World', in O. Horsfall Turner, (ed.), *'The Mirror of Great Britain': National Identity in Seventeenth-Century British Architecture* (Reading, 2012), 233–259.
32. Worsley, *Classical Architecture in Britain*, 170.
33. G. Hood, *The Governor's Palace in Williamsburg: A Cultural Study* (Chapel Hill, NC, 1991), 42.
34. C. Carson and C. R. Lounsbury, (eds), *The Chesapeake House: Architectural Investigations by Colonial Williamsburg* (Chapel Hill, NC, 2013), 18.
35. M. Johnson, *English Houses 1300–1800: Vernacular Architecture, Social Life* (Harlow, 2010), 179, 187–189.
36. Landsman, *From Colonials to Provincials*, 7. The difficulty Americans encountered in jettisoning their connection with Britain is treated in K. Yokota, *Unbecoming British: How Revolutionary America Became a Post-colonial Nation* (Oxford, 2011).
37. M. Dresser and A. Hahn, *Slavery in the English Country House* (Swindon, 2013); M. Dresser, *Slavery Obscured: The Social History of the Slave Trade in Bristol* (Bristol, 2007).
38. D. Armitage, 'Three Concepts of Atlantic History', in Armitage and M. Braddick, (eds), *The British Atlantic World, 1500–1800* (London, 2002), 11–27, especially 18–21.

39. C. B. Estabrook, *Urbane and Rustic England: Cultural Ties and Social Spheres in the Provinces, 1660–1780* (Manchester, 1998), 3, 152.
40. Wilson and Mackley, *Creating Paradise*, 5–9; Girouard, *Life in the English Country House*, 3.
41. J. S. Ackerman, *The Villa: Form and Ideology of Country Houses* (Princeton, 1995); M. Airs and G. Tyack, (eds), *The Renaissance Villa in Britain, 1500–1700* (Reading, 2007); D. Arnold, (ed.), *The Georgian Villa* (Stroud, 1998); B. Arciszewska, (ed.), *The Baroque Villa: Suburban and Country Residences, c. 1600–1800* (Wilanow, Poland, 2009); J. Archer, *Architecture and Suburbia: From English Villa to American Dream House, 1690–2000* (Minneapolis and London, 2005).
42. Williamson noted this feature in relation to larger estates, see T. Williamson, 'Archaeological Perspectives on Landed Estates: Research Agendas', in J. Finch and K. Giles, (eds), *Estate Landscapes: Design, Improvement and Power in the Post-medieval Landscape* (Woodbridge, Suffolk, 2007), 1–16.
43. P. Langford, *Public Life and the Propertied Englishman 1689–1798* (Oxford, 1991), especially 58–70.
44. J. Fowler and J. Cornforth, *English Decoration in the Eighteenth Century* (London, 1978); Saumarez Smith, *Eighteenth-Century Decoration: Design and the Domestic Interior in England* (New York, 1993); J. Cornforth, *Early Georgian Interiors* (London and New Haven, 2004); Vickery, *Behind Closed Doors*. For objects, A. Bowett, *English Furniture 1660–1714: Charles II to Queen Anne* (Woodbridge, Suffolk, 2002) and *Early Georgian Furniture 1715–1740* (Woodbridge, Suffolk, 2009); C. Edwards, *Eighteenth-Century Furniture* (Manchester, 1996); S. Richards, *Eighteenth-Century Ceramics: Products for a Civilised Society* (Manchester, 1999); P. Glanville, *Silver in England* (London, 1986). T. Murdoch, (ed.), *Noble Households: Eighteenth-Century Inventories of Great English Households: A Tribute to John Cornforth* (Cambridge, 2006); J. Ayres, *Domestic Interiors: The British Tradition 1500–1850* (New Haven and London, 2003); P. Earle, *The Making of the English Middle Class: Business, Society and Family Life in London, 1660–1730* (London, 1989); Shammas, *The Pre-industrial Consumer in England and America*; Weatherill, *Consumer Behaviour and Material Culture*; M. Overton, J. Whittle, D. Dean, and A. Hann, *Production and Consumption in English Households, 1600–1750* (London, 2004).
45. The idea of emulation draws largely on T. Veblen, *The Theory of the Leisure Class: An Economic Study of Institutions* (New York, 1899). The work of Pierre Bourdieu, however, has suggested a measure of differentiation, where different social ranks exhibited consumption practices unrelated to a concept of 'taste' from above. P. Bourdieu, *Distinction: A Social Critique of the Judgment of Taste* (London, 1984); Weatherill, *Consumer Behaviour and Material Culture*, 194–196; Hunt, *The Middling Sort*.
46. The former view is in Stone and Stone, *An Open Elite?*; M. Girouard, 'The Power House', in G. Jackson-Stops, (ed.), *The Treasure Houses of Britain: Five Hundred Years of Private Patronage and Art Collecting* (New Haven, 1985), 23; D. Hancock, *Citizens of the World: London Merchants and the Integration of the British Atlantic Community, 1735–1785* (Cambridge, 1995).

2 The Gentleman's House in Context

1. N. Cooper, *Houses of the Gentry 1480–1680* (New Haven and London, 1999) and 'Rank', in M. Johnson, *English Houses 1300–1800: Vernacular Architecture, Social Life* (Harlow, 2010); B. B. Mooney, *Prodigy Houses of Virginia: Architecture and the Native Elite* (Charlottesville, VA, 2008); D. Reiff, *Small Georgian Houses in England and Virginia: Origins and Development through the 1750s* (London, 1986).
2. The essential survey for country houses is N. Kingsley, *The Country Houses of Gloucestershire: Volume Two 1660–1830* (Chichester, 1992) [hereafter *CHG II*].

3. R. Atkyns, *The Ancient and Present State of Glostershire* [Electronic Resource] (London, 1712). His monumental work documents the county, describes its administrative structures and offers a detailed parish by parish analysis at the beginning of the eighteenth century. S. Rudder, *A New History of Gloucestershire* (Cirencester, 1779) [hereafter Rudder].
4. Kingsley, *CHG II*; for vernacular architecture L. J. Hall, *The Rural Houses of North Avon and South Gloucestershire, 1400–1720* (Bristol, 1983); D. Verey and A. Brook, *The Buildings of England: Gloucestershire I: The Cotswolds* (London, 2002) and *The Buildings of England: Gloucestershire II: The Vale and the Forest of Dean* (London, 2002) [hereafter *BoE: C* and *BoE: VF*]; for Bristol, A. Gomme, M. Jenner, and B. Little, *Bristol: An Architectural History* (London, 1979), with the relevant chapters for the seventeenth and eighteenth centuries by M. Jenner, and A. Foyle, *Pevsner Architectural Guides: Bristol* (London, 2004) [hereafter *PAGB*].
5. Verey and Brooks, *BoE: VF*, 23.
6. Rudder, v.
7. Verey and Brooks, *BoE: VF*, 96.
8. B. Smith and E. Ralph, *A History of Bristol and Gloucestershire* (Chichester, third edition, 1996), 73–77.
9. Quoted in J. D. L. Mann, *The Cloth Industry in the West of England from 1640 to 1880* (Oxford, 1971), 227; Rudder, 61; D. Rollison, *The Local Origins of Modern Society: Gloucestershire 1500–1800* (London, 1992), 27.
10. J. Johnson, *The Gloucestershire Gentry* (Gloucester, 1989), 4; R. Wilson and A. Mackley, *Creating Paradise: The Building of the English Country House, 1660–1880* (London 2000), 204.
11. Rudder, 21, 25; Smith and Ralph, *A History of Bristol and Gloucestershire*, 79.
12. N. Herbert, *Road Travel and Transport in Georgian Gloucestershire* (Ross-on-Wye, 2009); Smith and Ralph, *A History of Bristol and Gloucestershire*, 104–107.
13. Smith and Ralph, *A History of Bristol and Gloucestershire*, 106, Image 121: Turnpike Roads. Also, P. T. Marcy, 'Bristol's Roads and Communications on the Eve of the Industrial Revolution', *Transactions of the Bristol and Gloucestershire Archaeological Society*, vol. 87 (1968), 158.
14. D. Hussey, *Coastal and River Trade in Pre-industrial England: Bristol and its Region, 1680–1730* (Exeter, 2000).
15. Herbert, *Road Travel and Transport*, chapter 8; Verey and Brooks, *BoE: VF*, 98; Johnson, *The Gloucestershire Gentry*, 162.
16. Gloucestershire Archives, Gloucester/D149/A8: 1731–1733, 'Estimates and Vouchers of Rich. Clutterbuck for Stonework during Construction of Frampton Court' [Gloucestershire Archives, Gloucestershire hereafter GA].
17. See, for instance, A. Gomme, *Smith of Warwick: Francis Smith, Architect and Master-Builder* (Stamford, 2000); G. Tyack, *Warwickshire Country Houses* (Chichester, 1994).
18. B. Donne, *This Map of the Country 11 Miles Round the City of Bristol* (London, 1769), also found at BRO/Bristol Plan 232c/30120(3).
19. GA/D1833/E1 (1–8): c. 1770–1797, 'Survey of Estates of Jas. Rooke of Bigswear'.
20. Amongst the more helpful volumes on Bristol's history are: J. Latimer, *The Annals of Bristol: The Eighteenth Century* (Bristol, 1893, reprinted with an introduction by P. McGrath, 1970); C. M. MacInnes, *A Gateway of Empire* (Bristol, 1939); P. McGrath, (ed.), *Bristol in the Eighteenth Century* (Newton Abbot, 1972); B. Little, *The City and County of Bristol: A Study in Atlantic Civilisation* (London, 1954); Smith and Ralph, *A History of Bristol and Gloucestershire*; D. H. Sacks, *The Widening Gate: Bristol and the Atlantic Economy, 1450–1700* (Berkeley and Oxford, 1991); K. Morgan, *Bristol and the Atlantic Trade in the Eighteenth Century* (Cambridge, 1993); Estabrook, *Urbane and Rustic England: Cultural Ties and Social Spheres in the Provinces, 1660–1780* (Manchester, 1998). The best works on Bristol's architecture are W. Ison, *The Georgian Buildings of*

164 *Notes for pages 12–16*

Bristol (Bristol, 1952), Gomme, Jenner, and Little, *Bristol: An Architectural History*, and Foyle, *PAGB*; P. Aughton, *Bristol: A People's History* (Lancaster, 2000) is the most recent modern effort.

21. R. Sweet, *The English Town: Government, Society and Culture, 1680–1840* (Harlow, 1999), 3, table 1.
22. Quote in Foyle, *PAGB*, 20. See also P. T. Marcy, 'Eighteenth-Century Views of Bristol and Bristolians', in P. McGrath, (ed.), *Bristol in the Eighteenth Century* (Newton Abbot, 1972), 11–40; J. H. Bettey, *Bristol Observed: Visitors' Impressions of the City from Domesday to the Blitz* (Bristol, 1986). Alexander Pope commented, 'The City of Bristol itself is very unpleasant and no civilized company in it. Only the Collector of the Customs would have brought me acquainted with the Merchants, of whom I hear no great character'. Quoted by Bettey, 69.
23. W. E. Minchinton, 'Bristol: Metropolis of the West', *Transactions of the Royal Historical Society*, fifth series, vol. 4 (1954), 69–89; W. E. Minchinton, *The Trade of Bristol in the Eighteenth Century*, Bristol Record Society, vol. 20 (1957).
24. D. Richardson, (ed.), *Bristol, Africa and the Eighteenth-Century Slave Trade to America*, Bristol Record Society, vols 38, 39, 42, 47; Morgan, *Bristol and the Atlantic Trade in the Eighteenth Century*; C. M. MacInnes, *A Gateway of Empire*; Dresser, *Slavery Obscured: The Social History of the Slave Trade in Bristol* (Bristol, 2007); M. Dresser and A. Hahn, *Slavery and the British Country House* (Swindon, 2013), especially the chapters by Dresser and Longmore.
25. Dresser, *Slavery Obscured*, especially chapter 3.
26. T. Mowl, *To Build the Second City: Architects and Craftsmen of Georgian Bristol* (Bristol, 1991), 9.
27. The Historic American Buildings Survey (HABS) has contributed significantly to this effort. See HABS website at http://www.nps.gov/history/hdp/habs/.
28. J. Summerson, 'The Classical Country House in 18th Century England', in *The Unromantic Castle and Other Essays* (London, 1990), 79–120; L. Stone and J. F. Stone, *An Open Elite? England 1540–1880* (Oxford 1984), especially 384, table 11.9; Saumarez Smith, 'Supply and Demand in English Country House Building, 1660-1740', *The Oxford Arts Journal*, vol. 11, no. 2 (1988), 3; R. Wilson and A. Mackley, *Creating Paradise: The Building of the English Country House, 1660–1880* (London, 200), 205, figure 2; H. Clemenson, *English Country Houses and Landed Estates* (London, 1982), 49, figure 3.1; M. W. Barley also suggests a decline in gentry and aristocratic house-building in the two decades 1730–1750 in 'Rural Building in England', in J. Thirsk, (ed.), *The Agrarian History of England and Wales, vol. 5, 1640–1750: Agrarian Change* (Cambridge, 1985), 590; Kingsley, *CHG II*, 8.
29. Kingsley, *CHG II*, 3–6; for building figures, 7–8.
30. Wilson and Mackley, *Creating Paradise*, 236.
31. Johnson, *English Houses*, 168.
32. The table draws on Wilson and Mackley's sample of six English counties, extrapolated numbers from Kingsley for country house building in Gloucestershire, and figures for the eighty-one small classical houses in Gloucestershire identified for this study. Kingsley does not provide numbers related to building construction, hence this graph reflects the overall trends he identifies rather than reflecting actual building campaigns. Also, I have included two houses in my figures for 1680–1690, Lower Slaughter Manor and Fairford Park, which were completed before that decade.
33. Eshott Hall Papers, LWL.
34. S. Buck, *Samuel Buck's Yorkshire Sketchbook Reproduced in Facsimile from Landsdowne MS. 914 in the British Library with an Introduction by Ivan Hall* (Wakefield, 1979).
35. J. Longmore, 'Rural Retreats: Liverpool Slave Traders and their Country Houses', in Dresser and Hahn, (eds), *Slavery and the British Country House*, 30–45.
36. D. Pope, 'The Wealth and Social Aspirations of Liverpool's Slave Merchants of the Second Half of the Eighteenth Century', in D. Richardson, S. Schwarz, and A. Tibbles, (eds), *Liverpool and Transatlantic Slavery* (Liverpool, 2007), 164–226.

37. R. G. Wilson, *Gentlemen Merchants: The Merchant Community in Leeds, 1700–1830* (Manchester, 1971), 203–204.
38. Pennsbury quote in G. Thomas, *An Account of Pennsylvania and West New Jersey* (London, 1698), 29.
39. Mooney, *Prodigy Houses of Virginia*, 10, and table 1, 15.
40. K. Sweeney, 'Mansion People: Kinship, Class, and Architecture in Western Massachusetts in the Mid Eighteenth Century', *Winterthur Portfolio*, vol. 19, no. 4 (Winter 1984), 231–255.
41. R. L. Bushman, *The Refinement of America: Persons, Houses, Cities* (New York, 1992), 16.
42. E. Hart, *Building Charleston: Town and Society in the Eighteenth-Century British Atlantic World* (Charlottesville and London, 2010).
43. Mowl, *To Build the Second City*, chapter 1; P. Borsay, *The English Urban Renaissance: Culture and Society in the Provincial Town 1660–1770* (Oxford, 1989); Bushman, *Refinement of America*, 5; Longmore, 'Rural Retreats'.
44. T. H. Breen, 'An Empire of Goods: The Anglicization of Colonial America, 1690–1776', *Journal of British Studies*, vol. 25, no. 4 (1986), 467–499.
45. Johnson, *English Houses*; Verey and Brooks, *BoE: C*, 95–97.
46. P. Mathias, 'The Social Structure in the Eighteenth Century', *Economic History Review*, vol. 10, no. 1 (1957), 30–45; G. Holmes, 'Gregory King and the Social Structure of Pre-industrial England', *Transactions of the Royal Historical Society*, fifth series, vol. 27 (1977), 41–68; P. H. Lindert and J. G. Williamson, 'Revising the Social Tables for England and Wales, 1688–1812', *Explorations in Economic History*, vol. 29 (1982), 385–408.
47. Mooney, *Prodigy Houses*, 105–107, table 9.
48. Stone and Stone, *An Open Elite?* 142–147, 191; H. J. Habakkuk, *Marriage, Debt, and the Estates System: English Landownership 1650–1950* (Oxford, 1994), especially chapters 1–3; K. Harvey, *Little Republic: Masculinity and Domestic Authority in Eighteenth-Century Britain* (Oxford, 2012), 102–106; Vickery, *Behind Closed Doors: At Home in Georgian England* (New Haven and London, 2009), 89, 133; Wilson, *Gentlemen Merchants*, 211–212.
49. Nuffield Health, St Mary's Hospital archive: Indenture, 17 August 1742.
50. Gomme, Jenner, and Little, *Bristol: An Architectural History*, 151; Beacon Planning, 'Chesterfield, No 3 Clifton Hill, Clifton, Bristol: Historic Building Assessment' (Unpublished report, October 2010), 5.
51. Mooney, *Prodigy Houses*, 85–87, 103–105.
52. These have been calculated where birth dates are known and where the construction date of the house is fairly precise, allowing for estimation of which decade of life builders undertook construction. The three peers who built these houses are not included.
53. Summerson, 'The Classical Country House', 86. The Stones noted but did not particularly emphasize this trend. Stone and Stone, *An Open Elite?* 191–192. Compare with Mooney, *Prodigy House*, 87–89.
54. Longmore, 'Rural Retreats', 35–36, 39.
55. Mooney, *Prodigy Houses*, 88.
56. James Logan to Thomas Story, Philadelphia, 26 June 1714, James Logan Letterbooks 1712–1715, 199, Historical Society of Pennsylvania (HSP).
57. Bushman, *Refinement of America*, 9–15.
58. A. Harford, *Annals of the Harford Family* (London, 1909), 33–34, 161.
59. Merchants may have been more cognizant of building costs than landowners as a result of their business background, which prompted them to wait before investing in a gentleman's house, see Wilson and Mackley, *Creating Paradise*, 248.
60. Aspects of Mrs Hort's nearly forty year tenure will be considered in Chapter 7.
61. *Gloucester Journal*, 11 February 1755; J. Milne and T. Mowl, *Castle Godwyn: A Guide and and Architectural History* (Painswick, 1996), 9–10.
62. These findings agree with some scholarship on English country houses and Virginia plantations, see Wilson and Mackley, *Creating Paradise*; Stobart, 'Gentlemen and Shopkeepers: Supplying the Country House in Eighteenth-Century England', *Economic History Review*, vol. 64, no. 3 (2011), 888; L. Walsh, *Motives of Honor, Pleasure & Profit: Plantation Management in the Colonial Chesapeake, 1607–1763* (Chapel Hill, NC, 2010)..

63. I. Christie, *British 'Non-Elite' MPs 1715–1820* (Oxford, 1995), 18.
64. W. R. Williams, *PHG*; *History of Parliament Trust: The House of Commons* on CD-ROM, volumes for 1660–1690, 1715–1754, 1754–1790; E. Cruickshanks, S. Handley, and D. W. Hayton, (eds), *The House of Commons, 1690–1715*, 5 vols (Cambridge, 2002).
65. G. E. Mingay, *The Gentry: The Rise and Fall of a Ruling Class* (London, 1976), 13–15.
66. Eight served as High Sheriff of Gloucestershire and one, Joseph Harford, as High Sheriff of Bristol. Rudder, 54; Harford, *Annals of the Harford Family*, 33.
67. N. Landau, *The Justices of the Peace, 1679–1760* (Berkeley, 1984), Appendix A.
68. It is worth noting that of the persons listed in each commission, a number were perfunctory appointments of Privy Councilors and other government officials with few or no local connections, see L. K. J. Glassey, *Politics and the Appointment of the Justices of the Peace 1675–1720* (Oxford, 1979), 4.
69. Commissions of the Peace, GA/CMS/202: Justices of the Peace of 1736 [Transcription of GA/Q/JC/3], GA/Q/JC/4, 1740; GA/Q/JC/5, 1746; GA/Q/JC/6, 1754; GA/Q/JC/7, 1762.
70. Landau, *The Justices of the Peace*; Glassey, *Politics and the Appointment of the Justices of the Peace*, 15–17.
71. J. E. Johnson, 'A Quaker Imperialist's View of the British Colonies in America: 1732', *Pennsylvania Magazine of History and Biography*, vol. 60, no. 2 (April 1936), 97–130, at 103.
72. A. Chan, *Slavery in the Age of Reason: Archaeology at a New England Farm* (Knoxville, TN, 2007), 60–61.
73. J. T. Flaxner, *Mohawk Baronet: A Biography of Sir William Johnson* (Syracuse, 1989); F. O'Toole, *White Savage: William Johnson and the Invention of America* (New York, 2005).
74. Bushman, *Refinement of America*, 113; Mooney, *Prodigy Houses*, 261–267.
75. Mooney, *Prodigy Houses*, 265.
76. Sweeney, 'Mansion People', 233.
77. GA/D678/1 F12/1/87: 18 September 1739, Revd Thomas Baker, Bibury, to Sir John Dutton.
78. Bristol Record Office, Bristol/RO/35893/1/a: Bristol Royal Infirmary Minute Book, 1736–1772 [Bristol Record Office, Bristol hereafter BRO].
79. G. E. Mingay, *English Landed Society in the Eighteenth Century* (London, 1963), 8; H. R. French, '"Ingenious and Learned Gentlemen": Social Perceptions and Self-fashioning among Parish Elites in Essex, 1680–1740', *Social History*, vol. 25, no. 1 (January 2000), 44–66.
80. Klein, 'Politeness and the Interpretation of the British Eighteenth Century', *The Historical Journal*, vol. 45, no. 4 (December 2002), 890.
81. P. Corfield, *The Impact of English Towns 1700–1800* (Oxford, 1982), 40, table VI.
82. Dresser, *Slavery Obscured*, for one example. A brief essay is H. G. M. Leighton, 'Country Houses Acquired with Bristol Wealth', *Transactions of the Bristol and Gloucestershire Archaeological Society* [hereafter *TBGAS*], vol. 123 (2005), 9–16.
83. Kingsley, *CHG II*, 3, 5–6.
84. S. G. Hague, '"A MODERN-built house…fit for a gentleman": Elites, Material Culture and Social Strategy in Britain, 1680–1770' (D.Phil. thesis, University of Oxford, 2011), 61.
85. F. Tolles, *Meeting House and Counting House: Quaker Merchants in Colonial Philadelphia* (Chapel Hill, 1948), 109.
86. For provincial cities in England, see Sweet, *The English Town*, 3. For American cities from 1740–1783, see B. Carp, *Rebels Rising: Cities and the American Revolution* (Oxford, 2007), 225, Appendix I.
87. J. J. McCusker and R. Menard, *The Economy of British America 1607–1789* (Chapel Hill, NC, 1985); C. Matson, (ed.), *The Economy of Early America: Historical Perspectives and New Directions* (University Park, PA, 2006).
88. C. Hobson, *The Raymond Barkers of Fairford Park*, Fairford History Society Monograph 3 (November 2007), 13.

89. J. Day, *Bristol Brass: A History of the Industry* (Newton Abbot, 1973); A. Raistrick, *Quakers in Science and Industry: Being an Account of the Quaker Contributions to Science and Industry During the Seventeenth and Eighteenth Centuries* (New York, 1968); H. Lloyd, *The Quaker Lloyds in the Industrial Revolution* (London, 1975); R. C. Allen, *The British Industrial Revolution in Global Perspective* (Cambridge, 2009), 222, 264, 269.
90. For Quakers in the Bristol region, see Estabrook, *Urbane and Rustic England*, 239–244.
91. For Warmley, see Atkins Heritage, 'Champion's Brassworks and Gardens Conservation Management Plan' (Unpublished report, January 2007).
92. Estabrook, *Urbane and Rustic England*, 239–244.
93. F. Tolles, *James Logan and the Culture of Provincial America* (Boston, 1957), 154–155. 'James Logan on Defensive War, or Pennsylvania Politics in 1741', *Pennsylvania Magazine of History and Biography*, vol. 6 (1882), 402–411, at 408.

3 Building Status

1. GA/D45/E17: Articles of Agreement, Richard Whitmore and Valentine Strong, 23 January 1655/1956. See also National Monuments Record [hereafter NMR] 87132; NMR Images of England 129913; N. Cooper, *The Houses of the Gentry 1480–1680* (New Have and London, 1999), 47–48; J. Johnson, *The Gloucestershire Gentry* (Gloucester, 1989), 66–67; Kingsley, *CHG I*, 139–141. Kingsley notes that Whitmore's cousin Sir George Whitmore built a five-bay hipped roof house slightly earlier, Balmes house, in Hackney near London, which may have served as a model. On Balmes, see C. Knight, *London's Country Houses* (Chichester, 2009), 159–160.
2. GA/D45/E17: Articles of Agreement, Richard Whitmore and Valentine Strong.
3. L. Hall, 'Yeoman or Gentleman? Problems in Defining Social Status in Seventeenth- and Eighteenth-Century Gloucestershire', *Vernacular Architecture*, vol. 20 (1991), 2–19.
4. R. W. Brunskill, *Vernacular Architecture: An Illustrated Handbook* (retitled) (London, fourth edition, 2000), 27–28.
5. Cooper, *The Houses of the Gentry*, 48; N. Cooper, 'Rank, Manners and Display: The Gentlemanly House, 1500–1750', *Transactions of the Royal Historical Society*, vol. 12 (2002), 291–310, 301.
6. Atkyns, 655.
7. Klein, 'Politeness and the Interpretation of the British Eighteenth Century', *The Historical Journal*, vol. 45, no. 4 (December 2002), 886.
8. M. Craske, 'From Burlington Gate to Billingsgate: James Ralph's Attempt to Impose Burlingtonian Classicism as a Canon of Public Taste', in B. Arciszewska and E. McKellar, (eds), *Articulating British Classicism: New Approaches to Eighteenth-Century Architecture* (Aldershot, 2004), 97–118, especially 97.
9. For instance, J. Summerson, *Architecture in Britain, 1530 to 1830* (New Haven and London, ninth edition, 1993) and Worsley, *Classical Architecture in Britain: The Heroic Age* (New Haven and London, 1995).
10. G. Gross, *Great Houses of New England* (New York, 2008), text by Robert Blackburn, 23.
11. P. Borsay, 'Why Are Houses Interesting?' *Urban History*, vol. 34, no. 2 (2007), 338–346, 343. Also, Arciszewska and McKellar, (eds), *Articulating British Classicism*, preface.
12. Verey and Brooks, *BoE: C*, 477.
13. Verey and Brooks, *BoE: C*.
14. J. Ayres, *Building the Georgian City* (London and New Haven, 1998), 145.
15. Verey and Brooks, *BoE: C*, 96, 684; Ayres, *Domestic Interiors: The British Tradition 1500–1850* (New Haven and London, 2003), 75–78. Ayres notes on 78 that sash are often found on principal elevations in the eighteenth and early nineteenth centuries, but casement in other areas. Nether Lypiatt, for instance, has cross-mullioned windows on the north side, and sash windows on the front, which Kingsley suggests may have been installed after John Coxe inherited the house in 1728. Kingsley, *CHG II*, 182.

16. J Ayres, *Two Hundred Years of English Naïve Art 1700–1900* (Art Services International, 1996), 62–63. Many thanks to James Ayres for drawing my attention to this painting.
17. C. Carson and C. Lounsbury, (eds), *The Chesapeake House: Architecural Investigations by Colonia Williamsburg* (Chapel Hill, NC, 2013), 110, figure 6.21.
18. M. Binney, 'Poulton Manor', *Country Life* (27 May 1976), 1400.
19. This date is found on a rainwater-head on the building.
20. Atkyns, 307.
21. The National Archives/PROB11/629 (12 May 1729); *VCH: G*, vol. 11, Bisley and Longtree Hundreds (1976), 111–119 [The National Archives hereafter TNA].
22. Verey and Brooks, *BoE: C*, 94.
23. Atkyns, between 400 and 401.
24. Atkyns, 400.
25. L. B. Namier, 'Three Eighteenth-Century Politicians', *English Historical Review*, vol. 42, no. 167 (July 1927), 408–413; Williams, *PHG*, 66. See also Rudder, 817.
26. Kingsley, *CHG II*, 218–221 and plate II. See also GA/PA117/1.
27. S. Buck, *Samuel Buck's Yorkshire Sketchbook Reproduced in Facsimile from Landsdowne MS. 914 in the British Library with an Introduction by Ivan Hall* (Wakefield, 1979).
28. L. Stone and J. F. Stone, *An Open Elite? England 1540–1880* (Oxford, 1984), 6–8.
29. *VCH: G*, vol. 6, 'Lower Slaughter', 128–134.
30. C. Hobson, *The Raymond Barkers of Fairford Park*, Fairford History Society Monograph 3 (November 2007), 2–4, 6–7; Kingsley, *CHG I*, 94–95; Kip illustration in Atkyns, 226.
31. D. W. Hayton, 'Sir Richard Cocks: The Political Anatomy of a Country Whig', *Albion: A Quarterly Journal Concerned with British Studies*, vol. 20, no. 2 (Summer 1988), 221–246. Hayton memorably described Cocks as, 'a rare bird among the crook-taloned specimens perched on the back benches of King William III's House of Commons', 221. See also Atkyns, 406 and image between 406 and 407.
32. *VCH: G*, vol. 4, 'Gloucester: Outlying Hamlets', 398; Williams, *PHG*, 207.
33. The date for Bigsweir is somewhat open to question. Rudge specifically notes rebuilding in 1755, T. Rudge, *The History of Gloucestershire: Brought Down to the Year 1803*, 2 vols (Gloucester, 1803), ii, 109. Kingsley uses this date. A 1930 report from estate agents suggests 1702, see GA/D2299/4342: 1930 Bruton, Knowles and Co, Gloucester, estate agents, Bigsweir House, St Briavels, Report Correspondence.
34. Bigland, 236.
35. Hood, *The Governor's Palace in Williamsburg: A Cultural Study* (Chapel Hill, NC, 1991), 38.
36. William Byrd to Mr Spencer, 28 May 1729 in M. Tinling, (ed.), *The Correspondence of the Three William Byrds of Westover, Virginia, 1684–1776* (Charlottesville, 1977), vol. 1, 399.
37. D. Reiff, *Small Georgian Houses in England and Viginia: Origins and Development through the 1750s* (London, 1986), 238–240 for Indian Banks and Ampthill; for Wilton, 253–255. Tolles briefly but somewhat ineffectively compares Westover and Stenton in *Meeting House and Counting House: Quaker Merchants in Colonial Philadelphia* (Chapel Hill, NC, 1948), 127 fn 47.
38. R. North, *Of Building*, H. Colvin and J. Newman (eds) (Oxford, 1981), 62.
39. Borsay, *The English Urban Renaissance: Culture and Society in the Provincial Town 1660–1770* (Oxford, 1989).
40. Foyle, *PAGB*, 19, 154–168; Mowl, *To Build the Second City: Architects and Craftsmen of Georgian Bristol* (Bristol, 1991), chapter 1; A. Gomme, M. Jenner, and B. Little, *Bristol: An Architectural History* (London, 1979), 94–105.
41. BRO/SMV/4/6/1/40: Charities, St Monica Home, Cote Deeds explained, n.d., probably c. 1930.
42. Atkyns does not mention it, suggesting it post-dates 1712, Atkyns, 804–805.
43. Ayres, *Building the Georgian City*, 230–231; Gomme, Jenner, and Little, *Bristol: An Architectural History*, 100–101.

44. This conclusion is based on physical examination of the buildings at Cote. I am grateful to Professor Roger Leech, Dr James Ayres and Laura Keim for their expertise in evaluating Cote. Elisabeth Robinson, 'Some Notes about Cote' (Unpublished MS, April, 1971), typescript on file at Cote House, relates that the service wing was an older structure, but without firm evidence. Ms Robinson's parents acquired Cote in 1919.
45. BRO/AC/WO/10/4: 3 March 1724/1725, Copy will of Thomas Moore; BRO/SMV/4/6/1/40: Charities, St Monica Home, Cote Deeds explained, n.d.
46. E. Ralph and M. Williams, (ed.), *Inhabitants of Bristol in 1696*, BRS vol. 25 (1968), 125; BRO/AC/WO/10/22.
47. BRO/34328/a: D. Jones, 'The Elbridge, Woolnough and Smyth Families of Bristol, in the Eighteenth Century: With Special Reference to the Spring Plantation, Jamaica' (Unpublished PhD Thesis, University of Bristol, 1972), 45. It should be noted, however, that Jones wrongly recorded Thomas Moore's death date as 1724, when in fact Moore did not die until 1728. Given that Elbridge therefore did not inherit Cote until 1728, it seems less likely that he was responsible for construction.
48. The second canto of 'Clifton' is reproduced in Rudder, 380–381.
49. K. Ross, 'Report on Bishop's House Clifton Hill Bristol' (Unpublished report, n.d. 2004?), 24–25. Many thanks to Kay Ross of McLaughlin Ross, The House Historians for kindly sharing this report with me. Mowl, *To Build the Second City*, 13–14, argues strongly for John Strahan as the architect, but this seems unlikely given its early date. Another possibility is George Townesend of Bristol, a member of the illustrious Oxford family of masons, see Colvin, 1045.
50. I. Ware, *A Complete Body of Architecture* (London, 1756), 405–406.
51. Mowl, *To Build the Second City*, chapter 1; Gomme, Jenner, and Little, *Bristol: An Architectural History*, 133–134.
52. GA/D149/P18: Thomas Fassett plans.
53. Colvin, 992.
54. J. Charlton and D. M. Milton, *Redland 791 to 1800* (Bristol, 1951), 40–41; E. Shiercliff, *Bristol & Hotwells Guide* (Bristol, 1789) states that Strahan, was 'the architect who built Redland-Court House, and many other capital mansions in and near Bristol'. In addition, a drawing in the British Library of Redland Court lists Strahan as the architect; see *King's Maps* xiii, 77. 3b as noted in Colvin, 992.
55. GA/D149/F21 and BRO/AC/WO/17/3 and AC/WO/20/1.
56. Mowl, *To Build the Second City*, 17.
57. Kingsley, *CHG II*, 5.
58. GA/D3921/III/5, *1950–1954*, Notes concerning the history of English Bicknor compiled by H. A. Machen, 5.
59. Rudder, 312.
60. Johnson, *Gloucestershire Gentry*, 151.
61. C. Lounsbury, *Essays on Early American Architecture: A View from the Chesapeake* (Charlottesville and London, 2011), 22.
62. K. Sweeney, 'Mansion People: Kinship, Class, and Architecture in Western Massachusetts in the Mid Eighteenth Century', *Winterthur Portfolio*, vol. 19, no. 4 (Winter 1984), 231–255, 235–236, 241–242, figure 7 and 244.
63. Reiff, *Small Georgian Houses*, 248.
64. James Logan to Thomas Penn, *Penn Manuscripts: Official Correspondence, 1728–1734*, vol. 2, 41, HSP.
65. Mowl, *To Build the Second City*, 40.
66. Summerson, 'The Classical Country House in 18th century England', in *The Unromantic Castle and Other Essays* (London, 1990), 79–120, 86.
67. GA/D149/A8, 1731–1733, 'Estimates and Vouchers of Rich. Clutterbuck for Stonework during Construction of Frampton Court'.

68. BRO/09467/12/a: 'Notes and Receipts for House Building at Clifton 1746–47–48–49 + 1750 +c'.
69. R. Wilson and A. Mackley, *Creating Paradise: The Building of the English Country House, 1660–1880* (London, 2000), especially chapter 8; B. B. Mooney, *Prodigy Houses of Virginia: Architecture and the Native Elite* (Charlottesville, VA, 2008), 159.
70. A. Vickery, *Behind Closed Doors: At Home in Georgian England* (New Haven and London, 2009), 156; Wilson and Mackley, *Creating Paradise*, 185–186.
71. Wilson and Mackley, *Creating Paradise*, chapter 5 offers a useful discussion of construction.
72. E. Clutterbuck, *The Clutterbuck Diaries, being the Journey with my Wife and Daughter Sally into Gloucestershire on a Visit to my Cousin Clutterbuck at King Stanley*, with notes by The Rev. Robert Nott and T. E. Sanders (Stroud, 1935). Photocopy at Frampton Court, 6. Entry for Wednesday, 14 July 1773.
73. GA/D45/E14: Bills for carpenter's work, rates, repairs and legal proceedings (1707–1726), building repairs, etc. (1728–1782), 'An Estimate for Stables for the Honbl Genl Whitmore at his Sete at Slaughter March ye 11th 1765'.
74. Kingsley, *CHG II*, 92–93. GA/Palling-Carruthers Papers/Bundle 55: Accounts of materials for building, 1788–1790.
75. Rudder, 629. See also *VCH: G*, vol. 11 (1976), 224.
76. Kingsley, *CHG II*, 212–214. These can be seen in an image of the house in S. Lysons, *An Account of Roman Antiquities Discovered at Woodchester* (London, 1797), plates II and III. GA/D589, accounts of Sir G. O. Paul, 1767–1813.
77. Ayres, *Building the Georgian City*, especially chapter 1. The interplay between client, architect and craftsman is captured in an account from Norfolk, Virginia in B. L. Herman, *Town House: Architecture and Material Life in the Early American City, 1780–1830* (Chapel Hill, NC, 2005), 51–53.
78. See GA/D45/E17; Colvin, 995.
79. J. Milne and T. Mowl, *Castle Godwyn: A Guide and an Architectural History* (Painswick, 1996), 6.
80. G. Priest, *The Paty Family: Makers of Eighteenth Century Bristol* (Bristol, 2003). I am grateful to Zara Anishanslin for drawing my attention to Paty's work for the Shippen family of Philadelphia.
81. GA/D149/A8.
82. Hood, *The Governor's Palace*, 42.
83. C. Lounsbury, 'The Design Process', in Carson and Lounsbury, (eds), *The Chesapeake House*, chapter 5, 64–85, 66.
84. Colvin, *A Biographical Dictionary of British Architects, 1600–1840* (New Haven and London, fourth edition, 2008) is invaluable as it comprehensively documents actual and attributed work for this period.
85. A. H. Gomme, *Smith of Warwick: Francis Smith, Architect and Master-Builder* (Stamford, 2000); Verey and Brooks, *BoE: C*, 390.
86. Kingsley, *CHG II*, 198; Verey and Brooks, *BoE: C*, 552.
87. Kingsley, *CHG II*, 291. Tully designed Andrews' house at Hotwells and was a trustee of a bequest to Andrews' daughter in 1743. W. Ison, *The Georgian Buildings of Bristol* (London, 1952), 47–48; BRO/AC/AS/57/3: Copy Will of John Andrews, drawn up on 10 June 1743 with a codicil of 3 December 1743.
88. Colvin, 467–469; Poet Robert Lloyd wrote: 'With Angles, Curves, and Zigzag Lines/ from Halfpenny's Exact Designs', in 'The Cit's Country Box, 1757', see W. Kenrick, *The Poetical Works of Robert Lloyd*, 2 vols (London, 1774), vol. 1, 41–46. Mowl terms Halfpenny's work 'bizarre but lively', Mowl, *To Build the Second City*, 41.
89. Colvin, 468.
90. E. Harris, *British Architectural Books and Writers 1556–1785* (Cambridge, 1990); J. Archer, *The Literature of British Domestic Architecture, 1715–1842* (Cambridge, MA and London, 1985). For gentlemanly libraries, see chapter 6; K. Sweeney, 'High Style Vernacular: Lifestyles of the Colonial Elite', in Carson et al., (eds), *Of Consuming Interest*, 1–58, at 11.

91. W. Halfpenny, *Practical Architecture, or a Sure Guide to the True Working According to the Rules of that Science* (London, c. 1724).
92. Kingsley, *CHG II*, 278 and 304.
93. A. H. Gomme and A. Maguire, *Design and Plan in the Country House: From Castle Donjons to Palladian Boxes* (New Haven and London, 2008), 289.
94. M. Johnson, *English Houses 1300–1800: Vernacular Architecture, Social Life* (Harlow, 2010), 175–177, overemphasizes pattern books. Nevertheless, gentlemanly building may have had an influence on the perceived market for pattern books and design manuals.
95. D. Upton, *Holy Things and Profane: Anglican Parish Churches in Colonial Virginia* (New Haven and London, 1997), 27–28.
96. Lounsbury, 'The Design Process', in Carson and Lounsbury, (eds), *The Chesapeake House*, chapter 5.
97. Mooney, *Prodigy Houses*, 149–151.
98. Wilson and Mackley, *Creating Paradise*, 240, 247.
99. There is a curious absence of work that engages with consumption as it relates to building. An exception is Wilson and Mackley, *Creating Paradise*, a major contribution that extensively evaluated country house building in this period.
100. W. Halfpenny, *A New and Complete System of Architecture Delineated, Delineated in a Variety of Plans and Elevations of Designs for Convenient and Decorated Houses* (London, 1749), plates 13, 14 and 16.
101. Wilson and Mackley, *Creating Paradise*, 290, table 15. For costs per cubic foot, see also figure 4 and 5, 291.
102. Stobart, 'Gentlemen and Shopkeepers: Supplying the Country House in Eighteenth-Century England', *Economic History Review*, vol. 64, no. 3 (2011), 885–904, 888.
103. Payments of £286.10.0, £560.2.8, and £1129.9.2 are in BRO/09467/12/a: 'Notes and Receipts for House Building at Clifton 1746–47–48–49 + 1750 + c'. See also G. Priest, *The Paty Family*, 51. Thomas Paty was from a prominent family of Bristol mason-architects.
104. GA/D3921/III/5, 1950–1954, Notes concerning the history of English Bicknor compiled by H. A. Machen, 5. In the 1950s the building accounts were in the possession of the family and were consulted by Machen, but these are now missing.
105. Longmore, 'Rural Retreats', in Dresser and Hahn, (eds), *Slavery and the English Country House* 35.
106. Wilson and Mackley, *Creating Paradise*, 244. No calculation of cost per cubic foot is included for Crowcombe.
107. Hood, *The Governor's Palace*, 39, 44, 58; H. R. McIlvaine, (ed.), *Journals of the House of Burgesses of Virginia, 1702–1712* (Richmond, VA, 1912), 240. The additional figure are in W. W. Hening, (ed.), *Hening's Statutes at Large, vol. 3, 1684–1710* (Philadelphia, 1823), 482–486, October 1710.
108. M. Tinkcom, 'Cliveden: The Building of a Country Seat', *Pennsylvania Magazine of History and Biography*, vol. 88, no. 1 (January 1964), 3–36. For Mt Pleasant, see Thomas Nevil Daybook, 1762–1784, Ms Codex 1049, The Wetherill Papers (1721–1797), University of Pennsylvania, and E. E. Kuykendall, 'Philadelphia Carpenters, Cabinetmakers and Captains: The Working World of Thomas Nevell, 1762–1784' (Unpublished Winterthur M.A. Thesis, 2011).
109. Jeremiah Lee inventory, 1775–1776, transcript on file at Jeremiah Lee Mansion, kindly provided by Judy Anderson.
110. Wilson and Mackley, *Creating Paradise*, chapter 7, especially 290–292.
111. Ibid., 247; Brunskill, *Vernacular Architecture*, 27–30; A. Green, 'The Polite Threshold in Seventeenth- and Eighteenth-Century Britain', *Vernacular Architecture*, vol. 41 (2010) 1–9.
112. Wilson and Mackley, *Creating Paradise*, 248.
113. L. Walsh, *Motives of Honor, Pleasure & Profit: Plantation Management in the Colonial Chesapeake, 1607–1763* (Chapel Hill, NC, 2010), 265.
114. Walsh seems to suggest that planters both adopted moderate courses of action with respect to debt and expenditure, but also built 'mansions emulating aristocratic country houses', see Walsh, *Motives*, 235–237 and 416.

115. Mooney, *Prodigy Houses*, 130–131.
116. Hague, 'A MODERN-BUILT HOUSE', chapter 2.
117. Sweeney, 'Mansion People', 232.
118. For quotes, see Mooney, *Prodigy Houses*, 10; Sweeney, 'High Style Vernacular', 24.
119. LWL/MSS 2: Adams, Thomas, Records relating to Eshott House: addition, 1589–1815 (bulk 1758–1803).
120. M. Rothery and J. Stobart, 'Inheritance Events and Spending Patterns in the English Country House: The Leigh Family of Stoneleigh Abbey, 1738–1806', *Continuity and Change*, vol. 27, no. 3 (2012), 379–407.
121. GA/D45/E14: 'Bills for carpenter's work, rates, repairs and legal proceedings (1707–1726), building repairs, etc. (1728–1782).
122. GA/D45/E14: Bills for carpenter's work, rates, repairs and legal proceedings (1707–1726), building repairs, etc. (1728–1782), Bill from Samuel Archer, 1759.
123. GA/D45/E14: Bills for carpenter's work, rates, repairs and legal proceedings (1707–1726), building repairs, etc. (1728–1782), 'A Estimate for Alterations at Gen; Whitmores' Letter describing the work. Detailed bill from Thomas Collett for work, including panelling and staircase. For discussion of timber construction, carpentry and joinery, see Ayres, *Building the Georgian City*, chapter 6, especially 122–124 for oak and 152–156 for staircase construction.
124. Ibid.
125. GA/D45/E14: Bills for carpenter's work, rates, repairs and legal proceedings (1707–1726), building repairs, etc. (1728–1782), 1765 'A Bill of timber for the Honble Genl Whitmores Stables March ye 5th 1765'. 1765 'An Estimate for Stables for the Honbl Genl Whitmore at his Sate at Slaughter March ye 11th 1765'. 'The Honble Genl Whitmore to Thos Collett for Work and Materials at His New Stables 1766', 'The Honble Genl Whitmore to Thos Andrews for Work at His Stables 1766'. 'The Honble Genl Whitmore to George Laurence for Freestone Usd at His Stables 1766'.
126. Charlton and Milton, *Redland 791 to 1800*, especially Appendix II, 61–75; Kingsley, *CHG II*, 203.
127. GA/D45/E14: Bills for carpenter's work, rates, repairs and legal proceedings (1707–1726), building repairs, etc. (1728–1782), 1 October 1761, 'A Particular of the Mannor of Slaughter and Norton'.
128. GA/B325/51387: F. A. Hyett, *The Hyetts of Painswick* (1907, Transcript), 31. Also GA/D6/E1: Estate Accounts of Nicholas Hyett; GA/D6/E4: Survey of Certain Estates belonging to Benjamin Hyett, Esq. in the County of Gloucester 1780; For rental values, see GA/D6/E6: Ben. Hyett's Estates, Miscellaneous, Including Summary Statement of Acreage, c. 1780.
129. For example, his father William Clutterbuck made a modest salary as Searcher, and Richard succeeded him in the post in 1724. In addition, custom officials made substantial sums from fees garnered as part of their work, sometimes ten times the salary. See E. E. Hoon, *The Organization of the English Customs System, 1696–1786* (New York, 1938, reprinted with an introduction by R. C. Jarvis, 1968), 13, and entry of 24 August 1694: To pay the fee or salary of £34 per annum to William Clutterbuck as searcher of Bristol port. Money Book XIV, p. 419. From: 'Warrants etc: August 1699, 21–25', Calendar of Treasury Books, vol. 15, 1699–1700 (1933), pp. 133–138, https://www.british-history.ac.uk/report.aspx?compid=83226 Date accessed: 27 March 2009.
130. R. W. Moss, *Historic Houses of Philadelphia* (Philadelphia, 1998), 166–168.
131. Mooney, *Prodigy Houses*, 105–107, and table 9; W. M. Billings, J. E. Selby, and T. W. Tate, *Colonial Virginia: A History* (White Plains, NY, 1986), 200.
132. M. Dresser, *Slavery Obscured: The Social History of the Slave Trade in Bristol* (Bristol, 2007), 108–116; M. Dresser and A. Hahn, *Slavery and the British Country House* (Swindon, 2013), chapters 2 and 3.
133. D. Jones, 'The Elbridge, Woolnough and Smyth Families of Bristol'.

134. Longmore, 'Rural Retreats' and D. Pope, 'The Wealth and Social Aspirations of Liverpool's Slave Merchants of the Second Half of the Eighteenth Century', in D. Richardson, S. Schwarz, and A. Tibbles, (eds), *Liverpool and Transatlantic Slavery* (Liverpool, 2007), 164–226.
135. Walsh, *Motives*, 237–245, 414–417; T. H. Breen, *Tobacco Culture: The Mentality of the Great Tidewater Planters on the Eve of Revolution* (Princeton, 1985); M. Rozbicki, *The Complete Colonial Gentleman: Cultural Legitimacy in Plantation America* (Charlottesville, VA, 1998), 111–126; R. Isaac, *The Transformation of Virginia 1740–1790* (Chapel Hill, NC, 1982).
136. A. Chan, *Slavery in the Age of Reason: Archaeology at a New England Farm* (Knoxville, TN, 2007); HSP/James Logan Ledger, 1720–1727, for example, 1 January 1720, 21 July 1720, 22 August 1720.
137. GA/Palling-Carruthers Papers, Bundle 61 [MF1443].
138. Report from the Egerton MS 3440 (Leeds Papers vol. cxvii) appearing as Appendix 5 in Christopher Phillpotts, 'Stroudend Tithing Painswick, Gloucestershire Final Documentary Report' (unpublished report for the Stroudend Tithing Educational Trust, 2010), 162. I am grateful to Mr Michael Little for making available his copy of this report.
139. Wilson and Mackley, *Creating Paradise*, 298; Rothery and Stobart, 'Inheritance Events and Spending Patterns'; Walsh, *Motives*, 235–237, 462–471.
140. Cooper, *The Houses of the Gentry*, 18. Wilson and Mackley describe 'highly emulative social structures', *Creating Paradise*, 236.
141. Ibid., 112–117; Kingsley, *CHG II*, 128–133; *Dyrham Park* (London, 2002).
142. On Kings Weston see Kingsley, *CHG II*, 167–170; Gomme, Jenner, and Little, *Bristol: An Architectural History*, 107; Foyle, *PAGB*, 291–292; J. Musson, *The Country Houses of John Vanbrugh* (London, 2008).
143. See original floor plan in C. Campbell, *Vitruvius Britannicus*, vol. 1 (1715), 47–48.
144. Gomme, Jenner, and Little, *Bristol: An Architectural History*, 115.
145. Mowl, *To Build the Second City*, 14; N. Pevsner, *The Buildings of England: North Somerset and Bristol* (Harmondsworth, 1958), 362–363.
146. A. Bantock, *The Earlier Smyths of Ashton Court from Their Letters, 1545–1741* (Bristol, 1982), 256–257.
147. Cooper, *The Houses of the Gentry*, 246.
148. Atkyns, and Rudder, 796.
149. Sweeney, 'High Style Vernacular', 47–49.
150. E. C. Carter, (ed.), *The Virginia Journals of Benjamin Henry Latrobe, 1795–1798*, 2 vols (New Haven, 1977), vol. 1, 75–76.
151. Cornforth, *Early Georgian Interiors* (London and New Haven, 2004), 8.
152. D. Defoe, *A Tour thro' the Whole Island of Great Britain*, vol. 1 (London, 1724), 281.
153. James Logan to William Logan, 15 10 mo 1730, James Logan Letterbook, vol. 4, 208, HSP.
154. Wilson and Mackley, *Creating Paradise*, 240; Klein, 'Politeness and the Interpretation of the British Eighteenth Century', especially 886–888; R. L. Bushman, *The Refinement of America: Persons, Houses, Cities* (New York, 1992).
155. 'The Cit's Country Box, 1757', in Kenrick, (ed.), *The Poetical Works of Robert Lloyd*, vol. 1, 41–46.

4 Situating Status

1. D. Rollison, *The Local Origins of Modern Society: Gloucestershire 1500–1800* (London, 1992), 55.
2. G. E. Mingay, *English Landed Society in the Eighteenth Century* (London, 1963), 25.

3. P. Langford, *Public Life and the Propertied Englishman 1689–1798* (Oxford, 1991); E. Hart, *Building Charleston: Town and Society in the Eighteenth-Century British Atlantic World* (Charlottesville and London, 2010), 114.
4. Wilson and Mackley note that historians of landownership such as J. V. Beckett have paid comparatively little attention to the actual building of houses and their landscapes, see R. Wilson and A. Mackley, *Creating Paradise: The Building of the English Country House, 1660–1880* (London, 2000), 247, fn 20.
5. H. Lefebvre, *The Production of Space* (Oxford, 1991, originally published 1974) is a key text. See also J. Stobart, A. Hann, and V. Morgan, *Spaces of Consumption: Leisure and Shopping in the English Town, c. 1680–1830* (London, 2007), 2; M. Ogborn and C. Withers, (eds), *Georgian Geographies: Essays on Space, Place and Landscape in the Eighteenth Century* (Manchester, 2004), 1–3.
6. Quoted in R. Isaac, *The Transformation of Virginia 1740–1790* (Chapel Hill, NC, 1982), 74.
7. L. J. Hall, 'Yeoman or Gentleman? Problems in Defining Social Status in Seventeenth- and Eighteenth-Century Gloucestershire', *Vernacular Architecture*, vol. 20 (1991), 2–19, 8. In Delaware, genteel two-storey brick houses 'stood out against the land', R. L. Bushman, *Refinement of America: Persons, Houses, Cities* (New York, 1992), 15.
8. J. Harris, *A Country House Index: An Index to over 2000 Country Houses Illustrated in 107 Books of Country Views Published between 1715 and 1872, Together with a List of British Country House Guides and Country House Art Collection Catalogues for the Period 1726–1880* (London, 1979).
9. N. Cooper, 'Rank, Manners and Display: The Gentlemanly House, 1500–1750', *Transactions of the Royal Historical Society*, vol. 12 (2002), 308.
10. J. Varley, 'John Rocque: Engraver, Surveyor, Cartographer and Map-Seller', *Imago Mundi*, vol. 5 (1948), 83–91; M. H. Edney, 'Mathematical Cartography and the Social Ideology of British Cartography', *Imago Mundi*, vol. 46 (1994), 101–116, 101; M. Bruckner, *The Geographic Revolution in Early America: Maps, Literacy, and Natural Identity* (Chapel Hill, NC, 2006).
11. See, for example, J. Millerd, *An Exact Delineation of the Famous Cittie of Bristoll and Suburbs Therof* (Bristol, 1671); J. Rocque, *A Collection of Plans of Principal Cities of Great Britain and Ireland with Maps of the Coast of Said Kingdoms* (London, 1764). B. Donn[e], *This Map of the Country 11 Miles Round the City of Bristol* (London, 1769), also found at BRO/Bristol Plan232c/30120(3); *A Plan of the City and Environs of Philadelphia, Surveyed by N. Scull and G. Heap. Engraved by Willm Faden. 1777*, Library Company of Philadelphia P.2008.34.3; I. Taylor, *The County of Gloucester* (London, 1800).
12. Wilson and Mackley, *Creating Paradise*, 297.
13. Wilson and Mackley, *Creating Paradise*, 7; F. M. L. Thompson, *English Landed Society in the Nineteenth Century* (London, 1963), 109–118.
14. Atkyns, 400.
15. *VCH: G*, vol. 9, 'Dowdeswell', 42–69.
16. 'The Jewel in the Crown: Sandywell Park', in *Andoversford Village: 2000 Years in the Making* (Andoversford, 2000).
17. GA/D1833/E1: 'A Survey of the Estates of Jam.s Rooke, Esq. of Bigswear in the County of Gloucester &c.', c. 1770–1797.
18. B325/51387: F. A. Hyett, *The Hyetts of Painswick* (1907), 31.
19. Ibid., 76.
20. GA/D6/E4: 'Survey of Certain Estates belonging to Benjamin Hyett, Esq. in the county of Gloucester', 1780.
21. GA/D6/E6: 'A Rental of the Estates of Benjamin Hyett Esqr., which have been measured mapped and surveyed distinguishing the present Rents and the Valuation of each Estate as sett by Mr Stone'.
22. GA/D149/E6: June 1768 survey of estate; 1768 estate map and Enclosure Map, 1815, Frampton Court collection. See also R. Hewlett and J. Speed, *Frampton on Severn: An Illustrated History* (Nailsworth, Gloucestershire, 2007), 107.

23. Frampton Court Collection, Richard Clutterbuck account book, 1768–1772.
24. B. B. Mooney, *Prodigy Houses: Architecture and the Native Elite* (Charlottesville, VA, 2008), 114–115.
25. W. Penn, *Fruits of Solitude* (New York, 1693, reprint in 1903), 49.
26. Figures 2–5 in C. L. Cavicchi, 'Pennsbury Manor Furnishing Plan', Morrisville, PA (Unpublished MS, 1988), 58 ff.
27. S. B. Kim, *Landlord and Tenant in Colonial New York: Manorial Society, 1664–1775* (Chapel Hill, NC, 1978).
28. W. Johnson, Sir, *Papers of Sir William Johnson* (Albany, 1921–1965) [*Papers of Sir William Johnson* hereafter *PSWJ*], vol. 1, 395.
29. Stenton HSP, 2.
30. P. J. Corfield, 'The Rivals: Landed and Other Gentlemen', in N. Harte and R. Quinault, (eds), *Land and Society in Britain, 1700–1914* (Manchester, 1996), 1–33, 18.
31. L. Stone and J. F. Stone, *An Open Elite? England 1540–1880* (Oxford, 1984), 22.
32. N. Roger, 'Money, Land, and Lineage: The Big Bourgeoisie of Hanoverian London', *Social History*, vol. 4, no. 3 (October 1979), 437–454, 452.
33. R. G. Wilson, *Gentlemen Merchants: The Merchant Community in Leeds, 1700–1830* (Manchester, 1971), 223.
34. See, for example, BRO/AC/WO/12 Elbridge Papers: Stainer estate; BRO/AC/WO/13 Elbridge Papers: Estate of Christopher Cole; BRO/AC/WO/14 Elbridge Papers: Stephen's estate, Horsley and Eastington, Glos.; BRO/AC/WO/20 Elbridge Papers: Hanham, Glos..
35. Quoted in Phillpotts, 'Stroudend Tithing Report', 95, from *Historical Manuscripts Commission – Portland* ii 304.
36. E. A. L. Moir, 'The Gentlemen Clothiers: A Study of the Organization of the Gloucestershire Cloth Industry, 1750–1835', in H. P. R. Finberg, (ed.), *Gloucestershire Studies* (Leicester, 1957), 240; Rudder, 711.
37. Phillpotts, 'Stroudend Tithing Report', 78–79 and Appendix 4.
38. E. C. Little, *Our Family History* (1892), 14; Phillpotts, 'Stroudend Tithing Report', 80.
39. GA/Palling-Carruthers Papers, Bundle 61 [MF1443]. Phillpotts, 'Stroudend Tithing Report', 79.
40. H. R. French, '"Ingenious and Learned Gentlemen": Social Perceptions and Self-fashioning among Parish Elites in Essex, 1680–1740', *Social History*, vol. 25, no. 1 (January 2000), 44–66, 45. Italics in original.
41. Cooper, *The Houses of the Gentry 1480–1680* (New Haven and London, 1999), 249.
42. Wilson and Mackley, *Creating Paradise*, 8.
43. B. Heller, 'Leisure and Pleasure in London Society, 1760–1820: An Agent-centred Approach' (D.Phil. thesis, University of Oxford, 2009), 77, 80.
44. Wilson and Mackley, *Creating Paradise*, 8. See also Mingay, *English Landed Society in the Eighteenth Century*, 20–23.
45. Ackerman, *The Villa: Form and Ideology of Country Houses* (Princeton, 1995); Arnold, (ed.), *The Georgian Villa* (Stroud, 1998); Archer, *Architecture and Suburbia: From English Villa to American Dream House, 1690–2000* (Minneapolis and London, 2005); Airs and Tyack, (eds), *The Renaissance Villa in Britain, 1500–1700* (Reading, 2007); E. McKellar, 'The Suburban Villa Tradition in Seventeenth and Eighteenth-Century London', in B. Arciszewska, (ed.), *The Baroque Villa: Suburban and Country Residences, c. 1600–1800* (Wilanow, Poland, 2009), 197–208; D. Gerhold, 'London's Suburban Villas and Mansions, 1660–1830', *The London Journal*, vol. 34, no. 3 (November 2009), 233–263; T. R. Slater, 'Family, Society and the Ornamental Villa on the Fringes of English Country Towns', *Journal of Historical Geography*, vol. 4, no. 2 (April 1978), 129–144.
46. T. Nourse, *Campagna Felix* (London, 1700), 297.
47. N. Cooper, 'The English Villa: Sources, Forms and Functions', in Airs and Tyack, (eds), *The Renaissance Villa in Britain, 1500–1700*, 15 and 24.
48. D. Arnold, (ed.), *The Georgian Villa*, ix–x.
49. R. North, *Of Building*, H. Colvin and J. Newman, (eds) (Oxford, 1981), 62.

50. Stobart, Hann and Morgan, *Spaces of Consumption*, 4.
51. Estabrook, *Urbane and Rustic England*, 3–5.
52. R. Sweet, 'Topographies of Politeness', *Transactions of the Royal Historical Society*, vol. 12 (2002), 355–374; Borsay, *English Urban Renaissance: Culture and Society in the Provincial Town 1660–1770* (Oxford, 1989); Hart, *Building Charleston*.
53. P. T. Marcy, 'Eighteenth-Century Views of Bristol and Bristolians', in P. McGrath, (ed.), *Bristol in the Eighteenth Century* (Newton Abbot, 1972), 11–40.
54. J. Macky, *A Journey through England: In Familiar Letters from a Gentleman Here, to his Friend Abroad* (London, 1722), vol. 2, 134.
55. Quoted in Sweet, 'Topographies of Politeness', 364.
56. *London Magazine, Or, Gentleman's Monthly Intelligencer* for October 1761 [LCP Per L 62.5 74.O].
57. B. Harris, 'Cultural Change in Provincial Scottish Towns, c. 1700–1820', *The Historical Journal*, vol. 54, no. 1 (2011), 105–141; J. Stobart, 'Culture Versus Commerce: Societies and Spaces for Elites in Eighteenth-Century Liverpool', *Journal of Historical Geography*, vol. 28, no. 4 (October 2002), 471–485.
58. C. Lounsbury, *Essays on Early American Architecture: A View from the Chesapeake* (Charlottesville and London, 2011), 114.
59. Foyle, *PAGB*, 208–217.
60. Estabrook, *Urbane and Rustic England*, 6–7, and the map by B. Donne, *This Map of the Country 11 Miles Round the City of Bristol* (London, 1769).
61. B. Donne, *This Map of the Country 11 Miles Round the City of Bristol* (London, 1769).
62. See for example a letter of 1767 addressed from William Champion in London to 'Mr Tho Goldney at Clifton near Bristol', emphasizing that Clifton was near but not part of Bristol, GA/D421/B, 12 June 1767. On Clifton, see D. Jones, *A History of Clifton* (Chichester, 1992); BRO/SMV/6/5/4/3: Jacob de Wilstar, 'A Survey of the Mannor of Clifton in the County of Gloucester Being part of the Estates belonging to the Merchants Hall at Bristol' (1746).
63. Rudder, 375, 377.
64. BRO/SMV/6/5/4/3: de Wilstar, 'A Survey of the Mannor of Clifton' (1746), 29 and 31.
65. Rudder, 377.
66. The second canto of 'Clifton' is reproduced in Rudder, 380–381.
67. Roger Leech has proposed that many of the dwellings erected by merchants near Bristol and elsewhere in the Atlantic world were suburban or country residences for occasional use, see R. H. Leech, 'Charlestown to Charleston: Urban and Plantation Connections in an Atlantic Setting', in D. Shields, (ed.), *Material Culture in Anglo-America: Regional Identity and Urbanity in the Tidewater, Lowcountry and Caribbean* (Columbia, SC, 2009), 170–187, at 184. My research suggests a somewhat different reading.
68. A recent article has conjectured that Goldney's new house, constructed in the 1720s, was smaller than generally assumed and used largely as a 'garden house', or second residence. See R. H. Leech, 'Richmond House and the Manor of Clifton', in M. Crossley-Evans, (ed.), *'A Grand City' – 'Life, Movement and Work': Bristol in the Eighteenth and Nineteenth Centuries, Essays in Honour of Gerard Leighton, FSA* (Bristol, 2010), 27–46, 36–38. Physical and documentary evidence raises some questions about this. Thomas Goldney II recorded the births of his children there, suggesting much more than a garden house retreat. P. K. Stembridge, *The Goldney Family: A Bristol Merchant Dynasty* (Bristol, 1998), 87–89. Thomas Goldney III is listed as 'of Clifton' in a range of documents and seems to have used Goldney House as his primary residence. On garden houses, see R. H. Leech, 'The Garden House: Merchant Culture and Identity in the Early Modern City', in S. Lawrence, (ed.), *Archaeologies of the British: Explorations of Identity in Great Britain and its Colonies, 1600–1945*, One World Archaeology Series, vol. 46 (2003), 76–86.

69. A. Burnside, *A Palladian Villa in Bristol: Clifton Hill House and the People Who Lived There* (Bristol, 2009).
70. I. Ware, *Complete Body of Architecture* (London, 1756), 405.
71. TNA/PROB11/884; Burnside, *A Palladian Villa in Bristol*, 19–21; A. Burnside and S. B. Brennan, 'Paul Fisher: Linen-Draper and Merchant, of Clifton Hill House', in M. Crossley-Evans, (ed.), *'A Grand City' – 'Life, Movement and Work': Bristol in the Eighteenth and Nineteenth Centuries, Essays in Honour of Gerard Leighton, FSA* (Bristol, 2010), 47–62.
72. Longmore, 'Rural Retreats', in Dresser and Hahn, (eds), *Slavery and the English Country House*, 36, 39.
73. J. Day, 'The Champion Family (per 1670–1794)' *Oxford Dictionary of National Biography* (Oxford, online edition, 2004). See also Stembridge, *The Goldney Family*, 22; Martha had acquired the property shortly before their marriage, see Nuffield Health, St Mary's Hospital archives, Indenture, 17 August 1742. Champion and Martha married in September 1742, Thomas Goldney Record Book, University of Bristol Library/DM1398: 'Nehem: Champion Sen:r to my Sister VandeWall, 7:br 16th 1742 [16 September 1742] [University of Bristol Library hereafter UBL].
74. BRO/SMV/6/5/4/3: de Wilstar survey (1746), 32.
75. A. Gomme, M. Jenner, and B. Little, *Bristol: An Architectural History* (London, 1979), 152.
76. BRO/SMV/4/6/1/40: Charities, St Monica Home, Cote Deeds explained, n.d., probably c. 1930.
77. See, for example, BRO/AC/WO/10/18: March 1738/9, 'Inventory and Appraisement of Royal Fort, St Michaels Hill'; BRO/AC/WO/11/1/a: 9 April 1739 'Case on the Will of John Elbridge Esq. deceased on behalf of Henry Woolnough and Rebecca his wife'; BCL/No. B19716, Letter from Customhouse, Bristol, 26 March 1739.
78. J. Charlton and D. M. Milton, *Redland 791 to 1800* (Bristol, 1951), 38.
79. B. Donn, *This Map of the Country 11 Miles Round the City of Bristol* (London, 1769); 'Plan of the Redland Court Estate, 1811', Collection of the Redland School for Girls.
80. TNA/C12/679/15: Daubeny v. Baker; TNA/C12/980/25: Daubeny v. Baker; The *London Gazette* 11–14 May 1799, quoted in J. Charlton and D. M. Milton, *Redland*, 55–57.
81. R. Bigland, *Historical, Monumental and Genealogical Collections toward a History of Gloucestershire*, 3 vols (London, 1789–1887, reprint Gloucester, 1989–1995), part 2, vol. 3, 833; BRO/AC/AS/57/3: Copy Will of John Andrews, drawn up on 10 June 1743 with a codicil of 3 December 1743.
82. R. Mortimer, (ed.), *Minute Book of the Men's Meeting of the Society of Friends in Bristol, 1686–1704*, Bristol Record Society, vol. 30 (Bristol, 1977), 233: John Andrews (d. 1743, of Castle Precincts) merchant.
83. *A Plan of the City and Environs of Philadelphia, Surveyed by N. Scull and G. Heap. Engraved by Willm Faden. 1777.* LCP/P.2008.34.3.
84. Quoted in A. Chan, *Slavery in the Age of Reason: Archaeology at a New England Farm* (Knoxville, TN, 2007), 57.
85. Hart, *Building Charleston*, 119, figure 4.1.
86. Ibid., 113–114; Lounsbury, *Essays*, 117.
87. Rudder, 629.
88. GA/D25/2/18: Deeds of Hill House estate and GA/D67/Z/28: Digest of Deed of Hill House Estate lists the estate as 51 acres; Rudder, 629.
89. Moir, 'Sir George Onesiphorus Paul', in H. P. R. Finberg, (ed.), *Gloucestershire Studies* (Leicester, 1957), 195–224.
90. T. R. Slater, 'Family, Society and the Ornamental Villa', 131.
91. See Rudder, Atkyns, and the de Wilstar survey (BRO/SMV/6/5/4/3). As one study of Highgate near London confirms, the sort of small classical house considered here – 'we would label it a villa' – was called a mansion in contemporary accounts, see McKellar, 'The Suburban Villa Tradition', 207.
92. Stone and Stone, *An Open Elite?* 329–330.

93. Important works on eighteenth-century landscape and gardens, again focused on larger landscapes, include: T. Williamson, *Polite Landscapes: Gardens and Society in Eighteenth-Century England* (Stroud, 1995); J. Dixon Hunt and P. Willis, (eds), *The Genius of the Place: The English Landscape Garden, 1620–1820* (Cambridge, MA, 1988); T. Richardson, *Arcadian Friends: Inventing the English Landscape Garden* (London, 2007); T. Mowl, *Gentleman and Players: Gardeners of the English Landscape* (Stroud, 2000).
94. Girouard, *Life in the English Country House: A Social and Architectural History* (New Haven and London, 1978), 151.
95. Bushman, *Refinement of America*, 138.
96. Rudder, 442; Hobson, *The Raymond Barkers of Fairford Park*, Fairford History Society Monograph 3 (November 2007) 14–15.
97. Kingsley, *CHG II*, 68.
98. Rudder, 667.
99. Kingsley, *CHG II*, 198; T. Mowl and R. White, 'Thomas Robins at Painswick', *Journal of Garden Design*, vol. 4, no. 2, 163–178. See also M. Richards, 'Two Eighteenth-Century Gloucester Cardens', *TBGAS*, vol. 99 (1981), 123–126.
100. J. J. Cartwright, (ed.), *The Travels through England of Dr Richard Pococke, Successively Bishop of Meath and of Ossory during 1750, 1751, and Later Years*, 2 vols (London, 1888–1889), vol. 2, 270.
101. J. Milne and T. Mowl, *Castle Godwyn: A Guide and an Architectural History* (Painswick, 1996), 9–10; C. Woodward, 'Castle Godwyn' *Country Life* (27 September 2007), 130–135.
102. T. Mowl, *Historic Gardens of Gloucestershire* (Stroud, 2002), 83–88.
103. Painting of Pitchcombe, House, private collection.
104. Williamson, 'Archaeological Perspectives on Landed Estates: Research Agendas', in J. Finch and K. Giles, (eds), *Estate Landscapes: Design, Improvement and Power in the Post-medieval Landscape* (Woodbridge, Suffolk, 2007), 1–16, 9.
105. M. Binney, 'Poulton Manor', *Country Life* (26 May 1976), 1400.
106. Rudder, 796.
107. Map, drawn from a missing original by Ellis Marsden, 1918, in W. St Clair Baddeley, *A Cotteswold Manor: Being the History of Painswick* (Gloucester, 1929), 34; *Gloucester Journal*, Tuesday, 11 February 1755.
108. GA/D149/Z1. The landscape is illustrated on a plan drawn in 1730, presumably to document the existing condition of the estate before Richard's major renovations. See GA/D149/P17.
109. J. Cornforth, *Early Georgian Interiors* (London and New Haven, 2004), 23; G. Worsley, *The British Stable* (New Haven and London, 2004).
110. GA/D149/P17. I am especially grateful to Rose Hewlett for her insights into the location and development of the two houses.
111. Compare GA/D149/P17, Plan of Frampton House, 1730, and the 1768 estate map, Frampton Court collection, with accompanying terrier, GA/D149/E6. See E. Clutterbuck, *The Clutterbuck Diaries, Being the Journey with my Wife and Daughter Sally into Gloucestershire on a Visit to my Cousin Clutterbuck at King Stanley* [1773], with notes by The Rev. Robert Nott and T. E. Sanders (Stroud, 1935) for Wednesday, 14 July 1773, describing a visit to Frampton Court, including the greenhouse, plants in it, and the use of various parts of the house.
112. Bigland, part 2, vol. 3, 618.
113. BRO/SMV/6/5/4/3: de Wilstar survey (1746).
114. Quoted in Stembridge, *Thomas Goldney's Garden: The Creation of an Eighteenth Century Garden* (Clifton, 1996), 26.
115. C. L. Blecki and K. A. Wulf, (eds), *Milcah Martha Moore's Book: A Commonplace Book from Revolutionary America* (University Park, PA, 1997), 208–209.
116. Stembridge, *Thomas Goldney's Garden*. He was likely inspired by his father's interest in botany, see for example, James Logan Letterbooks, Box 2, B1, 86–87, JL to Thomas Goldney, 23 October 1727; Box 2, B2, 86, James Logan to Thomas Goldney, 30 June 1730. Copies at Stenton. Originals at the Historical Society of Pennsylvania.

117. William Penn to James Harrison, 25 October 1685, in R. S Dunn and M. M. Dunn, *The Papers of William Penn* (Philadelphia, 1986), vol. 3, 65–68.
118. J. Oldmixon, *The British Empires in North America* (London, 1708) vol. 1, 176.
119. Thomas Graeme to Thomas Penn, 1 July 1755, *Penn Manuscripts: Official Correspondence 1728-1734*, HSP, vol. 7, 67.
120. Bushman, *Refinement of America*, 133.
121. Ibid., 129.
122. See the discussion of Fairhill in M. Reinberger and E. McLean, 'Isaac Norris's Fairhill: Architecture, Landscape, and Quaker Ideals in a Philadelphia Colonial Country Seat', *Winterthur Portfolio*, vol. 32, no. 4 (Winter 1997), 243–274.
123. Sweeney, 'Mansion People: Kinship, Class, and Architecture in Western Massachusetts in the Mid Eighteenth Century', *Winterthur Portfolio*, vol. 19, no. 4 (Winter 1984), 231–255, 242, figure 7.
124. Chan, *Slavery in the Age of Reason*, 41, figure 19.
125. Mooney, *Prodigy Houses*, 257, figure 137.
126. C. Wells, 'The Planters Prospect: Houses, Outbuildings, and Rural Landscapes in Eighteenth-Century Virginia', *Winterthur Portfolio*, vol. 28, no. 1 (Spring 1993), 1–31.
127. J. Tucker, *Instructions for Travellers* (London, 1757), 25.
128. J. M. Vlatch, *The Planter's Prospect: Privilege and Slavery in Plantation Paintings* (Chapel Hill, NC and London, 2002).
129. Atkins Heritage, 'Champion's Brassworks and Gardens Conservation Management Plan' (Unpublished report, January 2007), figure 2 and especially 28–34.
130. All this in 1754 according to Swedish industrial spy Reinhold Angerstein, quoted in Atkins Heritage, 'Champion's Brassworks and Gardens Conservation Management Plan', 21.
131. A. P. Woolrich, (ed.), *Ferner's Journal, 1759–1760: An Industrial Spy in Bath and Bristol* (Eindhoven, 1986), 32.
132. A. Young, *A Six weeks Tour through the Southern Counties of England and Wales* (London, 1768), 150.
133. Atkins Heritage, 'Champion's Brassworks and Gardens Conservation Management Plan', 22.
134. Quoted in Lambert, 'The Prospect of Trade: The Merchant Gardeners of Bristol in the Second Half of the Eighteenth Century', in M. Conan, (ed.), *Bourgeois and Aristocratic Encounters in Garden Art, 1550–1850*, vol. 23 (Washington, DC, 2002), 123–145, 137.
135. A. Vickery, 'An Englishman's Home Is His Castle? Thresholds, Boundaries and Privacies in the Eighteenth-Century London House', *Past and Present*, no. 199 (May 2008), 153–158.

5 Arranging Status

1. A. Flather, *Gender and Space in Early Modern England* (Woodbridge, 2007), 2.
2. For discussion of their methodology, see L. Stone and J. F. Stone, *An Open Elite? England 1540–1880* (Oxford, 1984), Appendix 2, 437–458.
3. Stone and Stone, *An Open Elite?* especially tables 2.6 and 2.7.
4. The average gentleman's house contained 6,000 square feet within its main block. Allocating space for service functions yields a total of 4,000 square feet, or forty Stone units.
5. Worsley, *Classical Architecture in Britain: The Heroic Age* (New Haven and London, 1995), 171 and Reiff, *Small Georgian Houses in England and Virginia: Origins and Development through the 1750s* (London, 1986), 323, Appendix 2, table 6, contend American houses were larger. The alternate view, S. G. Hague, 'Historiography and the Origins of the Gentleman's House in the British Atlantic World', in O. Horsfall Turner, (ed.), *'The Mirror of Great Britain': National Identity in Seventeenth-Century British Architecture* (Reading, 2012), 233–259, table 1, 254.

6. See, for example, the comparison of double and single-storey entrance halls in Cornforth, *Early Georgian Interiors* (London and New Haven, 2004), 23–38.
7. An unusual example is Tazewell Hall in Virginia, see M. Wenger, 'The Central Passage in Virginia: Evolution of an Eighteenth-Century Living Space', *Perspectives in Vernacular Architecture*, vol. 2 (1986), 137–149, 142–145, especially figure 10.
8. J. Ayres, *Domestic Interiors: The British Tradition 1500–1850* (New Haven and London, 2003), viii; B. L. Herman, *Town House: Architecture and Material Life in the Early American City, 1780–1830* (Chapel Hill, NC, 2005), 39.
9. Cornforth, *Early Georgian Interiors*, 3. The compact floor plan has received its fullest treatment in A. H. Gomme and A. Maguire, *Design and Plan in the Country House: From Castle Donjons to Palladian Boxes* (New Haven and London, 2008). See also M. Girouard, *Life in the English Country House: A Social and Architectural History* (New Haven and London, 1978), 150–151; Worsley, *Classical Architecture in Britain*, 10–19, 21–31; N. Cooper, *The Houses of the Gentry: 1480–1680* (New Haven and London, 1999), 244–249; J. Bold, 'The Design of a House for a Merchant, 1724', *Architectural History*, vol. 33 (1990), 75–82; P. Smith, 'Plain English or Anglo-Palladian? Seventeenth-Century Country Villa Plans', in M. Airs and G. Tyack, (eds), *The Renaissance Villa in Britain 1500–1700* (Reading, 2007), 89–110.
10. Girouard, *Life in the English Country House*, chapter 5 'The Formal House' and 7 'The Social House', especially 123–128, 144, 194.
11. Klein, 'Politeness and the Interpretation of the British Eighteenth Century', *The Historical Journal*, vol. 45, no. 4 (December 2002), 869–898, 887.
12. Girouard, *Life in the English Country House*, 151.
13. Gomme and Maguire, *Design and Plan in the Country House*, 73, 289–290.
14. E. Chappell, 'Fieldwork', in C. Carson and C. R. Lounsbury, (eds), *The Chesapeake House: Architectural Investigations by Colonia Williamsburg* (Chapel Hill, NC, 2013), 29–47, at 38–39.
15. Gomme and Maguire, *Design and Plan*, 282.
16. Bushman, *The Refinement of America: Persons, Houses, Cities* (New York, 1992), 7. See also Reiff, *Small Georgian Houses*; B. B. Mooney, *Prodigy Houses of Virginia: Architecture and the Native Elite* (Charlottesville, VA, 2008).
17. Hall, 'Yeoman or Gentleman? Problems in Defining Social status in Seventeenth- and Eighteenth-Century Gloucestershire', *Vernacular Architecture*, vol. 20 (1991), 2–19, 5, 8. It should be noted that Hall's sample is not restricted to classical houses. Rooms and room use are also explored in M. Overton, J. Whittle, D. Dean, and A. Hann, *Production and Consumption in English Households, 1600–1750* (London, 2004), chapter 6.
18. My calculations based on P. Jenkins, *The Making of a Ruling Class: The Glamorgan Gentry, 1640–1790* (Cambridge, 1983), Appendices 2 and 3, 292–293.
19. E. T. Cooperman, 'Historic Context Statement: Cluster 1: Frankford, Tacony, Wissinoming, Brideburg' (Unpublished report for Preservation Alliance for Greater Philadelphia, July 2009), 10–12.
20. Cornforth, *Early Georgian Interiors*, 23.
21. Carson and Lounsbury, (eds), *Chesapeake House*, 123, 139. These are what Mooney describes as vestigial hall plans, *Prodigy Houses*, 62–65.
22. BRO/14581/HA/D/313: Particulars and Conditions of Sale, Hill House, Mangotsfield, 9 April 1874. The floor plan shows the main house from the 1730s as about forty-five foot by forty foot, with later additions.
23. Carson and Lounsbury, (eds), *Chesapeake House*, 133, 137.
24. Mooney, *Prodigy Houses*, 68; Wenger, 'The Central Passage'.
25. A. Gomme, 'Halls into Vestibules', in M. Airs and G. Tyack, (eds), *The Renaissance Villa in Britain 1500–1700* (Reading, 2007), 38–63, quote on 40. Cornforth argues that in larger country houses, the main door was seldom used, with the preference for side entrances. The number of entrances in compact plans tended to be rather smaller, suggesting that

Notes for pages 78–84 181

this practice was less likely to have been true of gentlemen's houses. Cornforth, *Early Georgian Interiors*, 19–20.
26. Ayres, *Domestic Interiors*, chapter 5.
27. Gomme and Maguire, *Design and Plan in the Country House*, 3.
28. Atkyns, between 428 and 429.
29. UBL/DM1398/A: Copy Inventory of furniture and effects at Goldney House, 1768.
30. R. Moss, *Historic Houses of Philadelphia* (Philadelphia, 1998), 96.
31. Eighteenth-century architectural books 'emphasize the symmetry and geometry of the house but seldom explain how they worked'. Cornforth, *Early Georgian Interiors*, 275.
32. A. Vickery, *Behind Closed Doors: At Home in Georgian England* (New Haven and London, 2009), 203.
33. GA/D45/F2: Inventory and valuation of goods of Richard Whitmore of Lower Slaughter, 31 January 1687/1688.
34. At Paradise, for instance, there are four main rooms on the ground floor, not including the hall/passage. Mark Wenger describes the development of halls in Virginia houses from a passage to a living space, a shift 'approaching the old hall in importance'. Wenger, 'The Central Passage'.
35. For rooms in Chesapeake houses, see Carson and Lounsbury, (eds), *Chesapeake House*, 132–140, 334–342; Sweeney, 'High Style Vernacular: Lifestyles of the Colonial Elite', in C. Carson, R. Hoffman, and P. J. Albert, *Of Consuming Interests: The Style of Life in the Eighteenth Century* (Charlottesville and London, 1994), 1–58, 18–20; Bushman, *The Refinement of America*, 118–120.
36. Carson and Lounsbury, (eds), *Chesapeake House*, 146.
37. R. Isaac, *The Transformation of Virginia 1740–1790* (Chapel Hill, NC, 1982), 75.
38. GA/D149/F7: 1683 Note of personal estate of John Clifford, with inventory of goods.
39. R. B. St George, 'Reading Spaces in Eighteenth-Century New England', 90–103 and K. Lipsedge, '"Enter into thy Closet": Women, Closet Culture, and the Eighteenth-Century Novel', 107–122, especially 109–112, in J. Styles and A. Vickery, (eds), *Gender, Taste, and Material Culture in Britain and North America 1700–1830* (New Haven and London, 2006); J. Bold, 'The Design of a House for a Merchant, 1724', 80; Vickery, 'An Englishman's Home Is His Castle?' 147–173.
40. Hall, 'Yeoman or Gentleman?' 2–19; On stairs, Gomme and Maguire, *Design and Plan in the Country House*, 152–172; For Parlor and Stair Halls, see also Bushman, *The Refinement of America*, 114–122.
41. Ayres, *Building the Georgian City* (New Haven and London, 1998), 120.
42. GA/D45/E14: Bill of Thomas and Samuel Collett, 'From ye 1st of March 1759 to the 25th of December 1760 My Self 45 days Drawing Defining and Making Moulds for Masons and Attending the Workmen'.
43. R. Leech, 'Clifton Wood House, Randall Road, Clifton, Bristol: An Archaeological Desk-based Assessment' (Unpublished report, 2003), 17. Many thanks to Prof. Leech for kindly sharing this report.
44. Weatherill, *Consumer Behavior and Material Culture 1660–1760* (London, second edition, 1996), 11–13.
45. UBL/DM1398/A: Copy Inventory of furniture and effects at Goldney House, 1768.
46. Saumarez Smith, *Eighteenth-Century Decoration: Design and the Domestic Interior in England* (New York, 1993), plates 37, 73, 76, 81, 89, 90, 105, 106, 133, 137, 138, 157.
47. Cornforth argues that because of the use of the Common Parlour for a range of daily activities, it should attract more attention as a room of key importance. Cornforth, *Early Georgian Interiors*, 38–40.
48. Ibid., 121, notes the importance of marble for chimneypieces.
49. Ibid., 195 and figure 259. At Frampton Court tiles appear in fireplaces on the ground and first floor.
50. Ibid., 49–50.

51. Gomme and Maguire, *Design and Plan in the Country House*, 185.
52. Girouard, *Life in the English Country House*, 151.
53. The presence of a separate kitchen was an important shift in the late seventeenth and early eighteenth centuries, see Vickery, *Behind Closed Doors*, 266.
54. Information from physical examination and from owner.
55. J. M. Vlach, *Back of the Big House: The Architecture of Plantation Slavery* (Chapel Hill, NC and London, 1993), chapter 4.
56. GA/D149/E6 and map in Frampton Court collection, June 1768.
57. Girouard, *Life in the English Country House*, 138, 151.
58. A. Bantock, *The Earlier Smyths of Ashton Court from their Letters 1545–1741* (Bristol, 1982), 256–257.
59. Girouard, *Life in the English Country House*, 140–143, 206–208.
60. BRO/AC/WO/10/19: 2 April 1739, Inventory of the goods of John Elbridge at his house at Stoke, Westbury [Cote House].
61. Whyman, *Sociability and Power in Late-Stuart England: The Cultural Worlds of the Verneys 1660–1720* (Oxford, 1999), especially 100–107.
62. Despite Ian Bristow's work cited below, paint analysis is lacking for British interiors especially at the level of housing considered here. This is an area where more technical investigation could yield rich research results. See H. Hughes, (ed.), *Layers of Understanding: Setting Standards for Architectural Paint Research* (London, 2002); M. A. Jablonski and C. R. Matsen, (eds), *Architectural Finishes in the Built Environment* (London, 2009).
63. C. Carson, 'Introduction', in Carson and Lounsbury, (eds), *Chesapeake House*, 9. For detailed analysis, see chapters 12–16.
64. HSP/Chew Papers, copy on file at Cliveden, Receipt for 'Painting a Carpitt' at Cliveden, 3 April 1767.
65. Ayres, *Domestic Interiors*, 86–90; C. Gilbert, J. Lomax, and A. Wells-Cole, *Country House Floors, 1660–1850* (Leeds, 1987). Leech, 'Clifton Wood House', 17.
66. I. Bristow, *Architectural Colour in British Interiors, 1615–1840* (New Haven and London, 1996), 53.
67. Carson and Lounsbury, (eds), *Chesapeake House*, 318.
68. Cornforth, *Early Georgian Interiors*, 113.
69. Ayres, *Domestic Interiors*, 54; Bristow, *Architectural Colour in British Interiors*, 38.
70. I am particularly grateful to James Ayres and Laura Keim for their observations about these features.
71. Bristow, *Architectural Colour in British Interiors*, 1, 11–12, 31–34.
72. Kingsley, *CHG II*, 83.
73. Will of Thomas Goldney II, quoted in P. K. Stembridge, *The Goldney Family: A Bristol Merchant Dynasty* (Bristol, 1998), 111; UBL/DM1398/A: Copy Inventory of furniture and effects at Goldney House, 1768.
74. A. Bowett, 'The Commercial Introduction of Mahogany and the Naval Stores Act of 1721', *Furniture History*, vol. 30 (1994), 116–123; C. Edwards, *Eighteenth-Century Furniture* (Manchester, 1996), 77–78.
75. M. Reinberger and E. McLean, 'Isaac Norris's Fairhill: Architecture, Landscape and Quaker Ideals in a Philadelphia Colonial Country Seat', *Winterthur Portfolio*, vol. 32, no. 4 (Winter 1997), 243–274, 251.
76. Examples may be seen at Frampton Court and Goldney house.
77. Ayres, *Domestic Interiors*, 57.
78. Bristow, *Architectural Colour in British Interiors*, 53. Cornforth notes that there a major change in the way houses were painted between 1700 and 1740 coincided with a move away from wood paneling left in its natural state. Cornforth, *Early Georgian Interiors*, 114.
79. I. Ware, *A Complete Body of Architecture* (London, 1756), 469; BRO/09467/12/a: 'Notes and Receipts for House Building at Clifton 1746-47-48-49 + 1750 + c'.

80. Carson and Lounsbury, (eds), *Chesapeake House*, 330.
81. Bristow, *Architectural Colour in British Interiors*. Descriptions of painting techniques and materials can be found in I. Bristow, *Interior House-Painting Colours and Technology, 1615–1840* (New Haven and London, 1996). E. Chappell, 'Fieldwork', in Carson and Lounsbury, (eds), *Chesapeake House*, at 40, and chapter 15 in the same.
82. Bristow, *Architectural Colour in British Interiors*, 40, 48.
83. Ibid., 51.
84. W. Salmon, *Palladio Londinensis* (London, 1734), 57–58. Prices ranged from 'best white lead' at 4d. per pound to 2s. 6d. per pound for 'fine deep green'. Paint costs drawn from surviving accounts can be found in Bristow, *Architectural Colour in British Interiors*, 35, and *Interior House-Painting Colours and Technology*, Appendix A.
85. L. C. Keim, 'Stenton Room Furnishings Study' (MS report, 2010, on file at Stenton); M. Mosca, 'Stenton Paint Analysis' (Unpublished report, 2000, on file at Stenton); J. G. Volk, (ed.), *The Warner House: A Rich and Colorful History* (Portsmouth, NH, 2006), chapter 2, figure 2.7. W. Graham, 'Architectural Paint Research at American Museums: An Appeal for Standards', in Jablonski and Matsen, (eds), *Architectural Finishes in the Built Environment* (London, 2009), 3–18.
86. Mosca, 'Stenton Paint Analysis'.
87. Saumarez Smith, *Eighteenth-Century Decoration*, for example, plates 80, 81, 90, 96 and 97.
88. Cornforth, *Early Georgian Interiors*, 113–121; Vickery, *Behind Closed Doors*, 173–175. Blue particularly became more popular during the eighteenth century, Cornforth, 120.
89. Cornforth, *Early Georgian Interiors*, 121.
90. BRO/AC/WO/10/18: March 1738/1739, Inventory and Appraisement of Royal Fort, St Michaels Hill. This might possibly refer to a stuccoed room, but this seems unlikely, see Bristow, *Architectural Colour in British Interiors*, 54.
91. E. S. Cooke, Jr, (ed.), *Upholstery in America and Europe from the Seventeenth Century to World War I* (New York and London, 1987); P. Thornton, *Authentic Décor: The Domestic Interior, 1660–1920* (New York, 1984), especially 57 and 100 for window curtains. F. Montgomery, *Textiles in America 1650–1840* (New York, 1984) has much to say of relevance to England.
92. Ayres, *Domestic Interiors*, 125.
93. GA/D45/F2: Inventory and valuation of goods of Richard Whitmore of Lower Slaughter, 31 January 1687/1688; For slips, see M. M. Brooks, *English Embroideries of the Sixteenth and Seventeenth Centuries in the Collection of the Ashmolean Museum* (London, 2004), 94.
94. GA/D149/F18: draft will of Wm Clutterbuck, gent. (1726) and TNA/PROB11/623 (1 July 1728).
95. Surviving tapestries at Bigsweir seem to have been fitted into the wall.
96. Thornton comments that, 'The windows in most rooms of any importance were furnished with curtains by 1720', but this is based on study of grander interiors. Thornton, *Authentic Décor*, 100.
97. BRO/AC/WO/10/19: 2 April 1739, Inventory of the goods of John Elbridge at his house at Stoke, Westbury (Cote House).
98. Cornforth, *Early Georgian Interiors*, 120, suggests that green was sometime thought 'a more agreeable colour for furnishing' and often chosen for best beds.
99. BRO/AC/WO/10/19: 2 April 1739, Inventory of the goods of John Elbridge at his house at Stoke, Westbury [Cote House].
100. UBL/DM1398/A: Copy Inventory of furniture and effects at Goldney House, 1768.
101. G. Beard, *Upholsterers and Interior Furnishings in England 1530–1840* (New Haven and London, 1997).
102. G. Saunders, *Wallpaper in Interior Decoration* (London, 2002); Hoskins, (ed.), *The Papered Wall: History, Pattern, Technique* (New York, 1994, also new and expanded edition, 2005), especially chapters 2, 3, and 7; R. C. Nylander, *Wallpapers for Historic Buildings*

(Washington, DC, second edition, 1992); Ayres, *Domestic Interiors*, 160–162. Ayres comments that taxation may have resulted in high cost hence low use of wallpaper, 160; Vickery, *Behind Closed Doors*, chapter 6, suggests that Ayres has offered 'too pessimistic an assessment of the dissemination of paper', 168, fn 5. The accounts on which her chapter is based, however, are from 1797 to 1808, by which time wallpaper was much more commonly available. C. Taylor, '"Figured Paper for Hanging Rooms": The Manufacture, Design and Consumption of Wallpapers for English Domestic Interiors, c. 1740 to c. 1800' (Unpublished PhD thesis, The Open University, 2010).

103. One house in Gloucestershire, Berkeley House, had hand-painted Chinese-style wallpaper dating from 1740–1760, which is now housed in the Victoria and Albert Museum. This remarkable survival demonstrates that at least some wealthy merchants had access to this form of adornment, although it may have been comparatively unusual. G. Saunders, 'The China Trade: Oriental Painted Panels', in L. Hoskins, (ed.), *The Papered Wall: History, Pattern, Technique* (London, new and revised edition, 2005), 42–55, who dates the paper to c. 1740, see 55. Images of England 128159 and Victoria and Albert Museum No W.93-1924 Berkeley House.
104. Frampton Court collection, Richard Clutterbuck account book, 1768–1772.
105. Quoted in M. B. Pritchard, 'Wallpaper', in Carson and Lounsbury, *Chesapeake House*, 378.
106. J. Anderson, *Glorious Splendor: The 18th-Century Wallpapers in the Jeremiah Lee Mansion* (Virginia Beach, VA, 2011).
107. E. C. Carter, (ed.), *The Virginia Journals of Benjamin Henry Latrobe, 1795–1798*, 2 vols (New Haven, 1977), vol. 1, 75–76.
108. G. Priest, *The Paty Family: Makers of Eighteenth-Century Bristol* (Bristol, 2003), 51–60; BRO/09467/12/a: 'Notes and Receipts for House Building at Clifton 1746-47-48-49 + 1750 + c'; A. Gomme, M. Jenner, and B. Little, *Bristol: An Architectural History* (London, 1979), 174; Mowl, *To Build the Second City: Architects and Craftsmen of Georgian Bristol* (Bristol, 1991), 64 fn 10, 71–73, cautions against the Stocking attribution at Royal Fort.
109. Bristow, *Architectural Colour in British Interiors*, 26.
110. Pritchard, 'Wallpaper', in Carson and Lounsbury, (eds), *Chesapeake House*, 374.
111. The hall may have been painted originally and was certainly painted by the early nineteenth century, before having the paint removed in the late twentieth century. The two parlours have never been painted, although they seem to have had a dark stain applied to them in the nineteenth century.
112. Family tradition claims that shipwrights from Bristol were involved in this work but there is no documentary evidence to support this. Visual connections with Bristol work at such houses as Goldney House lend support.
113. 'The Study at Frampton Court', Frampton Court collection, Image 41, c. 1840s. Physical examination of this small and asymmetrical room indicates that the shelving is likely original. I am grateful to Dr Susie West for her thoughts on this subject.
114. Gomme and Maguire, *Design and Plan in the Country House*, 140–147.

6 Furnishing Status

1. For the following account see BRO/AC/WO/11/1/a: 9 April 1739 'Case on the Will of John Elbridge Esq. deceased on behalf of Henry Woolnough and Rebecca his wife'.
2. J. Cornforth, *Early Georgian Interiors* (London and New Haven, 2004), x.
3. A. Vickery, *The Gentleman's Daughter: Women's Lives in Georgian England* (New Haven and London, 1998), 229.
4. The idea draws largely on T. Veblen, *The Theory of the Leisure Class: An Economic Study of Institutions* (New York, 1899), and tends to be the more usual line taken by architectural and decorative arts historians. See also N. McKendrick, 'The Consumer Revolution of Eighteenth-Century England', in N. McKendrick, J. Brewer, and J. H. Plumb, (eds), *The Birth of Consumer Society: The Commercialization of Eighteenth-Century England* (London, 1982), 9–33.

5. P. Bourdieu, *Distinction: A Social Critique of the Judgment of Taste* (London, 1984). See also Hunt, *The Middling Sort: Commerce, Gender and the Family in England, 1680–1780* (Berkeley, CA and London, 1996). A recent discussion is B. Blondé, N. Coquery, J. Stobart, and I. Van Damme, (eds), *Fashioning Old and New: Changing Consumer Patterns in Europe (1650–1900)* (Turnhout, Belgium, 2009), especially the essay by Blondé, 'Conflicting Consumption Models'.
6. See, for example, J. Styles, and A. Vickery, (eds), *Gender, Taste and Material Culture in Britain and North America 1700–1830* (New Haven and London, 2006); H. Greig and G. Riello, (eds), Special Issue on Georgian Interiors in *Journal of Design History*, vol. 20, no. 4 (Winter 2007); K. Harvey, 'Barbarity in a Tea Cup? Punch, Domesticity and Gender in the Eighteenth Century', *Journal of Design History*, vol. 21, no. 3 (autumn 2008), 205–221; D. Goodman and K. Norberg, (eds), *Furnishing the Eighteenth Century: What Furniture Can Tell Us about the European and American Past* (New York and London, 2007); A. Vickery, *Behind Closed Doors: At Home in Georgian England* (New Haven and London, 2009).
7. L. Weatherill, *Consumer Behavior and Material Culture 1660–1760* (London, second edition, 1996); C. Shammas, *The Pre-industrial Consumer in England and America* (Oxford, 1990); M. Overton J. Whittle, D. Dean, and A. Hann, *Production and Consumption in English Households, 1600–1750* (London, 2004).
8. H. R. French, *The Middle Sort of People in Provincial England, 1600–1750* (Oxford, 2007), especially chapter 3; P. Earle, *The Making of the English Middle Class: Business, Society and Family Life in London, 1660–1730* (London, 1989), chapter 8.
9. H. Greig and G. Riello, 'Eighteenth-Century Interiors – Redesigning the Georgian: Introduction', *Journal of Design History*, vol. 20, no. 4 (Winter 2007), 279. Peter Earle commented that a huge literature on the decorative arts is 'addressed mainly to art historians, collectors and restorers rather than the social historian'. Earle, *The Making of the English Middle Class*, 292 fn 39; J. Fowler and J. Cornforth, *English Decoration in the Eighteenth Century* (London, 1978); P. Thornton, *Authentic Décor: The Domestic Interior, 1660–1920* (New York, 1984); C. Saumarez Smith, *Eighteenth-Century Decoration: Design and the Domestic Interior in England* (New York, 1993); Cornforth, *Early Georgian Interiors*; T. Murdoch, (ed.), *Noble Households: Eighteenth-Century Inventories of Great English Households: A Tribute to John Cornforth* (Cambridge, 2006). J. Ayres, *Domestic Interiors: The British Tradition 1500–1850* (New Haven and London, 2003), emphasizes smaller dwellings and craftsmen.
10. Vickery, *Behind Closed Doors*, 130.
11. K. Harvey, *The Little Republic: Masculinity and Domestic Authority in Eighteenth-Century Britain* (Oxford, 2012). See also K. Harvey and A. Shepard, 'What Have Historians Done with Masculinity? Reflections on Five Centuries of British History, circa 1500–1950', introduction to a special feature on masculinities in *The Journal of British Studies*, vol. 44, no. 2 (2005), 274–280; M. Finn, 'Men's Things: Masculine Possession in the Consumer Revolution', *Social History*, vol. 25, no. 2 (May 2000), 133–155; K. Harvey, 'Men Making Home: Masculinity and Domesticity in Eighteenth-Century Britain', *Gender and History*, vol. 21, no. 3 (November 2009), 520–540; M. Berg, *Luxury and Pleasure in Eighteenth-Century Britain* (Oxford, 2005), 243.
12. J. Stobart, 'Gentlemen and Shopkeepers: Supplying the Country House in Eighteenth-Century England', *Economic History Review*, vol. 64, no. 3 (2011), 885–904, 888.
13. Weatherill, *Consumer Behavior and Material Culture*, 6.
14. Shammas, *The Pre-industrial Consumer*, 179.
15. In England this was especially the case from the late sixteenth to the late seventeenth century, whilst evidence for Massachusetts sees a steep decline between the 1670s and 1770s. See C. Shammas, 'Changes in English and Anglo-American Consumption from 1550 to 1800', in J. Brewer and R. Porter, (eds), *Consumption and the World of Goods* (London, 1993), 190–193, especially tables 9.7 and 9.8. Cornforth calls this the 'primacy of upholstery', see Cornforth, *Early Georgian Interiors*, 75.

16. Weatherill, *Consumer Behavior and Material Culture*, tables 8.1 and 8.2. Weatherill includes all pictures and prints in her account, but makes no distinction between, for example, a fine portrait and cheaper prints, 207.
17. Vickery, *Behind Closed Doors*, 21; E. Harris, *British Architectural Books and Writers 1556–1785* (Cambridge, 1990).
18. K. Retford, *The Art of Domestic Life: Family Portraiture in Eighteenth-Century England* (New Haven and London, 2006); K. Retford, 'Patrilineal Portraiture? Gender and Genealogy in the Eighteenth-Century Country House', in Styles and Vickery, (eds), *Gender, Taste, and Material Culture*, 323–352; D. Johnson, 'Living in the Light: Quakerism and Colonial Portraiture', in E. J. Lapsansky and A. Verplanck, (eds), *Quaker Aesthetics: Reflections on a Quaker Ethic in American Design and Consumption* (Philadelphia, 2003), 122–146.
19. Report from the Egerton MS 3440 (Leeds Papers vol. 117) appearing as Appendix 5 in C. Phillpotts, 'Stroudend Tithing, Painswick, Gloucestershire Final Documentary Research Report' (Unpublished report for Stroudend Tithing Educational Trust, 2010).
20. GA/D45/F2: Inventory and valuation of goods of Richard Whitmore of Lower Slaughter, 31 January 1687/1688.
21. Slipps were embroidered elements applied to textiles. Purple was an unusual choice of colour.
22. It is unclear whether the carpets were on furniture, as often depicted in the seventeenth and early-eighteenth centuries, or on the floor. See Saumarez Smith, *Eighteenth-Century Decoration*, plates 15 and 38.
23. A. H. Gomme and A. Maguire, *Design and Plan in the Country House: From Castle Donjons to Palladian Boxes* (New Haven and London, 2008), 213, plan 159; GA/D45/F3: Inventory and copy will of William Whitmore of Lower Slaughter, 1724–1725.
24. GA/D45/F3: Inventory and copy will of William Whitmore of Lower Slaughter, 1724–1725.
25. Weatherill, *Consumer Behavior and Material Culture*, table 8.1 indicates that only 6 per cent of gentry families owned china and 7 per cent utensils for hot drinks in the 1675–1725 period. Overton, Whittle, Dean, and Hann, *Production and Consumption in English Households*, table A4.1, 192, states that between 1700 and 1740, only 20 per cent of Cornish gentlemen and 23.1 per cent of Kentish gentlemen possessed material goods related to hot drinks.
26. K. Lipsedge, '"Enter into thy Closet": Women, Closet Culture, and the Eighteenth-Century Novel', in J. Styles and A. Vickery, (eds), *Gender, Taste, and Material Culture in Britain and North America 1700–1830* (New Haven and London, 2006), 107–122; R. B. St George, 'Reading Spaces in Eighteenth-Century New England', in J. Styles and A. Vickery, (eds), *Gender, Taste, and Material Culture in Britain and North America 1700–1830* (New Haven and London, 2006), 90–103.
27. GA/D45/F4: Inventories of goods, linen, etc. belonging to Elizabeth Whitmore of Slaughter House, 1724–1735.
28. This room almost certainly functioned as a personal informal sitting area. Cornforth, for instance, notes that comfortable seating furniture, such as easy chairs, only began to appear in parlours from the 1730s. Cornforth, *Early Georgian Interiors*, 42. See also J. Crowley, *The Invention of Comfort: Sensibilities and Design in Early Modern Britain and America* (Baltimore, 2001), 145–146.
29. GA/D45/F4: Inventories of goods, linen, etc. belonging to Elizabeth Whitmore of Slaughter House, 1724–1735.
30. Cane chairs were out of fashion by about 1720, but they were still in widespread use by gentlemanly owners for many years afterward, see Thornton, *Authentic Décor*, 102.
31. Vickery asserts the importance of feminine intervention in the domestic interior, suggesting 'evidence of female designs and patronage dates from 1600 at least'. Vickery, *Behind Closed Doors*, 131. Cornforth and Saumarez Smith see the eighteenth century as the period when ladies became central to interior decoration, although Cornforth argues this occurred in the 1720s whilst Saumarez Smith contends it was not until the 1760s. Cornforth, *Early Georgian Interiors*, 206; Saumarez Smith, *Eighteenth-Century Decoration*, 233.

32. Records relating to Cote house have remained virtually unexplored. A 1972 doctoral thesis by Donald Jones mined some of the papers, but with more emphasis on Elbridge's plantation in Jamaica. See BRO/34328/a: Donald Jones, 'The Elbridge, Woolnough and Smyth Families of Bristol, in the Eighteenth Century: With Special Reference to the Spring plantation, Jamiaca' (Unpublished PhD thesis, University of Bristol, 1972).

33. This account is based on BRO/AC/WO/10/19: 2 April 1739, Inventory of the goods of John Elbridge at his house at Stoke, Westbury (Cote House) and E. Robinson, 'Some Notes about Cote' (Unpublished MS at Cote, April, 1971), and physical examination of the surviving house.

34. Thornton, *Authentic Décor*, 24, 59; A. Bowett, *English Furniture: 1660–1714: Charles II to Queen Anne* (Woodbridge, Suffolk, 2002), 76–79.

35. Both Virginia walnut and mahogany became much more readily available after the passing of the Naval Stores Act in 1721. See A. Bowett, 'The Commercial Introduction of Mahogany and the Naval Stores Act of 1721', *Furniture History*, vol. 30 (1994), 43–57; A. Bowett, 'After the Naval Stores Act: Some Implications for English Walnut Furniture', *Furniture History*, vol. 31 (1995), 116–123.

36. Bowett, *English Furniture*, 80–83, discusses leather. Matted bottoms are mentioned on 272. Common parlours usually had chairs with cane or rush seats until about 1725, but leather more often after that. Cornforth, *Early Georgian Interiors*, 40.

37. Ayres, *Domestic Interiors*, 82; G. Beard, *Upholsterers and Interior Furnishings in England 1530–1840* (New Haven and London, 1997).

38. N. Rothstein and S. M. Levy, 'Furnishings, c. 1500–1780', in D. Jenkins, (ed.), *The Cambridge History of Western Textiles*, 2 vols (Cambridge, 2003), vol. 1, 631–658, 633. For comparative bed values, see Cornforth, *Early Georgian Interiors*, 91–92. Cornforth notes how rare were survivals of 'simple beds hung in woollen materials and cotton'.

39. B. Lemire, 'Fashioning Cottons: Asian Trade, Domestic Industry and Consumer Demand, 1660–1780', in D. Jenkins, (ed.), *The Cambridge History of Western Textiles*, 2 vols (Cambridge, 2003), vol. 1, 493–512; Idem, *Fashion's Favourite: The Cotton Trade and the Consumer in Britain 1660–1800* (Oxford, 1991), 12–42.

40. Lemire, *Fashion's Favourite*, 41. The restrictions were ineffective, however, and by the 1730s cotton manufacturing had resumed in Britain. Lemire, 'Fashioning Cottons', 504; G. Riello and P. Parthasarathi, (eds), *The Spinning World: A Global History of Cotton Textiles, 1200–1850* (Oxford, 2009), especially chapters 10, 11, and 13.

41. As suggested by Elisabeth Robinson's recollection that, at the top of the stairs, 'the first door on the left was...panelled in dark oak'. Robinson, 'Some Notes about Cote', 8: Laura Keim pointed out that the unfinished inside of cupboards in this room is oak.

42. Likely cushions for window seats in this room.

43. On gilt leather hangings, see Saunders, *Wallpaper in Interior Decoration* (London, 2002), 121–123.

44. BRO/AC/WO/10/18: Inventory and Appraisement of Royal Fort, St Michaels Hill, March 1738/1739; W. D. [William Darrell], *The Gentleman Instructed, in the Conduct of a Virtuous and Happy Life* [Dublin], 1725. Eighteenth-Century Collections Online, accessed 4 June 2010.

45. Floor coverings such as carpets and floor cloths were unusual in genteel houses until well into the eighteenth century. Ayres, *Domestic Interiors*, 93.

46. GA/D45/F4: Inventories of goods, linen, etc. belonging to Elizabeth Whitmore of Slaughter House, 1724–1735. This object was valued at £1.1.0, indicating a modestly priced piece with an exotic flavor.

47. BRO/09467/12/a: 'Notes and Receipts for House Building at Clifton 1746-47-48-49 + 1750 + c'. BRO/09467/12/b: 'Notes and Rects for Mr P Fishers Private Affairs/Bundle No 12/1729' and 'Notes + Receipts for Furniture + c at Clifton (Bundle 13)'.

48. UBL/DM1398/A: Copy Inventory of furniture and effects at Goldney House, 1768.

49. Cornforth, *Early Georgian Interiors*, 88–89, 92; Rothstein and Levy, 'Furnishings, c. 1500–1780', 653. For textile prices, see C. Shammas, 'The Decline of Textile Prices in

England and British America Prior to Industrialization', *Economic History Review*, vol. 47, no. 3 (1994), 483–507.
50. UBL/DM1398/A: Copy Inventory of furniture and effects at Goldney House, 1768.
51. For discussion of scientific instruments in the domestic setting see Vickery, *Behind Closed Doors*, 261–265.
52. C. L. and K. A. Wulf, (eds), *Milcah Martha Moore's Book: A Commonplace Book from Revolutionary America* (University Park, PA, 1997), 209.
53. Vickery, *Behind Closed Doors*, chapter 6, especially 167.
54. GA/MF1442: Palling-Caruthers (Smith) Papers, Bundle 57, 16 February 1733/1734.
55. Bowett, *Early Georgian Furniture*, 116–117.
56. The first recorded instance of the compass or rounded seat was in 1726, and shell carving at the knees on a chair leg appears in a furniture bill of November 1728. Bowett, *Early Georgian Furniture*, 171–175.
57. Ibid., especially 178–180; A. Bowett, 'The India-Back Chair, 1715–1740', *Apollo* (January 2003), 3–9.
58. Bowett, *Early Georgian Furniture*, 171.
59. Frampton Court collection, Richard Clutterbuck account book, 1768–1772, 24 December 1771.
60. Description from Frampton Court files, Christie's Report (November 2003). GA/D149/F18: draft will of Wm Clutterbuck, gent. (1726) and TNA/PROB11/623(1 July 1728). William's final will leaves the 'hangings and chairs in the Parlour Chamber' specifically to Richard.
61. This despite the fact that pewter was 'gradually being usurped by earthenware and china' and gradually moved to the 'backstage' of the house, see Overton, Whittle, Dean, and Hann, *Production and Consumption in English Households*, 135.
62. Harvey, *Little Republic*, 101. A 1766 inventory of Hinwick House, Bedfordshire, 'shows a conservative addition of pieces to the furnishings rather than wholesale replacement under the pressures of changing fashions'. J. Collett-White, (ed.), *Inventories of Bedfordshire Country Houses, 1714–1830*, Publications of the Bedfordshire Record Society, vol. 74 (Bedford, 1995), 93. Sharnbrook house, fitted out in the late 1740s or early 1750s, demonstrates a similar mix in the principal rooms, 205. Stobart traces similar processes at Stoneleigh Abbey in 'Gentlemen and Shopkeepers'.
63. L. G. Carr and L S. Walsh, 'Changing Lifestyle and Consumer Behavior in the Colonial Chesapeake', in C. Carson, R. Hoffman, and P. J. Albert, (eds), *Of Consuming Interest: The Style of Life in the Eighteenth Century* (Charlottesville, 1994), 59–166, at 65–66.
64. Berg, *Luxury and Pleasure*, chapter 8.
65. W. Hening, (ed.), *Hening's Statutes at Large, vol. 3, 1684–1710* (Philadelphia, 1823), 484, October 1710.
66. Quoted in Carr and Walsh, 'Changing Lifestyles and Consumer Behavior', 64.
67. Library of Congress, Robert Beverly Letterbook, 27 December 1762 and 15 April and 16 July 1771, quoted in Carr and Walsh, 'Changing Lifestyles and Consumer Behavior', 68.
68. Carr and Walsh, 'Changing Lifestyles and Consumer Behavior', 103–104. See also W. B. Gusler, *Furniture of Williamsburg and Eastern Virginia, 1710–1790* (Williamsburg, VA, reprint edition, 1993), 178–181.
69. W. Eddis, *Letters from America*, in A. C. Land, (ed.) (Cambridge, MA, 1969), 19.
70. R. C. Nash, 'Domestic Material Culture and Consumer Demand in the British Atlantic World: Colonial South Carolina, 1670–1770', in D. Shields, (ed.), *Material Culture in Anglo-America: Regional Identity and Urbanity in the Tidewater, Lowcountry and Caribbean* (Columbia, SC, 2009), 221–266.
71. Sweeney, 'Mansion People: Kinship, Class, and Architecture in Western Massachusetts in the Mid Eighteenth Century', *Winterthur Portfolio*, vol. 19, no. 4 (Winter 1984), 231–255, 246, 249–150.
72. J. G. Volk, (ed.), *The Warner House: A Rich and Colorful History* (Portsmouth, NH, 2006), 55.

73. Chan, *Slavery in the Age of Reason: Archaeology at a New England Farm* (Knoxville, TN, 2007), 106, Table 6.
74. J. K. Hosmer, *The Life of Thomas Hutchinson* (Boston and New York, 1896), Appendix A, 351–362.
75. W. Burch, 'Furnishing Plan: Johnson Hall State Historic Site' (Unpublished report on file at Johnson Hall, 2003); John Weatherhead, New York, to WJ, *PSWJ*, vol. 7, 173; 14 October 1771, Carpenter Wharton to WJ, *PSWJ*, vol. 8, 293–294.
76. L. C. Rubenstein, 'Johnson Hall' (Unpublished Winterthur/University of Delaware M.A. Thesis, 1958), 118–119; W. Burch, 'Furnishing Plan'.
77. R. V. Shepherd, 'James Logan's Stenton: Grand Simplicity in Quaker Philadelphia' (MA Thesis, Winterthur/University of Delaware, 1968), is a reliable guide to Logan's furnishing of Stenton, although it somewhat overemphasizes the Quaker plainness idea. This has been supplemented and corrected in parts by recent research on the Stenton collection, especially the furniture. See L. C. Keim, 'Stenton Room Furnishings Study' (MS report, 2010, on file at Stenton). P. D. Zimmerman's series of articles: 'Philadelphia Case Furniture at Stenton', *The Magazine Antiques* (May 2002), 94–101; 'Eighteenth-Century Chairs at Stenton', *The Magazine Antiques* (May 2003), 122–129; 'Early American Tables and Other Furniture at Stenton', *The Magazine Antiques* (May 2004), 102–109.
78. On currency exchange, see J. J. McCusker, *Money and Exchange in Europe and America, 1600–1775: A Handbook* (Chapel Hill, NC, 1978), especially 175–188. For comparative costs for beds see John Cornforth, *Early Georgian Interiors*, 83, 91.
79. O. Bradbury, 'Handel at Home', *Country Life*, 15 December 2005 for the recent recreation of a similar bed at a London house museum.
80. Transcript of James Logan Inventory, 1752, on file at Stenton.
81. Around 1700 chairs made of walnut for great country houses cost £1 or £2, only becoming more expensive with the addition of fine upholstery, Cornforth, *Early Georgian Interiors*, 100.
82. Several archaeological investigations were conducted by Barbara Liggett between 1968 and 1983, see especially, 'Archeological Notes on Stenton' (Unpublished MS at Stenton, 1983[?]) but materials have been most usefully catalogued and evaluated by Deborah L. Miller and Dennis S. Pickeral.
83. In their study of Cornwall and Kent, for example, 'gentlemen' and 'esquire' made up less than 6 per cent of the sample between 1700 and 1749. Overton, Whittle, Dean, and Hann, *Production and Consumption in English Households*, 22, table 2.2.
84. Inventories collected and transcribed by Gunston Hall are suggestive of this trend. http://www.gunstonhall.org/library/probate/probate_list.html. See, for example, Inventory of Henry Fitzhugh, who matriculated at Christ Church Oxford in 1722, died in 1742, and had a chintz bedstead with raised tester worth £20 VA, http://chnm.gmu.edu/probateinventory/pdfs/ftzhgh42.pdf. Thomas Lee's 1758 inventory of Stratford Hall reflects values for household goods similar to those seen in England http://chnm.gmu.edu/probateinventory/pdfs/lee58.pdf.
85. Inventory takers examining the same house at Lower Slaughter Manor delineated certain spaces separately, which accounts for the variation in number across the three Whitmore inventories.
86. Weatherill, *Consumer Behavior and Material Culture*, 6, 168, table 8.1.
87. Overton, Whittle, Dean and Hann, *Production and Consumption in English Households*; Weatherill, *Consumer Behavior and Material Culture*, table 2.1.
88. G. L. Main and J. T. Main, 'Economic Growth and the Standard of Living in Southern New England, 1640–1774', *Journal of Economic History*, vol. 48, no. 1 (March 1988), 27–46.
89. Nash, 'Domestic Material Culture and Consumer Demand', 234–242.

90. Cornforth, *Early Georgian Interiors*; Murdoch, *Noble Households*; Collett-White, (ed.), *Inventories of Bedfordshire Country Houses*.
91. Murdoch, *Noble Households*, 143–165.
92. Ibid., 152.
93. M. Rothery and J. Stobart, 'Inheritance Events and Spending Patterns in the English Country House: The Leigh Family of Stoneleigh Abbey, 1738–1806', *Continuity and Change*, vol. 27, no. 3 (2012), 379–407, 388.
94. Murdoch, *Noble Households*, 243.
95. Collett-White, (ed.), *Inventories of Bedfordshire Country Houses*. Some of the smaller houses described include Colworth House (1723, £365) and Hinwick House (1766, £570); G. Glanville and P. Glanville, 'The Art Market and Merchant Patronage in London 1680 to 1720', in M. Galinou, (ed.), *City Merchants and the Arts* (London, 2004), 11–24, especially 11–12.
96. Murdoch, *Noble Households*, 119. What is more is that the Drayton House inventory lists 82 separate spaces, more than three times the number of spaces in most gentlemen's houses.
97. D. Cohen, *Household Gods: The British and their Possessions* (New Haven, 2006), 86.
98. Carr and Walsh, 'Changing Lifestyles and Consumer Behavior', 67.
99. Cornforth, *Early Georgian Interiors*, 8; Collett-White, (ed.), *Inventories of Bedfordshire Country Houses*, 93, 207; Stobart, 'Gentlemen and Shopkeepers'.
100. Quoted in R. Hoffman, 'Preface', in Carson et al., (eds), *Of Consuming Interest: The Style of Life in the Eighteenth Century* (Charlottesville, 1994), xi.

7 Enacting Status

1. On letters, letter-writing and communication see, S. Whyman, *The Pen and the People: English Letter Writers, 1660–1800* (Oxford, 2009); R. Earle, (ed.), *Epistolary Selves: Letters and Letter-Writers, 1600–1945* (Aldershot, 1999); C. Brant, *Eighteenth-Century Letters and British Culture* (Basingstoke, 2006); I. K. Steele, *The English Atlantic 1675–1740: An Exploration of Communication and Community* (Oxford, 1986); S. M. S. Pearsall, *Atlantic Families: Lives and Letters in the Later-Eighteenth Century* (Oxford, 2008); K. Dierks, *In my Power: Letter Writing and Communications in Early America* (Philadelphia, 2009).
2. A. Flather, *Gender and Space in Early Modern England* (Woodbridge, 2007), 2.
3. H. R. French, *The Middle Sort of People in Provincial England, 1600–1750* (Oxford, 2007), 265.
4. M. R. Hunt, *The Middling Sort: Commerce, Gender and the Family in England, 1680–1780* (Berkeley, CA and London, 1996), 47–48.
5. P. Langford, *A Polite and Commercial People: England 1727–1783* (Oxford, 1989), 6.
6. L. Stone and J. F. Stone, *An Open Elite? England 1540–1880* (Oxford, 1984), 298–322; M. Girouard, *Life in the English Country House: A Social and Architectural History* (New Haven and London, 1978), 2–3. See also M. Girouard, 'The Power House', in G. Jackson-Stops, (ed.), *The Treasure Houses of Britain: Five Hundred Years of Private Patronage and Art Collecting* (New Haven, 1985), 22–27, 22.
7. A. Vickery, *Behind Closed Doors: At Home in Georgian England* (New Haven and London, 2009), 146.
8. BRO/AC/WO/11/2/f-m: Woolnough v. Scrope.
9. S. West, 'Social Space and the English Country House', in S. Tarlow and S. West, (eds), *The Familiar Past? Archaeologies of Later Historical Britain* (London and New York, 1999), 103–122, 104; Vickery, *Behind Closed Doors*, 201.
10. B. Heller, 'Leisure and the Use of Domestic Space in Georgian London', *The Historical Journal*, vol. 53, no. 3 (2010), 623–645, 627. See also J. Melville, 'The Use and Organisation of Domestic Space in Late Seventeenth-Century London' (University of Cambridge Ph.D. thesis, 1999); A. Vickery, 'An Englishman's Home Is His Castle? Privacies, Boundaries and Thresholds in the Eighteenth-Century London House', *Past and Present*, vol. 199 (May 2008), 147–173, especially 153–158.

11. Tadmor, 'The Concept of the Household-Family in Eighteenth-Century England', *Past and Present*, vol. 151, no. 1 (May 1996), 111–140; Harvey, *The Little Republic: Masculinity and Domestic Authority in Eighteenth-Century Britain* (Oxford, 2012), 12–13.
12. R. C. Richardson, *Household Servants in Early Modern England* (Manchester, 2010), 63. The numbers of servants in gentlemanly households do not compare with many gentry and aristocratic households, which often had ten or more, 65. J. M. Vlach, *Back of the Big House: The Architecture of Plantation Slavery* (Chapel Hill, NC and London, 1993); A. Chan, *Slavery in the Age of Reason: Archaeology at a New England Farm* (Knoxville, TN, 2007).
13. Access tools have helped to illustrate how spaces interconnected and interacted. B. Hillier and J. Hanson, *The Social Logic of Space* (Cambridge, 1984). See also West, 'Social Space and the English Country House', especially 108–109; S. Pennell, 'Pots and Pans History: The Material Culture of the Kitchen in Early Modern England', *Journal of Design History*, vol. 11, no. 3 (1998), 201–216.
14. T. Meldrum, 'Domestic Service, Privacy and the Eighteenth-Century Metropolitan Household', *Urban History*, vol. 26, no. 1 (1999), 27–39, especially 34.
15. Hood, *The Governor's Palace in Williamsburg: A Cultural Study* (Chapel Hill, NC, 1991), 30.
16. Flather, *Gender and Space*, 44.
17. See especially Harvey, *Little Republic*.
18. J. Lewis, 'When a House Is not a Home: Elite English Women and the Eighteenth-Century Country House', *Journal of British Studies*, vol. 48 (April 2009), 336–363, 363; Harvey, *The Little Republic*; K. Harvey, 'Barbarity in a Teacup? Punch, Domesticity and Gender in the Eighteenth Century', *Journal of Design History*, vol. 21, no. 3 (autumn 2008), 205–221, especially 217–218; J. Styles and A. Vickery, (eds), *Gender, Taste and Material Culture in Britain and North America 1700–1830* (New Haven and London, 2006), 4–6; Heller, 'Leisure and the Use of Domestic Space in Georgian London', 624, suggests 'the relative under-representation of men in historians' analyses of domestic space is problematic'.
19. K. Harvey, 'The History of Masculinity, circa 1650–1800', *Journal of British Studies*, vol. 44, no. 2 (April 2005), 296–311, 305.
20. Flather, *Gender and Space*, 60–74; Richardson, *Household Servants*, 97–101.
21. BRO/AC/WO/10/19: 2 April 1739, Inventory of the goods of John Elbridge at his house at Stoke, Westbury [Cote House].
22. L. Weatherill, *Consumer Behavior and Material Culture 1660–1760* (London, second edition, 1996), 9–11.
23. Vickery, *Behind Closed Doors*, 265.
24. Pennell, 'Pots and Pans History'.
25. BRO/AC/WO/10/19: 2 April 1739, Inventory of the goods of John Elbridge at his house at Stoke, Westbury [Cote House]. On kitchens and their equipment see Pennell, 'Pots and Pans History'; S. Pennell, 'The Material Culture of Food in Early Modern England, c. 1650–1750', in S. Tarlow and S. West, (eds), *The Familiar Past? Archaeologies of Later Historical Britain* (London and New York, 1999).
26. C. Carson and C. R. Lounsbury, (eds), *The Chesapeake House: Architectural Investigations by Colonial Williamsburg* (Chapel Hill, NC, 2013), 163–164.
27. Richardson, *Household Servants*, 79.
28. BRO/AC/WO/10/14/b-d: Copy wills of John Elbridge. BRO/AC/AS/57/3: Copy Will of John Andrews, drawn up on 10 June 1743 with a codicil of 3 December 1743; TNA/PROB11/629, Will of Charles Coxe; TNA/PROB11/808, Will of William Springett; GA/D149/T358, Will of William Clutterbuck, 1726; J. R. Soderlund, 'Black Women in Colonial Pennsylvania', in J. W. Trotter and E. L. Smith, (eds), *African Americans in Pennsylvania: Shifting Historical Perspectives* (University Park, PA, 1997), 73–92, 73–74.
29. Report from the Egerton MS 3440 (Leeds Papers vol. cxvii) appearing as Appendix 5 in C. Phillpotts, 'Stroudend Tithing, Painswick, Gloucestershire Final Documentary Research Report' (Unpublished report for Stroudend Tithing Educational Trust, 2010), 162–165.

30. UBL/DM1398/A: Copy Inventory of furniture and effects at Goldney House, 1768.
31. Vickery, *Behind Closed Doors*, 27; Richardson, *Household Servants*, 79; T. Meldrum, *Domestic Service and Gender, 1660–1750: Life and Work in the London Household* (Harlow, 2000); T. Meldrum, 'Domestic Service, Privacy and the Eighteenth-Century Metropolitan Household', 27–39; B. Hill, *Servants: English Domestics in the Eighteenth Century* (Oxford, 1996).
32. Girouard, *Life in the English Country House*, 138.
33. See especially Vickery, *Behind Closed Doors*, chapter 1.
34. See GA/D45/E14: 'Bills for carpenter's work, rates, repairs and legal proceedings (1707–1726), building repairs, etc. (1728–1782)', including 7 May 1729, Bill from John Collett for 'repareing ye stables'; May and August 1729 from Giles [Laurence?] for work on the Stables and 'ye dogkennel wall'; 'A particular of the Materials Bout & repairs done at Slaughter House… in the Year 1730'; 'Work done for Mrs Whitmore 1730'.
35. J. Johnson, *The Gloucestershire Gentry* (Gloucester, 1989), 153.
36. TNA/PROB11/629 (12 May 1729), where Coxe's will identifies him as 'of Lincolns Inn in the County of Middlesex'.
37. BRO/AC/WO/11/2/p: 3 June 1740. 'The joint & separate answers of John Scrope and John Cossins Esqr'.
38. GA/D45/E14: Bills for carpenter's work, rates, repairs and legal proceedings (1707–1726), building repairs, etc. (1728–1782), Letter, 25 May 1756, William Whitmore to Richard Jervis.
39. GA/D45/E6: Cash accounts of Richard Jervis, steward to William Whitmore (1735–1773); GA/D45/E13: Estate papers, 1674–1837, Farm accounts (1741–1774). On 19 March 1735, William Whitmore appointed his brother and 'my Trusty friend Richard Jervis of Lower Slaughter aforesaid Gentleman My Joint Attorneys for Me'. GA/D45/F8: Bills of books, clothing, harness, household, etc. of Whitmore family, 1673–1796.
40. GA/D45/F8: Bills of books, clothing, harness, household, etc. of Whitmore family, 1673–1796. Slaughter – Bills – 1773–1782 – Household Accounts – Bread, Meat, Coal, Candles, Tea, Wines, etc., 7 February 1775.
41. Quoted in Johnson, *Gloucestershire Gentry*, 141.
42. GA/D45/F8: Bills of books, clothing, harness, household, etc. of Whitmore family, 1673–1796. Slaughter – Bills – 1774–1782 – Clothing – including jewellery, tailor, gloves, boots, shoes, weaving, Haberdashery, etc.; A 1774 bill records 'Making the Butler a Livery 0.12.0' and 'Making the Groom a Livery 0.12.0'. For discussion of livery, which seems to have been the province of larger households, see Richardson, *Household Servants*, 107–109; J. Stobart, Gentlemen and Shopkeepers: Supplying the Country House in Eighteenth-Century England', *Economic History Review*, vol. 64, no. 3 (2011), 885–904, 898, highlights servants in livery as a form of conspicuous consumption.
43. GA/D45/F8: Bills of books, clothing, harness, household, etc. of Whitmore family, 1673–1796. Slaughter – Bills – 1774–1782 – Clothing – including jewellery, tailor, gloves, boots, shoes, weaving, Haberdashery, etc.; Slaughter – Bills – 1775–1781 – Books and Binding; Slaughter – Bills – 1728–1796 – Miscellaneous – Shot, Timber, Hops, Malting, Medicine, Musical Instruments, Shaving, Seeds, Veterinary fees Impounding, Legal Charges'.
44. R. Moss, *Historic Houses of Philadelphia* (Philadelphia, 1998), 162.
45. W. Penn, *Fruits of Solitude* (New York, 1693, reprint in 1903), 49.
46. R. Isaac, *Transformation of Virginia 1740–1790* (Chapel Hill, NC, 1982), 76–80, 301–305.
47. H. R. French, '"Ingenious and Learned Gentlemen": Social Perceptions and Self-fashioning among Parish Elites in Essex, 1680–1740', *Social History*, vol. 25, no. 1 (January 2000), 44–66, 46.
48. W. E. Minchinton, 'The Merchants in England in the Eighteenth Century', *Explorations in Entrepreneurial History*, vol. 10, no. 20 (December 1957), 62–71, 69.
49. 'Warrant Books: December 1708, 1–10', *Calendar of Treasury Books*, vol. 22: 1708 (1952), 8 December 1708. 'By his personal unwearied care and great skill the said Elbridge hath

carried on the accounts of the said port of Bristol which were left by the late Collector in the utmost confusion'.
50. BRO/04356/9: Apprentice Book, 1709–1719, 112, May 1718, no. 139. Henry Bodman fils Abraham Bodman pilot of Shirehampton, for seven years. BRO/AC/WO/11/2/l: [1740?]. Henry Bodman Answer.
51. BCL/No. B19716, Letter from Custom House, 26 March 1739.
52. BRO/AC/WO/11/2/v: January 1740/1741, Depositions.
53. BRO/AC/WO/11/2/n: n.d. [likely 1740] Thomas Elbridge Answer.
54. BRO/AC/WO/11/2/x: Depositions in favour of Henry and Rebecca Woolnough.
55. Girouard, *Life in the English Country Jouse*, 143.
56. BRO/09474/1: Copy will of Henry Bodman, 4 June 1768.
57. J. Flavell, *When London Was Capital of America* (New Haven and London, 2010); B. B. Mooney, *Prodigy Houses of Virginia: Architecture and the Native Elite* (Charlottesville, VA, 2008), 198–207.
58. UBL/DM1466/11: 'Journal of a Tour of Europe'; For Goldney correspondence with James Logan of Philadelphia see, for example, James Logan Letterbooks, Box 2, copies at Stenton, originals at the Historical Society of Pennsylvania.
59. P. K. Stembridge, *The Goldney Family: A Bristol Merchant Dynasty* (Bristol, 1998), 21.
60. P. K. Stembridge, *Thomas Goldney's Garden: The Creation of an Eighteenth Century Garden* (Bristol, 1996); D. Lambert, 'The Prospect of Trade: The Merchant Gardeners of Bristol in the Second Half of the Eighteenth Century', in M. Conan (ed.), *Bourgeois and Aristocratic Encounters in Garden Art, 1550–1850*, vol. 23 (Washington, DC, 2002), 123–145.
61. C. L. and K. A. Wulf, (eds), *Milcah Martha Moore's Book: A Commonplace Book from Revolutionary America* (University Park, PA, 1997), 208–209.
62. UBL/DM1398/A: Copy Inventory of furniture and effects at Goldney House, 1768.
63. UBL/DM1398/A: Copy Inventory of furniture and effects at Goldney House, 1768. Also, UBL/DM1398: Memorandum Book kept by Thomas Goldney III, entry for Deaths 1756, 'Mr Stranover, the Painter, at Bath, 22 February 1756', quoted in Stembridge, *The Goldney Family*, 157.
64. *Milcah Martha Moore's Book*, 208–209.
65. Rudder, 592.
66. Phillpotts, 'Stroudend Tithing Report', 79.
67. Report from the Egerton MS 3440 (Leeds Papers vol. cxvii) ff 289–289v, 10 May 1758, appearing as Appendix 5 in Phillpotts, 'Stroudend Tithing Report', 162–165.
68. GA/MF1443: Palling-Caruthers (Smith) Papers, Bundle 59, Thomas Merrett to William Palling, n.d. [possibly 1746].
69. GA/MF1443: Palling-Caruthers (Smith) Papers, Bundle 59, Edmund Clutterbuck to John Wathen, 14 October 1754.
70. GA/MF1442: Palling-Caruthers (Smith) Papers, Bundle 54, 'Memorandum my sister Sarah Palling tabl'd with me 2 years and a Quarter' and 'my sister Mary Palling tabl'd with me 2 years and 6 weeks'. GA/MF1442, Palling Caruthers (Smith) Papers, Bundle 57, 'February 3d 1737/8...to put his two Sisters Sarah Palling and Mary Palling to School'.
71. GA/MF1443: Palling-Caruthers (Smith) Papers, Bundle 65; GA/MF1445: Palling-Caruthers (Smith) Papers, Bundle 70.
72. Report from the Egerton MS 3440 (Leeds Papers vol. cxvii), in Phillpotts, 'Stroudend Tithing Report', Appendix 5, 162.
73. Ibid., 163.
74. Melville, 'The Use and Organisation of Domestic Space', 176–182 about keys. Locked rooms are in Flather, *Gender and Space*, 46–47.
75. On men and kitchens, see Harvey, *Little Republic*, 126–132.
76. Report from the Egerton MS 3440 (Leeds Papers vol. cxvii) in Phillpotts, 'Stroudend Tithing Report', Appendix 5.
77. Physical exterior survey, 22 November 2010. A rococo chimneypiece inscribed 'William Palling, Brownshill, MDCCLX' provides the date for reconstruction, Kingsley, *CHG II*, 92.

78. GA/B673/19132GS: E. C. Little, *Our Family History* (1892), plus Corrections in, with Additions to, 'Our Family History' by E. Caruthers Little, 26–27. At least thirty-six firearms from the collection eventually made their way to the Museum in the Park, Stroud, where a number have stock plates marked 'William Palling' and the year. Museum in the Park, Stroud, Wathen donation, 1987, 327–362.
79. D. Defoe, *A Tour through England and Wales*, 2 vols (London and New York, 1928), vol. 1, 281.
80. A. Randall, 'Paul, Sir Onesiphorus, first baronet (*bap*. 1706, *d*. 1774)', *ODNB* (Oxford, online edition, 2004).
81. Museum in the Park, Stroud, Patent 1748/no. 630: 'Preparation of Cloth for Dying'.
82. *Gentleman's Magazine*, first series, vol. 20 (20 July 1750), 331; E. A. L. Moir, 'Sir George Onesiphorus Paul', in H. P. R. Finberg, (ed.), *Gloucestershire Studies* (Leicester, 1957), 195–224, 196.
83. Rudder, 629.
84. TNA/PROB11/1002: Will of Sir Onesiphorus Paul, Bart.
85. J. Heneage Jesse, *George Selwyn and his Contemporaries*, 4 vols (London, 1882), vol. 1, 312–313.
86. Moir, 'Sir George Onesiphorus Paul'.
87. John Sinclair, quoted in. Moir, 'Sir George Onesiphorus Paul', 224.
88. Sweeney, 'Mansion People: Kinship, Class, and Architecture in Western Massachusetts in the Mid Eighteenth Century', *Winterthur Portfolio*, vol. 19, no. 4 (Winter 1984), 231–255, 246.
89. H. D. Farish, (ed.), *Journal and Letters of Philip Vickers Fithian* (Colonial Williamsburg, 1957).
90. A. C. Meyers, *Hannah Logan's Courtship* (Philadelphia, 1904), 252.
91. Girouard, *Life in the English Country House*, 169. See C. B. Estabrook, *Urbane and Rustic England: Cultural Ties and Social Spheres in the Provinces, 1660–1780* (Manchester, 1998), chapter 7; Weatherill, *Consumer Behavior and Material Culture*, especially tables 8.1 and 8.2.
92. K. T. Hayes, *The Library of William Byrd of Westover* (Madison, WI, 1997); M. W. Hamilton, 'The Library of Sir William Johnson', *New York Historical Society Quarterly*, vol. 40 (July 1956), 209–251.
93. E. Wolf, 2nd, *The Library of James Logan of Philadelphia, 1674–1751* (Philadelphia, 1974).
94. Minutes of LCP, 29 March 1732.
95. W. Black, 'The Journal of William Black', 1 June 1744, *Pennsylvania Magazine of History and Biography*, vol. 1, no. 4 (1877), 406–407.
96. *Papers of Benjamin Franklin*, vol. 4 (*Pennsylvania Gazette*, 7 November 1751), 207.
97. Hunt, *The Middling Sort*, 216.
98. Rudder, 452.
99. D. S. Howard, *Chinese Armorial Porcelain*, vol. 1 (London, 1974) and vol. 2 (London, 2004), especially 9 and 815 for numbers produced.
100. Ibid., vol. 1, 375, with another set carrying the Clifford coat of arms on 479. Although D. S. Howard initially dated the set to c. 1755 during the peak decade in the form's production (Howard, *Chinese Armorial Porcelain*, vol. 1, 31), further study suggests a date 'five or six years earlier', see personal correspondence, 21 November 2005, Angela Howard to Jean Speed, Frampton Court Archives.
101. Carson and Lounsbury, *Chesapeake House*, 155.
102. Cornforth links the fashion for Chinese armorial porcelain with the development of the Dining Room. Cornforth, *Early Georgian Interiors* (London and New Haven, 2004), 49.
103. Frampton Court Collection, Richard Clutterbuck Account Book.
104. Frampton Court Collection, portrait by Samuel Besly, 1741, and Cane.

105. E. Clutterbuck, *The Clutterbuck Diaries, Being the Journey with my Wife and Daughter Sally into Gloucestershire on a Visit to my Cousin Clutterbuck at King Stanley* [1773], with notes by The Rev. Robert Nott and T. E. Sanders (Stroud, 1935), entry for Wednesday 14 July 1773.
106. P. J Corfield, 'Class by Name and Number in Eighteenth Century Britain', in P. J. Corfield, (ed.), *Language, History and Class* (Oxford, 1991), 101–130 and Keith Wrightson's essay in the same volume, 'Estates, Degrees and Sorts: Changing Perceptions of Society in Tudor and Stuart England', 30–52.

8 Social Strategies and Gentlemanly Networks

1. A. Grant, *Memoirs of an American Lady: With Sketches of Manners and Scenes in America, as They Existed Previous to the Revolution* (Albany, NY, 1876), 218–220.
2. N. Mereness, (ed.), 'Journal of Lord Adam Gordon', in *Travels in the American Colonies* (New York, 1916), 417–418.
3. R. G. Wilson, *Gentlemen Merchants: The Merchant Community in Leeds, 1700–1830* (Manchester, 1971); P. Jenkins, *The Making of a Ruling Class: The Glamorgan Gentry, 1640–1790* (Cambridge, 1983); A. Vickery, *The Gentleman's Daughter: Women's Lives in Georgian England* (New Haven and London, 1998); H. Berry and J. Gregory, (eds), *Creating and Consuming Culture in North-East England, 1660–1830* (Aldershot, 2004); S. E. Whyman, *Sociability and Power in Late-Stuart England: The Cultural Worlds of the Verneys 1660–1720* (Oxford, 1999).
4. Wilson, *Gentlemen Merchants*, 213; M. R. Hunt, *The Middling Sort: Commerce, Gender and the Family in England, 1680–1780* (Berkeley, CA and London, 1996); J. Smail, *The Origins of Middle Class Culture: Halifax, Yorkshire, 1660–1780* (Ithaca and London, 1994). M. Mascuch, 'Social Mobility and Middling Self-identity: The Ethos of British Autobiographers, 1600–1750', *Social History*, vol. 20, no. 1 (January 1995), 45–61 problematizes the issue of social mobility.
5. I am grateful to Dr Patrick Tierney of the Jenner Museum for kindly sharing his research and thoughts on the evolution of the Chantry.
6. H. R. French, *The Middle Sort of People in Provincial England, 1600–1750* (Oxford, 2007), 19–20.
7. Vickery, *Gentleman's Daughter*, 298, fn 4.
8. See BRO/P/St.A/OP/1 (a): Overseers to Clifton Parish 1708 to 1732 and BRO/P/St.A/OP/1 (b): Overseers to Clifton Parish 1732 to 1749.
9. GA/D149/F19; Rudder, 452.
10. See GA/D149/F18: 10 November 1702, Coll. Colchester to WC, and GA/D421/B1.
11. L. Stone and J. F. Stone, *An Open Elite? England 1540–1880* (Oxford, 1984), 6–9.
12. P. Borsay, *The English Urban Renaissance: Culture and Society in the Provincial Town 1660–1770* (Oxford, 1989), 176–177.
13. Vickery, *Gentleman's Daughter*, 32.
14. J. Swift, *The Conduct of the Allies* (1711), quoted in J. Black, *Eighteenth-Century Britain, 1688–1783* (Basingstoke, second edition, 2008), 95.
15. Quoted in I. Christie, *British 'Non-Elite' MPs 1715–1820* (Oxford, 1995), 4.
16. W. Kenrick, *The Poetical Works of Robert Lloyd*, 2 vols (London, 1774), 'The Cit's Country Box', vol. 1, 41–46.
17. P. J. Corfield, 'The Rivals: Landed and Other Gentlemen', in N. Harte and R. Quinault, (eds), *Land and Society in Britain, 1700–1914* (Manchester, 1996), 1–33, 17.
18. Quoted in P. T. Marcy, 'Eighteenth-Century Views of Bristol and Bristolians', in P. McGrath, (ed.), *Bristol in the Eighteenth Century* (Newton Abbot, 1972), 11–40, 29.
19. T. Doerflinger, *A Vigorous Spirit of Enterprise: Merchants and Economic Development in Revolutionary Philadelphia* (Chapel Hill, NC, 1986), 15–16, 42.

20. J. Tucker, *Instructions for Travellers* (London, 1757), 25.
21. E. A. L. Moir, 'Sir George Onesiphorus Paul', in H. P. R. Finberg, (ed.), *Gloucestershire Studies* (Leicester, 1957), 195–224, 196.
22. C. Phillpotts, 'Stroudend Tithing Painswick, Gloucestershire Final Documentary Research Report' (Unpublished report for Stroudend Tithing Educational Trust, 2010), 90.
23. J. M. Price 'Who Cared about the Colonies?: The Impact of the Thirteen Colonies on British Society and Politics, circa 1714–1775', in B. Bailyn and P. Morgan, (eds), *Strangers within the Realm: Cultural Margins of the First British Empire* (Chapel Hill, NC, 1991), 395–436, 423.
24. R. Mortimer, (ed.), *Minute Book of the Men's Meeting of the Society of Friends in Bristol, 1686–1704*, Bristol Record Society, vol. 30 (1977), 244–245; Stembridge, *The Goldney family*, 6.
25. P. K. Stembridge, *The Goldney Family: A Bristol Merchant Dynasty* (Bristol, 1998), 14–17; UBL/DM1466/11: Journal of a Tour of Europe, 1725; UBL/DM1499/9: Account Book of Thomas Goldney, 1708–1713, 14th 8br 1710; Survey of Goldney House, Clifton, Bristol.
26. P. K. Stembridge, *Thomas Goldney's Garden: The Creation of an Eighteenth Century Garden* (Bristol, 1996); UBL/DM1398/A: Copy Inventory of furniture and effects at Goldney House, 1768.
27. Stembridge, *The Goldney Family*, 16–20, 101–104; J. Day, *Bristol Brass: A History of the Industry* (Newton Abbot, 1973); Raistrick, *Quakers in Science and Industry: Being an Account of the Quaker Contributions to Science and Industry during the Seventeenth and Eighteenth Centuries* (New York, 1968); R. C. Allen, *The British Industrial Revolution in Global Perspective* (Cambridge, 2009), 269.
28. On the Champion family see J. Day, 'Champion Family (per 1670–1794)', *Oxford Dictionary of National Biography* (Oxford, online edition, 2004); Atkins Heritage, 'Champion's Brassworks and Gardens Conservation Management Plan' (Unpublished report, January 2007).
29. W. E. Minchinton, 'Bristol: Metropolis of the West', *Transactions of the Royal Historical Society*, fifth series, vol. 4 (1954), 69–89, 84.
30. F. Tolles, *James Logan and the Culture of Provincial America* (Boston, 1957), 188–189.
31. GA/D421/B1: 19 June 1761, Charles Whittuck to [Charles Bragge?].
32. GA/D421/B1: 20 and 26 October 1767, Letters from Lord Botetourt.
33. E. E. Hoon, *The Organization of the English Customs System, 1696–1786* (New York, 1938, with a new introduction by R. C. Jarvis, 1968), emphasizes the corrupt aspects. For percentage of revenue, see J. Brewer, *The Sinews of Power: War, Money and the English State, 1688–1783* (London, 1989), figure 4.3, 98.
34. Hoon, *The Organization of the English Customs System*, 6–11.
35. D. Jones, 'The Elbridge, Woolnough and Smyth Families of Bristol, in the Eighteenth Century: With Special Reference to the Spring Plantation' (Ph.D. Thesis, University of Bristol, 1972) [BRO/34328/a], 42.
36. See table of apprentices in Jones, 'The Elbridge, Woolnough and Smyth Families of Bristol', 42.
37. GA/D149/F19: 22 May 1711, William Clutterbuck [WC] to John Chamberlyne.
38. GA/D149/F21: WC to Richard Clutterbuck [RC], 19 October 1723.
39. GA/D149/F21: WC to RC, June 1725.
40. GA/D149/F21: WC to RC [probably March] 1725. Strikeouts in the original.
41. GA/D149/F21: WC to RC, June 1725.
42. BRO/AC/WO/11/4/k: Results from auction of Elbridge goods.
43. Day, *Bristol Brass*, 37.
44. Mortimer, (ed.), *Minute Book of the Men's Meeting of the Society of Friends in Bristol*, 233.
45. BRO/00485/21–22: Related to the mortgage of Rummers Tavern.
46. G. Munro Smith, *A History of the Bristol Royal Infirmary* (Bristol, 1917), 9.

47. See, for example, HSP/James Logan Ledger, 1720–1727, vol. 10, 268: '1726 12 Mo 27 To Jno Andrews Sterl Accot for wines..............................£8.6.2'.
48. HSP/James Logan Letterbooks 1717–1731, 87: 15th 8br 1719, James Logan Phila to John Andrews.
49. C. Muldrew, *The Economy of Obligation: The Culture of Credit and Social Relations in Early Modern England* (Basingstoke, 1998); M. Finn, *The Character of Credit: Personal Debt in English Culture, 1740–1914* (Cambridge, 2003). For credit related to the West Country textile industry, see J. Smail, 'The Culture of Credit in Eighteenth-Century Commerce: The English Textile Industry', *Enterprise and Society*, vol. 4 (June 2003), 299–325.
50. GA/D589/30 April 1809, Sir George O. Paul to Sir B. W. Guise.
51. See especially J Johnson, *The Gloucestershire Gentry* (Gloucester, 1989), chapter 9; F. O. Gorman, *Voters, Patrons, and Parties: The Unreformed Electorate of Hanoverian England, 1734–1832* (Oxford, 1989); N. Rogers, *Whigs and Cities: Popular Politics in the Age of Walpole and Pitt* (Oxford, 1989) has much to say about Bristol.
52. GA/D678/1 F12/1/1–452: Sir John Dutton, 2nd Baronet: political and other correspondence and accounts, 1718–1743. Although Dutton was owner of Sherborne Park, a large country house, he was politically active and had extensive communication with a number of individuals in this study.
53. GA/D678/1 F12/1/100–101: William Bell to Sir John Dutton [JD], 11 July 1739 and 22 September 1739.
54. GA/D678/1 F12/1/172: 12 January 1739/40, Samuel Creswicke to JD and D678/1 F12/1/175: 28 June 1740, Samuel Creswicke to JD.
55. GA/D678/1 F12/1/235: 12 September 1739, James Lambe to JD.
56. GA/D678/1 F12/1/23: 20 July 1733, John Small to JD.
57. GA/D678/1 F12/1/87: 18 September 1739, Revd Thomas Baker, Bibury to JD.
58. GA/D149/F18: 10 November 1702, 'Coll. Colchester to WC, To Capt. Clutterbuck', with William Clutterbuck's lengthy response; see also 2 December 1710, Col. M[atthew] Ducie Morton to William Clutterbuck, and WC's response.
59. GA/D149/F18: 11 October 1716, Henry Colchester to William Clutterbuck and quote in October 1716, WC to Henry Colchester about Colchester standing. See related correspondence: 26 April 1717, Coll. Matthew Ducie Morton to WC, To Capt. Clutterbuck, and May 2d. 1717, Henry Colchester to WC.
60. GA/D149/F18: 21 March 1719/1720, Henry Berkeley to WC.
61. R. Sedgwick, (ed.), *The House of Commons, 1715–1754*, vol. I (London, 1970), 246–247.
62. GA/D149/F18: 25 February 1726/1727, Kinard De La Bere to WC.
63. I. Krausman Ben-Amos, *The Culture of Giving: Informal Support and Gift-Exchange in Early Modern England* (Cambridge, 2008); F. Heal, *Hospitality in Early Modern England* (Oxford, 1990); F. Heal, 'Gifts and Gift-Exchange in the Great Household: 1500–1650', *Past and Present*, vol. 199, no. 1 (2008), 41–70.
64. GA/D149/F18: 18 May 1722, Lady Ducie to WC. Rudder notes that the salmon of the River Severn, 'of which there is great plenty, is truly excellent'; Rudder, 46.
65. GA/D149/F21: 5 April 1725, WC to RC.
66. GA/D149/F18: [Edward?] Clifford to WC, 31 March 1705, and WC's response.
67. See, for example, GA/D1833/F1/13; GA/D1833/F1/19/1–3; GA/D1833/F3/4; GA/D1833/F3/6.
68. GA/D149/F113–114: Letterbooks of Daniel Packer, 1760–1761 and 1768–1791.
69. GA/D149/F18: 23 June 1714, Mr Joseph Denham to WC, and WC's response.
70. GA/D149/F18: 4 November 1720 and 29 November 1720, Dr William Cradock to WC. On advowsons, see Johnson, *Gloucestershire Gentry*, 147–148.
71. GA/D149/F18: 12 November 1720, WC to Dr William Cradock.
72. BRO/34328/b: Photocopies, correspondence and notes used by Donald Jones in his thesis. Letter from Pauline King, Librarian, New England Genealogical Society, 18 March 1970.
73. BRO/28049 (25) a (i): n.d. [early C20?] 'Certain Extracts & Abridgements of the Will of John Elbridge Esqr, deceased, together with a Set of Orders & Regulations for the

well governing of the Charity School on St Michaels Hill by him lately founded for ye instruction of twenty four poor Girls'; BRO/35893/1/a: *Bristol Infirmary Minute Book*, for 1736 ff.
74. BRO/35893/1/a: *Bristol Infirmary Minute Book, 1736–1772*, Minute of 6 January 1737/1738 and 12 December 1738.
75. BRO/35893/1/a: *Bristol Infirmary Minute Book, 1736–1772*.
76. BRO/35893/21/a: Various, including accounts, officers, etc. 1742–1805, for 1751–1775; Rudder, 452.
77. GA/D1815/19/Box 16: Edward Caruthers Little of Field place, Stroud, 'State of the Gloucester Infirmary for the Year 1775' [Amongst misc. papers in bundle]. Subscribers included Richard Clutterbuck, Nicholas Hyett, Sir Onesiphorus Paul, Thomas Palling, and Charles Sheppard.
78. A. Chan, *Slavery in the Age of Reason: Archaeology at a New England Farm* (Knoxville, TN, 2007), 61.
79. E. Wolf, 2nd, *The Library of James Logan of Philadelphia, 1674–1751* (Philadelphia, 1974), xxxviii and 361.
80. GA/D45/E14: Bills for carpenter's work, rates, repairs and legal proceedings (1707–1726), building repairs, etc. (1728–1782) 4 April 1767, John Dolphin to William Whitmore, and Whitmore's response.
81. Hort was Thomas Elbridge's mother in law. BRO/5535/28: Copy will of Ann Hort, 3 March 1766 [Proved 26 January 1782].
82. BRO/AC/WO/14/8: 15 October 1744. Declaration of Ejectment; BRO/AC/WO/14/10/a: n.d. [prob. October 1744], Henry Woolnough to John Baker.
83. BRO/AC/WO/14/16: 1747, Advertisement concerning Cutting or Stealing of Wood.
84. BRO/AC/WO/14/19/a: Richard Wallington to RW, 20 July 1749; BRO/AC/WO/14/19/c: 20 July 1750.
85. BRO/AC/WO/14/19/b: 20 July 1750, RW to David Thomas; BRO/AC/WO/14/19/d: 7 April 1753, David Thomas to Rebecca Woolnough.
86. BRO/AC/WO/14/19/d: 28 November 1776, Richard Davies to [John Hugh] Smyth Esqr at Ashton Court.
87. BRO/AC/WO/14/19/d: 23 December 1776, John Hugh Smyth to Richard Davies.
88. H. V. Bowen, *Elites, Enterprise and the Making of the British Overseas Empire, 1688–1775* (London, 1996), 103.
89. B. B. Mooney, *Prodigy Houses of Virginia: Architecture and the Native Elite* (Charlottesville, VA, 2008), 271–276; G. Hood, *Governor's Palace in Williamsburg: A Cultural Study* (Chapel Hill, NC, 1991), 38–39.
90. Mooney, *Prodigy Houses*, 276–280.
91. Price, 'Who Cared about the Colonies?' 416.
92. Price, 'Who Cared about the Colonies'; Doerflinger, *A Vigorous Spirit of Enterprise*; D. Hancock, *Citizens of the World: London Merchants and the Integration of the British Atlantic Community, 1735–1785* (Cambridge, 1995); A. G. Olson, *Making the Empire Work: London and American Interest Groups, 1690–1790* (Cambridge, MA and London, 1992); P. Gauci, *Emporium of the World: The Merchants of London, 1660–1800* (London, 2007).
93. Chan, *Slavery in the Age of Reason*, 47–50.
94. Quotes in Tolles, *James Logan*, 93.
95. JL Correspondence Letterbooks, Box 2, B1, 86–87, JL to Thomas Goldney, 23 October 1727. Copies at Stenton.
96. Stenton HSR, 16–17.
97. James Logan Letterbooks, Box 2, B2, 69–70 JL to Dr WL, 28 September 1729; 83–84, JL to WL, 23 May 1730; 86, JL to Thomas Goldney, 30 June 1730. Copies at Stenton.
98. R. D. Brown, *Knowledge Is Power: The Diffusion of Information in Early America, 1700–1865* (Oxford, 1989), 63.
99. R. Hoffman, 'Preface', in Carson et al., (eds), *Of Consuming Interest: The Style of Life in the Eighteenth Century* (Charlottesville, 1994), vii–xii, at vii.

100. F. O'Toole, *White Savage: William Johnson and the Invention of America* (New York, 2005), 288.
101. Rozbicki, 'The Curse of Provincialism: Negative Perceptions of the Colonial American Plantation Gentry', *Journal of Southern History*, vol. 63, no. 4 (November 1997), 727–752 claims a great deal; S. Conway, 'From Fellow-Nationals to Foreigners: British Perceptions of the Americans, circa 1739–1783', *The William and Mary Quarterly*, third series, vol. 59, no. 1 (January 2002), 65–100; E. G. Evans, *A 'Topping People': The Rise and Decline of Virginia's Old Political Elite, 1680–1790* (Charlottesville, VA, 2009); J. Flavell, *When London Was Capital of America* (New Haven and London, 2010) suggest less.
102. Tolles, *James Logan*, 95; James Logan to Johann Fabricius, 11 November 1721, *James Logan Letterbooks 1717–1731*, vol. 3, 20–22. 'Common American' quoted in *James Logan 1674–1751: Bookman Extraordinary* (Philadelphia, 1971), 3.
103. N. Landsman, *From Colonial to Provincials: American Thought and Culture 1680–1760* (Cornell, 1997), 3.
104. Ibid., 177.
105. T. Burnard, *Creole Gentlemen: The Maryland Elite 1691–1776* (New York and London, 2002), 226.
106. M. Rozbicki, *The Complete Colonial Gentleman: Cultural Legitimacy in Plantation America* (Charlottesville, VA, 1998), 2.
107. Mooney, *Prodigy Houses*, 269.
108. Rozbicki, *The Complete Colonial Gentleman*, 141.
109. T. H. Breen, '"Baubles of Britain": The American and Consumer Revolutions in the Eighteenth Century', in Carson et al., (eds), *Of Consuming Interest*, 444–482.
110. R. L. Bushman, *Refinement of America: Persons, Houses, Cities* (New York, 1992), 5; Mooney, *Prodigy Houses*, 268.
111. K. Sweeney, 'Mansion People: Kinship, Class, and Architecture in Western Massachusetts in the Mid Eighteenth Century', *Winterthur Portfolio*, vol. 19, no. 4 (Winter 1984), 231–255, 231, 250.
112. B. Bailyn, *The Ordeal of Thomas Hutchinson* (Cambridge, MA, 1974).
113. Quoted in O'Toole, *White Savage*, 326.
114. Wilson, *Gentlemen Merchants*, 231.

9 Conclusion

1. M. Miers, 'Eshott Hall', *Country Life* (3 January 2002), 56–61.
2. R. E. Carr, *The History of the Family of Carr of Dunston Hill, Co. Durham*, 3 vols (London, 1893–1899), vol. 3, 64.
3. LWL MSS 2/Box 2 /Folders 4–5.
4. LWL MSS 2/Box 6/Folder 4: 4 April 1791. Thomas Adams [TA] to Robert Hopper Williamson Esqr, Newcastle upon Tyne.
5. LWL MSS 2/Box 26/Folder 1: 30 April 1785, Thomas Carr to TA.
6. LWL MSS 2/Box 20/Folder 1: 2 September 1799, TA to J. J. Powels, Lincolns Inn, London.
7. L. E. Klein, 'Politeness for Plebes: Consumption and Social Identity in Early Eighteenth-Century England', in A. Bermingham and J. Brewer, (eds), *The Consumption of Culture 1600–1800: Image, Object, Text* (London, 1995), 362–382, 364; P. J. Corfield, 'The Rivals: Landed and Other Gentlemen', in N. Harte and R. Quinault, (eds), *Land and Society in Britain, 1700–1914* (Manchester, 1996), 1–33, 21.
8. L. E. Klein, 'Politeness and the Interpretation of the British Eighteenth Century', *The Historical Journal*, vol. 45, no. 4 (December 2002), 869–898, 896.
9. N. Landsman, *From Colonials to Provincials: American Thought and Culture 1680–1760* (Cornell, 1997).
10. Several historians, especially Amanda Vickery, have made efforts along these lines recently, for example, A. Vickery, *Behind Closed Doors: At Home in Georgian England* (New Haven and London, 2009).

11. C. Carson, 'The Consumer Revolution in Colonial America: Why Demand?' in C. Carson, R. Hoffman, and P. J. Albert, *Of Consuming Interest: The Style of Life in the Eighteenth Century* (Charlottesville, 1994), 691.
12. For example, William Hamilton of the Woodlands in Philadelphia, and States Dyckman of Boscobel in New York.
13. K. Yokota, *Unbecoming British: How Revolutionary America Became a Post-colonial Nation* (Oxford, 2011).
14. A. Vickery, *Gentleman's Daughter: Women's Lives in Georgian England* (New Haven and London, 1998), 13–14.
15. Ibid., 14.
16. L. Stone and J. F. Stone, *An Open Elite? England 1540–1880* (Oxford, abridged edition, 1995), x; see also, P. Gauci, *The Politics of Trade: The Overseas Merchant in State and Society, 1660–1720* (Oxford, 2001), 90–93.
17. See, for example, D. Hancock, *Citizens of the World: London Merchants and the Integration of the British Atlantic community, 1735–1785* (Cambridge, 1995). Hancock recognized that 'for every merchant building fabulous piles, there were at least three merchants who fit Isaac Ware's generic description of the gentleman', 343.

Select Bibliography

(1) Manuscript and archival sources

Bodleian Library, Oxford
MSS, Gough Somerset 2, fol. 13 and fol. 15: Drawings by James Stewart, 9 and 10 April 1752.
MSS, Gough Somerset 8: Drawings of Bristol by James Stewart, 1745–1753.

Bristol Central Reference Library, Bristol
No. B19716: Letter from Customhouse, Bristol, 26 March 1739.
23274: List of books donated to Bristol Library by Paul Fisher, 1763.

Bristol Museum and Art Gallery, Bristol
K101: 'View of Clifton from Rownhan Meads', c. 1785, 'Granby Hill, Clifton, from the west', 1822.

Bristol Record Office, Bristol
00485/21–22: Related to the mortgage of Rummers Tavern.
04356/1: Apprentice Book, 1684–1686.
04356/9: Apprentice Book, 1709–1719.
14581/HA/D/313: Particulars Conditions of Sale, Hill House, Mangotsfield, 9 April 1874.
5535/28: Copy will of Ann Hort, 3 March 1766 [proved 26 January 1782].
8015: Documents relating the Slade baker family [Redland Court].
09467/12/a: Notes and Receipts for House Building at Clifton 1746–47–48–49 + 1750 + c
09467/12/b: 'Notes and Rects for Mr P Fishers Private Affairs/Bundle No 12/1729' and 'Notes + Receipts for Furniture + c at Clifton (Bundle 13)'
09474/1: Copy will of Henry Bodman, 4 June 1768.
28049 (25)a (i): n.d. [early C20?] 'Certain Extracts & Abridgements of the Will of John Elbridge Esqr, deceased, together with a Set of Orders & Regulations for the well governing of the Charity School on St Michaels Hill by him lately founded for ye instruction of twenty four poor Girls'.
34328/a: Jones, D., 'The Elbridge, Woolnough and Smyth Families of Bristol, in the Eighteenth Century: With Special Reference to the Spring Plantation, Jamaica' (Unpublished PhD thesis, University of Bristol, 1972).
34328/b: Photocopies, correspondence and notes used by Jones in his thesis
35893: Records related to the Bristol Royal Infirmary.
AC/AS/57/3: Copy Will of John Andrews, drawn up on 10 June 1743 with a codicil of 3 December 1743.
AC/WO/1 Woolnough Papers: Personal.
AC/WO/10–20 Elbridge Papers.
P/St.A/OP/1 (a): Overseers to Clifton Parish 1708 to 1732.
P/St.A/OP/1 (b): Overseers to Clifton Parish 1732 to 1749.
P/St MS/Ch/3: Copy will of Henry Bodman, 4 June 1768.
P/St MS/ChW/1 (a): Chappell Warden Accounts for Shirehampton from 1791.
SMV/4/6/1/22: Copy Extract from Will of Thomas Elbridge, 10 January 1742/1743.

SMV/4/6/1/40: Charities, St Monica Home, Cote Deeds explained, n.d., probably c. 1930.
SMV/6/5/4/3: Jacob de Wilstar, 'A Survey of the Mannor of Clifton in the County of Gloucester Being Part of the Estates belonging to the Merchants Hall at Bristol' (1746).

Cote, Bristol
Robinson, E., 'Some Notes about Cote' (Unpublished MS, April, 1971), typescript on file at Cote House.

Frampton Court Collection, Frampton-on-Severn
Angela Howard to Jean Speed, personal correspondence, 21 November 2005.
Christie's Report (November 2003).
India-back chairs, early 1730s.
Portrait of Richard Clutterbuck, by Samuel Besly, 1741.
Richard Clutterbuck Account Book, 1768–1772.
Richard Clutterbuck Cane.
'The Study at Frampton Court', Image 41, c. 1840s.
Watercolours and drawings of interior, c. 1840–1850.

Gloucestershire Archives, Gloucester
B325/51387: F. A. Hyett, *The Hyetts of Painswick* (1907, Typescript).
B673/19132GS: E. C. Little, *Our Family History* (1892), plus Corrections in, with Additions to, 'Our Family History' by E. Caruthers Little.
C/DC/E/88/13: Drawing of Cowley Manor about 1790.
D6: Records of the Hyett family of Painswick.
CMS/202: Justices of the Peace of 1736.
D25: Paul family [Deeds of Hill House].
D33: Whyrall and Machen family papers.
D45: Manorial records, deeds, and papers, 1389–1842 of Whitmore family.
D67/T/4: Related to G. O. Paul, 1712–1791.
D67/Z28: Digest of Deeds of Hill House.
D149: Clifford family papers.
D182/iv/9: Marriage settlement between Charles Bragge of Cleve Hill and Ann Bathurst, 1752.
D421/B1: Proposals, bills, memoranda and correspondence including letters to Chas. Bathurst from Lord Botetourt regarding Warmley Copper and Brass Co.
D340a/T38: Ducie family of Tortworth, deeds, including Hill House, Mangotsfield and copy will of John Andrews, 1743.
D587: Clark and Smith of Tetbury, solictors [Paul family].
D589: Paul family of Minchinhampton and Tetbury.
D610: Hodges and Leigh families of Broadwell.
D637/II/6: Vizard + son of Monmouth, solicitors [Machen family].
D678/1/F12/1: Sir John Dutton correspondence.
D873/T54: Copy will of Sir Onesiphorus Paul, 1773, proved 1774.
D873/T74-T75: Related to Dudbridge house and land.
D1156: Eyres-Mansell, Cocks and Holland families of Dumbleton, 1559–1832.
D1241/Box 14/Bundle 4: Ebworth estate.
D1347: Winterbotham, Ball and Gadsden, solicitors papers [including Palling-Caruthers family of Painswick: deeds and copyhold; copy will of Charles Cox].
D1456: 3 bundles of MS and typed notes compiled by Rev. G. E. Rees while compiling *The History of Bagendon*.
D1610/P334: Estate map of Marshfield.
D1806/F203: William Springett letter.
D1806/T13: Alderley Grange and park, 1864.

D1815/19: Little and Hutton of Stroud, solicitors [related to Pitchcombe house].
D1833: Rooke family papers.
D1866: Hicks Beach family of Coln St Aldwyns.
D2299: Bruton, Knowles and co. papers.
D3798/7/10: Sale particulars of the Hill House estate, Mangotsfield.
D3921/III/5: Notes concerning English Bicknor by H. A. Machen.
D4355/167: Moore + Maberly, Architects of Gloucester, 'Rodborough Manor, new Drains, 1889–1899'.
D8027: Guiting Power manor.
PA117/1: *A Short History of Sandywell Park* (Cirencester, n.d., c. 1966).
PA138/1: H. A. Machen, *English Bicknor: A History* (1954).
Palling-Caruthers (Smith) Papers [MF1440–1446, 1457].
Q/JC: Commissions of the peace, 1728–1878.

Historical Society of Pennsylvania, Philadelphia
Chew Papers [Copy at Cliveden].
James Logan Inventory, 1752 [on file at Stenton].
James Logan Ledger, 1720–1727.
James Logan Letterbooks, 1712–1715.
James Logan Letterbooks, 1717–1731.
James Logan Letterbooks, Box 2, B1 [Copies at Stenton].
James Logan Letterbooks, Box 2, B2 [Copies at Stenton].
James Logan to Thomas Penn, *Penn Manuscripts: Official Correspondence, 1728–1734*.

Lewis Walpole Library
MSS 2: Adams, Thomas, Records relating to Eshott House.

Library Company of Philadelphia
Isaac Norris, Manuscript Catalogue of James Logan's Library, 1743–1744.
Edwin Wolf 2nd, Professional and Personal Papers.
A Plan of the City and Environs of Philadelphia, Surveyed by N. Scull and G. Heap. Engraved by Willm Faden. 1777. LCP/P.2008.34.3.
London Magazine, Or, Gentleman's Monthly Intelligencer for October 1761 [LCP Per L 62.5 74.O].
Minutes of LCP, 29 March 1732.

Museum in the Park, Stroud
Patent 1748/no. 630.
Wathen donation, 1987.327–362.

National Monuments Record, Swindon
Images of England [http://www.imagesofengland.org.uk].
Red box photographic collection.

Nuffield Health, St Mary's Hospital archive
Indenture, 17 August 1742 [Clifton Court].

Redland School for Girls, Bristol
'Plan of the Redland Court Estate, 1811'.
Portraits of John and Martha Cossins.

The National Archives, Kew

C12/679/15: Daubeny v. Baker.
C12/980/25: Daubeny v. Baker.
C12/1215/7: Bill Supplement Brereton v Blanch, 2d May 175[7?].
C12/1932/11: Brereton v. Roberts.
C12/1946/10: Brereton v. Roberts.
C211/11/H64: Writ de lunatic inquirendo [Thomas Horton].
PROB 3: Prerogative Court of Canterbury: Filed Engrossed Eighteenth Century Inventories and Associated Documents, 1701–1782.
PROB 4: Prerogative Court of Canterbury and Other Probate Jurisdictions: Engrossed Inventories Exhibited from 1660 to c. 1720.
PROB 11: Prerogative Court of Canterbury and Related Probate Jurisdictions: Will Registers.
PROB 31: Prerogative Court of Canterbury: Exhibits, Main Class, 1722–1858.

University of Bristol Library (special collections)

DM1398: Goldney Family Papers, 1603–1933.
DM1466: Further Papers of the Goldney Family, 1687–1851.
DM1499/9: Account Book of Thomas Goldney, 1708–1713.
DM1910: Goldney House Plans, 1865–1933.
DM1911: Deeds Transferred from the Secretary's Office Relating to Property Owned by the University of Bristol.

University of Pennsylvania

Thomas Nevil Daybook, 1762–1784, MS Codex 1049, The Wetherill Papers.

(2) Printed Primary Sources

Books

Atkyns, R., Sir, *The Ancient and Present State of Glocestershire* [Electronic Resource] (London, 1712).
——, *The Ancient and Present State of Glocestershire* [Electronic Resource] (London, 1768).
——, *The Ancient and Present State of Glostershire* (Wakefield, 1974).
Bigland, R., *Historical, Monumental and Genealogical Collections toward a History of Gloucestershire*, 3 vols (London, 1789–1887, reprint Gloucester, 1989–1995).
Barlow, T., *The Justice of the Peace: A Treatise Containing the Power and Duty of that Magistrate* (London, 1745).
Bishop Benson's Survey of the Diocese of Gloucester, 1735–1750, John Fendley (ed.), Bristol and Gloucestershire Archaeological Society, vol. 20 (2000).
Black, W., 'The Journal of William Black', 1 June 1744, *Pennsylvania Magazine of History and Biography*, vol. 1, no. 4 (1877), 406–407.
Brewer, J. N., *Delineations of Gloucestershire: Views of the Principal Seats of Nobility and Gentry* (Stroud, Gloucestershire, 1825, reprint 2005).
Buck, S., *Samuel Buck's Yorkshire Sketchbook Reproduced in Facsimile from Lansdowne MS. 914 in the British Library with an Introduction by Ivan Hall* (Wakefield, 1979).
Campbell, C., *Vitruvius Britannicus*, vol. 1 (1715).
Carter, E. C., (ed.), *The Virginia Journals of Benjamin Henry Latrobe, 1795–1798*, 2 vols (New Haven, 1977).
Cartwright, J. J., (ed.), *The Travels through England of Dr Richard Pococke, Successively Bishop of Meath and of Ossory during 1750, 1751, and Later Years*, 2 vols (London, 1888–1889).

Clutterbuck, E., *The Clutterbuck Diaries, being the Journey with My Wife and Daughter Sally into Gloucestershire on a Visit to my Cousin Clutterbuck at King Stanley* [1773], with notes by The Rev. Robert Nott and T. E. Sanders (Stroud, 1935).

Darrell, W. [W. D. (William Darrell)]. *The Gentleman Instructed, in the Conduct of a Virtuous and Happy Life* [Dublin], 1725. Eighteenth-Century Collections Online.

Defoe, D., *A Tour thro' the Whole Island of Great Britain*, vol. 1 (London, 1724).

Farish, H. D., (ed.), *Journal and Letters of Philip Vickers Fithian* (Colonial Williamsburg, 1957).

Ferner's Journal, 1759–1760: An Industrial Spy in Bath and Bristol, A. P. Woolrich, (ed.) (Eindhoven, 1986).

Gentleman's Magazine.

Gibbs, J., *A Book of Architecture, Containing Designs of Buildings and Ornaments* (London, 1728).

Grant, A., *Memoirs of an American Lady: With Sketches of Manners and Scenes in America, as They Existed Previous to the Revolution* (Albany, NY, 1876).

Halfpenny, W., *Practical Architecture, or a Sure Guide to the True Working According to the Rules of that Ccience* (London, c. 1724).

———, *The Art of Sound Building: Demonstrated in Geometrical Problems* (London, 1725).

——— [pseud. Michael Hoare], *The Builder's Pocket Companion: Shewing an Easy and Practical Method for Laying Down of Lines ...* (London, 1728).

———, *A New and Complete System of Architecture Delineated, Delineated in a Variety of Plans and Elevations of Designs for Convenient and Decorated Houses* (London, 1749).

Halfpenny, W. and J. Halfpenny, *The Country Gentleman's Pocket Companion, and Builder's Assistant for Rural Decorative Architecture* (London, 1753).

———, *New Designs for Chinese Temples* (London, 1750).

Johnson, W., Sir, *Papers of Sir William Johnson* (Albany, 1921–1965).

Jones, H., *Clifton: A Poem* (Bristol, 1767).

Kenrick, W., *The Poetical Works of Robert Lloyd*, 2 vols (London, 1774).

Kip, J., *Britannia Illustrata, or Views of Several of the Queens Palaces: As Also of the Principal Seats of the Nobility and Gentry of Great Britain Curiously Engraven on 80 Copper Plates* (London, 1707).

———, *Britannia Illustrata, or Views of Several of the Queens Palaces: As Also of the Principal Seats of the Nobility and Gentry of Great Britain. 80pl.* (London, 1708).

———, *Britannia Illustrata, or Views of Several of the Queens Palaces: As Also of the Principal Seats of the Nobility and Gentry of Great Britain. 80pl.* (London, 1714).

———, *Britannia Illustrata [Electronic Resource], or Views of Several of the Queens Palaces: As Also of the Principal Seats of the Nobility and Gentry of Great Britain Elegantly Engraven on Lxxx Copper Plates. Tom. I* (London, 1720).

Logan, James, 'James Logan on Defensive War, or Pennsylvania Politics in 1741', *Pennsylvania Magazine of History and Biography*, vol. 6 (1882), 402–411.

Lyson, S., *An Account of Roman Antiquities Discovered at Woodchester* (London, 1797).

Macky, J., *A Journey through England: In Familiar Letters from a Gentleman Here, to his Friend Abroad*, 2 vols (London, 1722).

Mereness, N., (ed.), 'Journal of Lord Adam Gordon', in *Travels in the American Colonies* (New York, 1916).

Meyers, A. C., *Hannah Logan's Courtship* (Philadelphia, 1904).

Middleton, C., *Picturesque and Architectural Vies for Cottages, Farm Houses, and Country Villas* (London, 1793).

Milcah Martha Moore's Book: A Commonplace Book from Revolutionary America, C. L. and K. A. Wulf, (eds) (University Park, PA, 1997).

Moore, J. S., (ed.), *Clifton and Westbury Probate Inventories, 1609–1761* (Bristol, 1981).

Neve, R., *The City and Country Purchaser, and Builder's Dictionary, or, the Compleat Builders Guide...the Second Edition, with Additions* (London, 1726).

North, R., *Of Building*, in H. Colvin and J. Newman, (eds) (Oxford, 1981), 62.
Nourse, T., *Campagna Felix* (London, 1700).
Oldmixion, J., *The British Empires in North America* (London, 1708).
Papers of Benjamin Franklin, vol. 4 (*Pennsylvania Gazette*, 7 November 1751).
Penn, W., *Fruits of Solitude* (New York, 1693, reprint in 1907).
Rogers, Woodes, *A Cruising Voyage Round the World* (London, 1712).
Rudder, S., *A New History of Gloucestershire* (Cirencester, 1779).
Rudge, T., *The History of the County of Gloucester, Brought Down to 1803*, 2 vols (Gloucester, 1803).
Salmon, W., *Palladio Londinensis* (London, 1734).
Shiercliff, E., *Bristol and Hotwells Guide* (Bristol, 1789).
Switzer, S., *Ichnographia Rustica, or, the Nobleman, Gentleman, and Gardener's Recreation*, 3 vols (London, second edition, 1718).
Thomas, G., *An Account of Pennsylvania and West New Jersey* (London, 1698).
Tinling, M., (ed.), *The Correspondence of the Three William Byrds of Westover, Virginia, 1684–1776* (Charlottesville, 1977).
Tucker, J., *Instructions for Travellers* (London, 1757).
Ware, I., *A Complete Body of Architecture* (London, 1756).
Young, A., *A Six Weeks Tour through the Southern Counties of England and Wales* (London, 1768).

Government papers

Calendar of Treasury Books, 32 vols [online at http://www.british-history.ac.uk].
Calendar of Treasury Papers, 6 vols [online at http://www.british-history.ac.uk].
Calendar of Treasury Books and Papers, 5 vols [online at http://www.british-history.ac.uk].

Maps

Donne, B., *This Map of the Country 11 Miles Round the City of Bristol* (Bristol, 1769) [also at BRO/Bristol Plan 232c/30120(3)].
Millerd, J., *An Exact Delineation of the Famous Cittie of Bristoll and Suburbs Thereof* (Bristol, 1671).
Rocque, J., *A Plan of the City and Suburbs of Bristol* (London, 1764).
——, *A Collection of Plans of Principal Cities of Great Britain and Ireland with Maps of the Coast of Said Kingdoms* (London, 1764).
Taylor, I., *The County of Gloucester* (London, 1800).
Warburton, J., *A New and Correct Map of the County of York in all It's Divisions* (s.l., 1720).

Newspapers

Farley's Bristol Newspaper (1725–1741).
Felix Farley' Bristol Journal (1748–1760).
Gloucester Journal (1722–1770).

(3) Printed secondary works

Ackerman, J. S., *The Villa: Form and Ideology of Country Houses* (Princeton, 1995).
Airs, M. and G. Tyack, (eds), *The Renaissance Villa in Britain, 1500–1700* (Reading, 2007).
Airs, M. and P. Barnwell, (eds), *Houses and the Hearth Tax: The Later Stuart house and Society* (York, 2006).
Allen, R. C., *The British Industrial Revolution in Global Perspective* (Cambridge, 2009).
Anderson, J., *Glorious Splendor: The 18th-Century Wallpapers in the Jeremiah Lee Mansion* (Virginia Beach, VA, 2011).

Archer, J., *The Literature of British Domestic Architecture, 1715–1842* (Cambridge, MA and London, 1985).
——, *Architecture and Suburbia: From English Villa to American Dream House, 1690–2000* (Minneapolis and London, 2005).
Arciszewska, B., (ed.), *The Baroque Villa: Suburban and Country Residences, c. 1600–1800* (Wilanow, Poland, 2009).
Arciszewska, B. and E. McKellar, (eds), *Articulating British Classicism: New Approaches to Eighteenth-Century Architecture* (Aldershot, 2004).
Armitage, D., 'Three Concepts of Atlantic History', in Armitage and M. Braddick, (eds), *The British Atlantic World, 1500–1800* (London, 2002), 11–27.
Armitage, D. and M. Braddick, (eds), *The British Atlantic World, 1500–1800* (London, 2002).
Arnold, D., (ed.), *The Georgian Country House: Architecture, Landscape and Society* (Stroud, 1998).
Arnold, D., (ed.), *The Georgian Villa* (Stroud, 1998).
Aughton, P., *Bristol: A People's History* (Lancaster, 2000).
Aynsley, J. and C. Grant, (eds), *Imagined Interiors: Representing the Domestic Interior since the Renaissance* (London, 2006).
Ayres, J., *Building the Georgian City* (New Haven and London, 1998).
——, *Domestic Interiors: The British Tradition 1500–1850* (New Haven and London, 2003).
——, *Two Hundred Years of English Naïve Art 1700–1900* (1996).
Ayres, P., *Classical Culture and the Idea of Rome in Eighteenth-Century England* (Cambridge, 1997).
Baigent, E. and R. Mayhew, (eds), *English Geographies 1600–1950: Historical Essays on English Customs, Cultures, and Communities in Honour of Jack Langton* (Oxford, 2009).
Bailyn, B., *The Ordeal of Thomas Hutchinson* (Cambridge, MA, 1974).
Bantock, A., *The Earlier Smyths of Ashton Court from Their Letters 1545–1741* (Bristol, 1982).
Barker, H. and E. Chalus, *Gender in Eighteenth-Century England: Roles, Representations and Responsibilities* (London, 1997).
Barry, J. and K. Morgan, (eds), *Reformation and Revival in Eighteenth-Century Bristol*, BRS (Bristol, 1994).
Barry, J. and C. Brooks, (eds), *The Middling Sort of People: Culture, Society and Politics in England, 1550–1800* (Basingstoke, 1994).
Beard, G., *Upholsterers and Interior Furnishings in England 1530–1840* (New Haven and London, 1997).
Beard, G. and C. Gilbert, *Dictionary of English Furniture Makers, 1660–1840* (Leeds, 1986).
Beckett, J. V., *The Aristocracy in England, 1660–1914* (Oxford, 1986).
Berg, M., *Luxury and Pleasure in Eighteenth-Century Britain* (Oxford, 2005).
Berg, M. and H. Clifford, (eds), *Consumers and Luxury: Consumer Culture in Europe, 1650–1850* (Manchester, 1999).
Berg, M. and E. Eger, (eds), *Luxury in the Eighteenth Century: Debates, Desires and Delectable Goods* (Basingstoke, 2003).
Bermingham, A. and J. Brewer, (eds), *The Consumption of Culture 1600–1800: Image, Object, Text* (London, 1995).
Berry, H. and E. Foyster, (eds), *The Family in Early Modern England* (Cambridge, 2007).
Berry, H. and J. Gregory, (eds), *Creating and Consuming Culture in North-East England, 1660–1830* (Aldershot, 2004).
Bettey, J. H., *Bristol Observed: Visitors' Impressions of the City from Domesday to the Blitz* (Bristol, 1986).
——, *The Royal Fort and Tyndall's Park: The Development of a Bristol Landscape* (Bristol, 1997).
Billings, W. M., J. E. Selby and T. W. Tate, *Colonial Virginia: A History* (White Plains, NY, 1986).
Binney, M., 'Poulton Manor', *Country Life* (27 May 1976), 1398–1400.
Black, J., *Eighteenth-Century Britain, 1688–1783* (Basingstoke, second edition, 2008).

Blondé, B., N. Coquery, J. Stobart, and I. Van Damme, (eds), *Fashioning Old and New: Changing Consumer Patterns in Europe (1650–1900)* (Turnhout, Belgium, 2009).

Bold, J., 'The Design of a House for a Merchant, 1724', *Architectural History*, vol. 33 (1990), 75–82.

Borsay, P., *The English Urban Renaissance: Culture and Society in the Provincial Town 1660–1770* (Oxford, 1989).

——, 'Why Are Houses Interesting?' *Urban History*, vol. 34, no. 2 (2007), 338–346.

Bourdieu, P., *Distinction: A Social Critique of the Judgment of Taste* (London, 1984).

Bowen, H. V., *Elites, Enterprise and the Making of the British Overseas Empire, 1688–1775* (London, 1996).

Bowett, A. 'The Commercial Introduction of Mahogany and the Naval Stores Act of 1721', *Furniture History*, vol. 30 (1994), 43–57.

——, 'After the Naval Stores Act: Some Implications for English Walnut Furniture', *Furniture History*, vol. 31 (1995), 116–123.

——, *English Furniture 1660–1714: Charles II to Queen Anne* (Woodbridge, Suffolk, 2002).

——, 'The India-Back Chair, 1715–1740', *Apollo* (January 2003), 3–9.

——, *Early Georgian Furniture 1715–1740* (Woodbridge, Suffolk, 2009).

Bradbury, O., 'Handel at Home', *Country Life*, 15 December 2005.

Brant, C., *Eighteenth-Century Letters and British Culture* (Basingstoke, 2006).

Breen, T. H., 'An Empire of Goods: The Anglicization of Colonial America, 1690–1776', *Journal of British Studies*, vol. 25, no. 4 (1986), 467–499.

——, *Tobacco Culture: The Mentality of the Great Tidewater Planters on the Eve of Revolution* (Princeton, 1985).

Breen, T. H.,'"Baubles of Britain": The American and Consumer Revolutions in the Eighteenth Century', in C. Carson, R. Hoffman, and P. J. Albert, *Of Consuming Interest: The Style of Life in the Eighteenth Century* (Charlottesville, 1994).

Brewer, J., *The Sinews of Power: War, Money and the English State, 1688–1783* (London, 1989).

Brewer, J. and R. Porter, (eds), *Consumption and the World of Goods* (London, 1993).

Bristow, I., *Architectural Colour in British Interiors, 1615–1840* (New Haven and London, 1996).

——, *Interior House-Painting Colours and Technology, 1615–1840* (New Haven and London, 1996).

Brooks, M. M., *English Embroideries of the Sixteenth and Seventeenth Centuries in the Collection of the Ashmolean Museum* (London, 2004).

Brown, R. D., *Knowledge Is Power: The Diffusion of Information in Early America, 1700–1865* (Oxford, 1989).

Bruckner, M., *The Geographic Revolution in Early America: Maps, Literacy, and Natural Identity* (Chapel Hill, NC, 2006).

Brunskill, R. W., *Vernacular Architecture: An Illustrated Handbook* (retitled) (London, fourth edition, 2000).

Burnard, T., *Creole Gentlemen: The Maryland Elite 1691–1776* (New York and London, 2002).

Burnside, A., *A Palladian Villa in Bristol: Clifton Hill House and the People Who Lived There* (Bristol, 2009).

Burnside, A. and S. B. Brennan, 'Paul Fisher: Linen-Draper and Merchant, of Clifton Hill House', in M. Crossley-Evans, (ed.), *'A Grand City' – 'Life, Movement and Work': Bristol in the Eighteenth and Nineteenth Centuries, Essays in Honour of Gerard Leighton, FSA* (Bristol, 2010), 47–62.

Bushman, R. L., *The Refinement of America: Persons, Houses, Cities* (New York, 1992).

Cannon, J. A., *Aristocratic Century: The Peerage of Eighteenth-Century England* (Cambridge, 1984).

Cannon, J. A. and P. McGrath, (eds), *Essays in Bristol and Gloucestershire History: The Centenary Volume of the Bristol and Gloucestershire Archaeological Society* (Bristol, 1976).

Carp, B. L., *Rebels Rising: Cities and the American Revolution* (Oxford, 2007).

Carr, R. E., *The History of the Family of Carr of Dunston Hill, Co. Durham*, 3 vols (London, 1893–1899).

Carr, L. G. and L. S. Walsh, 'Changing Lifestyle and Consumer Behavior in the Colonial Chesapeake', in C. Carson, R. Hoffman, and P. J. Albert, (eds), Of Consuming Interest: *The Style of Life in the Eighteenth Century* (Charlottesville, 1994), 59–166, at 65–66.

Carson, C., 'The Consumer Revolution in Colonial America: Why Demand?' in C. Carson, R. Hoffman, and P. J. Albert, *Of Consuming Interest: The Style of Life in the Eighteenth Century* (Charlottesville, 1994).

Carson, C. and C. R. Lounsbury, (eds), *The Chesapeake House: Architectural Investigations by Colonial Williamsburg* (Chapel Hill, NC, 2013).

Carson, C., R. Hoffman, and P. J. Albert, *Of Consuming Interest: The Style of Life in the Eighteenth Century* (Charlottesville, 1994).

Chan, A., *Slavery in the Age of Reason: Archaeology at a New England Farm* (Knoxville, TN, 2007).

Chalkin, C. W., *The Provincial Towns of Georgian England: A Study of the Building Process 1740–1820* (London, 1974).

Chappell, E., 'Fieldwork', in C. Carson and C. R. Lounsbury, (eds), *The Chesapeake House: Architectural Investigations by Colonia Williamsburg* (Chapel Hill, NC, 2013), 29–47.

Charlton, J. and D. M. Milton, *Redland 791 to 1800* (Bristol, 1951).

Christie, C., *The British Country House in the Eighteenth Century* (Manchester, 2000).

Christie, I., *British 'Non-Elite' MPs 1715–1820* (Oxford, 1995).

Clark, J. C. D., *English Society 1660–1832: Religion, Ideology and Politics during the Ancien Régime* (Cambridge, 2000).

——, *English Society 1688–1832: Ideology, Social Structure and Political Practice during the Ancien Regime* (Cambridge, 1985).

Clark, P., 'The Civic Leaders of Gloucester 1580–1800', in P. Clark, (ed.), *The Transformation of English Provincial Towns* (London, 1984), 311–345.

Clark, P. and P. A. Slack, (eds), *Crisis and Order in English Towns 1500–1700* (London, 1972).

Clayton, T., 'Publishing Houses: Prints of Country Seats', in D. Arnold, (ed.), *The Georgian Country House: Architecture, Landscape and Society* (Stroud, 1998), 43–60.

Clemenson, H., *English Country Houses and Landed Estates* (London, 1982).

Cohen, D., *Household Gods: The British and Their Possessions* (New Haven, 2006).

Cohen, M. and T. Hitchcock, (eds), *English Masculinities, 1660–1800* (Harlow, 1999).

Collett-White, J., (ed.), *Inventories of Bedfordshire Country Houses, 1714–1830*, Publications of the Bedfordshire Record Society, vol. 74 (Bedford, 1995).

Colvin, H. M., *A Biographical Dictionary of British Architects, 1600–1840* (New Haven and London, fourth edition, 2008).

Colvin, H. M. and J. Harris, (eds), *The Country Seat: Studies in the History of the British Country House Presented to Sir John Summerson on his Sixty-Fifth Birthday Together with a Select Bibliography of His Published Writings* (London, 1970).

Conway, S., 'From Fellow-Nationals to Foreigners: British Perceptions of the Americans, circa 1739–1783', *The William and Mary Quarterly*, third series, vol. 59, no. 1 (January 2002), 65–100.

Cooke, Jr, E. S., (ed.), *Upholstery in America and Europe from the Seventeenth Century to World War I* (New York and London, 1987).

Cooper, N., *Houses of the Gentry 1480–1680* (New Haven and London, 1999).

——, 'Rank, Manners and Display: The Gentlemanly House, 1500–1750', *Transactions of the Royal Historical Society*, vol. 12 (2002), 291–310.

——, 'The English Villa: Sources, Forms and Functions', in M. Airs and G. Tyack, (eds), *The Renaissance Villa in Britain, 1500–1700* (Reading, 2007), 9–24.

——, 'A Home with Hidden Depths: Bourton House, Gloucestershire', *Country Life* (22 September 2010), 103–107.

Corfield, P. J., *The Impact of English Towns 1700–1800* (Oxford, 1982).

——, *Power and the Professions in Britain, 1700–1850* (London, 1995).

——, 'The Rivals: Landed and Other Gentlemen', in N. Harte and R. Quinault, (eds), *Land and Society in Britain, 1700–1914* (Manchester, 1996), 1–33.

——, 'Class by Name and Number in Eighteenth Century Britain', in P. J. Corfield, (ed.), *Language, History and Class* (Oxford, 1991), 101–130.
Corfield, P. J., (ed.), *Language, History and Class* (Oxford, 1991).
Cornforth, J., *Early Georgian Interiors* (London and New Haven, 2004).
Cotterell, H. H., *Old Pewter: Its Makers and Marks in England, Scotland and Ireland* (London, 1929, reprinted 1963).
Craske, M., 'From Burlington Gate to Billingsgate: James Ralph's Attempt to Impose Burlingtonian Classicism as a Canon of Public Taste', in B. Arciszewska and E. McKellar, (eds), *Articulating British Classicism: New Approaches to Eighteenth-Century Architecture* (Aldershot, 2004), 97–118.
Crossley-Evans, M., (ed.), *'A Grand City' – 'Life, Movement and Work': Bristol in the Eighteenth and Nineteenth Centuries* (Bristol, 2010).
Crowley, J., *The Invention of Comfort: Sensibilities and Design in Early Modern Britain and America* (Baltimore, 2001).
Cruickshank, D., *Georgian Town Houses and Their Details* (London, 1990).
——, *Life in the Georgian City* (London, 1990).
Cruickshanks, E., S. Handley, and D. W. Hayton, (eds), *The House of Commons, 1690–1715*, 5 vols (Cambridge, 2002).
Day, J., *Bristol Brass: A History of the Industry* (Newton Abbot, 1973).
——, 'The Champion Family (per 1670–1794)', *Oxford Dictionary of National Biography* (Oxford, online edition, 2004).
Deetz, J., *In Small Things Forgotten: An Archaeology of Early American Life* (New York, revised edition, 1996).
Delderfield, E. R., *West Country Historic Houses and Their Families* (Newton Abbot, 1968).
Devine, T. M., *The Tobacco Lords: A Study of the Tobacco Merchants of Glasgow and Their Trading Activities, c. 1740–1790* (Edinburgh, 1975).
Dierks, K., *In My Power: Letter Writing and Communications in Early America* (Philadelphia, 2009).
Dixon Hunt, J. and P. Willis, (eds), *The Genius of the Place: The English Landscape Garden, 1620–1820* (Cambridge, MA, 1988).
Doerflinger, T., *A Vigorous Spirit of Enterprise: Merchants and Economic Development in Revolutionary Philadelphia* (Chapel Hill, NC, 1986).
Donald, M. and L. Hurcombe, (eds), *Gender and Material Culture in Historical Perspective* (Basingstoke, 2000).
Dresser, M., 'Squares of Distinction, Webs of Interest: Gentility, Urban Development and the Slave Trade in Bristol c. 1673–1820', *Slavery and Abolition*, vol. 21, no. 3 (December 2000), 21–47.
——, *Slavery Obscured: The Social History of the Slave Trade in Bristol* (Bristol, 2007).
Dresser, M. and A. Hahn, *Slavery and the British Country House* (Swindon, 2013).
Dunn, R. S. and M. M. Dunn, (eds), *The Papers of William Penn*, 3 vols (Philadelphia, 1986).
DuPlessis, R. S., 'Cotton Consumption in the Seventeenth- and Eighteenth-Century Atlantic', in G. Riello and P. Parthasarathi, (eds), *The Spinning World: A Global History of Cotton Textiles, 1200–1850* (Oxford, 2009), 227–246.
Dyrham Park (London, 2002)
Earle, P., *The Making of the English Middle Class: Business, Society and Family Life in London, 1660–1730* (London, 1989).
Earle, R., (ed.), *Epistolary Selves: Letters and Letter-Writers, 1600–1945* (Aldershot, 1999).
Eddis, W., *Letters from America*, in A. C. Land (ed.) (Cambridge, MA, 1969).
Edney, M. H., 'Mathematical Cartography and the Social Ideology of British Cartography', *Imago Mundi*, vol. 46 (1994), 101–116.
Edwards, C., *Eighteenth-Century Furniture* (Manchester, 1996).
English Houses and Gardens in the 17th and 18th Centuries: A Series of Bird's-Eye Views, by Kip, Badeslade, Harris and Others (London, 1908).

Estabrook, C. B., *Urbane and Rustic England: Cultural Ties and Social Spheres in the Provinces, 1660–1780* (Manchester, 1998).
Evans, E. G., *A 'Topping People': The Rise and Decline of Virginia's Old Political Elite, 1680–1790* (Charlottesville, VA, 2009).
Evans, W., 'Redland Hill House and Redland Chapel, Bristol', *TBGAS*, vol. 118 (2000), 206–212.
Finch, J. and K. Giles, (eds), *Estate Landscapes: Design, Improvement and Power in the Post-medieval Landscape* (Woodbridge, Suffolk, 2007).
Finberg, H. P. R., (ed.), *Gloucestershire Studies* (Leicester, 1957).
Finn, M., 'Men's Things: Masculine Possession in the Consumer Revolution', *Social History*, vol. 25, no. 2 (May 2000), 133–155.
——, *The Character of Credit: Personal Debt in English Culture, 1740–1914* (Cambridge, 2003).
Fischer, D. H., *Albion's Seed: Four British Folkways in America* (New York and Oxford, 1989).
Flather A., *Gender and Space in Early Modern England* (Woodbridge, 2007).
Flavell, J., *When London Was Capital of America* (New Haven and London, 2010).
Flaxner, J. T., *Mohawk Baronet: A Biography of Sir William Johnson* (Syracuse, 1989).
Fowler, J. and J. Cornforth, *English Decoration in the Eighteenth Century* (London, 1978).
Foyle, A., *Pevsner Architectural Guides: Bristol* (London, 2004).
French, H. R., *The Character of English Rural Society: Earls Colne, 1550–1750* (Manchester, 2007).
——, *The Middle Sort of People in Provincial England, 1600–1750* (Oxford, 2007).
——, 'The Search for the Middle Sort of People in England, 1600–1800', *The Historical Journal*, vol. 43, no. 1 (2000), 277–293.
——, '"Ingenious and Learned Gentlemen": Social Perceptions and Self-fashioning among Parish Elites in Essex, 1680–1740', *Social History*, vol. 25, no. 1 (January 2000), 44–66.
French, H. and M. Rothery, *Man's Estate: Landed Gentry Masculinities 1660–1900* (Oxford, 2012).
Galinou, M., (ed.), *City Merchants and the Arts* (London, 2004).
Gauci, P., *Emporium of the World: The Merchants of London, 1660–1800* (London, 2007).
——, *The Politics of Trade: The Overseas Merchant in State and Society, 1660–1720* (Oxford, 2001).
George, E. and S. George, (eds), *Guide to the Probate Inventories of the Bristol Deanery of the Diocese of Bristol, 1542–1804* (Bristol, 1988).
Gerhold, D., 'London's Suburban Villas and Mansions, 1660–1830', *The London Journal*, vol. 34, no. 3 (November 2009), 233–263.
Gilbert, C., J. Lomax, and A. Wells-Cole, *Country House Floors, 1660–1850* (Leeds, 1987).
Girouard, M., *Life in the English Country House: A Social and Architectural History* (New Haven and London, 1978).
——, 'The Power House', in G. Jackson-Stops, (ed.), *The Treasure Houses of Britain: Five Hundred Years of Private Patronage and Art Collecting* (New Haven, 1985), 22–27.
Glaisyer, N., *The Culture of Commerce in England, 1660–1720* (Woodbridge, Suffolk, 2006).
Glanville, P., *Silver in England* (London, 1986).
Glanville, G. and P. Glanville, 'The Art Market and Merchant Patronage in London 1680 to 1720', in M. Galinou, (ed.), *City Merchants and the Arts* (London, 2004), 11–24.
Glassey, L. K. J., *Politics and the Appointment of the Justices of the Peace 1675–1720* (Oxford, 1979).
Gogarty, T., 'Henry Jones, Bricklayer and Poet', *Journal of the County Louth Archaeological Society*, vol. 2, no. 4 (November 1911), 363–374.
Gomme, A. H., *Smith of Warwick: Francis Smith, Architect and Master-Builder* (Stamford, 2000).
——, 'Halls into Vestibules', in M. Airs and G. Tyack, (eds), *The Renaissance Villa in Britain 1500–1700* (Reading, 2007), 38–63.

Gomme, A. H. and A. Maguire, *Design and Plan in the Country House: From Castle Donjons to Palladian Boxes* (New Haven and London, 2008).

Gomme, A., M. Jenner and B. Little, *Bristol: An Architectural History* (London, 1979).

Goodman, D. and K. Norberg, (eds), *Furnishing the Eighteenth Century: What Furniture Can Tell Us about the European and American Past* (New York and London, 2007).

Gorman, F. O., *Voters, Patrons, and Parties: The Unreformed Electorate of Hanoverian England, 1734–1832* (Oxford, 1989).

Graham, W., 'Architectural Paint Research at American Museums: An Appeal for Standards', in M. A. Jablonski and C. R. Matsen, (eds), *Architectural Finishes in the Built Environment* (London, 2009), 3–18.

Grassby, R., 'Social Mobility and Business Enterprise in Seventeenth-Century England', in D. Pennington and K. Thomas, (eds), *Puritans and Revolutionaries: Essays in Seventeenth-Century History Presented to Christopher Hill* (Oxford, 1978).

Green, A., 'The Polite Threshold in Seventeenth- and Eighteenth-Century Britain', *Vernacular Architecture*, vol. 41 (2010) 1–9.

Greig, H., 'Leading the Fashion: The Material Culture of London's Beau Monde', in J. Styles and A. Vickery, (eds), *Gender, Taste, and Material Culture in Britain and North America, 1700–1830* (New Haven and London, 2006), 295–310.

Greig, H. and G. Riello, 'Eighteenth-Century Interiors – Redesigning the Georgian: Introduction', *Journal of Design History*, vol. 20, no. 4 (Winter 2007), 273–289.

Greig, H. and G. Riello, (eds), 'Special Issue on Georgian Interiors', in *Journal of Design History*, vol. 20, no. 4 (Winter 2007).

Gross, G., *Great Houses of New England* (New York, 2008).

Guillery, P., *The Small House in Eighteenth-Century London* (New Haven and London, 2004).

Gusler, W. B., *Furniture of Williamsburg and Eastern Virginia, 1710–1790* (Williamsburg, VA, reprint edition, 1993).

Habakkuk, H. J., *Marriage, Debt, and the Estates System: English Landownership 1650–1950* (Oxford, 1994).

Hague, S. G., 'Historiography and the Origins of the Gentleman's House in the British Atlantic World', in O. Horsfall Turner, (ed.), *'The Mirror of Great Britain': National Identity in Seventeenth-Century British Architecture* (Reading, 2012), 233–259.

———, 'Furnishing for Gentility: Evidence from Small Classical Houses in Gloucestershire, 1680–1770', *Regional Furniture*, vol. 27 (2013), 45–74.

Hall, L. J., *The Rural Houses of North Avon and South Gloucestershire, 1400–1720* (Bristol, 1983).

———, 'Yeoman or Gentleman? Problems in Defining Social Status in Seventeenth- and Eighteenth-Century Gloucestershire', *Vernacular Architecture*, vol. 20 (1991), 2–19.

Hamilton, M. W., 'The Library of Sir William Johnson', *New York Historical Society Quarterly*, vol. 40 (July 1956), 209–251.

Hancock, D., *Citizens of the World: London Merchants and the Integration of the British Atlantic Community, 1735–1785* (Cambridge, 1995).

Harford, A., *Annals of the Harford Family* (London, 1909).

Harris, B., 'Cultural Change in Provincial Scottish Towns, c. 1700–1820', *The Historical Journal*, vol. 54, no. 1 (2011), 105–141.

Harris, E., *British Architectural Books and Writers 1556–1785* (Cambridge, 1990).

Harris, J., *The Architect and the British Country House, 1620–1920* (Washington, DC, 1985).

———, *A Country House Index: An Index to over 2000 Country Houses Illustrated in 107 Books of Country Views Published between 1715 and 1872, Together with a List of British Country House Guides and Country House Art Collection Catalogues for the Period 1726–1880* (London, 1979).

———, *The Palladians* (London, 1981).

Hart, E., *Building Charleston: Town and Society in the Eighteenth-Century British Atlantic World* (Charlottesville and London, 2010).

Harte, N. and R. Quinault, (eds), *Land and Society in Britain, 1700–1914* (Manchester, 1996).
Harvey, K., (ed.), *History and Material Culture: A Student's Guide to Approaching Alternative Sources* (London, 2009).
Harvey, K., *The Little Republic: Masculinity and Domestic Authority in Eighteenth-Century Britain* (Oxford, 2012).
——, 'The History of Masculinity, circa 1650–1800', *Journal of British Studies*, vol. 44, no. 2 (April 2005), 296–311.
——, 'Barbarity in a Tea Cup? Punch, Domesticity and Gender in the Eighteenth Century', *Journal of Design History*, vol. 21, no. 3 (Autumn 2008), 205–221.
——, 'Men Making Home: Masculinity and Domesticity in Eighteenth-Century Britain', *Gender and History*, vol. 21, no. 3 (November 2009), 520–540.
Harvey, K. and A. Shepard, 'What Have Historians Done with Masculinity? Reflections on Five Centuries of British History, circa 1500–1950', Introduction to a Special Feature on Masculinities, *The Journal of British Studies*, vol. 44, no. 2 (2005), 274–280.
Hayes, K. T., *The Library of William Byrd of Westover* (Madison, WI, 1997).
Hayton, D. W., 'Sir Richard Cocks: The Political Anatomy of a Country Whig', *Albion: A Quarterly Journal Concerned with British Studies*, vol. 20, no. 2 (Summer 1988), 221–246.
Heal, A., *London Furniture Makers, 1660–1840* (London, 1988).
——, *Hospitality in Early Modern England* (Oxford, 1990).
——, 'Gifts and Gift-Exchange in the Great Household: 1500–1650', *Past and Present*, vol. 199, no. 1 (2008), 41–70.
Heal, F. and C. Holmes, *The Gentry in England and Wales, 1500–1700* (Stanford, 1994).
Heller, B., 'Leisure and the Use of Domestic Space in Georgian London', *The Historical Journal*, vol. 53, no. 3 (2010), 623–645.
Hemphill, C. D., 'Manners and Class in the Revolutionary Era: A Transatlantic Comparison', *William and Mary Quarterly*, vol. 63, no. 2 (April 2006), 345–372.
Heneage Jesse, J., *George Selwyn and His Contemporaries*, 4 vols (London, 1882).
Hening, W., (ed.), *Hening's Statutes at Large, Vol. 3, 1684–1710* (Philadelphia, 1823).
Herbert, N., *Road Travel and Transport in Georgian Gloucestershire* (Ross-on-Wye, 2009).
Herman, B. L., *Town House: Architecture and Material Life in the Early American City, 1780–1830* (Chapel Hill, NC, 2005).
——, 'Tabletop Conversations: Material Culture and Everyday Life in the Eighteenth-Century Atlantic World', in J. Styles and A. Vickery, (eds), *Gender, Taste and Material Culture in Britain and North America 1700–1830* (New Haven and London, 2006).
Hewlett, R. and J. Speed, *Frampton on Severn: An Illustrated History* (Nailsworth, Gloucestershire, 2007).
Hicks, D. and M. C. Beaudry, (eds), *The Oxford Handbook of Material Culture Studies* (Oxford, 2010).
Hill, B., *Servants: English Domestics in the Eighteenth Century* (Oxford, 1996).
Hillier, B. and J. Hanson, *The Social Logic of Space* (Cambridge, 1984).
History of Parliament Trust: The House of Commons on CD-ROM, Volumes for 1660–1690, 1715–1754, 1754–1790.
Hobson, C., *The Raymond Barkers of Fairford Park*, Fairford History Society Monograph 3 (November 2007).
Hoffman, R., 'Preface', in C. Carson, R. Hoffman, and P. J. Albert, *Of Consuming Interest: The Style of Life in the Eighteenth Century* (Charlottesville, 1994).
Holmes, G. *Augustan England: Professions, State and Society, 1680–1730* (London, 1982).
——, 'Gregory King and the Social Structure of Pre-industrial England', *Transactions of the Royal Historical Society*, fifth series, vol. 27 (1977), 41–68.
Hood, G., *The Governor's Palace in Williamsburg: A Cultural Study* (Chapel Hill, NC, 1991).
Hoon, E. E., *The Organization of the English Customs System, 1696–1786* (New York, 1938, with a new introduction by R. C. Jarvis, 1968).

Horsfall Turner, O., (ed.), 'The Mirror of Great Britain': National Identity in Seventeenth-Century British Architecture (Reading, 2012).

Hoskins, L., (ed.), The Papered Wall: History, Pattern, Technique (New York, 1994, also new and expanded edition, 2005).

Hosmer, J. K., The Life of Thomas Hutchinson (Boston and New York, 1896).

Howard, D. S., Chinese Armorial Porcelain, vol. 1 (London, 1974).

——, Chinese Armorial Porcelain, vol. 2 (London, 2004).

Hughes, H., (ed.), Layers of Understanding: Setting Standards for Architectural Paint Research (London, 2002).

Hunneyball, P. M., Architecture and Image-Building in Seventeenth-Century Hertfordshire (Oxford, 2004).

Hunt, M. R., The Middling Sort: Commerce, Gender and the Family in England, 1680–1780 (Berkeley, CA and London, 1996).

Hussey, D., Coastal and River Trade in Pre-industrial England (Exeter, 2000).

Hussey, D. and M. Ponsonby, Buying for the Home: Shopping for the Domestic from the Seventeenth Century to the Present (Aldershot, 2008).

Isaac, R., The Transformation of Virginia 1740–1790 (Chapel Hill, NC, 1982).

Ison, W., The Georgian Buildings of Bristol (Bristol, 1952).

Jablonski, M. A. and C. R. Matsen, (eds), Architectural Finishes in the Built Environment (London, 2009).

Jackson-Stops, G., The Treasure Houses of Britain: Five Hundred Years of Private Patronage and Art Collecting (New Haven, 1985).

Jenkins, D., (ed.), The Cambridge History of Western Textiles, 2 vols (Cambridge, 2003).

Jenkins, P., The Making of a Ruling Class: The Glamorgan Gentry 1640–1790 (Cambridge, 1983).

Jenkins, R., 'The Copper Works at Redbrook and at Bristol', TBGAS, vol. 63 (Gloucester, 1942), 145–167.

'The Jewel in the Crown: Sandywell Park', in Andoversford Village: 2000 Years in the Making (Andoversford, 2000).

Johnson, D., 'Living in the Light: Quakerism and Colonial Portraiture', in E. J. Lapsansky and A. Verplanck, (eds), Quaker Aesthetics: Reflections on a Quaker Ethic in American Design and Consumption (Philadelphia, 2003), 122–146.

Johnson, J., The Gloucestershire Gentry (Gloucester, 1989).

——, Broadwell: A Short History (n.d.).

Johnson, J. E., 'A Quaker Imperialist's View of the British Colonies in America: 1732', Pennsylvania Magazine of History and Biography, vol. 60, no. 2 (April 1936), 97–130.

Johnson, M., An Archaeology of Capitalism (Oxford, 1996).

——, English Houses 1300–1800: Vernacular Architecture, Social Life (Harlow, 2010).

Jones, A. E., History of Mangotsfield and Downend (Bristol, 1899).

Jones, D., A History of Clifton (Chichester, 1992).

Jones, R. W., Gender and the Formation of Taste in Eighteenth-Century Britain (Cambridge, 1998).

Kim, S. B., Landlord and Tenant in Colonial New York: Manorial Society 1664–1775 (Chapel Hill, NC, 1978).

Kingsley, N., The Country Houses of Gloucestershire: Volume One 1500–1660 (Cheltenham, 1989).

——, The Country Houses of Gloucestershire: Volume Two 1660–1830 (Chichester, 1992).

——, 'Kip's Conundrum', Country Life (15 November 1990), 60–61.

Klein, L. E., Shaftesbury and the Culture of Politeness: Moral Discourse and Cultural Politics in Early Eighteenth-Century England (Cambridge, 1994).

——, 'Politeness and the Interpretation of the British Eighteenth Century', The Historical Journal, vol. 45, no. 4 (December 2002), 869–898.

——, 'Politeness for Plebes: Consumption and Social Identity in Early Eighteenth-Century England', in A. Bermingham and J. Brewer, (eds), *The Consumption of Culture 1600–1800: Image, Object, Text* (London, 1995), 362–382.
Knight, C., *London's Country Houses* (Chichester, 2009).
Krausman Ben-Amos, I., *The Culture of Giving: Informal Support and Gift-Exchange in Early Modern England* (Cambridge, 2008).
Kuchta, D., 'The Making of the Self-made Man: Class, Clothing, and English Masculinity, 1688–1832', in V. de Grazia, (ed.), *The Sex of Things: Gender and Consumption in Historical Perspective* (Berkeley, 1996), 54–78.
Lambert, D., 'The Prospect of Trade: The Merchant Gardeners of Bristol in the Second Half of the Eighteenth Century', in M. Conan, (ed.), *Bourgeois and Aristocratic Encounters in Garden Art, 1550–1850*, vol. 23 (Washington, DC, 2002), 123–145.
Landau, N., *The Justices of the Peace, 1679–1760* (Berkeley, 1984).
Landsman, N., *From Colonials to Provincials: American Thought and Culture 1680–1760* (Cornell, 1997).
Langford, P., *A Polite and Commercial People: England 1727–1783* (Oxford, 1989).
——, *Public Life and the Propertied Englishman 1689–1798* (Oxford, 1991).
——, 'The Uses of Eighteenth-Century Politeness', *Transactions of the Royal Historical Society*, vol. 12 (2002), 311–331.
Lapsansky, E. J. and A. Verplanck, (eds), *Quaker Aesthetics: Reflections on a Quaker Ethic in American Design and Consumption* (Philadelphia, 2003).
Latimer, J., *The Annals of Bristol: The Eighteenth Century* (Bristol, 1893 reprinted with an introduction by P. McGrath 1970).
——, 'Clifton in 1746', *TBGAS*, vol. 23 (1900), 127–136.
Lawrence, R. J., 'Integrating Architectural, Social and Housing History', *Urban History*, vol. 19, no. 1 (1992), 39–63.
Lawrence, S., (ed.), *Archaeologies of the British: Explorations of Identity in Great Britain and its Colonies, 1600–1945*, One World Archaeology Series, vol. 46 (2003).
Leech, R., 'Charlestown to Charleston: Urban and Plantation Connections in an Atlantic Setting', in D. Shields, (ed.), *Material Culture in Anglo-America: Regional Identity and Urbanity in the Tidewater, Lowcountry and Caribbean* (Columbia, SC, 2009), 170–187.
——, 'Richmond House and the Manor of Clifton', in M. Crossley Evans, *'A Grand City' – 'Life, Movement and Work': Bristol in the Eighteenth and Nineteenth Centuries, Essays in Honour of Gerard Leighton, FSA* (Bristol, 2010), 27–46.
——, *The St Michael's Hill Precinct of the University of Bristol: Medieval and Early Modern Topography*, Bristol Record Society, no. 52 (Bristol, 2000).
——, 'The Symbolic Hall: Historical Context and Merchant Culture in the Early Modern City', *Vernacular Architecture*, vol. 31 (2000), 1–10.
——, 'The Garden House: Merchant Culture and Identity in the Early Modern City', in S. Lawrence, (ed.), *Archaeologies of the British: Explorations of Identity in Great Britain and its Colonies, 1600–1945*, One World Archaeology Series, vol. 46 (2003), 76–86.
Lees-Milne, J., *Some Cotswold Country Houses* (Wimborne, 1987).
Lefebvre, H., *The Production of Space* (Oxford, 1991, originally published 1974).
Leighton, H. G. M., 'Country Houses Acquired with Bristol Wealth', *Transactions of the Bristol and Gloucestershire Archaeological Society*, vol. 123 (2005), 9–16.
Lemire, B., *Fashion's Favourite: The Cotton Trade and the Consumer in Britain 1660–1800* (Oxford, 1991).
——, 'Fashioning Cottons: Asian Trade, Domestic Industry and Consumer Demand, 1660–1780', in D. Jenkins, (ed.), *The Cambridge History of Western Textiles*, 2 vols (Cambridge, 2003), vol. 1, 493–512.
Levitt, S., *The Red Lodge* (Bristol, 1986).
Lewis, J., 'When a House Is not a Home: Elite English Women and the Eighteenth-Century Country House', *Journal of British Studies*, vol. 48 (April 2009), 336–363.

Lindert, P. H. and J. G. Williamson, 'Revising the Social Tables for England and Wales, 1688–1812', *Explorations in Economic History*, vol. 19 (1982), 385–408.

Lipsedge, K., *Domestic Space in Eighteenth-Century British Novels* (Basingstoke, 2012).

——, '"Enter into thy Closet": Women, Closet Culture, and the Eighteenth-Century Novel', in J. Styles and A. Vickery, (eds), *Gender, Taste, and Material Culture in Britain and North America 1700–1830* (New Haven and London, 2006), 107–122.

Little, B., *The City and County of Bristol: A Study in Atlantic Civilisation* (London, 1954).

Little, E. C., *Our Family History* (1892).

Lloyd, H., *The Quaker Lloyds in the Industrial Revolution* (Bristol, 1975).

Lounsbury, C., *Essays on Early American Architecture: A View from the Chesapeake* (Charlottesville and London, 2011).

MacInnes, C. M., *A Gateway of Empire* (Bristol, 1939).

Maclain, G., D. Landry, and J. Ward, (eds), *The Country and City Revisited: England and the Politics of Culture, 1550–1850* (Cambridge, 1999).

Main, G. L. and J. T. Main, 'Economic Growth and the Standard of Living in Southern New England, 1640–1774', *Journal of Economic History*, vol. 48, no. 1 (March 1988), 27–46.

Mander, N., *Country Houses of the Cotswolds* (London, 2008).

Mann, J. D. L., *The Cloth Industry in the West of England from 1640 to 1880* (Oxford, 1971).

Marcy, P. T., 'Bristol's Roads and Communications on the Eve of the Industrial Revolution', *Transactions of the Bristol and Gloucestershire Archaeological Society*, vol. 87 (1968), 149–172.

——, 'Eighteenth-Century Views of Bristol and Bristolians', in P. McGrath, (ed.), *Bristol in the Eighteenth Century* (Newton Abbot, 1972), 11–40.

Mascuch, M., 'Social Mobility and Middling Self-identity: The Ethos of British Autobiographers, 1600–1750', *Social History*, vol. 20, no. 1 (January 1995).

Mathias, P., 'The Social Structure in the Eighteenth Century', *Economic History Review*, vol. 10, no. 1 (1957), 30–45.

Matson, C., (ed.), *The Economy of Early America: Historical Perspectives and New Directions* (University Park, PA, 2006).

McCusker, J. J., *Money and Exchange in Europe and America, 1600–1775: A Handbook* (Chapel Hill, NC, 1978).

McCusker, J. J. and R. Menard, *The Economy of British America 1607–1789* (Chapel Hill, NC, 1985).

McGrath, P., *Records Relating to the Society of Merchant Venturers of the City of Bristol in the Seventeenth Century*, BRS, vol. 17 (1952).

——, *The Merchant Venturers of Bristol* (Bristol, 1975).

McGrath, P., (ed.), *Bristol in the Eighteenth Century* (London, 1972).

McIlvaine, H. R., (ed.), *Journals of the House of Burgesses of Virginia, 1702–1712* (Richmond, VA, 1912).

McKellar, E., *The Birth of Modern London: The Development and Design of the City, 1660–1720* (Manchester, 1999).

——, 'The Suburban Villa Tradition in Seventeenth and Eighteenth-Century London', in B. Arciszewska, (ed.), *The Baroque Villa: Suburban and Country Residences, c. 1600–1800* (Wilanow, Poland, 2009), 197–208.

——, *Landscapes of London: The City, the Country and the Suburbs 1660–1840* (London and New Haven, 2013).

McKendrick, N., J. Brewer, and J. H. Plumb, *The Birth of Consumer Society: The Commercialization of Eighteenth-Century England* (London, 1982).

McKeon, M., *The Secret History of Domesticity: Public, Private, and the Division of Knowledge* (Baltimore, 2005).

McLean, J., 'On the Manor, Advowson and Demesne Lands of English Bicknor, Co. of Gloucester', *TBGAS*, vol. 1 (1876), 69–95.

Meldrum, T., 'Domestic Service, Privacy and the Eighteenth-Century Metropolitan Household', *Urban History*, vol. 26, no. 1 (1999), 27–39.

——, *Domestic Service and Gender, 1660–1750: Life and Work in the London Household* (Harlow, 2000).
Miers, M., 'Eshott Hall', *Country Life* (3 January 2002), 56–61.
Middleton, S. and B. G. Smith, (eds), *Class Matters: Early North America and the Atlantic World* (Philadelphia, 2008).
Milne, J. and T. Mowl, *Castle Godwyn: A Guide and an Architectural History* (Painswick, 1996).
Minchinton, W. E., 'Bristol: Metropolis of the West', *Transactions of the Royal Historical Society*, fifth series, vol. 4 (1954), 69–89.
——, *The Trade of Bristol in the Eighteenth Century*, Bristol Record Society, vol. 20 (1957).
——, 'The Merchants in England in the Eighteenth Century', *Explorations in Entrepreneurial History*, vol. 10, no. 20 (December 1957), 62–71.
Minchinton, W. E., (ed.), *Politics and the Port of Bristol in the Eighteenth Century: The Petitions of the Society of Merchant Venturers, 1698–1803* (Bristol, 1963).
Mingay, G. E., *English Landed Society in the Eighteenth Century* (London, 1963).
——, *The Gentry: The Rise and Fall of a Ruling Class* (London, 1976).
Moir, E. A. L., 'The Gentlemen Clothiers: A Study of the Organization of the Gloucestershire Cloth Industry, 1750–1835', in H. P. R. Finberg, (ed.), *Gloucestershire Studies* (Leicester, 1957), 225–266.
——, 'Sir George Onesiphorus Paul', in H. P. R. Finberg, (ed.), *Gloucestershire Studies* (Leicester, 1957), 195–224.
——, 'The Gloucestershire Association for Parliamentary Reform, 1780', *TBGAS*, vol. 75 (1956), 171–192.
Montgomery, F., *Textiles in America 1650–1840* (New York, 1984).
Mooney, B. B., *Prodigy Houses of Virginia: Architecture and the Native Elite* (Charlottesville, VA, 2008).
Morgan, K., *Bristol and the Atlantic Trade in the Eighteenth Century* (Cambridge, 1993)
——, 'Bristol West India Merchants in the Eighteenth Century', *Transactions of the Royal Historical Society*, vol. 3 (1993), 185–208.
Morrison, H., *Early American Architecture* (Oxford, 1952).
Mortimer, R., (ed.), *Minute Book of the Men's Meeting of the Society of Friends in Bristol, 1686–1704*, Bristol Record Society, vol. 30 (Bristol, 1977).
Moss, R., *Historic Houses of Philadelphia* (Philadelphia, 1998).
Mowl, T., *Bristol: Last Age of the Merchant Princes* (Bath, 1991).
——, *To Build the Second City: Architects and Craftsmen of Georgian Bristol* (Bristol, 1991).
——, *An Insular Rococo: Architecture, Politics and Society in Ireland and England, 1710–1770* (London, 1999).
——, *Gentleman and Players: Gardeners of the English Landscape* (Stroud, 2000).
——, *Historic Gardens of Gloucestershire* (Stroud, 2002).
Mowl, T. and B. Earnshaw, *Architecture without Kings: The Rise of Puritan Classicism under Cromwell* (Manchester, 1995).
Mowl, T. and R. White, 'Thomas Robins at Painswick', *Journal of Garden Design*, vol. 4, no. 2 (n.d.), 163–178.
Muldrew, C., *The Economy of Obligation: The Culture of Credit and Social Obligations in Early Modern England* (Basingstoke, 1998).
Munro Smith, G., *A History of the Bristol Royal Infirmary* (Bristol, 1917).
Murdoch, T., (ed.), *Noble Households: Eighteenth-Century Inventories of Great English Households: A Tribute to John Cornforth* (Cambridge, 2006).
Musson, J., *The Country Houses of John Vanbrugh* (London, 2008).
Namier, L. B., 'Three Eighteenth-Century Politicians', *English Historical Review*, vol. 42, no. 167 (July 1927), 408–413.
Nash, R. C., 'Domestic Material Culture and Consumer Demand in the British Atlantic World: Colonial South Carolina, 1670–1770', in D. Shields, (ed.), *Material Culture in*

Anglo-America: Regional Identity and Urbanity in the Tidewater, Lowcountry and Caribbean (Columbia, SC, 2009), 221–266.

Nylander, R. C., *Wallpapers for Historic Buildings* (Washington, DC, second edition, 1992).

O'Connell, S., *London 1753* (London, 2003).

Ogborn, M., *Spaces of Modernity: London's Geographies, 1680–1780* (London, 1998).

Ogborn, M. and C. Withers, (eds), *Georgian Geographies: Essays on Space, Place and Landscape in the Eighteenth Century* (Manchester, 2004).

Olsen, D. M., 'Richard Champion and the Society of Friends', *TBGAS*, vol. 102 (1984), 173–195.

Olson, A. G., *Making the Empire Work: London and American Interest Groups, 1690–1790* (Cambridge, MA and London, 1992).

O'Toole, F., *White Savage: William Johnson and the Invention of America* (New York, 2005).

Overton M., J. Whittle, D. Dean, and A. Hann, *Production and Consumption in English Households, 1600–1750* (London, 2004).

Park, H., *A List of Architectural Books Available in America before the Revolution* (Los Angeles, revised edition, 1973).

Pearsall, S. M. S., *Atlantic Families: Lives and Letters in the Later Eighteenth-Century* (Oxford, 2008).

Peck, L. L., *Consuming Splendor: Society and Culture in Seventeenth-Century England* (Cambridge, 2005).

Pennell, S., 'Pots and Pans History: The Material Culture of the Kitchen in Early Modern England', *Journal of Design History*, vol. 11, no. 3 (1998), 201–216.

——, 'The Material Culture of Food in Early Modern England, c. 1650–1750', in S. Tarlow and S. West, (eds), *The Familiar Past? Archaeologies of Later Historical Britain* (London and New York, 1999).

Pevsner, N., *The Buildings of England: North Somerset and Bristol* (Harmondsworth, 1958).

Phillmore, W. P. W., *Gloucestershire Notes and Queries*, vol. 5, pts 1–13 (1891–1893).

Pointon, M. R., *Hanging the Head: Portraiture and Social Formation in Eighteenth-Century England* (New Haven and London, 1993).

Ponsonby, M., *Stories from the Home: English Domestic Interiors, 1750–1850* (Aldershot, 2007).

Pope, D., 'The Wealth and Social Aspirations of Liverpool's Slave Merchants of the Second Half of the Eighteenth Century', in D. Richardson, S. Schwarz, and A. Tibbles, (eds), *Liverpool and Transatlantic Slavery* (Liverpool, 2007), 164–226.

Port, M. H., 'Town House and Country House: Their Interaction', in Dana Arnold, (ed.), *The Georgian Country House: Architecture, Landscape and Society* (Stroud, 1998), 117–138.

Price, J. M., 'The Great Quaker Business Families of Eighteenth-Century London: The Rise and Fall of a Sectarian Patriciate', in M. Dunn and R. Dunn, (eds), *The World of William Penn* (Philadelphia, 1986), 363–399.

——, 'Who Cared about the Colonies?: The Impact of the Thirteen Colonies on British Society and Politics, circa 1714–1775', in B. Bailyn and P. Morgan, (eds), *Strangers within the Realm: Cultural Margins of the First British Empire* (Chapel Hill, NC, 1991), 395–436.

Priest, G., *The Paty Family: Makers of Eighteenth Century Bristol* (Bristol, 2003).

Ralph, E. and M. Williams, (eds), *Inhabitants of Bristol in 1696*, BRS, vol. 25 (1968).

Raistrick, A., *Quakers in Science and Industry: Being an Account of the Quaker Contributions to Science and Industry during the Seventeenth and Eighteenth Centuries* (New York, 1968).

Rees, G. E., *The History of Bagendon* (Cheltenham, 1932).

Reiff, D., *Small Georgian Houses in England and Virginia: Origins and Development through the 1750s* (London, 1986).

Reinberger, M. and E. McLean, 'Isaac Newton's Fairhill: Architecture, Landscape and Quaker Ideals in a Philadelphia Colonial Country Seat', *Winterthur Portfolio*, vol. 32, no. 4 (Winter 1997), 243–274.

——, 'Pennsbury Manor: Reconstruction and Reality', *Pennsylvania Magazine of History and Biography*, vol. 131, no. 3 (July 2007), 263–306.

Retford, K., *The Art of Domestic Life: Family Portraiture in Eighteenth-Century England* (New Haven and London, 2006).
——, 'Patrilineal Portraiture? Gender and Genealogy in the Eighteenth-Century Country House', in J. Styles, and A. Vickery, (eds), *Gender, Taste and Material Culture in Britain and North America 1700–1830* (New Haven and London, 2006), 323–352.
Richards, M., 'Two Eighteenth-Century Gloucester Gardens', *TBGAS*, vol. 99 (1981), 123–126.
Richards, S., *Eighteenth Century Ceramics: Products for a Civilised Society* (Manchester, 1999).
Richardson, A. E. and H. D. Eberlein, *The Smaller English House of the Later Renaissance, 1660–1830: An Account of its Design, Plan, and Details* (London, 1925).
Richardson, D., (ed.), *Bristol, Africa and the Eighteenth-Century Slave Trade to America*, Bristol Record Society, vols 38, 39, 42, 47.
Richardson, R. C., *Household Servants in Early Modern England* (Manchester, 2010).
Richardson, T., *Arcadian Friends: Inventing the English Landscape Garden* (London, 2007).
Riello, G. and P. Parthasarathi, (eds), *The Spinning World: A Global History of Cotton Textiles, 1200–1850* (Oxford, 2009).
Roads, S., *The History and Traditions of Marblehead* (New York, 1880).
Roebuck, P., *Yorkshire Baronets, 1640–1760: Families, Estates, and Fortunes* (Oxford, 1980).
Roger, N., 'Money, Land, and Lineage: The Big Bourgeoisie of Hanoverian London', *Social History*, vol. 4, no. 3 (October 1979), 437–454.
Rogers, N., *Whigs and Cities: Popular Politics in the Age of Walpole and Pitt* (Oxford, 1989).
Rollison, D., *The Local Origins of Modern Society: Gloucestershire 1500–1800* (London, 1992).
Rosenheim, J. M., *The Emergence of a Ruling Order: English Landed Society 1650–1750* (London, 1998).
Rothery, M. and J. Stobart, 'Inheritance Events and Spending Patterns in the English Country House: The Leigh Family of Stoneleigh Abbey, 1738–1806', *Continuity and Change*, vol. 27, no. 3 (2012), 379–407.
Rothstein, N. and S. M. Levy, 'Furnishings, c. 1500–1780', in D. Jenkins, (ed.), *The Cambridge History of Western Textiles*, 2 vols (Cambridge, 2003), vol. 1, 631–658.
Rozbicki, M., 'The Curse of Provincialism: Negative Perceptions of the Colonial American Plantation Gentry', *Journal of Southern History*, vol. 63, no. 4 (November 1997), 727–752.
——, *The Complete Colonial Gentleman: Cultural Legitimacy in Plantation America* (Charlottesville, VA, 1998).
Ruggui, F. J., 'The Urban Gentry in England, 1660–1780: A French Approach', in *Historical Research*, vol. 74, no. 185 (August 2001), 249–270.
Sacks, D. H., *The Widening Gate: Bristol and the Atlantic Economy, 1450–1700* (Berkeley and Oxford, 1991).
St Clair Baddeley, W., *A Cotteswold Manor: Being the History of Painswick* (Gloucester, 1929).
St George, R. B., (ed.), *Material Life in America, 1600–1860* (Boston, 1988).
——, 'Reading Spaces in Eighteenth-Century England'.
Saumarez Smith, C., *Eighteenth-Century Decoration: Design and the Domestic Interior in England* (New York, 1993).
——, 'Supply and Demand in English Country House Building, 1660–1740', *The Oxford Art Journal*, vol. 11, no. 2 (1988), 3–9.
Saunders, G., *Wallpaper in Interior Decoration* (London, 2002).
——, 'The China Trade: Oriental Painted Panels', in L. Hoskins, (ed.), *The Papered Wall: History, Pattern, Technique* (London, new and revised edition, 2005), 42–55.
Schimmelman, J. G., *Architectural Books in Early America: Architectural Treatises and Building Handbooks Available in American Libraries and Bookstores through 1800* (New Castle, DE, 1999).
Sedgwick, R., (ed.), *The House of Commons, 1715–1754* (London, 1970).
Shammas, C., *The Pre-industrial Consumer in England and America* (Oxford, 1990).
——, 'The Decline of Textile Prices in England and British America Prior to Industrialization', *Economic History Review*, vol. 47, no. 3 (1994), 483–507.

——, 'Changes in English and Anglo-American Consumption from 1550 to 1800', in J. Brewer and R. Porter, (eds), *Consumption and the World of Goods* (London, 1993).

Shields, D., (ed.), *Material Culture in Anglo-America: Regional Identity and Urbanity in the Tidewater, Lowcountry and Caribbean* (Columbia, SC,, 2009)

Slack, P. A., 'The Politics of Consumption and England's Happiness in the Later Seventeenth Century', *English Historical Review*, vol. 122, no. 497 (June 2007), 609–631.

Slater, T. R., 'Family, Society and the Ornamental Villa on the Fringes of English Country Towns', *Journal of Historical Geography*, vol. 4, no. 2 (April 1978), 129–144.

Smail, J., *Merchants, Markets and Manufacture: The English Wool Textile Industry in the Eighteenth Century* (Basingstoke, 1999).

——, *The Origins of Middle-Class Culture: Halifax, Yorkshire, 1660–1780* (Ithaca and London, 1994).

——, 'The Culture of Credit in Eighteenth-Century Commerce: The English Textile Industry', *Enterprise and Society*, vol. 4 (June 2003), 299–325.

Smith, B. and E. Ralph, *A History of Bristol and Gloucestershire* (Chichester, third edition, 1996).

Smith, P., 'Plain English or Anglo-Palladian? Seventeenth-Century Country Villa Plans', in M. Airs and G. Tyack, (eds), *The Renaissance Villa in Britain 1500–1700* (Reading, 2007), 89–110.

Soderlund, J. R., 'Black Women in Colonial Pennsylvania', in J. W. Trotter and E. L. Smith, (eds), *African Americans in Pennsylvania: Shifting Historical Perspectives* (University Park, PA, 1997), 73–92.

Spring, D. and E. Spring, 'The English Landed Elite, 1540–1879: A Review', *Albion: A Quarterly Journal Concerned with British Studies*, vol. 17, no. 2 (Summer 1985), 149–166.

Spufford, M., 'The Limitations of the Probate Inventory', in J. Chartres and D. Hey, (eds), *English Rural Society, 1500–1800: Essays in Honour of Joan Thirsk* (Cambridge, 1990), 139–174.

St George, R. B., 'Reading Spaces in Eighteenth-Century New England', in J. Styles and A. Vickery, (eds), *Gender, Taste, and Material Culture in Britain and North America 1700–1830* (New Haven and London, 2006), 90–103.

Steele, I. K., *The English Atlantic 1675–1740: An Exploration of Communication and Community* (Oxford, 1986).

Stembridge, P. K., *The Goldney Family: A Bristol Merchant Dynasty* (Bristol, 1998).

——, *Thomas Goldney's Garden: The Creation of an Eighteenth Century Garden* (Bristol, 1996).

——, *Goldney: A House and Family* (Bristol, 1969).

Stewart, R., *The Town House in Georgian London* (London and New Haven, 2009).

Stobart, J., 'A Settled Little Society? Networks, Friendship, and Trust in Eighteenth-Century Provincial England', in E. Baigent and R. Mayhew, (eds), *English Geographies 1600–1950: Historical Essays on English Customs, Cultures, and Communities in Honour of Jack Langton* (Oxford, 2009), 58–70.

——, 'Culture Versus Commerce: Societies and Spaces for Elites in Eighteenth-Century Liverpool', *Journal of Historical Geography*, vol. 28, no. 4 (October 2002), 471–485.

——, 'Gentlemen and Shopkeepers: Supplying the Country House in Eighteenth-Century England', *Economic History Review*, vol. 64, no. 3 (2011), 885–904.

Stobart, J., A. Hann, and V. Morgan, *Spaces of Consumption: Leisure and Shopping in the English Town, c. 1680–1830* (London, 2007).

Stoddard, S., *Bristol before the Camera: The City in 1820–1830, Watercolours and Drawings from the Braikenridge Collection* (Bristol, 2001).

Stone, L. and J. F. Stone, *An Open Elite? England 1540–1880* (Oxford, 1984).

——, *An Open Elite? England 1540–1880* (Oxford, abridged edition, 1995).

Styles, J. and A. Vickery, (eds), *Gender, Taste and Material Culture in Britain and North America 1700–1830* (New Haven and London, 2006).

Summerson, J., *Architecture in Britain, 1530 to 1830* (New Haven and London, ninth edition, 1993).

——, *The Unromantic Castle and Other Essays* (London, 1990).

——, 'The Classical Country House in 18th century England', in *The Unromantic Castle and Other Essays* (London, 1990), 79–120.
Sweeney, K., 'Mansion People: Kinship, Class, and Architecture in Western Massachusetts in the Mid Eighteenth Century', *Winterthur Portfolio*, vol. 19, no. 4 (Winter 1984), 231–255.
——, 'High Style Vernacular: Lifestyles of the Colonial Elite', in C. Carson, R. Hoffman, and P. J. Albert, *Of Consuming Interests: The Style of Life in the Eighteenth Century* (Charlottesville and London, 1994), 1–58.
Sweet, R. H., *The English Town, 1680–1840: Government, Society, Culture* (Harlow, 1999).
——, 'Topographies of Politeness', *Transactions of the Royal Historical Society*, vol. 12 (2002), 355–74.
Tadmor, N., 'The Concept of the Household-Family in Eighteenth-Century England', *Past and Present*, vol. 151, no. 1 (May 1996), 111–140.
——, *Family and Friends in Eighteenth-Century England: Household, Kinship and Patronage* (Cambridge, 2000).
Tann, J., *Gloucestershire Woollen Mills: Industrial Archaeology* (Newton Abbot, 1967).
Tarlow, S. and S. West, (eds), *The Familiar Past? Archaeologies of Later Historical Britain* (London and New York, 1999).
Thirsk, J., (ed.), *The Agrarian History of England and Wales, Vol. 5, 1640–1750: Agrarian Change* (Cambridge, 1985).
Thompson, F. M. L., *English Landed Society in the Nineteenth Century* (London, 1963).
Thornton, P., *Authentic Décor: The Domestic Interior, 1660–1920* (New York, 1984).
Tinkcom, M., 'Cliveden: The Building of a Country seat', *Pennsylvania Magazine of History and Biography*, vol. 88, no. 1 (January 1964), 3–36.
Tolles, F., *James Logan and the Culture of Provincial America* (Boston, 1957).
——, *Meeting House and Counting House: Quaker Merchants in Colonial Philadelphia* (Chapel Hill, 1948).
Tyack, G., *Warwickshire Country Houses* (Chichester, 1994).
Tyack, G., S. Bradley, and N. Pevsner, *The Buildings of England: Berkshire* (New Haven and London, 2010).
Upton, D., *Holy Things and Profane: Anglican Parish Churches in Colonial Virginia* (New Haven and London, 1997).
Varley, J., 'John Rocque: Engraver, Surveyor, Cartographer and Map-Seller', *Imago Mundi*, vol. 5 (1948), 83–91.
Veblen, T., *The Theory of the Leisure Class: An Economic Study of Institutions* (New York, 1899).
Verey, D. and A. Brooks, *The Buildings of England: Gloucestershire I: The Cotswolds* (London, 2002).
——, *The Buildings of England: Gloucestershire II: The Vale and the Forest of Dean* (London, 2002).
Vlach, J. M., *Back of the Big House: The Architecture of Plantation Slavery* (Chapel Hill, NC and London, 1993).
Vickery, A., 'Golden Age to Separate Spheres: A Review of the Categories and Chronology of English Women's History', *Historical Journal*, vol. 36 (June 1993), 383–414.
——, *The Gentleman's Daughter: Women's Lives in Georgian England* (New Haven and London, 1998).
——, 'An Englishman's Home Is His Castle? Privacies, Boundaries and Thresholds in the Eighteenth-Century London House', *Past and Present*, vol. 199 (May 2008), 147–173.
——, *Behind Closed Doors: At Home in Georgian England* (New Haven and London, 2009).
Victoria Country History: A History of the County of Gloucester, 9 volumes to date (1907–2010).
Vlatch, J. M., *The Planter's Prospect: Privilege and Slavery in Plantation Paintings* (Chapel Hill, NC and London, 2002).
Volk, J. G., (ed.), *The Warner House: A Rich and Colorful History* (Portsmouth, NH, 2006).
Walsh, L., *Motives of Honor, Pleasure & Profit: Plantation Management in the Colonial Chesapeake, 1607–1763* (Chapel Hill, NC, 2010).

Warren, I., 'The English Landed Elite and the Social Environment of London c. 1580–1700: The Cradle of an Aristocratic Culture?' *English Historical Review*, vol. 126, no. 518 (2011), 44–74.

Weatherill, L., *Consumer Behavior and Material Culture 1660–1760* (London, second edition, 1996),

——, 'The Meaning of Consumer Behaviour in Late Seventeenth- and Early Eighteenth-Century England', in J. Brewer and R. Porter, (eds), *Consumption and the World of Goods* (London, 1993), 206–227.

Wells, C., 'The Planters Prospect: Houses, Outbuildings, and Rural Landscapes in Eighteenth-Century Virginia', *Winterthur Portfolio*, vol. 28, no. 1 (Spring 1993), 1–31.

Wenger, M., 'The Central Passage in Virginia: Evolution of an Eighteenth-Century Living Space', *Perspectives in Vernacular Architecture*, vol. 2 (1986).

West, S., 'Social Space and the English Country House', in S. Tarlow and S. West, (eds), *The Familiar Past? Archaeologies of Later Historical Britain* (London and New York, 1999), 103–122.

White, J., 'A World of Goods? The Consumption Turn and Eighteenth-Century British History', *Cultural and Social History*, vol. 3 (2006), 93–104.

Whyman, S. E., *Sociability and Power in Late-Stuart England: The Cultural Worlds of the Verneys 1660–1720* (Oxford, 1999).

——, *The Pen and the People: English Letter Writers, 1660–1800* (Oxford, 2009).

Whyte, W., 'How Do Buildings Mean? Some Issues of Architectural Interpretation', *History and Theory*, vol. 45 (May 2006), 153–177.

Williams, W. R., *The Parliamentary History of the County of Gloucester* (Hereford, 1898).

Williamson, T., *Polite Landscapes: Gardens and Society in Eighteenth-Century England* (Stroud, 1995).

——, 'Archaeological Perspectives on Landed Estates: Research Agendas', in J. Finch and K. Giles, (eds), *Estate Landscapes: Design, Improvement and Power in the Post-medieval Landscape* (Woodbridge, Suffolk, 2007), 1–16.

Wills, M., *Gibside and the Bowes Family* (Chichester, 1995).

Wilson, R. G., *Gentlemen Merchants: The Merchant Community in Leeds, 1700–1830* (Manchester, 1971).

——, 'The Landed Elite', in H. T. Dickinson, (ed.), *A Companion to Eighteenth-Century Britain* (Oxford, 2002).

Wilson, R. and A. Mackley, *Creating Paradise: The Building of the English Country House, 1660–1880* (London, 2000).

Wolf, E., 2nd, *The Library of James Logan of Philadelphia, 1674–1751* (Philadelphia, 1974).

Woodward, C., 'Castle Godwyn', *Country Life* (27 September 2007), 130–135.

Worsley, G., *Classical Architecture in Britain: The Heroic Age* (New Haven and London, 1995).

——, *The British Stable* (New Haven and London, 2004).

Worsley, G., (ed.), *The Role of the Amateur Architect: Papers Given at the Georgian Group Symposium 1993* (London, 1994).

Wrightson, K., *English Society, 1580–1680* (London, 1982).

——, 'Estates, Degrees and Sorts: Changing Perceptions of Society in Tudor and Stuart England', in P. J. Corfield, (ed.), *Language, History and Class* (Oxford, 1991), 30–52.

——, 'Sorts of People in Tudor and Stuart England', in J. Barry and C. Brooks, (eds), *The Middling Sort of People: Culture, Society and Politics in England, 1550–1800* (Basingstoke, 1994), 28–51.

Yokota, K., *Unbecoming British: How Revolutionary America Became a Post-colonial Nation* (Oxford, 2011).

Zimmerman, P. D., 'Philadelphia Case Furniture at Stenton', *The Magazine Antiques* (May 2002), 94–101.

——, 'Eighteenth-Century Chairs at Stenton', *The Magazine Antiques* (May 2003), 122–129.

——, 'Early American Tables and Other Furniture at Stenton', *The Magazine Antiques* (May 2004), 102–109.

Select Bibliography 223

(4) Electronic secondary sources

Gunston Hall Inventory Database, http://www.gunstonhall.org/library/probate/probate_list.html.
Henry Fitzhugh Inventory, http://chnm.gmu.edu/probateinventory/pdfs/ftzhgh42.pdf.
The Historic American Buildings Survey, http://www.nps.gov/history/hdp/habs/.
Randall, A., 'Paul, Sir Onesiphorus, first baronet (bap. 1706, d. 1774)', ODNB (Oxford, online edition, 2004).
Thomas Lee Inventory of Stratford Hall, 1758, http://chnm.gmu.edu/probateinventory/pdfs/lee58.pdf.

(5) Unpublished theses, papers, and reports

Anderson, J., 'Jeremiah Lee Mansion Guides Handbook' (Unpublished report, 2009).
'Archeological Notes on Stenton' (Unpublished MS at Stenton, 1983[?]).
Atkins Heritage, 'Champion's Brassworks and Gardens Conservation Management Plan' (Unpublished report, January 2007).
Barry, J., 'The Cultural Life of Bristol, 1640–1775' (D.Phil. thesis, University of Oxford, 1985).
Beacon Planning, 'Chesterfield, No. 3 Clifton Hill, Clifton, Bristol: Historic Building Assessment' (Unpublished report, October 2010).
Bristol and Region Archaeological Services, 'Archaeological Desk-based Assessment of Land at Chesterfield Hospital, Clifton Hill, Clifton, Bristol for Nuffield Health', Report No. 2206/2209 (Unpublished report, October 2009).
Burch, W., 'Furnishing Plan: Johnson Hall State Historic Site' (Unpublished report on file at Johnson Hall, 2003).
Cavicchi, C. L., 'Pennsbury Manor Furnishing Plan', Morrisville, PA (Unpublished MS, 1988).
Cooperman, E. T., 'Historic Context Statement: Cluster 1: Frankford, Tacony, Wissinoming, Brideburg' (Unpublished report for Preservation Alliance for Greater Philadelphia, July 2009).
Engle, R., 'Historic Structure Report: Stenton' (Unpublished MS for The NSCDA/PA, 1982).
Hague, S. G., '"A MODERN-built house...fit for a gentleman": Elites, Material Culture and Social Strategy in Britain, 1680–1770' (D.Phil. thesis, University of Oxford, 2011).
Heller, B., 'Leisure and Pleasure in London Society, 1760–1820: An Agent-centred Approach' (D.Phil. thesis, University of Oxford, 2009).
Keim, L. C., 'Stenton Room Furnishings Study' (MS report, 2010, on file at Stenton).
Kuykendall, E. E., 'Philadelphia Carpenters, Cabinetmakers and Captains: The Working World of Thomas Nevell, 1762–1784' (Unpublished Winterthur M.A. Thesis, 2011).
Leech, R., 'Clifton Wood House, Randall Road, Clifton, Bristol: An Archaeological Desk-based Assessment' (Unpublished report, 2003).
——, 'Mortimer House, Clifton Down Road, Clifton, Bristol: An Archaeological Desk-based Assessment and Building Assessment' (Unpublished report, 2008).
Longmore, J., 'Rural Retreats: Liverpool Merchants and the British Country House' (Unpublished paper, Slavery and the English Country House Conference, London School of Economics, November 2009).
Melville, J., 'The Use and Organization of Domestic Space in Late Seventeenth-Century London' (Ph.D. thesis, University of Cambridge, 1999).
Mosca, M., 'Stenton Paint Analysis' (Unpublished report, 2000, on file at Stenton).
Pennell, S., 'The Material Culture of Food in Early Modern England, circa 1650–1750' (D.Phil. thesis, University of Oxford, 1997).
Personal communication regarding Frampton Court library, with Dr Susie West, 21 May 2010.

Personal communication regarding pewter, from Alyson Marsden, 2 May 2009.
Phillpotts, C., 'Stroudend Tithing, Painswick, Gloucestershire Final Documentary Research Report' (Unpublished report for Stroudend Tithing Educational Trust, 2010).
Ross, K., 'Report on Bishop's House Clifton Hill Bristol' (Unpublished report, n.d. 2004?).
Rubenstein, L. C., 'Johnson Hall' (Unpublished Winterthur/University of Delaware M.A. Thesis, 1958).
Shepherd, R. V., 'James Logan's Stenton: Grand Simplicity in Quaker Philadelphia' (MA Thesis, Winterthur/University of Delaware, 1968).
Taylor, C., '"Figured Paper for Hanging Rooms": The Manufacture, Design and Consumption of Wallpapers for English Domestic Interiors, c. 1740–c. 1800' (Ph.D. thesis, The Open University, 2010).
Wright, N., 'The Gentry and Their Houses in Norfolk and Suffolk, c. 1550–1850' (Ph.D. thesis, University of East Anglia, 1990).

Index

Page references in **bold** indicate illustrations

Adams, John, 153
Adams, Thomas, 46, 154
Age, of builders, 19–20, 33
Alderley Grange (Glos.), 40
Algonquin, 130
Ampthill (Virginia), 35
Andrews, John, 43, 60–1, 120, 145–6, 147, 148
apprentices, 40, 123, 124, 144
architects, 43
architectural style, 5, 27–30
 baroque, 28, 38, 39, 42, 48, 135
 form, 4
 function, 4
 Georgian, 6, 16, 67, 74, 75, 107, 152, 153
 Gothick, 44, 60, 63, 66, 71, 135
 Palladian, 28, 38, 39, 40, 59, 60, 66, 80, 87, 92, 118, 135, 137, 146
 Queen Anne, 28
 'West Country baroque', 1, 53
Arscott, Alexander, 151
Ashton Court (Somerset), 48
Atkyns, Sir Robert, 10, 50, 54, 64, 81
Avery, George, 121
Avon river, 11

Bagendon Manor, 23
Baltic, 102
Barker, Andrew, 33
Barrington Park (Glos.), 43, 63
basements, 26, 30, 31, 77, 84, 86, 87, 93, 98, *see also* cellars
Bath, 11, 58, 129, 142
Bath stone, 42
Bathurst family, 11
Beaufort, dukes of, 11, 140
Beck, Joseph, 24, 61
bedchambers, 26, 80, 82, 84, 90–1, 98, 101–3, 106, 113, 120
bedhangings, 91
 flying tester, 109
Belcher, Jonathan, 61
Bell, William, 146–7
Berkeley castle, 140
Berkeley family, 11, 147
Berkeley, Henry, 147
Berkeley House (Glos.), 184n103

Berkeley, Norborne (later Lord Botetourt), 143
Beverly, Robert, 107
Beverly, Robert of Blandfield, 51, 75, 92, 107
Bicknor Court (Glos.), 87
Bigsweir House (Glos.), 11, 20, 33, **34**, 55, 91,
Bishop's House (Glos.), 38, 77, **78**
Bishopsworth Manor (Somerset), 48–50, **49**, 87
Black, William, 131–2
Blandfield, (Virginia), 51, 75, 92, 107
Blathwayt, William, 48
Bodleian Library, 148
Bodley, Thomas, 148
Bodman, Henry, 123–4, 145
Bonnin and Morris, 107
Boodles, 129
Book of Architecture, A (James Gibbs), 44, 75
bookcases, *see* furniture
books and book collecting, 2, 8, 60, 97, 102, 107, 112, 113, 130–3, 134, 135
 account books, 47, 92, 97, 118, *see also* libraries; pattern books
Borsay, Peter, 16
Boston, 7, 16, 22, 23, 28, 61, 107, 112, 123, 152
Botetourt, Lord, *see* Berkeley, Norborne
Bourdieu, Pierre, 96
Bourton House (Glos.), 86–7, 89
Bourton on the Water, 148
Bragge, Major Charles, 141, 143
Brett, Henry, 20, 31, 33, 55
Bristol, 7, 9, 10, 11–12, 13, 14–16, 20, 22, 24, 25, 40, 42, 43, 45, 46, 46, 51, 53, **59**, 60, 61, 80, 90, 92, 93, 95, 103, 117, 119, 123, 133, 135, 142, 143, 144, 147, 148, 151, 156
 descriptions of, 41, 58, 59, 142, 143
 goods made in, 106
 houses built near, 36–9, 44–6, 56, 58–9, 60, 71, 77, 84, 91, 99–101
 inward trade of, 23
 population growth of, 58
 and transatlantic trade, 12, 90, 145, 151

226 Index

Bristol Brass works, 143, 145
Bristol Infirmary, 60, 145, 148
Bristol Yearly meeting, 145
Broadwell Manor (Glos.), 40, 44
Brownshill Court (Glos.), 42, 47, 57, 97, 117, 121, 126, 129, 148
Bryan, John (mason), 43
Buck, Samuel, sketches of Yorkshire houses, 16, 33
Buffet cupboards, 84, **86**, 89, 108, 134
building: architect's estimates, 44
 costs of, 42–3, 45–6
 manuals, 44
Building Acts, London, 1707 and 1709, 37
building status, 7, 12, 18, 35, 41, 156, 158
 definition of, 4
Bush Hill (Penn.), 151
Bushman, Richard, 67
Buttery, 82
Byrd II, William, 35, 130

Cantwell's Bridge (Delaware), 153
Carkesse, Charles, 144–5
Carr, Lois, 113, 114
Carr, Thomas, 46, 154
Carrington, Nathan, 127
Carroll, Charles, 115
Carson, Cary, 157
Carter, Robert 'King', 45, 55, 114
Carter III, Robert, 54
Carter's Grove (Virginia), 90
Castle Godwyn, *see* Paradise
Catchmay family, 33
Cato Major, 130, **132**
ceilings, 26, 101, 109
 decoration of, 89, 90, 92
 height of, 26
cellars, 42, 66, 87, 102, 120
ceramics, 106, 107, 109–11, 134, **Plate VII**, *see also* China
chairs, *see* furniture
Chalkley Hall (Penn.), 77
Chamberlyne, Thomas, 146
Champion family, 24
Champion, Martha (Goldney Vandewall), 18, 19, 60, 143
Champion, Nehemiah, 18, 19, 24, 38, 60, 71, 143, 148, 151
Champion, William, 24, 28, 71, 141, 143, 156
Chantry, The (Glos.), 87, 140
Charleston, 7, 16, 23, 61
Chew, Benjamin, 45, 51, 61, 153
Chew family, 45

China, 133, *see also* ceramics
China (ceramics), 98–9, 107, 110, 112–13, 125, 135
Chinese armorial porcelain, 94, 106, 133, **134**
Cicero, 130
Cirencester, 30, 31, 129
Classical houses, *see* Small Classical Houses
Cleve Hill (Glos.), 141, 143
Clifton, 22, 77, 80, 89, 97, 102, 125, 140, 143
 focus for gentlemanly building, 38, 58–9, **59**
 gardens in, 66, **70**, 103
 'Clifton' (poem), 38, 59, 66, 125
Clifton Court (Glos.), 18, 38, 44, 59, 60, 71, 143, 151
Clifton Hill House (Glos.), 19, 38, 42, 43, 45, 51, 59, 60, 77, 80, 90, 92, 102, 112, 140
Clifton Wood House (Glos.), 38, 59, 84, 89, 92
Cliveden (Penn.), 45, 51, 61, 153
closets, 82, 89, 90, 92, 93, 98, 102, 117, 121
cloth trade, 1, 9, 11, 16, 36, 53, 56, 70, 91, 133, 142, 145
 value of, 47, 57, 126, 129
Clutterbuck, Edmund, 135
Clutterbuck, Richard, of Frampton Court, 11, 21, 38, 39, 40, 42, 44, 51, 66, 91, 92–4, 97, 104, 106, 116, 118, 133–5, 144–5, 146, 147, 148, 156, **Plate VIII**
Clutterbuck, William, 66, 116, 133, 140, 141, 144–5, 147
Coalbrookdale, 24, 143
Coats of arms, 51, 106, 116, 117, 133, 135
Cocks, Sir Richard, 33
Cohen, Deborah, 114
Colchester, Maynard, 141, 147
Coleshill, 11, 33
colour, 89, 90–1, 94, 109, **Plate V**
 hierarchy of, 91, 102
Commissions of the Peace, 21–2
Complete Book of Architecture, A (Isaac Ware), 90
Consumption and consumption
 literature on, 5, 96
 practices, 36, 44, 96–7, 106–7, 111–15, 118, 122
Conway, 1st baron, Francis Seymour-Conway, 33, 42, 55
Corfield, Penelope, 56, 142, 154
Cornbury, viscount, Edward Hyde, 67
Cossins, John, 38, 39–40, 46, 51, 60, 122

Cote (Glos.), 20, **37**, 51, 60, **85**, 89, 91, 95–6, 97, **99**, **100**, 112, 149
 description of, 37–8, 99–102, 120
Cotswolds, 1, 10, 11, 15, 40, 43
country houses, 4, 5, 6, 7, 8, 12, 16, 20, 33, 35, 47, 48, 50, 53, 55, 57–8, 60, 61, 63, 73, 74, 75, 118, 122, 123, 130, 155, 156–7
 building campaigns of, 12–13, 23, 36, 42, 44–5
 inventories and contents of, 108, 113–14, *see also* 'house in the country'
Cowles, Francis, 121
Coxe, Charles, 31, 121, 122
Cradock, Dr. William, 147
craftsmen, 11, 28, 30, 43–4, 94
Crowcombe Court (Somerset), 45
Custom house (Bristol), 123–4, 135, 142, 143, 144
Customs service and officials, 37, 38, 39, 55, 95, 101, 102, 123, 133, 141, 143 154
 Commissioners of Customs, 145

Darby, Abraham, 143, 145
De La Bere, Kinard, 147
Defoe, Daniel, 12, 129, 142
Delany, Mary, 66
Delaware, 16, 19, 153
Delaware Valley, 47
Delft tiles, 84, 125
desks, and desks and bookcases, *see* furniture
Dinah, 121
Ditchley Park (Oxon), 113
Dolphin, John, 63, 148
domestic interior, history of, 6, 7, 90, 96, 99
domestic space, men's role in shaping, 6, 96, 103, 120
Donn, Benjamin, 58–9
Dowry Square, Bristol, 36
Drayton House, (Northants.), 114
Drew, Richard, 121
Ducie, Lord and Lady, 147
Dudbridge House (Glos.), 40
Dumbleton Hall (Glos.), 33
Dutton family, 146
Dutton, Sir John, 146–7
Dyrham (Glos.), 48, 90, 92

Eagles, Robert, 146
Eastbach Court (Glos.), 43, 45, 89, 92

Elbridge, John, 22, 39, 40, 47, 91, 96, 97, 103, 112, 113, 114, 119, 143–4, 145, 149, 156
 auction of goods of, 145
 bequests of, 95, 121, 123–4
 death of, 123, 145
 ownership of Cote, 37–8, 99–102, 120
 philanthropy of, 148
Elbridge, Thomas, 123, 124
'Empire of Goods', 5
English Urban Renaissance, 3, 16, 36
Ephraim Williams House (Mass.), 40, 70
Eshott Hall (Northumb.), 16, 46, 154
estates, landed, 7–8, 13, 18, 20, 22, 28, 33, 35, 46, 48, 50, 53–7, 60–1, 67, 72, 80, 118, 122, 133, 137, 140, 149, 154, 156–7, 158
Evans, Anne, 121
expenses, household, 46, 122, 126, 129
Eyford House (Glos.), 63, 148

Fabricius, Johann Albrecht, 152
Fairford Park (Glos.), 24, 33, 43, 63, **64**, 147
Fairhill (Penn.), 67, 130, **Plate IV**
Fane, Thomas, 145
Fassett, Thomas, 38
Ferguson, Elizabeth Graeme, 66, 125
financial responsibility/hardship, 20, 45, 46, 47, 52, 142, 143
financial resources of builders and owners:
 commerce, 23, 38, 46–7, 56
 professional service, 23, 46, 55
 slave trade, 6, 12, 16, 45, 47, 150
 tobacco, 45
Finch, Lady Charlotte, 125
finishes, interior, 4, 8, 73, 88–94, 111, 114
firearms, 97, 127, 128
Fisher, Paul, 19, 22, 38, 45, 51, 59, 60, 91, 97, 102, 112, 140, 148
floor plans, 1, 2, 4, 44, 73, 75–9, 81, 90, 112, 119, 155, 157–8
 double-pile, 26, 38, **76**, **78**, **79**, **99**, 103, **108**, **111**
 relationship between exterior and interior, 66, 80
floors
 brick, **83**
 parquet, 89, 92
 stone, 77, 89, 92
 wood, 89
Forest of Dean, 10, 11, 40, 43
'formal house', 75
Fort Johnson (New York), 137, **138**

Foster-Hutchinson House (Mass.), 28, 107, 153
Frampton Court (Glos.), old, 66, **67**, **68**, 82, 116, 144
Frampton Court (Glos.), new, 11, 21, 38, **39**, 40, 42, 43, 44, 51, 55, 66, **69**, 77, 80, 84, 87, 89, 91, 92–4, 97, 104, 106, **116**, 117, 133–5, 156
Franklin, Benjamin, 2, 130, 131, 132, 133
Frenchay Manor (Glos.), 24, 43, 61
furniture
 bookcases, 106
 camera obscura, 103, 125
 chairs, 97–104, **105**, 106–11, 115, 120, 121
 chests, 92, 99, 102, 103, **104**, 106, 109
 clock jack, 151
 clocks, 101, 107, 112, 113, 120
 desk and bookcase (also scrutore), 98, 102, 108, **110**
 globes, 103
 looking glass, 98, 101, 103
 sconces, 100, 101, 109
 tables, 98, 100, 101, 103, 117, 120, 121, 123, 124, 125, 133, 134, 135, 137

Gainsborough, Thomas, 129
gardens, *see* landscapes and gardens
garret (garrats), 87, 102
gender, 6, 20, 99, 119–20, 126, *see also* domestic space
General Court of Boston, 22
gentility, 4–5, 7–8, 48, 51, 57, 63, 70–1, 82, 87, 94, 95–6, 107, 111–14, 117–18, 119, 123, 126, 135–6, 141, 142, 152, 155–6
Gentleman Instructed, The, 102
Gentleman's Calling, The, 102
Gentleman's Daughter, The, 157
gentlemen
 backgrounds, 18
 life-cycle, 18–20
 office-holding, 21–3
 and politics, 139, 141, 143, 146–8
 religious affiliation, 23–4, 139, 142–3
gentlemen clothiers, 15, 25, 47, 51, 56, 70, 91, 117, 126, 142
'gentry house', 15–16, 26, 30–6, 40, 48, 53, 54, 55, 63, 72, 117, 156
gentry, landed, 1, 5, 6, 9, 10, 11, 18–19, 20, 21, 23, 24, 28, 37, 51, 54–5, 60, 64, 74, 77, 94, 108, 121–2, 129, 140–1, 143, 144, 148, 149, 157
 colonial gentry, 45, 52, 67, 97, 122, 152, 154

international culture of, 5, 139, 152
'parish' and 'county' gentry, 141
possessions of, 112–14
geography, 9, 10–11, 14–15, 43, 90
Germain, Lady Elizabeth, 114
Germantown (Penn.), 61
 battle of, 153
Gibbons, Grinling, 89
Gibbs, James, 44, 75, 81, *see also A book of architecture*
gift-giving, *see* sociable routines
gilding, 48, 92, 100, 101
Girouard, Mark, 7, 63, 75, 84, 121
Glamorganshire, 77
Glasgow, 23
glass, 101, 106, 110
 window, 151
Gloucestershire, 13, 23, 27, 28, 33, 40, 48, 53, 55, 56, 61, 64, 70, 71, 77, 91, 103, 113, 133, 141, 147, 153
 core sample of houses and builders and owners, 8, 9, 18–23, 36–8, 43, 46, 54, 58, 86, 90, 99, 112
 description of, 10–12, 126
 map of small classical houses in, **14**, **15**
Goldney II, Thomas, 24, 38, 59, 60, 89–90, 124–5, 142, 151
Goldney III, Thomas, 22, 59, 60, 66, 80, 84, 91, 97, 103, 112, 120, 121, 125, 135, 140, 143, 148
Goldney House (Glos.), 38, 59, 80, 89, 92, 103, 112, 125, 142
Gomme, Andor, and Maguire, Alison, 75
Gordon, Lord Adam, 137
Governor's Council (Mass.), 22
Governor's Council (New York), 22
Governor's Council (Virginia), 40
Governor's Palace (Virginia), 6, 22, **35**, 43, 45, 107, 119, 150
Graeme Park (Penn.), 67
Graeme, Thomas, 67
grottoes, 59, 66, 71, 143
Guillery, Peter, 5
Guy Park (New York), 137

Halfpenny, William, 43–5, 60
Hamilton, Andrew, 151
Harford, Joseph, 20, 24, 143
Harrington, William, 148
Hawker, Richard, 40, 56, 91
Heacham Hall (Norf.), 45
Hearths, number of, 77
Herman, Bernard, 75

High Sheriff, 21, 129, 141, 154
Hill House (Mangotsfield, Glos.), 22, 24, 43, 61, 77, 147
Hill House (Rodborough, Glos.), 40, 42, 117, 129
Hodges, John, 22
Homosociability, 123
Hood, Graham, 6
Hort, Ann, 20, 149–50
Horton, Thomas, 33
Houghton Hall (Norf.), 146
'house in the country', 7, 53, 57–8, 61, 156
House of Burgesses (Virginia), 22
House of Commons, 21, 22
 'household family', 119
 households, 2, 4, 6, 18, 94, 96, 97, 106, 112, 114, 117, 124, 127, 157
 organization of, 75, 81–4, 87, 101–2, 118–21, 135
Hudson Valley, 23
Hunt, Margaret, 118
Hutchinson, Thomas, 22, 107, 153
Hyett, Benjamin, 55, 63, 124
Hyett, Charles, 43, 46, 55
Hyett, Nicholas, 55, 64

identity, 4, 5, 6, 13, 95, 117, 121, 122, 123, 124, 140, 149, 151, 153
images of houses, 54
income, 13, 46–7, 60, 129, 158
 estate, 1, 7, 33, 47, 55–7
 from slave trade, 47
 offices, 46, 55, 133, 141
Indian Banks (Virginia), 35
interiors, 5, 6, 7, 26, 30, 45, 48, 66, 73–4, 95–6, 97, 99, 103, 119, 125, 130, 133, 143, 157
 arrangement of, 74–81, 81–4, 86–8, 92–4
 finish of, 84, 88–92

japanning, 48, 92, 94, 99, 101, 102
Jeff, Thomas, 121
Jefferson, Thomas, 151
Jeremiah Lee Mansion (Mass.), 40, **41**, 45, 92, 117
Jervis, Richard, 122, 148
Johnson, Guy, 137
Johnson Hall (New York), 56, 87, 107, 120, 137, **139**, 151, 153
Johnson, Sir John, 153
Johnson, Sir William, 22, 56, 107, 117, 130, 137, 151, 153
Jones, Henry (poet), 38, 59

Jones, Inigo, 28
Justice of the Peace (JP), 21, 22, 55, 154

Kempsford Manor (Glos.), 33
Kent County (Delaware), 16, 19
Kings Weston (Glos.), 48, 50
Kingsley, Nicholas, 13
Kip, Johannes, 31, 54, 63
kitchens, 66, 74, 82, 84, 86–7, 93, 98, 102, 120, 127, 136
 equipment in, 120
Kiveton (Yorks.), 114
Knyff, Leonard, 54

Lambe, James, 24, 63, 147
Lambe, Mrs (Esther), 63
landscapes and gardens, 33, 46, 48, 53–4, 59, 63–72, **64–5**, **67–70**, 80, 87, 88, 93, 103, 125, 135, 143, 150, 156 **Plate II**, **Plate III**, **Plate IV**
Landsman, Ned, 155
Latrobe, Benjamin, 51, 92
Lee, Jeremiah, *see* Jeremiah Lee Mansion
Lee Hall (Liverpool), 45
Lee, Thomas, 130, 131
Leeds, 16, 23, 25, 56
Lewis, Judith, 119
libraries, 23, 44, 93, 97, 130, 133, 148, *see also* books and book collecting
Lichfield, 2nd earl of, 113–14
Liverpool, 7, 16, 19, 23, 45, 47, 58, 60, 123
Lloyd, Robert (poet), 51
 'Cit's Country Box', 51
Logan family, 121, 151
Logan, James, 2–3, 19, 22, 23, 24, 41, 42, 47, 51, 56, 61, 67, 91, 107–11, 113, 119, 124, 130, **131**, 132–3, 135, 143, 145–6, 150–1, 152 156, 158, *see also* Stenton
Logan, Sarah, 3, 109–11, 151
Logan, William, 124, 151
Loganian Library, 23, 148
London Magazine, 58
Lower Slaughter Manor, 21, 26, **27**, 33, 42, 43, 46, 82, 84, 86, 87, 91, 92, 97–9, 102, 112, 114, 117, 121, 122
Ludwell III, Philip, 40
Ludwell House (Virginia), 40

Machen, Edward, 45
Macky, John, 58
Macphaedris, Archibald, 40, 107

Marblehead (Mass.), 40–1, 45, 92, 118, 148
marriage, 18–19, 40, 60
Maryland, 24, 107, 113, 152
Massachusetts, 16, 22, 40, 41, 45, 46, 70, 92, 107, 118, 120, 130, 148, 153
material culture approach, 3, 6, 8, 96, 155, 157–8
Medford house (Glos.), 28
Medford (Mass.), 61, 107, 148
Melton Constable (Norf.), 50
Members of Parliament (MP), 21, 141
merchants, 4, 6, 8, 15–16, 18–19, 20, 23–4, 37, 41, 45, 48, 56, 58, 59, 60–1, 74, 91, 106, 112, 114, 115, 122–3, 142–3, 150, 152, 153
Middling Sort, 1, 5, 139, 140, 157
'Modern-built house', 1, 2, 8, 72, 119, 136, 155
Monmouthshire, 11, 55
Mooney, Barbara, 19, 22, 45
Moore, Rebecca, 38
Moore, Thomas, 37–8, 60
Mt Pleasant (Penn.), 45, 80

Native Americans, 2, 130, 137, 146, 151
Nelson House (Virginia), 43, 77
Nelson, Thomas, 43
Neptune, statue of, 71, 143
Nether Lypiatt (Glos.), 31, **32**, 75, **76**, 77, 121, 122
New England, 16, 23, 24, 40, 47, 115, 118, 143, 145, 150
New York, 22, 23, 56, 67, 107, 120, 137–8, 139
Newcastle, 23
Nibley House (Glos.), 90, 92
Nomini Hall (Virginia), 54, 70, 82, 130
Norris, Sr., Isaac, 67, 70, 130
North America, 9, 12, 23, 36, 41, 61, 70, 89, 90, 106, 108, 130, 139, 145–6
North, Roger, 35, 50, 51, 57
Northumberland, 16, 46, 154
Northumberland, duchess of, 66

Oeil-de-boeuf window, 1
offices, *see* outbuildings
Okill, John, 19, 45
Oldmixon, John, 66–7
outbuildings, 1, 31, 38, 46, 66, 70, 87, 119, 120, 135, **138**
　barns, 46, 63, 66
　coach houses, 87, 102, 120
　coal house, 66, 87
　dovecote, 64
　garden houses, 87
　laundries, 66, 93
　necessary ('Little House'), 66
　offices, 1, 44, 59, 66, 77, 81, 87, 88, 92, 93, 94, 119
　orangery, 44, 66
　stables, 42, 46, 66
　storehouses, 87
　summerhouses, 71, 87
　woodhouses, 87, 120

Packer, Daniel and Mary, 147
Painswick, 1, 43, 47, 56
Painswick House, also Buenos Ayres (Glos.), 43, 55, 63, 64
paint, 40, 46, 89, 99
　colours and prices, 90–1, **Plate V**
paintings, *see* pictures
Palladianism, *see* architectural style, Palladian
Palling, Mary, 126
Palling, Sarah, 126
Palling, Thomas, 33, 56, 91
Palling, William, 47, 56–7, 91, 97, 103–4, 117, 121, 126–9, 135, 142, 148
panelling, 26, 42, 48, 84, 89–90, 93, 94, 100, 101, 103
Paradise (Castle Godwyn), 1, **2**, 7, 20, 40, 43, 47, 53, 56, 64, **65**, 81, 158
parlours, 26, 77, 82, 84, 89, 91, 94, 100, 102, 103, 108, 110, 114, 117, 125, 143
　Great Parlour, 82, 89, 90, 92, 98, 99, 100, 102
　Little Parlour, 82, 98, 99, 101
pattern books, 43–4, 134
Paty, Thomas, 43, 92
Paul, Sir George Onesiphorus (G. O.), 42, 61, 124, 129, 130, 146
Paul, Sir Onesiphorus, 40, 42, 51, 56, 61, 91, 117, 129, 142
peers, 18, 20, 140
Penn family, 2
Penn, Lady Juliana, 125
Penn, Thomas, 41
Penn, William, 16, 22, 56, 66, 122, 151
Pennsbury Manor (Penn.), 16, 33, 56, 122
Pennsylvania, 2, 3, 12, 16, 19, 22, 23, 24, 33, 56, 61, 66, 67, 77, 90, 107, 108, 111, 115, 120, 124, 125, 130, 143, 145, 152
Philadelphia, 2, 3, 7, 12, 16, 22, 23, 24, 43, 45, 47, 50, 51, 58, 61, **62**, 67, 77, 80, 83, 86, 88, 107, 108, 109, 112, 119, 122, 123, 131, 142, 151, 152

pictures, 64, 97, 100, 101, 112, 113, 125, 129, 134, 135,
 landscape paintings, 64, 103
 miniatures, 98
 overmantel, 84, 90, 94
 portraits, 97, 103, **131**, 134, 148,
 Plate VIII
Pinchbeck, 135
Pitchcombe house, 33, **34**, 57, 64, 87,
 Plate III
planters, 18, 23, 35, 45, 46, 47, 56, 61, 70, 71, 77, 89, 107, 115, 122, 130, 150, 152, 153
plate, *see* silver
Pococke, Bishop, 11, 63
polite architecture, 5, 28, 79
polite threshold, 5, 26, 45
politeness, 8, 28, 58, 70, 71, 84, 118, 126, 135, 155
 and good breeding, 118
Pope, Alexander, 58
portraits, *see* pictures
Portsmouth (New Hampshire), 40, 107
Poulton Manor (Glos.), 23, 28, **29**, 30, 64, 87
Pratt, Roger, 11, 33, 90
Prince Street, Bristol, 36
Provincial Council (Pennsylvania), 2, 22
Puritans, 16, 23, 24

Quakers, 20, 22, 23, 24, 37, 40, 60, 71, 115, 120, 125, 140, 142, 143, 145, 147, 151, 152
Queen's Square, Bristol, 36
Queensware, 107
Quoins, 26, 30

race, 6
Ragley Hall (Warwicks.), 33
Randolph III, William, 35
Redland Chapel (Glos.), 44
Redland Court (Glos.), 38, **39**, 43, 46, 51, 60, 65, 77, 80, 92, 122
repairs, to buildings, 46
Repton, Humphrey, 71
Ridgeley family (Delaware), 19
Ridgeley, Nicholas, 19
'River God' families (Mass.), 22, 40, 46, 107, 115
Robins, Thomas
 painting of Painswick (Buenos Ayres), 63, **Plate II**
Rococo, 63, 90, 92
Rooke, Admiral Sir George, 33
Rooke family, 113, 147

Rooke, James, 11, 20, 33, 91
Rosewell (Virginia), 6, 77
Rothery, Mark and Stobart, John, 48
Royal African Company, 12
Royal Fort (Glos.), 43, 77, **79**, 90, 92
Royal Magazine, 138
Royall, Jr, Isaac, 22, 148
Royall, Sr., Isaac, 61, 70, 107, 120, 150
Rudder, Samuel, 10, 50, 51, 54, 58, 63, 64, 133, 134
Ryston (Norf.), 45

Sabine Hall (Virginia), 45, 77
St James's Square, Bristol, 36
St Michael's Church Marblehead, Mass., 148
St Michael's Hill House (Glos.), 91
St Peter's Church, Bristol, 38
Salmon, William, 90
Sandywell Park (Glos.), 31, **32**, 33, 42, 43, 55
Scull, Nicholas, and Heap, George, 61, **62**
sealing wax, 116
Searcher (Customs office), 40, 46, 133, 144, 147
segmental arches, 37
segmental pediment, 1, 28, 30,
Selwyn, George Augustus, 129–30
servants, 8, 23, 38, 47, 66, 74, 82, 87, 101–2, 117, 119–20, 123–4
 enslaved people as, 23, 47, 71, 119, 120, 121
 halls for, 87, 102, 120–1, 126, 127, 129, 135–6
 indentured, 23, 47, 119
 wages, 129
service, 123, 127
 buildings, *see* outbuildings
 segregation of service spaces, 64, 66, 70–1, 77, 80, 84, 86–7, 94, 102, 103
 service space as 'backstage', 120
 yard, 64
Severn river, 10, 11
Severn, Vale of, 10
Shell decorations, 59, 66, 84
Shirley (Virginia), 77
Shropshire, 28, 33, 121, 140
silver (plate), 97, 98, 103, 106, 107, 108, **109**, 112, 114, 125, 129, 135, 145
slave trade, 6, 12, 16, 45, 47, 150
slipps, 91, 97

small classical houses, 1, 3, 4, 5, 10, 51, 53–4, 60–1, 119, 141, 148, 152, 153, 155–8
 construction patterns, 11, 12–17, 18, 20, 23, 28, 36–44, 55–6, 122–3
 contemporary terms used to describe, 51
 description of, 1, 7, 74, 82, 140, 142, 150
 flexibility of arrangement, 47, 73, 74–9
Smith family, 43
Smith, John, 130
Smith, Robert, 38
Smyth, Anne, 48, 87
Smyth, George, 92
social mobility, 4, 7, 8, 10, 25, 52, 57, 74, 140, 153, 155, 156, 158
sociable routines, 6, 8, 75, 103
 book collecting, 102, 130–3, 152
 gift-giving, 142, 147
 letter-writing, 117, 122, 123, 126, 133, 144, 147, 148, 149
 tea-drinking, 84, 99, 108, **109**, 116, 133
Society of Friends, *see* Quakers
Somerset, 11, 61
South Carolina, 16, 58, 107, 113, 153
Southey, Robert, 141
Southwell, Edward, 48
Spotswood, Alexander, 150
Springett, William, 40, 121
stage sets, architecture and interiors as, 8, 17, 117, 120
stairs, 4, 43, 75, 85–4, 89, 92, 93, 121, 127, 134
 main staircases, 26, 46, 75, 77, 79, 82, **83**, **100**, 101–2, 103, 108, 135
 back or service stairs, 46, 83, 87, **88**, 93, 102, 119, 121
Stapleton Court (Glos.), **80**
Stapleton Grove (Glos.), 20, 24
status
 enactments of, 117–8, 130, 157
 uncertainty about, 40, 135, 149, 152
Stenton (Penn.), 2, **3**, 6, 7, 19, 41, 42, 47, **50**, 51, 56, 61, 84, 90, 107–11, 119, 120, 121, 124, 130–3, 150, 152, 156
 back stairs, **88**
 Blue Lodging Room, 111, 130
 entry hall, 77, **83**
 floor plans, **108**, **111**
 Parlour, **86**, 108
 Yellow Lodging Room, 108–9, 110, **Plate VI**
Stocking, Thomas, 92

Stone and Stone, Lawrence and Jeanne Fawtier, 4, 8, 74, 157
Stoneleigh Abbey (Warwicks.), 45, 114
Strahan, John, 39, 40, 43, 44, 48, 60
Stranover, Tobias, 125
Stratford Hall (Virginia), 130–1, 133
Strong, Valentine, 26, 33, 43
Stroudwater valleys, 9, 11, 14–15, 25, 56, 70, 115, 126, 153
 cloth manufacturing in, 1, 53, 117, 142
study, 82, **93**, 103, 117, 125
Superintendent of Indian Affairs, 22, 137
'superior features' (architecture), 26
Swift, Jonathon, 141

Talbot, 1st baron, Charles Talbot, 43, 63
tapestry hangings, 89, 91, 106
tenants, 23, 55, 126–7, 149, 154
textiles, 89, 91, 97, 102
 calico, 101
 camblet, 101
 chintz, 101, 102
 damask, 98, 103, 108, 109, 110
 price of, 103
 silk, 101, 103
 wool, 10, 56, 101, 109
tobacco, 6, 18, 47
 'tobacco tonges', 101
townhouses, 16, 129
Townsend, William, 1, 3, 40, 53, 56, 158
Tracy, Thomas, 33, 55
Trent House (New Jersey), 33, 47, 87
Trent, William, 47
Tucker, Josiah, 70, 142
Tully, George, 43
Turkey carpets, 98
Turkey work, 100
turnpikes, 11

upholsterer (upholder) and upholstery, 91, 101, 110
Urchfont Manor (Wilts.), 28

Vanbrugh, Sir John, 48, 50
Vickery, Amanda, 5, 8, 96, 157
villa, 7, 42, 53, 59, 61, 63, 77, 129, 155, 156
 definition of and the small classical house, 57–8, 72
Viner, Henry, 104
Virginia, 6, 16, 18, 19, 22, 23, 24, 28, 35, 36, 40, 41, 43, 44, 45, 46, 47, 51, 54, 56, 70, 75, 77, 82, 84, 92, 100, 102, 103, 107, 113, 119, 122, 130, 131, 133, 143, 150, 152, 153

wainscot, 89–90, 92, 99
Wales, 10, 11, 77, 106, 140
Wales, Prince and Princess of, 129–30, 142
Wallpaper, 89, 91–2
Walpole, Horace, 58
Walpole, Sir Robert, 146
Walsh, Lorena, 48, 114
Ware, Isaac, 38, 43, 59, 60, 90, *see also* *Complete Body of Architecture, A*
Warmley (Glos.), 24, 28, **30**, 71, 143, 156
 manufacturing at, 141, 143
Warwickshire, 11, 20, 31, 45, 114
Westbury on Trym, 37
Westend House (Glos.), 121
Weston, Charles, 140
Westover (Virginia), 35, 77, 90, 130
Whitmore, Elizabeth, 46, 98–9, 112, 114, 122
Whitmore family, 21, 27, 33, 46, 97–8, 102, 121
Whitmore, Richard, 26, 91, 97–8, 112, 121
Whitmore, William, 112
Whitmore, William (General), 42, 46, 84, 122, 148
Whole Duty of Man, The, 102
Whyrall, George, 40
Williamsburg, Virginia, 22, 35, 40, 45, 107, 119, 122, 150

Wilson, Richard, and Mackley, Alan, 7, 13, 48, 57
Wilton (Virginia), 35, **36**, 90
windows, 4, 37, 71
 arrangement of, 26, 28, 30, 78–9, 137
 curtains, 91, 97, 101, 102, 108, 112
Winson Manor (Glos.), 44
Wintle, Mr, 147
wood, 1, 40, 89, 90, 94, 100, 101, 102, 106, 107, 108, 109
 deal, 46, 92
 firewood, 149–50
 mahogany, 84, 89, 90, 92, 98, 99, 100, 102, 103, 107, 108, 109, 120, 125, 143
 oak, 46, 89, 90, 93, 99, 100, 101, 102
 walnut (bannut), 100, 101, 102, 103, 107, 109, 115, 120
Woodes Rogers expedition, 142
Woolnough, Rebecca, 95–6, 99, 149
Wotton (Glos.), **31**, 33, 77, 80, **81**
Wye river, 10, 33

Yokota, Kariann, 157
York County (Virginia), 107
Yorkshire, 16, 33, 114, 140
Young, Arthur, 71

CPSIA information can be obtained
at www.ICGtesting.com
Printed in the USA
LVOW04*0920141115
462575LV00007B/52/P

9 781137 378378